MW01028707

The Content of Our Caricature

POSTMILLENNIAL POP

General Editors: Karen Tongson and Henry Jenkins

THE CONTENT OF OUR CARICATURE

African American Comic Art and Political Belonging

REBECCA WANZO

NEW YORK UNIVERSITY PRESS

New York

NEW YORK UNIVERSITY PRESS
New York
www.nyupress.org

© 2020 by New York University
All rights reserved

References to Internet websites (URLs) were accurate at the time of writing. Neither the author nor New York University Press is responsible for URLs that may have expired or changed since the manuscript was prepared.

Half title page image: © Kyle Baker, *Nat Turner* (detail), Harry N. Abrams, 2006

Library of Congress Cataloging-in-Publication Data
Names: Wanzo, Rebecca Ann, 1975– author.
Title: The content of our caricature : African American comic art and
political belonging / Rebecca Wanzo.
Description: New York : New York University Press, 2020. |
Series: Postmillennial pop | Includes bibliographical references and index.
Identifiers: LCCN 2019030821 | ISBN 9781479840083 (cloth) |
ISBN 9781479889587 (paperback) | ISBN 9781479813636 (ebook) |
ISBN 9781479822195 (ebook)
Subjects: LCSH: African Americans—Caricatures and cartoons. | Racism in
cartoons—United States. | Belonging (Social psychology)—United States. |
Belonging (Social psychology) in art.
Classification: LCC E185 .W27 2020 | DDC 305.800973022/2—dc23
LC record available at https://lccn.loc.gov/2019030821

New York University Press books are printed on acid-free paper, and their binding materials are chosen for strength and durability. We strive to use environmentally responsible suppliers and materials to the greatest extent possible in publishing our books.

Manufactured in the United States of America

10 9 8 7 6 5 4 3 2 1

Also available as an ebook

Colored people and Germans form no small part of the population of Caricature Country. The negroes spend much of their time getting kicked by mules, while the Germans, all of whom have large spectacles and big pipes, fall down a good deal, and may be identified by the words, "Vass iss," coming out of their mouths. There is also a sprinkling of Chinamen, who are always having their pigtails tied to things, and a few Italians, mostly women, who have wonderful adventures while carrying enormous bundles on their heads. The Hebrew residents of Caricature Country, formerly numerous and amusing, have thinned out of late years—it is hard to say why. This is also true of the Irish dwellers, who at one time formed a large percentage of the population . . . in Caricature Country you can always smile, and often laugh, and it is only the natives who have trouble and never the visitors.

—**Frederick Burr Opper, "Caricature Country: Independent"**

But in order to influence public opinion, caricature must contain a certain element of prophecy.

—**Frederic Taber Cooper and Arthur Bartlett Maurice,**
 "A History of the Nineteenth Century in Caricature"

Contents

Color illustrations appear as an insert following page 128.

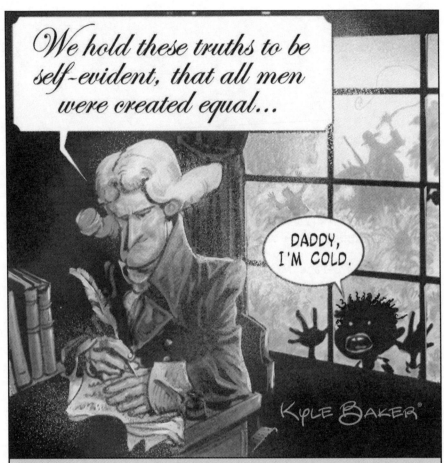

FIGURE I.1. Kyle Baker, "Happy Independence Day!," July 2, 2007. Copyright Kyle Baker.

INTRODUCTION

A Visual Grammar of Citizenship

US citizens are accustomed to the ironic Fourth of July cartoon that calls attention to tensions between what the nation ostensibly stands for and contradictions in its practices. In his 2007 contribution to the Independence Day cartoon tradition, African American cartoonist Kyle Baker depicts a man dressed in eighteenth-century wig and garb writing in his study, immediately recognizable as a caricature of Thomas Jefferson through his speech (Figure I.1). A small figure peers in through the panes behind him, a black inkblot-shaped character with white dots for eyes, white lips, and hair often used on the "pickaninny" figure in racist caricatures. While this grotesque representation has no relationship to real phenotype, readers' knowledge of whom the child references doubly emphasizes the phantasmagoric nature of stereotype. Jefferson had multiple children with enslaved woman Sally Hemings, the half sister of his deceased wife, and this black figure nonetheless evokes their very light-skinned children.[1] The child says, "Daddy, I'm cold," with a silhouetted backdrop of what appears to be an overseer riding a horse and casting his whip toward a slave woman with her arms in the air (the gender signified by the faint hint of the scarf on her head). Black people are outsiders of the Framer's frame, literally and figuratively.

I posted this cartoon on Facebook, and a brilliant African American scholar asked me why I was circulating such an ugly, racist image. She understood why I shared the cartoon after I explained who the creator was and my interpretation. But an image needing explanation even for discerning readers demonstrates the perils of using such representations. Nevertheless it is the grotesque caricature that makes the joke of the editorial cartoon work. The dark humor of the cartoon (pun intended) depends on the black child in the window. Andrew Kunka sees the paneled windows as structuring the cartoon's meaning, leading

the reader, "regardless" of race, to be "positioned inside the house with Jefferson, looking out, thus aligning the reader with the beneficiaries of the freedoms associated with the Declaration of Independence."[2] He also imagines the readers as "aligned with the perspective of the slave owner in that the real violence happens far off in the distance, away from our realm of experience, and in a shadowy silhouette."[3] Nevertheless, the racist caricature upsets identification with the idealized caricature of Jefferson. Because the caricature is the most visceral representation in the image, it *disrupts* the framing (in all senses of the word), foregrounding black injury in the nation's founding.

I begin this book with what may seem like interpretative minutiae to call attention to the occasionally disruptive critical work of racist caricature. Intuitively, we may always imagine racist representations as aligning with racist gazes. However, in this case the black figure makes identification with Jefferson and slave owners challenging, as the meanness of the caricature is a jarring reminder of the representations constructed in the past that haunt the present and still have the capacity to wound. While many of us may want to lock away the grotesque images in this cartoon and never see them again, Baker demonstrates how these images might also be generative in exploring ways to confront the treatment of African Americans in citizenship discourse.

Progressive and reflexive uses of "negative" representations like Baker's risk audiences consuming them uncritically or being condemned by very sophisticated readers. African American comedian Dave Chappelle (who has both resisted and somewhat uncritically circulated stereotypes) once poignantly described this problem as the difference between "dancing" and "shuffling."[4] Comedy and comic art are similar in that they have stereotypes—repetition of a generalized typology—embedded in their foundations, which makes their use of stereotype almost inescapable. But what happens when someone uses the stereotype to challenge the representation? What do we do with a racial caricature that is a mechanism for identification or idealization instead of satire? When is resistance present despite the repetition of the image? Might the focus on positive and negative representations and stereotype as "bad" contribute to an aesthetic flattening out of the work that the denigrating image might do? Perhaps the cartoon speaks to the intransigence of the black grotesque as a nightmare African Americans cannot escape in national discourse, a visual grammar that always haunts attempts at full enfranchisement?

The Content of Our Caricature answers these questions by examining how black cartoonists criticize constructions of ideal citizenship

in the United States and black alienation from such fantasies. African Americans are often rendered as noncitizens or nonrepresentative in relationship to romanticized typologies such as the kind of revolutionary Jefferson models, the soldier, or infantile citizen. Rather than treat cartoon and comic art as obscure ephemera, this book invites readers to recognize the wide circulation of comic and cartoon art in contributing to a common language of national belonging and exclusion in the United States. Editorial cartoons (typically excluded from scholarship about comics because they are usually single panel) often indict bad citizens. The funnies have given us iconographic children to symbolize innocence, a status shored up by the heavy commodification of characters such as Charlie Brown and Little Orphan Annie. Superhero comics sell the ideal citizen soldier, and underground comics interpellate countercultural citizens. These *citizenship genres* are often masculine categories of representation that the state's subjects are interpellated to inhabit. White caricatures are often made a virtue in representations of American identity. In contrast, black caricatures have traditionally shut out African Americans from the kind of idealized excesses that are embraced in discourses of American exceptionalism.

My inclusive understanding of citizenship recognizes the ways in which the "good citizen" is a figure mobilized in a variety of spaces beyond ones attached to legal rights. We are invited to be "good citizens" in school, at work, in our local communities, and in imagining ourselves as part of a national community. My idea of citizenship is drawn from literature that sees it as both full membership in a political community and the "extent and quality of one's citizenship" in particular communities.[5] Richard Bellamy has cautioned people against constructing too broad an understanding of citizenship that includes all kinds of belonging, a narrow definition that ignores the expansive ways in which the word "citizen" is used and the concept is experienced.[6] Seeing voting, as he suggests, as the central prong of citizenship misses how voting rights (although often denied and still quite still precarious) have not produced full legal, political, or social equality.[7] Moreover, political discourse, news media, and popular culture are constantly filled with visual representations of who should and should not be included in the category of citizenship. We should thus examine the role visual culture plays in selling, disavowing, and romanticizing national belonging. Laurence Bobo argues that the "ongoing conundrum" of black life is the question of whether or not "African Americans will ever achieve full, true 'unmarked' citizenship," and I take seriously

the idea of black citizenship as perpetually and visually *marked*.[8] Caricature is a way of excessively marking difference, and these excesses are a means of describing how people are seen and the caricatured subjects' relationship to the communities they inhabit.

Comic art evolves from the tradition of caricature: exaggerated representations of the human face and form. Exaggerated, grotesque representations emerged in sixteenth-century Italian art, but neither the term nor the practice of representation came of age until eighteenth-century Britain.[9] Not necessarily recognizable likenesses of people, caricatures were not only exaggerated faces or body types, but also fantastic depictions of inanimate objects or humans. The latter clearly were a precursor to anthropomorphic characters in many popular comics.[10] Like many eighteenth- and nineteenth-century artists, father of the modern comic strip Rodolphe Töpffer (1799–1846) explored the aesthetic possibilities of the "doodle," communicated excess with streamlined forms, told visual stories in sequential panels, and moved away from realism in exploring how moral character might be written on the face.[11] It is not an accident that caricature and scientific racism emerged in roughly the same period. The enlightenment brought travel literature, phrenology, and many popular systems of classification that argued clear moral and intellectual differences could be discerned from the face and body. Caricaturing racial bodies became an instrument of what I term visual imperialism—the production and circulation of racist images that are tools in justifying colonialism and other state-based discrimination.

African Americans often long for more complex or "authentic" representations—as elusive or impossible as the latter may be. But if we recognize that representational struggles often occur not in attempts at the realistic but in fantastic representations of "real Americanness" in history, film, and news media, then caricature becomes a language used to demonstrate a citizen's value. Baker's cartoon employs this language to push his audience to think about the relationship between the ideal and grotesque representation. By placing a possible black perspective at the center of our reading practice—applying what I call an identity hermeneutic in reading the caricature—we can explore the ways in which some images respond to black degradation and not only replicate it. These representations are part of an expansive visual grammar about citizenship that is deployed frequently in the United States, and Baker and other cartoonists have taken on these injurious images of blackness to deepen our understanding of idealized and undesirable citizenship typologies.

Because caricature is the art of reducing people to real and imagined excesses in order to represent something understood as essential about their character, its work in political cartooning has often been to frame ridiculed subjects as outside the bounds of good citizenship in the nation. At the same time, some caricatures, like that of Jefferson in other contexts, are idealized representations. Caricatures can be about individuals and thus are not the exact same as stereotypes, even as they can also circulate ideas about groups through stereotyping—the reproduction of a generalization about a group over and over again.[12]

I move back and forth somewhat liberally between the use of the words "stereotype" and "caricature," seeing stereotyping as a subset of caricature. Stereotyping is about generalization, a reference to what all of a group is like. Nothing about the stereotype inherently connotes excess. At its root meaning, it simplifies. In my use of "stereotype" I return to and play with the original technological meaning of the word in printmaking, as a repetition of a type, which is characteristic of much of comic art, even if it is not caricature. The multigenerational pleasure in the comics medium has come not only from consumption of the art in itself, but from the expansive visual grammar about identity it gives the audience through this representation of a type of character. This grammar, deployed frequently in the United States, uses racialized caricature as a mechanism for constructing both ideal and undesirable types of citizens.

Scholars frequently discuss the role of racial representations in literature, film, photography, and television in the construction of and resistance to discourses about black identity. But comic and cartoon art have traditionally had a very small role in histories of black representation.[13] Ignoring this tradition means neglecting a visual and political grammar of idealized and ugly typologies explicated in American comic and cartoon art. Baker's caricature compels and repels here, but he is not alone doing that work in the African American tradition of cartooning.

Unfortunately, few people would be aware of this tradition because many works of black comic art are not well known. Scholars working in black comics studies (a field that is larger than some people in the early twenty-first century might imagine) certainly know it, as evidenced by the number of edited collections and monographs dealing with African American comics. Sheena Howard and Ronald L. Jackson's *Black Comics: Politics of Race and Representation*; Frances Gateward and John Jennings's *The Blacker the Ink: Constructions of Black Identity in Comics and Sequential Art*; Deborah Elizabeth Whaley's *Black Women*

in *Sequence: Re-inking Comics, Graphic Novels, and Anime*; and work by leading black comics scholars such as Michael Chaney, Jonathan W. Gray, and Qiana Whitted have shaped black comics studies into a robust field.[14] And yet many of these works focus on cultural histories or pay little attention to aesthetics.

Furthermore, the reputation of comics as "for kids" and unsophisticated has doubtlessly impacted the treatment of cartoonists in overviews of black visual culture histories. Even with its growth in the book industry and status as source material for other media, comics are still often seen as infantile. The proclamation that "comics aren't just for kids anymore" appears routinely in the mainstream press and ignores the long history of multigenerational or adult audiences.[15] Scholars may also avoid discussions of black cartoonists in overviews of a black arts tradition because of the idea that the aesthetic path to better black representational futures eschews the black grotesque and privileges complexity over reductiveness. And as this book shows, caricature's language—visual and linguistic, excessive and indeterminate, mean and stereotyping—has been an indelible part of how citizenship discourses have circulated.

A number of scholars have made a case for the ways in which comics circulate ideology.[16] But comics scholars and a more general audience are often inattentive to caricature as a language of citizenship and site for conflict, despite the occasional high-profile debate over a caricature's political meaning. These genres of citizenship—the child, the solider, the revolutionary leader, the countercultural subject—can be so naturalized that they mask the racialized ideological work of these typologies. An examination of the history of black representation and its absence in that tradition highlights this investment in racial logics on the part of many comic producers and helps us think through how identity can impact the hermeneutics we use to read not only US comics, but popular narratives about what it means to be American.

COMICS PLAYING IN THE DARK

The relationship between race and citizenship discourse is apparent very early in the history of American cartoon art. Cartoon and comic art began to come of age in the United States in the lead-up to the Civil War and during the conflict. The first prominent cartoonist in the United States was inarguably Thomas Nast, who began working for *Harper's Weekly* in 1862. *Harper's* was the most widely read journal during the war, and not a

cultural outlier in circulating representations of heroic citizenship ideals. Racial and ethnic caricatures were prominent features of Nast's work as the "father of the American political cartoon."[17] He depicted noble white Union soldiers during the war and sympathetic, suffering slaves with realistic phenotypes. But after the war, he often depicted the Irish (before they became white) and black people using racist caricature when showing their participation in government. They were a grotesque contrast to white rule. Racist caricature was thus not a side note to US cartooning's emergence. It was central to it.

Editorial cartoons like those Nast produced sometimes had elaborate compositions depicting urban or wartime conflict and would influence the first newspaper comic strips. Advances in printing technology over the course of the nineteenth century would also make it feasible to print cartoons cheaply in newspapers. Richard Outcault's *Hogan's Alley* (1895–1898) is usually (and somewhat controversially) identified as the first successful comic strip with a recurring character in the United States.[18] Outcault had a background in editorial cartooning, and his strips painted gleeful pictures of urban melee, disorder precipitated by the games and squabbles of city children in "Hogan's Alley," or "McFadden's Row of Flats," descending into chaos.[19] Such comics were consistent with European comic strips that were, as David Kunzle explains, "unsentimental, irreverent, and arguably immoral," and that violated the adult bourgeois order in which "good will triumph[s]" and "obedience will be rewarded."[20] There were thus transnational connections between the United States and the European continent, even as American comics would come to dominate the genre and have their own unique comic and graphic style.[21] The strip often depicted an ethnically heterogeneous world, and as Christina Meyer notes, immigrants with "sufficient visual literacy" could enjoy the visual representations without knowing English.[22] The key to *Hogan's Alley*'s success was the Yellow Kid, the first continuing character in newspaper comics, and the diverse world he inhabited.

The Yellow Kid is one of the first examples of the idealized child citizen in comics.[23] Given the fact that he often seemed to create chaos and was often surrounded by it, it may seem incongruous to see Mickey as "ideal." But one of the characteristics of the newspaper comic strip is the precocious, disorderly child, a beloved archetype that circulates across media. The violence and chaos perpetuated by the white child overlays a mask of innocence on top of racial violence. While sometimes seen as Chinese, Mickey was a white character, and a particularly racialized

FIGURE I.2.
Richard Felton
Outcault, "The
Yellow Kid's
Great Fight," New
York Journal,
December 20,
1896. Courtesy of
the Library of
Congress, Serial
and Government
Publications
Division.

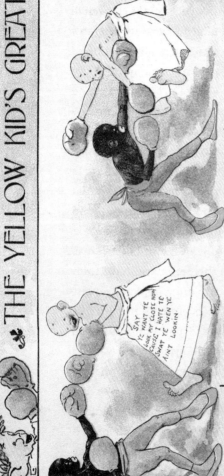

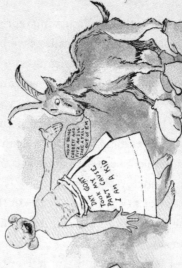

THE YELLOW KID'S GREAT FIGHT.

NEW YORK JOURNAL, SUNDAY, DECEMBER 20, 1896.

example of Mickey functioning as a site of white identification is in one of the more racist strips, "The Yellow Kid's Great Fight" (Figure I.2). In the strip Mickey boxes a young black boy who has the white mouth typically seen on minstrels, as well as simian features. The poem underneath the images of the six-panel strip tells the story of the two having a fight. Other people have names, including the unseen referee, but the featherweight with whom Mickey spars is referred to only as a "nigger" and "coon." The black boxer lands one punch in the second frame, and after that a goat comes into the ring to help Mickey with the fight. The goat eats the "wool" of the black boxer's hair and kicks him through the ropes. Mickey's shirt tells the audience in the last frame, "Dat goat took my part cause I'm a kid."

While the kid and the black boxer are approximately the same size, Mickey's statement suggests that his opponent is not a child, illustrative of the ways in which black children were consistently denied child status or innocence in American visual culture and narratives.[24] A faithful reader of the Yellow Kid's exploits would know that he often perpetuates or is surrounded by violence that he seems to take pleasure in, but it is an urban anarchy that invites the reader's pleasure as opposed to condemnation. The kinds of urban chaotic scenes that the Yellow Kid is at the center of would be neither cathartic nor points of identification for a white audience if the comic had a predominantly black cast of characters. One or two black characters are included in Outcault's urban scenes, but they never seem to cause the chaos. While in other comic strips African Americans were often a source of comical disruption, African Americans causing chaos in the urban landscape of *Hogan's Alley* might be cause for anxiety (even though riots in nineteenth and early twentieth centuries were overwhelmingly started by whites).[25] Depictions of the (white) child in comics and other forms of popular culture often represented an endearing unruliness. But at the same time these representations were circulating of white children, black children were constantly being eaten by crocodiles or experiencing other kinds of violence in US visual culture.[26] The violability of black children's bodies was a major characteristic of popular representations, while the audience was assured that white children in peril would consistently emerge unscathed.

The cartoon also gestures toward the importance of boxing as a mode of demonstrating ethnic and racial pride, a discourse that played out frequently in the popular genre of sports cartoons in the nineteenth century.[27] The sports cartoon was an offshoot of the editorial cartoon,

and boxing cartoons were sometimes not only commentaries on sports events, but meditations on masculine citizenship models,[28] so much so that political candidates were often pictured as boxers in allegorical representations of political bouts.[29] We would see this discourse racialized most profoundly when Jack Johnson, the first black heavyweight boxing champion, would come to dominate the ring in the early twentieth century and flout his wealth and sexual relationships with white women. Many whites saw him as a threat to white civilization.[30]

We see the transnational circulation of Johnson as a threat to whiteness in this G. H. Dancey cartoon from *Melbourne Punch* (Figure I.3). Black and white races are depicted as individuals looking down at the downed James J. Jeffries, with globes for heads. The white race is formally dressed in a suit and hat, looking down sorrowfully, while the black race is shoeless, laughing, and dancing. Johnson's head is only a shadow at the bottom of the frame, with Jeffries's beaten body at the center. The caption, "Knocked Out! Two Ways of Looking at It," might suggest an ambivalence about the racial stakes of the fight, but the minstrel-like look of the "Black World" crafts a representation of black dominance over whiteness as a loss for civilization and dangerous. The shoeless, dancing figure with the toothy grin and arched brows looks vaguely menacing.

The distinction between the sports cartoon and the editorial cartoon could be quite fine, which was particularly apparent when race was an aspect of the reporting. Louis N. Hoggatt, the *Chicago Defender*'s first editorial cartoonist, would perform one of the primary jobs of the black press—counter the discourse in white newspapers—in his more realist depiction of Johnson (Figure I.4). In his depiction of the fight, the African American boxer stands in contrast to Jim Jeffries who is shown to represent not only himself but the work of white supremacy: "prejudice," "race-hatred," and "negro persecution." Jeffries becomes more of a panicked shadow as he bears the weight of racial hatred—despite being surrounded by the "public sentiment" of a white nation. A caricature of a devilish-looking Uncle Sam stands behind the great white hope, smoking a cigarette and representing white supremacist public sentiment. The boxing cartoons were thus about more than narrating a sporting event—they were spaces in which national anxieties and desires about power and citizenship were articulated.

These early comics and cartoons illustrate what Toni Morrison has described as "playing in the dark"—an Africanist presence in the canon of American literature—but in comics contexts.[31] In many comics and

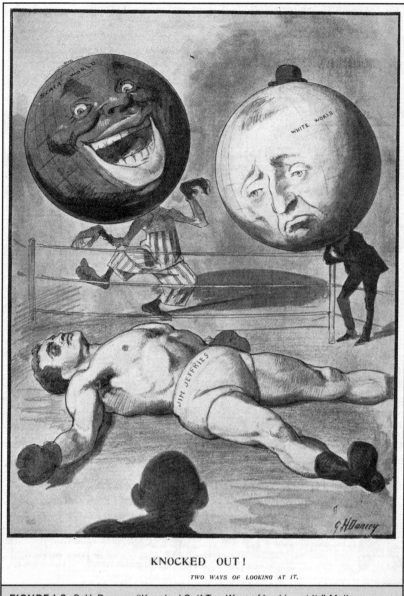

KNOCKED OUT!

TWO WAYS OF LOOKING AT IT.

FIGURE I.3. G. H. Dancey, "Knocked Out! Two Ways of Looking at It," *Melbourne Punch*, July 7, 1910, 23. Courtesy of the State Library Victoria.

cartoons, blackness is the villainous threat to the state, but in a large number of other early important comics, the Africanist presence facilitates white adventure. The characters in *The Katzenjammer Kids* interacted with the fictional King of Bongo and blacks in a foreign land. The protagonist in Winsor McCay's gorgeously drawn *Little Nemo in Slumberland* has an African imp companion on many of his adventures.[32] Such caricatures demonstrated the view of black people as less human

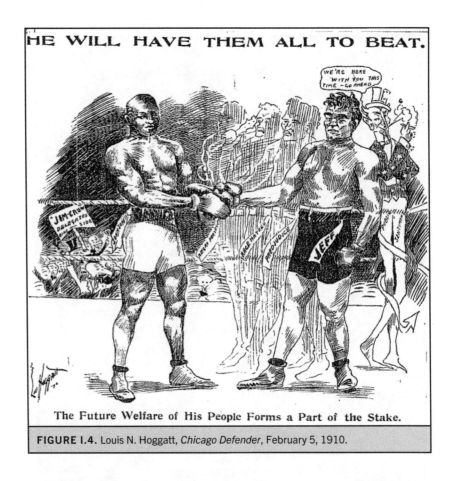

FIGURE I.4. Louis N. Hoggatt, *Chicago Defender*, February 5, 1910.

than white citizens while also functioning as a consistent means of pleasure.

Racial stereotypes were thus common in the early days of the newspaper comics page, which would become the most popular section in American newspapers. The Yellow Kid was the first in a long line of comic strip characters that would have commercial afterlife beyond the comics page or be recognizable references for types of people—Dick Tracy, Brenda Starr, Little Orphan Annie, Hägar the Horrible, Dennis the Menace, Charlie Brown, and Dilbert are a few of the more prominent examples. But many of these characters became well known at the same time that African Americans largely disappeared from the comics pages of the mainstream press after World War II.[33] Eventually the civil rights movement would affect the demographics of comic strips, particularly with the national syndication of Morrie Turner's integrated strip *Wee Pals* in 1965.

Integration often took one of two forms in mainstream comics— either black characters who showed little difference from white

characters, or black characters who still referenced some essentialist understanding of black people. The race-neutral characters speak to a desire to avoid such stereotypes, but their depiction also denied black characters the individuality of their white counterparts. Part of what caricatures provide is the pleasure of idiosyncrasy that nevertheless functions as a site of recognition.

The excesses shape the character into a *caricature*. But blackness complicates excess given the hypervisibility of racism in black representational histories. In many integrated casts of characters, if we tried to imagine black people as having similar excesses that make the character humorous, those same characters would be read as racist stereotypes. This is perhaps best demonstrated by the creation of Franklin in Charles Schulz's *Peanuts* in 1968. Asked by a white school teacher, Harriet Glickman, to introduce a black character into the group to help address the "vast sea of misunderstanding, hate, and violence," Schulz was hesitant because he and other cartoonists did not want to be "patronizing to our Negro friends."[34] But later that year he would introduce Franklin, who often served to observe the idiosyncrasies of the other characters.

Franklin, however, never developed any "character flaws" that would make him a standout character in the strip. As African American newspaper columnist Clarence Page lamented when Schulz ended *Peanuts*, Franklin's "perfections hampered [his] character development. The humor in *Peanuts* is derived precisely from those qualities Franklin did not have. Anxieties, longings, hang-ups and obsessions gave other characters a wholeness of life and an ability to engage and surprise us. Their imperfections reminded us that we all fall short of perfection and touched us in ways that enabled us to identify easily with them."[35] Page acknowledges that Schulz may have been nervous about giving a black character the same kinds of excesses he gave white characters because of a justifiable fear of criticism.[36] If Franklin was a "walking dust storm like Pigpen" or "dancer and dreamer like Snoopy," the "self-declared image police would call for a boycott. If Schulz's instincts told him his audience was not ready for the same complications his other characters endured, he probably was right."[37]

What Page calls attention to is contrary to commonsense narratives about representation by suggesting that *being portrayed as a caricature can be a sign of your humanity*. Being a caricature is not always a bad thing. The caricature conundrum is that in the comic strip, excesses and character failures make them human, so black heroism and ideality can

be another mechanism for limiting representations of black human-ity. And indeed a black Charlie Brown would have been both unimag-inable and problematic for a number of conceptual reasons for those concerned with progress in racial representation. What made Brown revolutionary for the funnies was his melancholy and inevitable failure. Readers can identify with his lack of success and anxiety. A black Char-lie Brown could confirm stereotypes about black failure in an era when black people were constantly working to demonstrate their equal ability.

And yet there is another aspect of Schulz's decision not to craft a more complex black character that is indicative of the ways in which black subjects often fail to be sites of recognition in the white imagina-tion. In an interview with Michael Barrier, Schulz explains,

> I've never done much with Franklin, because I don't do race things. I'm not an expert on race, I don't know what it's like to grow up as a little black boy, and I don't think you should draw things unless you really understand them, unless you're just out to stir things up or try to teach people different things. I'm not in this business to instruct; I'm just in it to be funny. Now and then I may instruct a few things, but I'm not out to grind a lot of axes. Let somebody else do it who's an expert on that, not me.[38]

But Schulz almost immediately contradicts himself. While he expresses disdain for comic strips that explore "social issues," he paradoxically says that the social issues he deals with are "much more long lasting and more important than losing the White House."[39] Moreover, his claim of required knowledge in character development is striking given the well-known girl characters in his comic strip. We are to understand from this argument that he does know or can imagine what it is like to grow up as a little white girl. For Schulz, gender is apparently less of an obstacle to identification than is race. He also implies that a topical strip about urgent political issues of the day must be "grinding axes." Ironically, the creator of the comic strip who arguably best crafted the conditions to imagine childhood melancholy on the funny pages pro-vides little room for a comic that addresses the material conditions that could shape a child's pain.[40]

While mainstream comic strips by white creators would handle inte-gration by producing children who did not traffic in excesses that would be marked as particularly raced, superhero comics initially highlighted the characters' racial identities, often to troubling effects. Marvel's Black

Panther (1966) would be an idealized black hero from a mythical land in Africa that was both part of a decolonial moment and outside of real historical time. Marvel's Luke Cage (1972) would embody a number of inner-city urban stereotypes, even as the comic book criticized white supremacy. If Schulz's Franklin demonstrates the perils of not allowing a black character to occupy the same representational economy of the comic strip characters whose value lies in their foibles and excesses, the superhero comic may demonstrate the perils of occupying the same structures. While these comic books were not color-blind, a foundational principle of the traditional superhero is excessive masculinity and strength as a mark of his ideal citizen-soldier status. Given the history of representing black men with brute strength, it can be challenging to see something politically transgressive about mapping blackness onto the hypermasculinity of the superhero. Comic producers would, however, constantly play with and challenge that stereotype over the decades.

Part of the story of racial integration in superhero comics has continued to be the idea that nonwhite characters challenged identification and marketability. The black experience calls attention not only to what the superhero serves, but to how racially marked their identities really are. If Charlie Brown couldn't be black, and if the logic of caricature in the strip would make a black character politically challenging, the blackening of heroes most identifiable with the superhero comic is illustrative of how superheroes as caricatures of ideals do not carry the same meaning when they are people of color. A number of mainstream superheroes have had black versions—the Green Lantern, Batman, Wonder Woman, Superman, Captain America, and Spiderman. However, some of these versions are in alternative universes, and when they have taken over for canonical white characters, the change has caused controversy.[41]

In 2015 Umapagan Ampikaipakan summed up the resistance to people of color as superheroes in an instantly infamous *New York Times* op-ed in which he explained why he, as an Asian American, felt no need for diverse superheroes: "The current push to draw diversity into comics and add variety to the canon is meant to reinforce the notion that anyone can be a superhero. But that only risks undercutting the genre's universal appeal." He suggests that Asians have too much "cultural baggage" to embody the ethos of the superhero. "By definition," he claims, "the American dream must be accessible to all. However monochromatic its characters, the superhero's message has always seemed universal."[42]

Whiteness functions as the universal in his logic, while other racial identities can be disruptive and distracting, calling attention to history and cultural contexts. Ironically, superheroes of color who are inattentive to their culture or the struggle of their people would be considered unrealistic. But the sleight of hand of the superhero narrative has been the ways in which making the superhero representative of the outsider displaces other outsider narratives that resist the seductive and often deceptive promises of the American Dream. In other words, if part of what the inclusion of nonwhite characters accomplishes in popular genres is challenging universalist narratives about US citizenship and creating new models, the white superhero has often stood in allegorically for people of color and ironically furthered universalist fantasies about national belonging.

The obfuscation of the racialized challenges facing outsiders in the United States is well on display in issue 106 of *Superman's Girl Friend, Lois Lane*: "I am Curious (Black)!" Lois decides she is going to get the "inside story of Metropolis's Little Africa," but when she goes she discovers that none of the black residents want to talk to her. Superman allows her to use his "Plastimold" machine and become black for a day so that she can "get inside" the community. She changes into "Afro attire," and when she returns she discovers she cannot get a cab and feels "conspicuous" because she is on the receiving end of a white gaze on the subway. She learns about the poor housing standards in the ghetto and sees a community activist get shot when he tries to keep white men from peddling drugs to black teenagers. Superman is conveniently on hand to keep Lois from getting hurt and takes the activist to a hospital— salvation that likely would not have happened without Lois's presence. She gives the activist a blood transfusion. He rejected her when he met her as a white woman, but once he learns that the black woman he just met who saved him with the transfusion is Lois, he is shocked but clasps her hand at the end of the comic—the universal, midcentury sign of interracial reconciliation.

The splash page at the beginning of the comic book, however, focuses not on her going into the black community but on whether or not Superman can still desire her as a black woman. Of course this question is the kind of odd logic ascribed to irrational women, as it is clearly a test. She will be black for less than a day, so it is not really an issue. The root of the question is if his love for her is more than "skin deep," and of course Superman expresses that he loves her, but in a way that is less about who she is than who he is. He asks, "Lois—how could

you ask such a question of Me? Me?" In case she (or the readers) might miss why he finds the question shocking, he elaborates, "You ask that of me . . . Superman? An alien from Krypton . . . Another planet? A Universal outsider? I don't even have human skin! It's tougher than steel!" She protests, "But your skin is the right color!"

This comic book explicitly represents Superman's status as the ideal, "universal outsider" while also suggesting that even as an alien he is not as alien as black people. Superman is a caricature of ideal citizenship that people reference in a variety of contexts, and a number of creators in various media have responded to the representation by showing how dissonant other identity categories—blackness, queerness, communist—can be when they try to perform the ideal. Even as an alien, his whiteness is an indelible part of who he is. This issue makes white characters the center of racial narratives because they are the ones who can best represent what it means to be an outsider, understand an outsider, *and* save an outsider. Here, as in many other contexts, black people are often displaced in narratives about discrimination, while also being foundational to the history and narrative framing of prejudice in the United States. White excessive types function as citizen ideals, but black subjects are their shadows.

BEYOND INJURY

This journey through the history of black representation in mainstream comic art may seem like much ado about comics and cartoons, as a considerable amount of cartoon and comic art has been ephemeral. Cartoons and comics also rarely generate headlines. Their status is typically peripheral, about something it references and not about the representation itself. On the rare occasion when the cartoon itself is an object, it is almost always because of an offense. In 1903, the Pennsylvania legislature passed the short-lived Salus-Grady libel law, prohibiting caricatures of political figures.[43] In 1954, the Comics Code was a reaction to representations of violence, sex, and alleged and actual queer subtexts in comic books that children read.[44] In the late twenty-first century, the news media occasionally discussed comics events that were transgressive in some way—a cartoonist who has violated norms or the treatment of an iconic comic book character who marries, dies, or changes race or sexual orientation.[45] And perhaps most infamously in the twenty-first century, gunmen, objecting to the portrayal of Muhammad in the satirical periodical *Charlie Hebdo*, murdered a

number of cartoonists and staff. In the aftermath, heated transnational debates took place about the representation of race and religion in the leftist magazine. Hermeneutical conflict reigned, with leftist allies all condemning the murders but divided on interpretation. In both scholarly and popular circles, people argued over how to read a cartoon.[46] Moreover, how you read the cartoons became a conflict over antiracist politics and progressive commitments.

While less violent and prominent than the *Hebdo* controversy, in 2008 an editorial cartoon in the United States produced similar debates and demonstrated caricature's enduring ability to capture conflicts in citizenship discourse. Caricaturist Barry Blitt depicted the Obamas as seditious citizens in a controversial cover of the *New Yorker* (Figure I.5). Erstwhile presidential candidate Barack Obama stands in the Oval Office with a picture of Osama bin Laden hanging on the wall and a flag burning in the fireplace. Obama wears a turban as he looks shiftily toward the viewer. He bumps fists with Michelle, a gesture the couple made after Obama accepted the nomination as a democratic nominee for president. A common form of intimacy in the African American community also present in athletic spaces and youth culture, the gesture nonetheless inspired some conspiracy-minded conservatives to see terrorism in a movement.[47] Blitt plays with Republican claims that Michelle is a dangerous black radical, transforming her relaxed hair into an Afro, the radicalism of her natural hair accessorized by a machine gun, camouflage pants, and combat boots.

Some people immediately took issue with the image. While the *New Yorker* claimed that Blitt "satirizes the use of scare tactics and misinformation in the Presidential election to derail Barack Obama's campaign," columnists like Rachel Sklar said it was the equivalent to "repeating a rumor":

> Presumably the *New Yorker* readership is sophisticated enough to get a joke, but still: this is going to upset a lot of people, probably for the same reason it's going to delight a lot of other people, namely those on the right: Because it's got all the scare tactics and misinformation that has so far been used to derail Barack Obama's campaign—all in one handy illustration. Anyone who's tried to paint him as a Muslim, anyone who's tried to portray Michelle as angry or a secret revolutionary out to get Whitey, anyone who has questioned their patriotism—well, here's your image.[48]

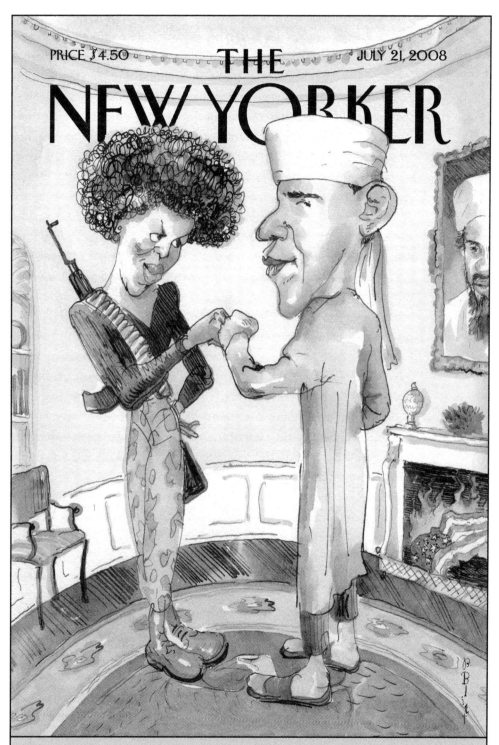

FIGURE I.5. Barry Blitt, "Fistbump: The Politics of Fear," *New Yorker*, July 21, 2008. Courtesy of Barry Blitt and Condé Nast.

Sklar calls the cover an illustration, while others called it a cartoon. This distinction is not insignificant. Medium and genre are incredibly important in terms of making the meaning of the image transparent. If it had been accompanied by Blitt's title/caption, "Fistbump: The Politics of Fear," which was inside the cover page, the tension between the image of the Obamas and the narratives that circulate about them would have been explicit.[49] What I term the *triangulated interpretive structure* of many editorial cartoons would be in place. Cartoons using a triangulated structure depict a subjected person or event of interest, and also show someone else's reaction to that person or thing. Some other referent in the cartoon then positions the reader to make the commentator the true object of the satire. Editorial cartoons often use this structure to criticize power relationships, indicting the perspective of the powerful and aligning the viewer with a different gaze. Language often provides the irony that contextualizes the image.

Of course, not all cartoons have words, and transparency should not be an expectation of art. However, the job of illustration is to help the viewer visualize an idea or narrative, while the editorial cartoon often depends upon satire and works with the tension between image and text. Irony is important to the genre. *New Yorker* editors may have believed that since their magazine was known for progressive politics and readership, the title of the magazine provided the appropriate progressive framing for interpreting the image. People still might have condemned the image itself without the cartoon's title/caption, and conservatives could have taken it up, but that would have required ignoring the clear indictment in the line "the politics of fear." In other words, people who wished to condemn Blitt for having a racist intent and the cartoon as perpetuating stereotypes would thus be narrowing the representational possibilities for attacking racist depictions, suggesting that the replication of the stereotype is always racist.

The controversy provides an opportunity to think about the difference medium and genre make in racial representations. Our interpretation of what "The Politics of Fear" does might vary depending on whether we understand it as an illustration or an editorial cartoon. Illustrations and editorial cartoons may do very different things; being attentive to the techniques and semiotics of cartoon art is important to understanding the work the medium does. But as the pillorying of well-known liberal Blitt illustrates, it can be difficult, even when a creator has the best intentions, to avoid producing pain when depicting black bodies given the long history of visual imperialism that constructs black

bodies as lesser human beings and citizens. And it is this problem that Blitt and many other creators working in a medium that makes use of caricature constantly confront—how do you avoid replicating racist representations or the accusation that you are?

I am ending my jaunt through the history of representation of African Americans in American comic art with the controversy over how to read this *New Yorker* cartoon because this subtle difference in seeing it as an editorial cartoon instead of illustration demonstrates the difference medium can make in reading practices. Like all media, the form does not guarantee the content—and cartoon and comic art have frequently been sites of injurious representation. But the aesthetic tradition of caricature in cartoon art may inherently challenge political commitments of artists who want to contest the history of representation that consistently reduces the complexity of black subjectivity through stereotyping.

Complex subjectivity is what the caricature eschews, which might make comics and cartoon art a particularly messy medium for representing blackness. A surface reading may always mean that any use of stereotype may be, on some level, racist. I mean surface reading in the most rigorous sense, that it is, as Stephen Best and Sharon Marcus explain, "what insists on being looked at rather than what we can train ourselves to see through."[50] Michelle Obama gestured toward this idea when she discussed the *New Yorker* cover years later. In a speech in 2015, she described her struggle to deal with public discourse around her identity: "Then there was the first time I was on a magazine cover. It was a cartoon drawing of me with a huge Afro and machine gun. Now, yeah, it was satire, but if I'm being really honest, it knocked me back a bit. It made me wonder 'just how are people seeing me.'"[51] When she states "it was satire," is she acknowledging the triangular structure of the cartoon and the critique of the right-wing narrative about her, or stating that she is the object of the satire? Perhaps no substantive difference exists between Blitt's intent and her reaction to the caricature. The problem is that the representation still wounded, a reminder that she was seen that way. She was thus "knocked back" affectively, just as that way of seeing her was meant to knock her back politically. Racist caricature can defy context and narrative because it can require people to work against the initial cognitive response of recognition.[52]

While the process of getting the joke can be almost instantaneous in the reader's comprehension (if the triangular structure and cultural knowledge of the reader are present), the representation does

not become something else, even if it is a tool to indict racist gazes or action. The past is always present in the figure, but it is also outside of time, able to travel and adapt. How should black people respond to the resistance to black progress embedded in so many visual representations of blackness? Most African American artists have responded with positive representations; thus, caricature would seem like a practice that black producers would not engage in if they make black bodies their referent.

And yet many black artists and writers have responded to a popular resistance to the burdens of history by using stereotypical representations to explore the relationship between painful black pasts, presents, and precarious futures. Blitt was accused of producing a "tasteless and insensitive cartoon," and I sometimes wonder if the conversation would have been different if the cartoonist had been African American. Perhaps not; as we see with Baker, black cultural producers certainly have created stereotypical images. They have sometimes been described—as Blitt and the *New Yorker* were—as participating in a racist aesthetic tradition. But what happens if we understand some African American producers, and specifically black cartoonists, as crafting a complex, aesthetic reaction to visual attacks on black citizenship through participation in a tradition of racial caricature? The fantastic, as Richard Iton has argued, unsettles the "governmentalities and the conventional notions of the political, the public sphere, and civil society that depend on the exclusion of black and other nonwhites from meaningful participation." By "pushing to the surface exactly those tensions and possibilities" that are "suppressed and denied in the standard respectability discourses," a black fantastic engages in the nexus of the political and popular that is intrinsic to public life.[53]

Not all caricatures, of course, take the form of the fantastic or transparently monstrous. One of the troubling outcomes of the unrelenting history of derogatory black representations is that representations that are "real" can also be seen as stereotypical representations. Depicting a black person as a woman on welfare, an impoverished child in the city, in a crime being committed, a well-endowed man, or even a slave can be characterized as negative caricature because of the idea that these are the predominant representations of blackness. The tyranny of a racist visual imperialism can make everyday lived experience a racial grotesque.

It is this history of the ideal, demonized, and situational grotesque that sets the stage for black comics creators' interventions into this

representational legacy and provides a gateway to the everyday visual vocabulary of citizenship. As I have argued, the oxymoronic nature of the caricature reduces the complexity of a subject to real or imagined excesses. And the capacity of the caricature to resist temporal fixity—they are not easily placed in the past—makes the depictions of blackness in US comic art profoundly melancholic. Wounded subjects may still hold an attachment to that which wounds. African Americans may still hold some attachments to representations of ideal citizenship as love objects that black subjects cannot fully embody or make their own. Baker's cartoon exemplifies this critique of citizenship aesthetics. Jefferson is the visual stereotype of the Founding Father, an ubiquitous, romantic representation contrasted with the black child that is his product and his shadow. The child is tied to him, unseen. And the figure cannot help but evoke repugnance for the reader sensitized to the cruelty of the caricature. The figure is simultaneously that which is ignored by the people who created him, an image that ideally would make the father—or the state—really see the pathological monstrosity that the state has crafted through a founding document that dehumanizes through the fractal framing of black people as less than whole. The black caricature stands in place of real black citizenship, with the ideal figuratively but not realistically in reach. Some nonblack creators have also explored this issue, but it is worth tracing the response of black artists to both ideal and racist caricature as part of a black art tradition.

COMICS GENRES AS CITIZENSHIP GENRES

With my emphasis on caricature, I tweak the focus on sequence in comics studies. I am not attempting to radically redefine commonly used definitions of comics, such as Scott McCloud's most frequently cited (and often challenged) definition of the medium as "juxtaposed pictorial and other images in deliberate sequence, intended to convey information and/or to produce an aesthetic response in the viewer."[54] Instead, I explore how comic art is a medium *in which the use of caricature and other aesthetic techniques to stereotype bodies is essential to constructing meaning. Caricatures work with the various other aspects of cartoon and comic art such as the panel, the gutter, and closure to produce meaning in narrative sequence.* I am not abandoning sequence as essential to the definition of comics, just foregrounding caricature as an essential part of the form. Given the importance of many single-panel cartoons in the history of the field (such as *Hogan's Alley*) and the

fact that many cartoonists have moved back and forth between editorial cartoons and the multipaneled strip, leaving editorial cartoons out of comics studies is a fairly recent disciplinary move.[55] By focusing on caricature, I place editorial cartoons back in conversation with multipaneled comic art.

Caricature traditionally addresses specificity, sometimes of an individual, but above all it is about excess. Some of the artists I discuss play with the dichotomy between idealized white citizens and alienated black subjects. Other artists construct a situational grotesque and demonstrate how it acts on black bodies, moving the grotesque away from the face. In other cases, the artist fully embraces the representation of a black grotesque or other kinds of caricatured excess to comment on the white pathologizing gaze. Many cartoonists address this structural challenge—how do you construct a picture of abject or pathological blackness to illustrate a white grotesque, instead of perpetuating the injurious image? In many cases you cannot, and the artists explore the representations that perhaps can never be vanquished. But it is in holding up what the white gaze shaped—how Jefferson crafted blackness into monstrosity—that the "object" reveals the monstrosity of its alleged opposite.

The abject opposite of the idealized white citizen in African American comics is, in most cases, black men. One of the surprises of the archival research for this book (which, in hindsight, should not have been a surprise) is that many idealized constructions of citizenship types in the United States are male, and as such the vast majority of the black artists who take up the concerns that are the narrative and aesthetic focus of my book are African American men. This book covers a century of cartooning, but Jackie Ormes (1911–1985) was the first African American woman cartoonist and one of a very small group. Barbara Brandon-Croft (1958–) was the first African American woman cartoonist to be nationally syndicated in the nonblack press. The twenty-first century has seen a substantial rise in African American women cartooning, with artists such as C. Spike Troutman and Afua Richardson gaining higher profiles. Interestingly enough, African American women cartoonists have been less likely to employ the kinds of aesthetic practices of abjection or the grotesque that I explore here. The historical limits of an archive focused on African American producers—in the medium and not just black characters—mean that Jennifer Cruté is the only black woman cartoonist I discuss at length in this book. My considerations of the hero, soldier, and counterculture citizenship address

predominately African American treatments of white masculine typologies, while the chapters on the general discourse of noncitizenship and the black child also explore black women and gender-fluid subjects. But while this book is unquestionably focused on citizenship categories and aesthetic practices that African American male cartoonists engage, I explore how the visual grammar of citizenship highlights how racialized *and* gendered this grammar is.

My first chapter, "'Impussanations,' Coons, and Civic Ideals: A Black Comics Aesthetic," explores how artists such as celebrated *Krazy Kat* creator George Herriman, *Pittsburgh Courier* editorial cartoonist Sam Milai, and contemporary artists Jeremy Love and Valentin De Landro utilize caricature in broad-ranging articulations of how African Americans are marked by noncitizenship status, and explorations of how black subjects negotiate—but perhaps not escape—such discursively shaped bodies. By trying to imagine what a black perspective in the creation of racialized caricature might accomplish, these cartoonists reorient a reading practice that focuses on the injury of the images and turn to the legacy of racism and black reworkings of these representations. In other words, what happens if we look at a racist representation and imagine that the image might be inviting us to think about black liberation instead of dehumanization? Can the racist caricature be used in aesthetic practices of freedom?

While my first chapter focuses almost exclusively on a racial grotesque, the following chapters move between "negative" and "positive" caricatures of blackness, exploring the liminality between such representations in crafting various types of citizens. The foundation of black citizenship is noncitizenship—slave status and later Jim Crow—and "The Revolutionary Body: *Nat Turner*, *King*, and Frozen Subjection" explores the lasting legacy of black subjection in archetypes of black heroism in the white popular imagination. Slaves and, later, the emancipated were typically portrayed as indistinguishable patient supplicants or apes unready for citizenship. The supplicant representation would be the other half of the dehumanizing image, and this caricature of the ideal black aspirant citizen would be present through the civil rights era and, arguably, up to today. The editorial cartoon archive, produced by influential cartoonists like Thomas Nast, aided in this representation of a frozen, noble black subject, whose actions are not radical and who sublimates rage. Two black comic biographies, Kyle Baker's *Nat Turner* and Ho Che Anderson's *King*, are responses to an idealized frozen aesthetic of black subjectivity. This chapter explores how these

cartoonists speak to the limited representation of the ideal black revolutionary citizen, representations that, while not always grotesque, are similarly limiting in positing black complexity or agency.

I continue my discussion of Baker's work in my third chapter, as he is one of the most proficient practitioners of destabilizing our common understandings of black caricature. Written by Robert Morales and drawn by Baker, the 2003 comic book miniseries *Truth: Red, White & Black* is the story of an African American Captain America who takes on the origin story of the legendary character, a scrawny white kid from New York who volunteered to take the army's experimental serum and become a super solider. Inspired by the Tuskegee experiment, an editor at Marvel imagined that the military would have experimented on black soldiers first, and *Truth* was born. Much of the scholarship about African Americans in comics discusses African American superheroes, and I do not retread that work in here. Instead, "Wearing Hero-Face: Melancholic Patriotism in *Truth: Red, White & Black*" places the black Captain America in conversation with the discourse surrounding the African American solider during World War II to explore a kind of melancholic citizenship aesthetic in African American comic art. In this chapter I take a turn toward thinking about the melancholic black subject as a kind of racialized caricature, exploring the ways in which melancholia indicts idealized white citizenship.

The next chapter continues to look at black caricatures as indictments of white caricatured ideals. While optimistic child characters like Little Orphan Annie serve a narrative of infantile citizenship that offers a better future through their representation of innocence, black children across comic genres place pressure on the futurity of the nation given the nation's treatment of children it has abandoned. My fourth chapter, "'The Only Thing Unamerican about Me Is the Treatment I Get!' Infantile Citizenship and the Situational Grotesque," explores how Ollie Harrington, Dwayne McDuffie, M. D. Bright, Brumsic Brandon Jr., Aaron McGruder, and Jennifer Cruté use caricatured representations of black youth to represent the far-from-ideal lives of many children dealing with structural oppression.

While my fourth chapter is about representations that should invite sympathy—the vulnerable child—but do not, my final chapter is about caricatures that abjure fellow feeling. The black riff on unsympathetic, abject comic protagonists engages with a countercultural citizenship model. Some of the leftist comix that emerged in the wake of the Comics Code of 1954 and multiple social movements would embrace both abject

and "equal opportunity offender" protagonists—archetypically modeled by cartoonists like Robert Crumb—and racist caricature with the expectation that the cartoonists were all "in on the joke" of racism and sexism. This early form of equal opportunity offensive humor defines a kind of post–civil rights era liberal, white subjectivity. "Rape and Race in the Gutter: Equal Opportunity Humor Aesthetics and Underground Comix" looks at black underground cartoonists Richard "Grass" Green and Larry Fuller, who were early critics—albeit not explicitly—of the notion of the "post-race" politics of allegedly liberal white citizens. In many ways this chapter speaks to the soul of my book as an intervention in the practice of discarding offensive representations too quickly.

While many of the caricatures I explore in the preceding chapters utilize excess to prompt a sympathetic look at vulnerable black bodies, in my final chapter I look at black cartoonists who largely eschew sympathy and identification by producing caricatures that invite readers to direct the gaze at not only society more broadly, but producers and consumers of racist caricature specifically. And finally, in my coda I turn toward Black Panther comics and the successful film adaptation as an example of the ongoing investment in revision—and not abandonment—of racial caricature and stereotype by black cultural producers.

READING RACIST CARICATURE—IN SEQUENCE

I was once jokingly told, "You are a caricature of yourself." In other words, the commentator was making a humorous observation that the excesses of my performance one day were tied to the identity that people already imagined of me. Most of the time, however, I feel as if caricature is waiting around the corner, the thing that I may move into or that may overtake me. Sometimes it is an identity that I willfully move into—righteously, vengefully—often because I have become undone by microaggressions. The quotidian nature of invisible injury invites excess. Embodying caricature can, for the racial other, become a way of being seen.

African American cartoonist Tom Floyd played with this idea in his 1969 comic *Integration Is a Bitch!* He uses his experiences as a "black white-collar worker" integrating a company to depict a series of moments that, in the twenty-first century, would be categorized as racist microaggressions (and many are transparently macroaggressions). The form of the comic lends itself to understanding the cumulative effect of the offenses. Each page is a self-contained gag cartoon, but

when read in sequence, the fragmentary moments give a whole picture of daily assaults on his sense of self. Initially, black white-collar worker George is smiling when he is "welcomed to industry," and then he settles into perplexed grimaces when he sees that the white man in the dashiki has a "Welcome Soul Brother" placard on his desk, is constantly asked about (or accused of knowing something about) crime, is treated as a token, and is avoided by his colleagues. His face settles into a frown when he is put in the front window so white passersby can see him, is introduced as "our Negro," or is asked constantly about watermelon. The white woman in the office is afraid of him. No one believes he knows anything about his field.

I read Floyd's comic as a response to citizenship projects and interpellations. In the twenty-first century, people are familiar with the language of "corporate citizenship," which involves not only their participation in the community but allegedly better practices of inclusion in the workplace. We are often asked to be "good citizens" at work. Civility is a prong of that citizenship discourse in the workforce, with African Americans often seen as violating civility when we call attention to discrimination. Floyd's work highlights the ways in which the demanded civility can break down in the face of injuries that dismantle the public face of the injured subject.

After seventy-nine pages of incidents, George snaps. He sticks his tongue out at his colleagues. He happily claps at the movies when the black native moves in to kill the white man. He starts asking his white colleagues if they know white criminals. He hails his coworkers as "Bigots . . . Extremists . . . and White Racists. . . ." He intentionally scares the woman who always acts as if he is poised to rape her (Figure I.6). And he punches a colleague.

By the time he stands angrily on the table with clenched fists and yells "Black Power," the reader understands exactly what produced his affect (Figure I.7). But varied readers might respond differently to the single frame in isolation—many people would still read it as having context, while others would need the sequence. Even in sequence, he might seem like an unfathomable caricature of black masculinity or a representation that is disruptive to attempts at integration. George acknowledges this, stating that he probably set integration back a hundred years as he stalks angrily out of an office where he apparently laid his boss out flat.

The last frame is the empty office, paper floating in the air after the force of his departure, white colleagues left behind, puzzled at his rage.

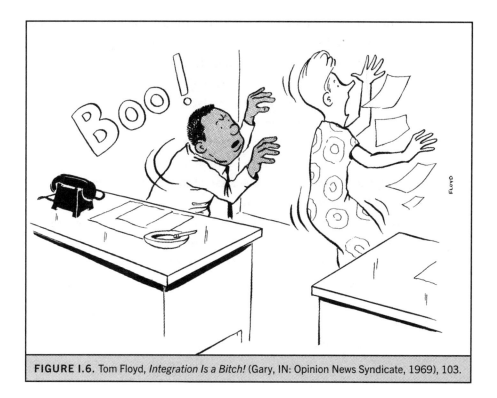

FIGURE I.6. Tom Floyd, *Integration Is a Bitch!* (Gary, IN: Opinion News Syndicate, 1969), 103.

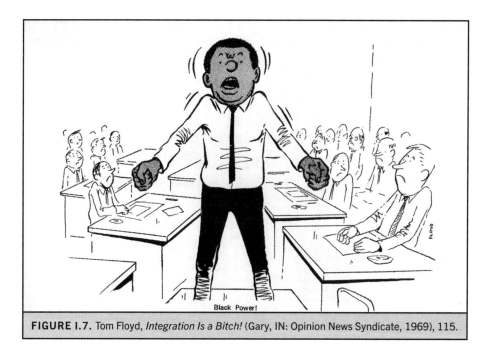

FIGURE I.7. Tom Floyd, *Integration Is a Bitch!* (Gary, IN: Opinion News Syndicate, 1969), 115.

The temporality of caricatures is multitudinous—the ones that will not depart, the ones that we may move into, the ones that evoke the old to create the new. Few people would state that embodying the angry black man in the workplace is a "positive" representation of black masculinity, but here it is, and embracing it provided the first step toward his freedom. I am not suggesting in this book that every racist caricature or stereotype should be embraced by African Americans. But what is clear is that African American cartoonists have made endless use of the wide visual vocabulary of black racial caricature to help us imagine what freedom looks like in its presence.

Many of the racial caricatures I deal with in the book look like this, real black bodies associated with caricatures, but others are real monstrosities. A truism of representing suffering is that recognition is most possible when people are presented with the jarring evidence of the real—real bodies, real people, and real events. But as Phillip Brian Harper argues, there are good reasons for the focus on realist aesthetics in black arts and culture, "but to the extent that this positivist ethic restricts the scope of artistic practice, the realism that underwrites it emerges as a central problem within African American aesthetics."[56] I, too, wish to replace the privileging of the realist aesthetic, but I do so to explore how the fantastic and excessive is a means of approaching real experience and affect. One of our challenges in the project of recognition is the conceptual framing that the "real" can resist. It resists it because so much of what shapes real events are phantasms of hatred and fictions that we must find ways of representing as well. Every day we live with the injuries of the past, constructing our material presents, while we fight to reconceptualize the future. The artists and writers I engage in this book suggest that the complexity of the real requires the fantastic, because the foundation of a history of race relations is clearly nightmares made real.

1

"IMPUSSANATIONS," COONS, AND CIVIC IDEALS

A Black Comics Aesthetic

In 1926, W. E. B. Du Bois famously described all art as propaganda in "Criteria of Negro Art."[1] For the scholar and activist, the beautiful creations of African Americans would elevate their status. Beauty was a mechanism for truth—the truth of black capacity, and an exhibition of how exquisite the black body and black life could be.[2] This early articulation of the need for positive representation suggests a black liberatory twist on Matthew Arnold's understanding of art as truth and beauty and the "best that has been thought and said in the world."[3] For Du Bois, truth and beauty can aid the project of black liberation. However, so much of the black *experience* is the *worst* that has been thought, said, and done—including the subject matter of some of the work that has been understood as the "best." Thus the ideal aesthetic response to racism is not always the beautiful. At times only the ugly and offensive will do, functioning as a powerful form of antiracist protest.

Racist caricature, although not always viewed as art, has typically functioned as propaganda supporting white supremacy. But the frame the caricature inhabits sometimes suggests a challenge to bigotry. One of Du Bois's contemporaries whose work might illustrate how racist representation could be the core of antiracist art was George Herriman, the creator of *Krazy Kat* (1910–1944), a comic strip often described as one of the greatest of all time. He produced a number of other works, including the short-lived *Musical Mose* in 1902 for Joseph Pulitzer's *New York World*.[4] Mose is a musician with a black eight ball for a head and white tubular mouth who tries to find work by impersonating other ethnic groups. In one strip he pretends to be Irish, only to be found out and disappear into a cloud of hands and feet as members of the group that he tries to "impussanate" pummel him (Figure 1.1). Biographer Michael Tisserand describes it as the "most brutal scene" the cartoonist

FIGURE 1.1. George Herriman, *Musical Mose, New York World*, 1902.

ever created.[5] Mose is the kind of inhuman representation of black subjects that was common in US culture at the turn of the century; behaviorally, his failed schemes are characteristic of narratives imagining that blacks are of low intelligence. Amusement in these three strips—for those so inclined—is shaped by incongruity. No one would fail to recognize that he is phantasmagorically black; the joke, then, is on those initially deceived as well as his delusional belief that he could pass as anything but what he is. Mose's wounded abjection at the end of two

strips depicts his inevitable comeuppance, as his girlfriend reminds him of more appropriate (black) spaces that he can inhabit.

The depiction of Mose clearly evokes blackface, and black suffering was often a source of comedy in minstrelsy, vaudeville, and other representations of black people in early twentieth-century mass culture. And yet the knowledge that Herriman was categorized as "colored" on his birth certificate and passed as white for most of his life cannot help but factor into an interpretation of this strip. Some people have argued that

his use of racial stereotype is counterintuitive if we see him as possess-ing any identification with people of African descent. In an essay that rejects reading Herriman as African American, M. Thomas Inge argues that the *Musical Mose* strips would be "strange humor for an African American passing as white."[6] His girlfriend calls him a "nagur," he wishes his color would fade, and she suggests impersonating a cannibal would have been better. Inge believes that Herriman "was not thinking very deeply about [it] and resorted to the standard racial humor of the day."[7] And yet Herriman was aware that discovery of the designation on his birth certificate would almost certainly destroy his career with not only William Randolph Hearst's papers but any other paper in the white world. Autobiographical criticism invites us to understand the strip as a violent illustration of the risks and potential costs when black people attempt to assimilate—even when their skills and abilities should create the conditions for acceptance.

The idea of Mose as a double for Herriman is perhaps too reductive given the commonplace nature of minstrelsy representations in early twentieth-century popular culture. But how could one *not* interpret the black artist, accepted and entertaining until discovered, beaten and brutalized for the sin of passing, as evocative of the risks in Herriman's life? He wore a hat constantly at work—was it a coincidence that this covered up hair that colleagues saw as "kinky"?[8] However, the cartoon-ist could and did successfully pass until after his death. What, then, would we make of the traditional racist caricature of Mose's phenotype if he is Herriman's double? Is it a representation of how he might be seen? Is Mose an example, in contrast to my proffered reading, of an idea of blackness far from how Herriman identified himself? Is Mose a kind of abject black subject he would never be? Reading Herriman as "black" could thus result in an antiracist reading, or it could mean that we have even more reason to imagine a self-hating assimilationist ide-ology captured in these few frames. But when we read *Musical Mose* in relationship to the rest of Herriman's work, his use of caricature invites us to interpret the cartoonist as using racist caricature to comment on white rejection of black success and belonging. Even his most well-known, surrealist work, *Krazy Kat*, can be read as speaking to issues of identity, rejection, and resilience.

Many African American cultural producers in a variety of media—the "high" art tradition, film, television, music, stand-up comedy, and comics—have utilized racist caricature, stereotypes, or "negative" rep-resentations. Performers may try to transcend the narrow confines of

the representations they are forced to embody by the market, others may use it to critique white supremacy in some way, and still others may use it for intraracial criticism.[9] Following art historian Richard J. Powell, I argue that there are enough examples of the black use of stereotypical representation and racist caricature that it is part of "black diasporal culture," which he defines as "things that significant numbers of black people do."[10]

Cartoonists are not usually discussed in relationship to a tradition of black arts. However, seeing them in relation to other work in a genealogy of black aesthetic traditions helps us understand a common strand in black aesthetic practices to which the medium lends itself particularly well. A black aesthetic practice is, as philosopher Paul Taylor explains, "the practice of using art, criticism, or analysis to explore the role that expressive objects and practices play in creating and maintaining black life worlds."[11]

In this chapter I explore how a number of cartoonists of African descent have utilized racist caricatures to mark the citizenship of black subjects in order to show that it is *marked*—by an absence of rights or alienation from the nation. They redeploy caricatures that have been used in the negation of black personhood in representational practices of freedom. I borrow the idea of the "practice of freedom" from Michel Foucault, who makes a distinction between liberation—collective political action to free oneself from oppressions—and the ongoing struggle to practice freedom for the self and others under power relations.[12] When cartoonists redeploy caricature to address racism instead of supporting it, they literally reframe a familiar negative image. Complete liberation from a history of negative representation is impossible, thus the continued presence of negative representations is illustrative of black experience, and the cartoonist shows various practices of negotiating their lingering presence.

Each artist I consider in this chapter—Herriman; Sam Milai, editorial cartoonist for one of the leading black newspapers in the civil rights era; and contemporary artists Jeremy Love, Afro-Canadian Valentine De Landro, and Avy Jetter—utilizes racial caricature to explore how blackness challenges white nationalist discourse and imagine resistance to white supremacy through varied practices of black embodiment. For Herriman, the caricature is a trickster, highlighting the possible affects created in the interstices of living in between identities and refusing the rigidity of identity constructions. Milai is an outlier in relationship to other artists I discuss, as he treats caricatures as subject positions

that black agents sometimes inhabit to their peril, as they enable the work of white supremacy. In De Landro's art in *Bitch Planet*, bodies that have been caricatured by the state as warranting surveillance and disciplining become models of resistance to state discourse. For Love, the caricature is trauma that lingers and that the black subject must escape. And while the paucity of African American women cartoonists in this book is reflective of a smaller percentage of them working in the industry throughout history as well as the fact that they have utilized the grotesque or abjection much less in their aesthetic practices, Jetter's interest in horror shapes her depiction of what can be the quotidian nature of violence in some African American lives. The work of these artists speaks to the various debates about black representation in the twentieth and twenty-first centuries: new and fluid modernist configurations of blackness, black nationalism versus assimilatory representations, black exploitation aesthetics, negative images as repressive specters, and the question of how we represent black death in addressing state violence.

"Negative" representations, as Racquel Gates argues in her discussion of blackness in film and media, are the inverse of "positive" images, and these images of blackness stand in contrast to white subjects and, in some cases, performances of black respectability.[13] "Rather than cut off analysis at the first sign of stereotype," I wish, like Gates, to explore how negativity can "move the discussion past this first level of scrutiny and on to the question of what meanings these texts hold relative to the culture that produces both them and their positive complements."[14] In these case studies, the artists use conceptually negative renderings of the black face and demonstrate how African Americans often move through the nation as the embodiment of alienated citizenship.[15]

THE *KRAZY KAT* CONUNDRUM; OR, THE ASPIRATIONAL BLACK MODERNIST IMAGINATION

My inclusion of George Herriman in this discussion of African American cartoonists will be controversial to some scholars. Can we call a cultural production black when the creator has not claimed it was so? Autobiographical criticism, despite the postmodern death of authorship that questions what we know when we know a life, can still be useful, and, in fact, revelatory in some contexts. Knowing George Herriman's origins invites reframings of his work that explore questions of black identity and belonging.

The revelation about his background startled family and friends, with many people doubting that "America's greatest cartoonist" could be considered African American.[16] Herriman is central to any history of comics. While not usually discussed in art surveys of modernisms, *Krazy Kat*'s play with language and logic has drawn frequent comparisons to Dadaism, while his colorful, western landscapes are often described as surrealist.[17] Twenty-seven years after Herriman's death in 1944, Arthur Asa Berger was researching a short biographical entry for the celebrated cartoonist of *Krazy Kat* and was taken aback when he saw that baby "George Herriman" had been categorized as "colored" in 1880.[18] Berger thought this could not possibly be the same person. He was wrong. A number of scholars have addressed the role of race in *Krazy Kat* after this news, but Michael Tisserand's 2016 biography builds the most rigorous, careful case for reading Herriman's work as concerned with racial identity. He demonstrates that Herriman came from a close-knit New Orleans family that knew their racial origins. His father clearly moved to California to escape increased inequality and threats to people of color in Louisiana, and a number of his strips explore issues of blackness, ancestry, and hidden or changed identity.

But since Herriman never acknowledged his origins, can he be read as an African American artist? The answer has been yes and no to various people, illustrating complex debates in black aesthetics.[19] Using autobiographical criticism to interpret Herriman's work as "black" art arguably invites searches for allegories that may not be present. One person asked me with a bit of disdain, "Why would you want to?" An identity hermeneutic that foregrounds blackness, however, does not foreclose other possibilities, as polyphonous interpretations are invited by his constantly signifying works. Thus, my answer to someone who might ask why I would want to privilege race in some interpretations of his work, for fear that such a reading practice might be reductive, is that there is a similar danger of reductiveness if I ignore it.

The question of whether Herriman's blackness, or more specifically "his own repressed body," is important to reading all of the work he created for over three decades illustrates the challenges of defining, as Stuart Hall postulates, exactly what the "black" is in black cultural production.[20] While most African Americans have whiteness mixed up in their DNA, does Herriman's mixed-race identity matter in the categorization of him or his work as "black," particularly since he could pass? Should we read him as a "Creole" artist? As Jeet Heer asks, "What are we to do with an artist who seems to have identified all his life with white

culture and was thought of as white by his family and friends?"[21] Should every articulation and performance be interpreted as black if someone has black ancestry? *Krazy Kat* has been read as nonsense literature, an example of the avant-garde, and surrealism. None of these traditions preclude reading it as a "black" strip. The quotidian, existential, and fantastic imagination at work in *Krazy Kat* will not always be captured by reading every strip as "black" in terms of thematic concerns, even if we define it as a black strip because of the identity of the creator—just as no black artist is served by understanding every artistic enunciation as exclusively about black identity. Jared Gardner argues that just as it is "wrong to insist on the fiction that Herriman was 'white,'" it is also "wrong to insist that Herriman was in fact 'black.'"[22] But if Herriman's strips were about play, his work certainly invites us to see blackness at play—and it is indeed, at *play*—in his work.

These are questions that can be explored if we think about how a black identity hermeneutic, foregrounding the centrality of black caricature, can be combined with principles of comics aesthetics and interpretation. The recognizable "gag" of the strip—a disguised man discovered—blends with the general question of what principles in black cultural production might help us understand about his work. Applying an identity hermeneutic to some of Herriman's comic strips also allows us to see him as part of the tradition of African American modernism. Houston Baker argues that fluidity is a characteristic of black modernism and linked to the idea of masking and identity destabilization.[23] African Americans played off white perceptions of blackness shaped by the minstrel tradition and sometimes found spaces to destabilize representations overdetermined by the white gaze.[24]

While most black modernist writers and artists were part of communities in which they knew and influenced each other, Herriman's work might still be illustrative of the goals and debates of the period despite his isolation from a black creative tradition. Herriman could be seen as doing the propagandistic work that Du Bois entreated black people to produce.[25] Du Bois argues, "We who are dark can see America in a way that white Americans cannot," establishing the idea that the work of black artists is important because their experiences and knowledge will result in different work than that of white producers. Such claims are still prominent today.[26] He explores the challenge of facing "the past as a people," and argues that lack of opportunity means that African Americans will be unable to show

what they are capable of producing. Arguing that whites are interested in consuming only narratives of black stereotype and subjection, the "Uncle Toms, Topsies, good 'darkies' and clowns," Du Bois sees positive representations of blackness as key to black liberation. Herriman's work makes use of stereotypes that Du Bois abhorred, but the nuances of *Mose* and his sports cartoons more clearly highlight how he was interested in complicating racial scripts with the use of black caricatures.

Like a few of the cartoonists I discussed in the introduction, Herriman produced boxing cartoons, many of which spoke to the ways in which the sporting events were mapped onto larger debates about the challenge black athletic skill offered to fantasies of white supremacy. On July 4, 1910, Jack Johnson competed against James Jeffries, who had retired five years earlier but returned to challenge the flamboyant African American boxer.[27] Jeffries was trumpeted as the great white hope. Herriman used racist caricature, but the desired affective response to the cartoon is not immediately transparent. In one cartoon a large elephant is representing the heavyweight title. Jeffries and Johnson are perched in a carrier on top, with Jeffries pushing out Johnson, depicted as a racist caricature (Figure 1.2). Jeffries, the promoters arguing at the feet of the elephant, and Jeffries's manager, Samuel Berger, are all white and depicted cartoonishly but not marked with any racialized or ethnic excess. Johnson not only looks like a coon but is alone in speaking in dialect: "Doan Shove Me Mistor Jeff, Dey Ain't Room on Heah fo Bof of Us." And yet he is clearly being victimized by Jeffries, who states, "Go Way. Go Way. I'm Uncomfortable with You in Here." His manager appears to be attempting to chisel off part of the unhappy looking elephant, stating, "I feel fully justified in saying that we will soon eliminate the dark person from the spine of this grand old pachyderm."

Single-panel gags often turn on a tension between text and image, thus the visual dissonance encourages a reading that is not fully pro-Jeffries. Jeffries's flat statement of discomfort when he is clearly the one threatening Johnson displaces the injury that Johnson is alleged to produce. Jeffries's manager is willing to do injury to a strong and powerful animal in order to eliminate the threat of blackness from the ring, but he is trying to remove blackness from the "spine," suggesting that Herriman believes that black boxers are embedded in the sport and it would do injury to it to try to extract them totally. As boxing matches were often culturally allegorical events in which identity

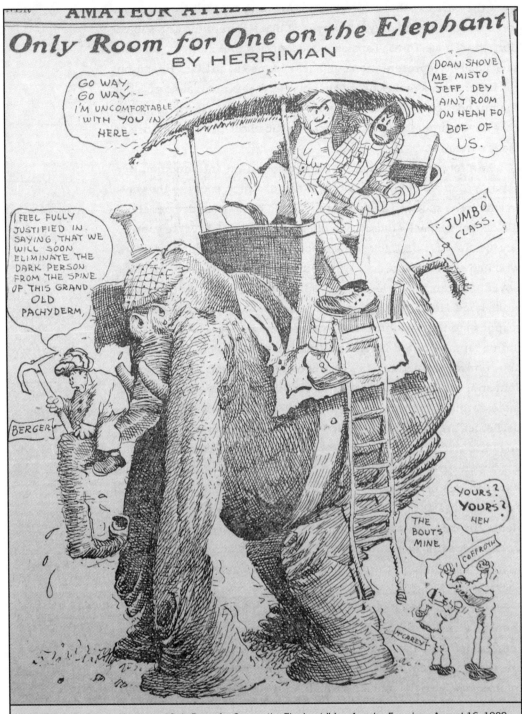

FIGURE 1.2. George Herriman, "Only Room for One on the Elephant," *Los Angeles Examiner*, August 16, 1909.

conflicts about racial and national supremacy played out, we can see how the possible injury of extraction reflects the possible injury to the nation that would be produced by African American removal. Thus, despite the stereotypical representation of Johnson, the object of the joke appears to be white anxieties about this seemingly abject black body.

Like many white cartoonists, Herriman caricatured Johnson by using a phenotype that was animalistic. He used two forms primarily, one that resembled primates and was consistent with many other racial caricatures, and another of cats—a choice that has interpretative significance if considered as part of the evolution to *Krazy Kat*. His strips depicting African American boxer "Laughing" Sam Langford may demonstrate what Jean Lee Cole has described as a black comic sensibility, manipulating the traditional racist conventions of the sports comic strip.[28] In one strip he depicts the boxer Fireman Jim Flynn entering a cave, apparently inhabited by the African American boxer Sam Langford, with a gun. Amid the cat growls coming from the cave, a few words in dialect are discernible: "Ah'se jese spil'in for a fight." After a fracas, Flynn emerges with a small, tamed cat on a leash, looking smug and speculating that the cat will make a nice rug. A month later Herriman depicts Flynn making Langford jump through hoops, bragging that he can get him to do anything he wants. He cages him only to return and find that he has broken out of the cage, a much larger cat wearing a smile (Figure 1.3). Langford would beat Flynn five out of the six times they encountered each other.

While not the realistic phenotype that Du Bois called for, such work can be "propaganda" for black people and more affectively akin to the comics in the black press about Johnson than many strips in the white press. And if we read Herriman's work genealogically, the black boxer as black cat shares an aesthetic connection with the artist's famous character, Krazy. But metaphorical reading that maps identities onto the animal characters of *Krazy Kat* fails to deliver an easy racial allegory. If Krazy is black and loves the white mouse Ignatz who continually abuses them (I use gender-indeterminate pronouns here because of Herriman's explicit decision not to gender Krazy), what would we make of the inherent gag of the strip of a cat loving a mouse and the mouse being predatory? Scholars have sometimes discussed the fact that Krazy Kat has an Uncle Tom in considering whether or not the character might be read as black.[29] Herriman referenced Harriet Beecher Stowe's famous novel in his comic strip more than once,

FIGURE 1.3. George Herriman, "Look Out! He's Not Tamed Yet," *Los Angeles Examiner*, March 16, 1910.

thus it is hard to read the presence of Uncle Tom Kat and the content without seeing a gesture to race, although again the direct mapping of the cats onto blackness becomes problematic in any number of strips. Ian Gordon may be right to see the indeterminacy and flexibility of the relationships as modeling something other than strict racial categorization.[30] It is tempting to read Krazy's love for an injurious oppressor as a racial allegory, but the characters function more as floating identity signifiers that prevent any simplistic racial mapping in the strip. He arguably can represent blackness at some points and not in others. The fluidity characteristic of the modernist aesthetic is facilitated by the form of the comic strip, allowing for an identity hermeneutic and complicating previous readings of *Krazy Kat* that do not consider race at all.

Privileging identity in a reading of Krazy Kat does not necessarily mean that we read Krazy as black, but the allegorical and affective messiness signified by his body can tell us something about how racial identity categories function. In a discussion of complex dialect and use of language in *Krazy Kat*, Edward A. Shannon argues that in comics, images "are truth; the words are not as reliable. . . . Krazy's meaning is the destruction of the form of which it is a product. The drawings are as unreliable as Herriman's mish-mash, randomly

punctuated dialogue."[31] People have spent a great deal of time trying to explore the relationship between words and image in comics, and scholars have debated whether or not comics should be defined by the relationship between word and image, and if comics need words at all. That debate is now settled (or should be), as there are many wordless comics, but an identity hermeneutic immediately illustrates why Shannon's claim is problematic. Given the history of representations of African Americans, of course it is clear that images are not always "truth." The unreliability of the body and text contributes to the project of destabilizing reliance on the body as the place where truth about race lies in *Krazy Kat*. The nonsense in which neither the body nor words completely make sense of *what* Krazy is directs readers instead to understand the cat by their desires. That such desires are not clearly transparent because of what we think we know from the body makes it a meditation on black identities as unfixed and that challenge categorization.

In one of the strips that has received the most critical attention, Krazy asks, "Why is 'Lengage' 'Ignatz'?," leaning over a table (Figure 1.4). The query and lean is seemingly indicative of their trust and innocence, one of their primary traits. "'Language,'" Ignatz replies, "is that we may understand one another." Krazy is skeptical, and unusually

confrontational with Ignatz as they put a finger in Ignatz's face and asks him if he can "unda-stend" a "Finn," "Leplender," or "Oskosher," or if they can understand him. In an unusual reversal Ignatz cowers in his seat with Krazy towering over him on the table when he replies no. Krazy leaves, and the mouse is now leaning on the table with racing thoughts. The cat inarguably wins the encounter with logic that nonetheless could be seen as nonsensical: "Then, I would say, 'Lenguage is that we may mis-unda-stend each udda.'"

Applying a racial identity hermeneutic to this strip, Krazy's interrogation of language reads as an attack on a white and Western logic that orders the world. Their argument is uncommon common sense. Language is a tool used to oppress with categorizations and alleged transparency of meaning. Krazy Kat is a comic where Krazy's failure to come out on top in conflicts with Ignatz is a constant theme, even as Krazy's refusal to respond to conflict in the way readers might expect is essential to understanding them as a subject. Krazy has a buoyant resistance to violence, rejection, and being misunderstood. Even if "blackness" is not a referent, the mention of the "Oshksosh" appears to be a reference to Chief Oshkosh of the Menominee tribe, whose trial for murder in 1830 in Wisconsin was quite famous. The chief executed a Pawnee Indian for accidentally killing a Menominee hunter. Under Indian law the killing was justified, but under white men's law it was illegal. The well-read Herriman, who made many historical and literary references in *Krazy Kat*, may have known about this case. If he did not, it is

an interesting and serendipitous juxtaposition of European languages with a reference to a Native American whose different language and law did not "translate" to settler colonialist frameworks.

That neither Herriman nor his work may translate to black-white identity binaries helps us understand how reading for and through identity may work. Seeing black bodies as a referent for reading may speak to how a black person is in the text or allegorically present, or it may address what blackness signifies or complicates. While Herriman is not addressing white racist violence and anxiety about black inclusion the way he does with the Mose and boxing strips, the theme of poor categorization of identity and misreading is suggestive of how we should read blackness, and what blackness helps us see: namely, that identity indeterminacy can be a site for not just survival, but joy. Regardless of whether Herriman thought of himself as "colored" or of African descent, it is not a reach to apply a black identity hermeneutic to his work. Twenty-five years before the Great Migration, his family moved to California, just as many black Louisiana natives would decades later. Alain Locke said that it was in "the very process of being transplanted" that the artist during the Great Migration "was transformed."[32] Herriman's movement west and then east to New York shaped the possibilities for his life and work. In the buoyancy and joy of a crazy cat, perhaps we see what Locke called for in resistance to Du Bois's black aesthetic mandates, a cultural production not over-determined in production or interpretation by a subject position of inferiority.[33] A black aesthetic practice here is something like spiritual emancipation in art that imagines issues of race tied to a whimsical and loving spirit.

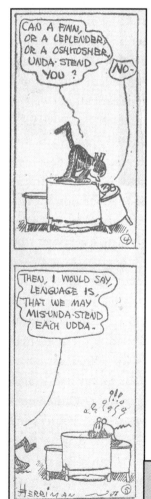

FIGURE 1.4. George Herriman, *Krazy Kat*, January 6, 1918.

FROM COON TO CIVIC IDEAL: THE BLACK MALE BODY AND CARTOON CITIZENSHIP IN THE CIVIL RIGHTS ERA

Herriman treated black integration as something that white people violently resisted and modeled creative challenges to identity categorization, but many other cartoonists of African descent looked toward integrated futures in their work. These cartoonists worked in the black press, which transparently embodied Du Bois's mandate that black cultural productions should be black propaganda. The first African American newspaper was founded in 1827, established to "plead our own cause" and circumvent white abolitionist voices.[34] In the nineteenth century, caricature and journalism merged, each giving the other more power than the genres would have had in isolation.[35] But African American editorial cartooning did not come of age until the twentieth century, its rise corresponding to the rise of the black press. Martha Banta describes great caricaturists as starting out radical and becoming conservative, suggesting that caricature "contains within itself the pull toward order. . . . The art of protest that aspires to break down the rules of social conduct vouched for by hegemonic systems often entails making a pact with the very devils the caricaturist wishes to exorcise."[36] Race again adds specificity to what might be a structural convention of cartoon art. The black press was often under suspicion for sedition, and as McCarthyism rose, conservatism became a measure of self-protection.[37] But when some African Americans frame black agency within a liberal rights framework, that position inevitably results in a politics of exclusion. For cartoonists like Ahmed Samuel Milai (1908–1970), drawing futurity entailed casting out those who refused to see black progress through anything other than an embrace of liberal subjectivity that privileges sameness over difference.

Milai was an editorial cartoonist for the *Pittsburgh Courier* for thirty-three years. He began working for the paper during its peak in influence and through its sharp decline after the war and through the civil rights movement.[38] Born in Washington, D.C., Milai's mother was mixed race, categorized as "mulatto" in the census. His father had Indian (South Asian) ancestry. Like Herriman, Milai was a light-skinned man, but unlike Herriman, he spent his life engaged with the black press and producing work about black history and life. The *Courier* may not have had the circulation of the papers in the white press, but it and the *Chicago Defender* were the most important black newspapers in the twentieth century. The *Courier* was instrumental in encouraging the Great

Migration, desegregating the military and the baseball league, and providing a role for black writers. At its peak after World War II, circulation reached as high as over 357,000 subscribers.[39] An irony of successes in the civil rights movement was that as African Americans chipped away at segregation and gained access to predominately white spaces, some predominately black spaces declined. For many years the white press rarely discussed African Americans except to include negative press. While white newspapers allegedly began embracing standards of objectivity in the 1920s, the hundreds of black newspapers across the country celebrated black life and made the lies of an allegedly objective white press visible.[40]

The FBI targeted the African American press's seditious content in the first half of the twentieth century, and by the 1950s the *Courier* would present a more conservative tone.[41] Milai's work suggests that he believed in the promise of law and government intervention as a response to racial injustice, but his cartoons were also illustrative of an editorial turn in the paper. Although he celebrated inclusion and assimilation, he was also conscious of how various political discourses disseminated by Lyndon B. Johnson and then Richard Nixon's administration diminished the possibilities for black citizenship. Using the body as a sign of legal rights and economic possibility—which, for Milai, marked the full measure of racial equality—Milai used bodies to reshape the look of ideal citizenship and contested various articulations of black radicalism that emerged in the period. Milai's work is an explicit attempt to shape and shore up black icons—those advancing in the civil rights struggle through institutions and nonviolent action—and place other kinds of African Americans outside the discourse of good citizenship. If Herriman's modernist aesthetic embraced play and ambiguity in the nadir of race relations, Milai's midcentury editorial art eschewed ambivalence in an era of heightened African American activism.

He typically employed realist phenotype in celebrating prominent African American heroes and civil rights movement success. Like the art in Du Bois's *Crisis*, much of Milai's work was "dignified and respectful and exuded race pride."[42] Dignified and respectful is nevertheless not the primary affective mode of editorial cartooning.[43] However, many African American cartoonists rejected using phenotypic excess to depict black people, even when they were satirizing their behavior. But in the 1960s and 1970s, new discussions of black aesthetics would challenge and defamiliarize black approaches to depicting the black body in a variety of media. In 1968, Larry Neal called for a black aesthetic that

would be a "radical reordering of the western cultural aesthetic."[44] This would require a "separate symbolism, mythology, critique, and iconology."[45] Grounded in the art of the Third World, it would spring from the cultural touchstones of an African past and revolutionary diasporic present to imagine a radically different future. For Black Arts Movement proponents, black people could not move into the future without a transformed aesthetic;[46] otherwise, the iconography of the past would tie them spiritually to Western attachments and debasement.

The closest the Black Arts Movement had to a cartoonist who embodies these ideas was Emory Douglas, the Minister of Culture for the Black Panther Party.[47] He accented the often-ridiculed phenotype of African American men and women, embracing heavy brows, large mouths and noses, and powerful frames, but in his work the black caricature connoted power and not abjection. He embraced the call for new iconography in revolutionary art, not only with caricature that treated as a virtue what had historically been imagined as a defect, but by caricaturing police as pigs who should be slaughtered. Cartooning, however, was not Douglas's primary medium, as he produced posters, photographs, and illustrations for the party.[48]

In contrast, on the cusp of a Black Arts Movement that emerged from the youthful and radical activism that he abhorred, Milai's aesthetic is demonstrably a rejection of the BAM aesthetic. Not only is he committed to affirming how African Americans fit into the Western imaginary, he adheres to the traditional triangulated structure of the joke in editorial cartooning. Focusing almost exclusively on the black male body, Milai sees the inclusion of them within institutionalized spaces—schools, government offices—as modeling the possibility of black progress.

French theorist Roland Barthes famously explicated how the black male citizen serves state discourse in his analysis of the image of a black soldier saluting on the cover of the popular periodical *Paris Match*. He argued that the signifier of the black citizen-soldier contributes to a nationalist mythology of equality under imperialism.[49] Milai often focuses on the assimilationist black body in his work in an attempt to illustrate what it would mean for African American men to be patriotic, but citizenship was not only tied to male bodies. Women were represented in a collective—particularly in relationship to a hopeful or youthful population—or as abstracted ideals of the nation. Drawing on traditional iconography that treats justice, nation, and liberty as female figures, women are typically nonactive models in Milai's visual lexicon, not actors.

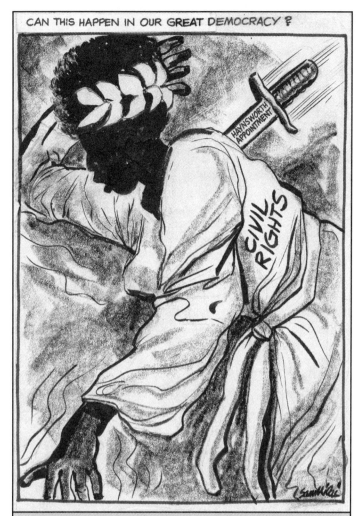

CAN THIS HAPPEN IN OUR GREAT DEMOCRACY ?

FIGURE 1.5. Sam Milai, "Can This Happen in Our Great Democracy?," October 25, 1969. Courtesy of the Sam Milai Collection, Billy Ireland Cartoon Library and Museum.

"Can This Happen in Our Great Democracy?" depicts a slightly androgynous figure, although the delicate profile suggests the female form (Figure 1.5). Decrying the nomination of segregationist Clement Haynsworth to the Supreme Court after so many gains in the Johnson administration, Milai treats Nixon's choice as a physical assault on black citizenship. In this image the body stands in not only for black people but for an event. The affective experience of feeling violated and betrayed is illustrated through the knife in the back, and the idealized past and possible future are made material through the flowing robes of citizenship. Milai was a gifted illustrator and capable of crafting very

FIGURE 1.6. Sam Milai, "September Morn," September 6, 1969. Courtesy of the Sam Milai Collection, Billy Ireland Cartoon Library and Museum.

realistic looking faces, but the featureless silhouette makes the black body a canvas upon which abstract concepts can easily be attached, as opposed to the realistically rendered face. A Western universal is present through the reference to Roman iconography, positioning black subjects in the tradition through the silhouette.

The African American woman is abstracted again in a satirical riff on the Paul Chabas painting *September Morn* (Figure 1.6). The Chabas painting suggests a voyeuristic gaze.[50] In contrast to the original work, Milai's figure shivers and is more physically exposed than the young woman in the Chabas painting. Her vulnerability is signified by the close-up that makes her breasts visible as well as her consciousness that she is being seen. Not being aware of the gaze is its own kind of violence, but the black woman's knowledge suggests the impossibility

of ignorance. African Americans must always be aware of the gaze. The text surrounding her body treats the Black Power movement and white supremacy as equally injurious elements that leave the black body vulnerable to exposure. But the woman here *is* civil rights, thus she is not an agent in relationship to the struggle.

Milai used references to European culture, expecting the audience to hold such knowledge. He was uninterested in the signs and symbols of a Black Power aesthetic. Black Power and urban uprisings are continually treated as the friends of white supremacy. For example, in the 1966 cartoon "Colored Help," a black man serves segregationists a meal of "riots." The African American who advocates or uses violent resistance—what Martin Luther King Jr. famously referred to as the "language of the unheard"—is simplistically reduced to "Violent Negro." This kind of citizen is abstracted, with only the hands representing the model of African American citizenship that Milai rejects. Both black liberty and black violent action are abstracted in relationship to the clearly represented whites at the "Anti–Civil Rights" dinner (Figure 1.7). Thus, black violent

FIGURE 1.7. Sam Milai, "Colored Help," *Pittsburgh Courier*, October 15, 1966.

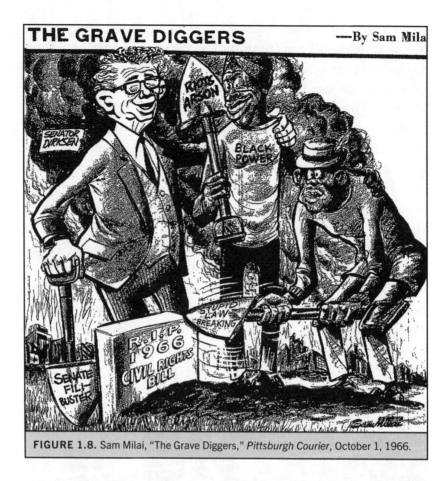

THE GRAVE DIGGERS —By Sam Mila

FIGURE 1.8. Sam Milai, "The Grave Diggers," *Pittsburgh Courier*, October 1, 1966.

action pushes all black agency into a subservient role here; both black liberty and violent black action are moved to the periphery of white desire and will.

One 1966 cartoon depicts Senator Everett Dirksen with a filibuster burying the 1966 civil rights bill (Figure 1.8). Dirksen, a Republican from Illinois, was known for facilitating the passage of the 1964 civil rights bill because he crafted a compromise about the power to regulate discriminatory action in private business that disrupted the southern filibuster.[51] He was not an easy ally, and in 1966 he rejected Johnson's civil rights bill, which would have prevented discrimination in the sale and rental or financing of housing—a cornerstone of discrimination in the United States.[52] In the debates in Congress, a mythical landlady named "Mrs. Murphy" was conjured up as the white woman they would want to protect from renting to African Americans like the ones pictured here.[53] The fictive Mrs. Murphy should not be forced to rent to these brutes. The features on the African American characters are traditionally coon-like. They hold shovels labeled with "riots," "arson," and

"stupid law breaking." One of the men is wearing a T-shirt indicating his allegiance to "Black Power." Recognizing the fear and anxiety produced by not only black urban uprisings but Black Power as a revolutionary force, Milai conflates the two. The complex affective and material realities of the moment—the variety of causes and effects of black resistance, black rage, and black despair—are not rendered with any complexity. Black rioting was clearly affecting national discourse about black rights, but Milai was not in sympathy with the idea that the unrest in the cities was, as Martin Luther King Jr. famously claimed, the "language of the unheard."[54] In Milai's images, violent black masculinity holds no place in the struggle.

It was not unusual to see caricatured representations of black people in gag or editorial cartoons in the black press. Directed at a black audience, at times the cartoons were a suggestion that the black community laugh at itself; at other times, there were specific moments of critique shaped by respectability politics. Milai knew black readers were the primary audience for his work. Unlike Emory Douglas, who wished to inspire revolution, Milai wanted the black audience to see "Black Power" and radical action as detrimental to black liberation. Milai critiqued both the black middle class and working class in his cartoons, but his greater focus on male radical subjects as actors is clearly a consistent indictment of the alleged dangers these radical black men posed. Milai treated white and black actors outside the law as doing the same damage. The visual dialectic of equal injury is an important aspect of Milai's repertoire of representing good citizenship.

In the 1968 cartoon "Racists, back to back . . . cause and effect," we see an equivalence of racial affect that will soon be part of "post–Civil Rights" political discourse (Figure 1.9). Milai's cartoon treats white bigotry as the cause of black resentment, but suggests that the racists and rioters have a dialectical relationship that results in the destruction of the state. For Milai, violent action and resistance cannot possibly result in political equality. Unlike some of his peers, such as Chester Commodore (1914–2004) at the *Chicago Defender*, Milai saw no possible model of citizenship in Black Power; moreover, he had no sympathy for the rioter's rage.

The struggle over representation—not only visual culture but how black people were seen by whites—was an old one, and Milai did nothing new in expressing black conservatism. But he did leave a profound visual archive of political splits among black people, particularly with his treatment of black youth as completely alienated from black

subjectivity and destroying black futurity. In 1966 Black Power took hold in the Student Nonviolent Coordinating Committee (SNCC) and the Congress of Racial Equality (CORE), with Stokely Carmichael and Floyd McKissick elected as leaders. The same year Milai depicted the organizations as rats in top hats, reframing groups that some people saw as heroic to lower life forms masked by previous discourses of respectability (Figure 1.10). He moved back and forth between realistic

FIGURE 1.9. Sam Milai, "Racists, Back to Back . . . Cause and Effect!" Courtesy of the Billy Ireland Cartoon Library and Museum, April 27, 1968.

FIGURE 1.10. Sam Milai, "You Can Put a Full-Dress Suit on a Rat but His Tail Will Stick Out!" September 24, 1966. Courtesy of the Sam Milai Collection, Billy Ireland Cartoon Library and Museum.

phenotypes celebrating black heroism and racist caricature to identify whom he found suitable for facilitating post–civil rights movement assimilation. Milai uses caricature to injure, imagining that black readers would feel the wound of being seen that way. But he does not see these black bodies as being something Other in *essence*. His concern is that they will become Other through radical acts, or that what white citizens see can change what black citizens can be.

EXPLOITATION UTOPIAS: EMBODYING RESISTANCE

In *Krazy Kat*, Herriman's use of phenotype and anthropomorphism (two traditional injurious aesthetic practices applied to black people) suggests the possibility of a liberating fluidity. Milai clearly rejects that

approach to combatting racist ideology and action. Nevertheless the cartoonists have in common the use of racist caricature as a means for exploring the relationship between injurious representation and liberation. But for some artists creating in the "post"–civil rights era, the caricature is not something one has to work around or reject—it actually models a new ideal.

If the black modernity project was deeply engaged in issues of positive and negative representations, late twentieth-century and early twenty-first-century artists took clear stands against always prevalent black respectability projects. Curator Thelma Golden and Glenn Ligon used the term "post-black" to describe the work of young black artists in her celebrated Freestyle exhibit at the Studio Museum in Harlem in 2001.[55] Of the post-black artist sensibility, Glenn Ligon stated that a younger generation of artists had "a different relationship to images and history than my generation or the generation before me," and one of the principal locations of that difference was the treatment of "negative and positive images."[56] The play with negative and painful representations involved a different resistance to art as propaganda than there was in earlier periods. While Milai was an example of an artist deeply concerned with the costs of white judgment, many artists pushed for art for black people that resisted calls for respectability from white *and* black gazes. Some "post-black" art and what Mark Anthony Neal has termed "post-soul" aesthetics have reflexively emphasized the ability to take pleasure in exploitative worlds and representations shaped by white imaginaries but reclaimed in imagined new futures.[57]

One comics series that models this aesthetic is *Bitch Planet*. Cocreated by black Canadian artist Valentine De Landro and feminist comics writer Kelly Sue DeConnick, the series is set on a prison planet in the future that houses "non-compliant women." De Landro's art is essential to the project, making use of a seventies exploitation aesthetic to craft liberatory representations of women who do not conform to Western ideals, but also playing with the pleasure some have taken in exploitative representations of people like themselves.

Of all the cartoonists I discuss in this chapter, De Landro has arguably produced the most "mainstream" work in other comics such as *Marvel Knights*, *Spider-Man*, *GI Joe*, and *X-Factor*. But this collaboration with DeConnick became the Toronto artist's first creator-owned property, and he diversified his rendering of women's bodies. In an interview on the genesis of *Bitch Planet* he described himself more as a "street level/ urban noir type of artist,"[58] so science fiction was a departure. More

importantly, early in the process he realized that he had "a lot of bad habits" in drawing women that sexualized them. He drew women differently after recognizing how he had been socialized to see.[59]

Bitch Planet is a feminist comic that is unabashed about indicting patriarchy—they name racist heteropatriarchy as the enemy explicitly. Such transparent politics overtly utilizes caricatures by evoking prison and blaxploitation films that were contemporaneous with second-wave feminism. It is a comic that acknowledges the pleasures of these representations for feminist and antiracist gazes—that fighting women and people of color that are often deployed for pornographic pleasures can be claimed by other audiences to take pleasure in representing resistance and nonconformity.

The comic calls attention to the role of surveillance—by women and men—in shaping women's understanding of themselves. By focusing so intently on the gaze, the temporality of the stereotypical and exploitative image is highlighted. The beginning of the comic book ostensibly seems to introduce caricatures of black womanhood. The piecemeal introduction to characters invites readers to move forward and back, unpacking the history that shapes readings of their first encounter with each character. Unlike with prose, comics encourage readers to read both linearly and nonlinearly, the eye glancing back to previous panels. Fragmentation in the comics medium serves a double purpose, to replicate the generically familiar that flattens identity (caricature) while also showing caricature as a potentially generative mask for the subjected.

Issue 3 gives readers the backstory to the character Penny Rolle. Her nomenclature, in the way of exploitation films, references her rolls of fat, black flesh. Proudly sporting a tattoo, "born big" on her arm, she protests the undersized uniform she is given to wear. In the tradition of women's prison narratives and blaxploitation flicks, the fat black woman's body is treated as a sign of the grotesque. But the creators suggest that it is the gaze that categorizes the body as grotesque, not the body in itself. De Landro and DeConnick open issue 3 with a splash page depicting Rolle looking out with clenched fists, thinking, "I can't see you, but I feel you . . ." and a small frame in the corner overlaying the image captures only her angry eye and finishing the thought, "judging me." Penny's ability to look back at those who judge her challenges the white gaze that gives power to caricature. Readers learn that her rap sheet includes not only assault, but crimes such as "repeated aesthetic offenses" and "wanton obesity."[60] Rolle's body is an example of the ways in which, as Susan Bordo has argued, "excess body weight" has come

FIGURE 1.11. Kelly Sue DeConnick (author), Valentine De Landro, Robert Wilson IV, et al. (illustrators), *Bitch Planet, Vol. 1: Extraordinary Machine* (Portland, OR: Image Comics, 2015).

to be seen as reflecting moral or personal inadequacy, or lack of will."[61] The fat body is treated as a burden on the state and lacking self-control, a pathological body not fit for care or acceptance from others. Men on screens, the "Fathers," who stand in judgment of the incarcerated Rolle tell her that they wish to "help," but aid would require a transformation from what they have deemed unsuitable for state inclusion. She looks down, seemingly shamed.

The state took her from her mother at age eight because she was allegedly "delusional" and "dangerous" and "refused to see the truth," suggesting that her mother's sin was nonconformity and resistance. When in state care, a blonde woman—Mother Siebertling—tells her she needs to learn to see herself through the (state) "father's eyes," and that her hair needs to learn to "behave," like her. While this is a dystopian fiction, the reference is to the consistent shaming and regulation of black women's hair in the real world, a legal means to deprive them of education and employment.

Rolle was incarcerated because of a moment of violent protest at work—one reminiscent of the angry eruption the beleaguered

protagonist exhibits in Tom Floyd's *Integration Is a Bitch!* Rolle works in a muffin shop and initially appears to have been subdued by the state. We learn she is "state sponsored"—lacking a husband in a world in which women must be supervised by men. A male customer becomes angry at a woman customer who rolls her eyes at him, other men discuss Rolle's lack of physical attractiveness, and white women gleefully debate their eating disorders. Rolle suddenly smashes the television screen displaying a woman schilling gastrointestinal parasites for weight control and the face of one of the men who was condemning her appearance with her rolling pin. As with *Integration Is a Bitch!*, Rolle's rage seemed inexplicable to the customers, but the reasons for her angry resistance were omnipresent if they cared to examine their own behavior, or knew her past.

Bitch Planet offers an explicit dystopian vision of a state-industrial regulation of unruly women citizens. The patriarchal leaders, literally called the Fathers, say their treatment of her was for her own good, and treat her pain as self-inflicted and anger as inexplicable. Believing that they have broken her, they subject her to an experimental machine that forces her to look in the mirror and see her "ideal" self, an image that would "prioritize how others see her." They hold the mirror up, and instead of some representation that conforms to racist, sexist, and sizeist standards, what she sees is herself. De Landro depicts her laughing at the image while the men on screens look appalled (Figure 1.11). Her refusal of this gaze indicts not only the gaze of the men within the fictional dystopia, but the cultural logic that overdetermines her as an abject figure.

Her body and this moment evoke a blaxploitation aesthetic, in that when she is initially introduced in the first issue she simply seemed to embody black stereotype, and yet the representation of anger and militancy serves a black liberation project. Rolle is rendered with much more complexity than most women receive in the traditional blaxploitation film, and the use of these representations is clearly reflexive and a metacommentary, but the exploitation aesthetic repetition with a difference in *Bitch Planet* invites the reader to see the black nonnormative body unapologetically.

De Landro's artwork consistently resists the idea that the white and male gaze overdetermines possibilities for black women. The central protagonist is Kamau Kogo, a beautiful, muscular, thick-bodied former athlete who is visually reminiscent of 1970s blaxploitation star Pam Grier. Kogo and other women in the comic are constantly nude, but

FIGURE 1.12. Kelly Sue DeConnick (author), Valentine De Landro, Robert Wilson IV, et al. (illustrators), *Bitch Planet, Vol. 1: Extraordinary Machine* (Portland, OR: Image Comics, 2015).

the nudity in itself does not evoke the pornographic. The decision to shift to the visual conventions of an erotic comic in issue 4 is another moment in which the gaze's power is destabilized. De Landro gives readers what appears to be the typical sexploitation prison shower scene. In an earlier issue, readers see one peering eye hidden from the showering women. Kogo appears to be masturbating, and the comic fragmentation of her body is evocative of not only porn's objectification of women into parts but *the idea* of porn objectifying women into parts. The image is erotic, and readers may take pleasure in the representation of this powerful black woman pleasuring herself as a pro-sex representation of black women's sexuality. At the same time, the reader's gaze may uncomfortably map onto the peeping Tom's. His eye splits the lower half of the page, and the last frame of the page is Kogo's atomized mouth stating "Gotcha," disrupting his pleasure and what we think we have seen. She goes on to break the wall and wrestle the masturbating guard to the ground (Figure 1.12). Having seen his now flaccid penis, she has grounds to blackmail him and gains more leverage in the prison.

An explicitly political comic with a rabid fan base, *Bitch Planet* is a series of "gotchas," taking representations that have been seen as unrespectable or exploitative and challenging what people think they know once they have seen the images, both diegetically and for readers. In this comic book the caricatured excess creates both the pleasure and the possibility. Without the idea of the grotesque, without the sensational, the characters could not flip the script of normativity. For De Landro and DeConnick, the caricature is unapologetically radical resistance to state oppression. While the object of criticism is regulatory, patriarchal state power, the images in *Bitch Planet* are representations that those adhering to discourses of respectable blackness might still struggle to reconcile with liberation politics. DeConnick and De Landro suggest there is no liberation without grabbing hold of the intransigent views of these representations and wrestling them to the ground.

HAUNTED

Herriman, Milai, and De Landro all explore what it might mean to understand ourselves as, identify with, or reject a racial caricature. But another common use of racial caricature as a black aesthetic practice is to understand it as something that we carry with us, that exists as our

shadow. In Jeremy Love's *Bayou*, black subjects struggling for liberation are literally chased by deadly caricatures.

Love was born in 1977, so his experiences of race relations are shaped by being raised after the "classical period" of the civil rights era. *Bayou* is set in the Jim Crow South, but his protagonist Lee's relationship with white friend Lily is nonetheless shaped by his "childhood experiences with white friends" whom he loved despite their "occasionally saying or doing racist things."[62] Love worked primarily as an independent comics artist, producing a couple of issues of the black superhero comic *Chocolate Thunder* in the late 1990s with his brothers. His big break appeared to be *Bayou*, a comic that won a contest to be featured in the new DC online comic imprint Zuda (2007–2010). Critically acclaimed, the comic was nonetheless discontinued online and then two volumes were printed. As of this writing, *Bayou* is out of print and the story remains incomplete.

A black *Alice in Wonderland*, *Bayou* tells the story of Lee Wagstaff, a sharecropper's daughter living in Charon, Mississippi, in 1933. When the white daughter of the woman who owns the land her father farms is swallowed up by a monster who lives in the bayou, Lee's father is blamed for her murder. Lee ventures into the bayou to retrieve her friend and save her father from lynching. The bayou is a land inhabited by people who have died unnatural deaths, and some of the most dangerous are those who were murdered by racialized violence. But "Bayou" is also the name of the title character and Lee's protector, suggesting that the thing that bogs us down—the swamp of racial discrimination that is ever grasping, hard to escape—can also be a source of strength. The complex relationship African Americans have to these suffering histories animates *Bayou*, a fantastic narrative that Love explicitly claims is an attempt to demonstrate the role African Americans can have in mythmaking that shapes our fictions and national discourse about race. In his call for a Black Arts Movement, Larry Neal described mythmaking as one of the essential aspects of black aesthetics, recognizing the role of mythmaking in politics.[63] With *Bayou*, Love is inserting heroic blackness into mythologies that romanticize the South in national history but have excluded black girls from the center of genre fictions.

The fact that Lee is a little black girl—and there are so few black female protagonists—encourages identification for some readers. Scott McCloud argues for the "universality" of the cartoon image by claiming that "the more cartoony a face is, for instance, the more people it could be said to describe."[64] By "*stripping down* an image to its essential

'meaning,' an artist can *amplify* that meaning in a way that realistic art can't."[65] Part of his point is that the absence of realism is still a compelling point of reference, but it is also not an accident that McCloud "stripped down" a white man's face to arrive at the circle, two dots, and a line to represent (nearly) all people. As the debate over color options and emojis demonstrates, the possibility of identification shaped by this simplified aesthetic is more racialized than McCloud acknowledges.[66]

When *Bayou* begins, Lee has been dispatched into the bayou to retrieve the corpse of Billy Glass, a young boy, evoking the history of Emmett Till, who was lynched for whistling at a white woman. Billy's body becomes tangled in the plant growth in the bayou, and a small child is needed to pull him out. Lee catches a glimpse of Billy, transformed into a creature of the bayou, understanding that his spirit remains even as his body has been destroyed. She is haunted and terrified by that knowledge, and she fears the bayou as a result.

Lee is clearly identifiable as a little black girl from the first frame. Love moves from the specificity of her cute, innocent face, juxtaposed with the specificity of the similarly youthful face of the lynched boy. Lee tells us what happened to Billy, but what she feels is absent, perhaps unutterable. The ellipsis between the frames suggests that she lacks the language to articulate the nature of this injury. When the next frame moves to a black silhouette, the simplified image is somewhat racially specified by the outline of her braids. Her silhouette, blended with his in her retrieval, has a symbiotic relationship with the image of Billy's corpse. Our knowledge of other images of lynched bodies in the comic as well as the well-known images of African Americans lynched through history adds specificity to the silhouette. The image is not universally applicable to other bodies, and recognition of the specificity of the image encourages more of an affective response. McCloud argues that "storytellers in *all* media know that a sure indicator of *audience involvement* is the degree to which the audience *identifies* with a story's characters."[67] The specificity of these bodies and images may narrowly reject universality if their meaning springs from identification with blackness.

Images of lynching run through *Bayou*. It becomes the violence likely awaiting her father, but also the thing that produces one of the most horrific monstrosities of the narrative—a monster that looks like a Golliwog. The Golliwog was initially a character in *The Adventures of Two Dutch Dolls and a Golliwogg*, a children's book published in 1895.[68] It is nonhuman and monstrous, a fantastic rendering of a black

FIGURE 1.13. Jeremy Love, *Bayou, Vol. 1* (Burbank, CA: DC Comics, 2009).

grotesque. But Love uses the rendering of this racist representation to explore issues of black history and time. When Billy dies he learns that he will become a Golliwog if he clings to his body after his violent death. Later, we learn that the multiple Golliwogs are ravenous monsters who will consume other creatures of the bayou. They seem to have no allegiances.

In describing the Golliwog as the "bad thing" that happens to your spirit if you cling to your body, Love suggests some agency despite victimization. In other words, monstrosity can result if racialized violence defines black subjects. African Americans are not all victims in the text; in fact, Lee finds herself fighting in a world largely filled with the spirits of departed African Americans. And the Golliwog—the grotesque, smiling monstrosity—is the most profound representation of both victimization and intraracial destructiveness. Part of Love's project is to demonstrate the afterlife of violence. The fantastic work of the Golliwog is to try to imagine intraracial violence as an effect of white supremacist violence on black subjects. They are transformed by violence, made into unrecognizable monstrosities. Love's interest in intraracial violence evokes Milai's concerns, although their approaches to thinking about this issue are quite different.

The relationship between temporality, space, and identity is essential to treating the grotesque as a commentary on the effects of

racialized violence. The bayou exists in the same time as our world, and the Golliwog is created after death, so it is quite clearly a representation imagined after the person killed by violence is completely lost. Love imagines violence both as creating another space—albeit a space that is too fantastic to have a direct referent to the real, like a black "ghetto"—but also as something that exists as a shadow to the world. Discourses around race, space, and violence often treat violence as the thing that is confined to certain spaces and always in danger of encroaching on spaces that are "safe." But in *Bayou* the southern pastoral, aided by the gorgeous work done by colorist Patrick Morgan, hides monsters and ghosts. It constantly threatens to pull more people into its grip.

At one point a Golliwog attempts to pull Lee under, and Bayou's large hand reaches into the water to retrieve her (Figure 1.13). The gutter demonstrates the role of comics in reimagining the kind of temporal narrative we tell about racism. If "post-race" discourse insists on placing racism in the past, comics is a medium that insists on placing the past, present, and future on the same page, and demonstrating the relationship between space and temporality. The Golliwog—representing the continued presence of historical violence—attempts to pull Lee down, and he is of both the past and the present, while the character Bayou (also shaped by the past) frees her.

A black comics hermeneutic thus requires understanding what is both absent and present in the gutter. As Thierry Groensteen explains, it is not a "virtual image" that is missing between frames, it is "a site of semantic articulation, a logical conversion, that of a series of utterables (the panels) in a statement that is unique and coherent (the story)."[69] If we place identity at the center of interpreting the articulation of the gutter, it can function structurally to say something about blackness. We might think about it as space that addresses what is not said or absent in cultural discourse about race. If comics is, as Groensteen argues, a medium "founded on reticence" and shaped by stillness, the black body in comics sometimes models waiting or silencing that reshapes the frame into an aesthetic structure that has attempted to contain blackness.

Despite the focus on temporality, fragmentation, and the "frame" as a way of thinking about space in the work of Groensteen and other comics theorists, Scott McCloud's framing of the "icon" is also central to understanding the semiotics of comic art. But when black aesthetics meet questions of iconicity, the racist caricature tradition can

overdetermine and haunt treatments of the black body. Fragmenting black bodies when they historically have often not been treated as whole takes on a different resonance. The treatment of time in comics might also be transformed if we think about the ways in which black people have been imagined as lacking futurity or, following Hegel, lacking a past.[70]

Bayou encourages a thicker understanding of what comics might explicate about African Americans' haunted histories. This is not to say that no other medium can make use of racist representations of the past to say something complex or even similar about race. But the comics medium clearly lends itself to Love's treatment of racial representations and history. Love illustrates that an identity hermeneutic can help us reimagine how the form works in comics about race. Form does not only act on content. Content acts on form. In this context, emptiness and space in the comic take on new meanings when read in relationship to race. While much of comics theory discusses a kind of emptiness or abstraction that is filled—the frame, the gutter, time, space, the face, the icon—we might see comics as a medium of presence in which specificity is always interacting with emptiness. The gutter often signifies action and time that readers must imagine, which takes on particular meaning in this text.

The Golliwog's body encourages readers to focus on the movement, and escape, from violently produced images and history. Like other black fantastic projects, Bayou is, as Richard Iton describes such work, "in conversation with, against, and articulated beyond the boundaries of the modern."[71] It tries to imagine a new modern subject, outside of one irrevocably tied down by history. Grasping hold of the mythologies of the black body helps push the black subject up, just as Lee is saved by a reconfiguration of history instead of being brought down by its legacy.

CODA: CARICATURES AS THE LIVING DEAD

In the twenty-first century African Americans continue to be *literally* brought down by the history of negative representation. Caricature—as part of the language of citizenship—has a relationship to stereotyping, racial profiling, and other forms of discrimination that inarguably have real-world effects.[72] Suggesting that representations consistently cause injury is empirically questionable and invites methodological disciplinary squabbles, so I am not making claims about causality, per se, but calling attention instead to representations as living—continuous,

active, and interacting with discursive practices in the world. Lines forming an image on the page, a photograph, and film are all examples of the many kinds of representations that exist temporally as things that were created before and that we still see and live with in the present. Ongoing debates about why negative representation matters in racial injury revolve around accusations that people have a wounded attachment to the past and that representations create the conditions and excuse for harm. The temporality of the reading and treatment of the body—and the ways these things are related—are issues that comics like *Bayou* take up in intriguing ways.

I end this chapter by gesturing toward a black comics producing future that understands the difference race makes in reading practices, transforming conventions people know. Like *Bayou*, the short comics story "Pull It Up from the Roots," by Avy Jetter, takes up the legacy of lynching and its relationship to police brutality in the present. Jetter's longest work is "Nuthin' Good Ever Happens at 4 a.m." (2012), a horror comic that follows four friends struggling in Oakland after a zombie outbreak. As an artist focused on the horror genre, her aesthetics speak to the broader challenge of representing violence to the black body or produced by the black body given the history of such representations as injurious. Performance studies scholar Koritha Mitchell has argued that the replication of lynching photographs produced and circulated by whites only replicates the politics of white supremacy that produced the lynching itself.[73] Others have questioned the efficacy of constantly circulating images of black death in the fight against police brutality, as the spectacle of it can offer sensationalist pleasures for some viewers.[74] The ethics and possible consequences of replication push us to think about how we might defamiliarize the treatment of the body in ways that may call attention to the horror as opposed to routinizing it.

The generic structure of horror narratives begins with either the everyday or a hint of something ominous in a domestic space. Monsters disrupt the lives of the protagonists, their bodies are brutalized and transformed by the threat and the violence, and not everyone survives. We are left with the aftermath of the horror and typically with the prospect that something will return. Jetter's story was published in *Artists Against Police Brutality: A Comic Book Anthology* (Figure 1.14). Her style is reminiscent of underground comics cartooning that emerged in the 1960s and 1970s, and Jetter is producing within this tradition of alternative comics. She drew in black-and-white; a stark

FIGURE 1.14. Avy Jetter, "Pull It Up from the Roots," in *Artists Against Police Brutality: A Comic Book Anthology*, ed. Bill Campbell, Jason Rodriguez, and John Jennings (Greenbelt, MD: Rosarium Publishing, 2015).

image of lynched African Americans is the opening panel, followed by images of household items—a lamp, knife, and fork—the everyday prefaced by histories of violence and later disrupted by it. The angry, maniacal eyes and screaming mouth of a police officer are fragmented and framed by the gasping utterances "I can't breathe!" which introduce the invisible victim to the reader. When we eventually see the effects of the chokehold, the eyes are asymmetrical and the face slightly evokes the grotesque. The body in pain is neither a heroic nor a pretty image. One of the penultimate panels after the police attack the crowd in a hail of bullets—depicted through fragmented narrative storytelling to evoke the experience of chaos—is a mass of black bodies and police bodies entwined. The largest face on the frame is contorted by a chokehold; other faces depict people with their eyes closed,

some attempting to block the blows of the police, others perhaps rendered unconscious by the struggle.

Her rendering of the face—both within and outside of context—evokes black abjection. Abjection and the grotesque are the result of what is done to the body by violence, and when it is displayed on the black body it cannot help but be a representation we do not want to see. She highlights the tendentious line between the black victim and monstrous blackness with the bones she makes visible beneath the victims' flesh. It calls attention to the vulnerability of their bodies under police assault but also evokes the skeletal remains of the undead. Here, horror genre conventions produce the conditions for production and reading. The slippage between the supernatural and the real characteristic of horror employing the uncanny elucidates the quotidian horror of black vulnerability. Jetter's work is not an example of something comics does uniquely that other kinds of media do not, but it is that very similarity that highlights why we place black comics in conversation with other kinds of black cultural productions. Her work emerges from a long tradition—initiated by print culture—that still resonates in other media. Black caricatures do not die.

I have outlined multiple ways a black identity hermeneutic can be applied across time and genre. In some ways autobiographical criticism is the easiest but least generative, as Herriman demonstrates. Knowing he was passing can inform our readings, and the vulnerability and indeterminacy of the "black" representations in his work invite a racialized hermeneutic without that knowledge. Milai used caricature to indict those who fail to adhere to respectability politics. And Love's caricatures are literally monstrosities that illustrate the injuriousness of history. Finally, De Landro embraces these caricatures as a way of refusing the regulatory scripts attached to transgressive, racial identities.

Play, indictment, history, and resistance largely map the ways in which black creators have made use of characters that might be seen as offensive outside of context. The tradition of people of African American descent using racial caricature or derided representations is long. Because there are such varied uses, they demonstrate that the racist or racialized representations are part of a vocabulary of black comics aesthetics that speak to the aesthetic questions of the moment while linking aesthetic traditions across time. In most cases, the representation is a tool to arrive at a meditation on something other than the

body itself. In *The Souls of Black Folk*, W. E. B. Du Bois famously stated that white citizens view African Americans and wonder, "How does it feel to be a problem?" These works are unpacking a related question, "How does it feel for the *black body* to be a problem?" In the interstices between the caricature and the gaze, people often only imagine the foreclosure of possibility. Milai may use caricature to suggest this is so. But from Herriman to De Landro, some artists imagine taking power away from the narrative attached to the image, to arrive at something that feels like liberation.

2

THE REVOLUTIONARY BODY

Nat Turner, King, and Frozen Subjection

Black liberatory aesthetic practices are a response to imperialist aesthetics that construct notions of not only alterity and the beautiful, but ideal political subjects.[1] The logic of these visual representations is often oppositional, with enslaved and colonized subjects functioning as a binary other to white citizens and caricatures of "good" black protestors standing in contrast to "bad" protestors. After the Ferguson uprising in 2014 that was a response to officer Darren Wilson shooting Michael Brown, many commentators and scholars noted how the "caricature" of the black brute was used to justify the shooting and that the "sainted caricature of the Civil Rights Leader" was used to brand the Ferguson protestors as resisting state violence in the wrong way.[2] The vast majority of protestors were nonviolent, but the media treatment of their response is illustrative of a long-standing racialized hypocrisy in depictions of revolution. White male violence is romanticized in a variety of genres as a marker of good citizenship, while violent black masculine subjects are often villainous others to black supplication. African American abolitionist Frederick Douglass famously recounted his use of "heroic violence" in his journey from slavery to freedom, but black political violence is consistently rejected in the Western public sphere.[3]

Hypocritical treatments of political violence should inform any reading of Kyle Baker's *Nat Turner.* He tells the story of the most notable slave rebellion in US history, in which Turner led slaves to revolt against white slaveholders in Southampton County in 1831. One of the most indelible and discussed images in *Nat Turner* depicts the decapitation of a smiling white child.[4] The scene lingers in readers' memories not only because of the atypical representation of the violence but also because of the (b)lack humor undergirding the scene. We are initially introduced to the doomed child when he smiles at a slave, whose name we later learn is Will, chopping wood. Will (also ill-fated) responds with a smile and a wave, suggesting affection between them.[5] As Consuela Francis notes,

tension builds because readers are aware that the story is leading to a slave rebellion, and might read as ominous the frame foregrounding an axe in the slave's hand with the child's diminutive figure waving in the background.[6] I might even suggest that it is *cheekily* ominous. When they encounter each other again, the white boy greets him with the same look of joy, but the smile is cut off, literally, by the violent swing of the axe. His face contorted with rage, the gentle slave is transformed—or perhaps his real affect is revealed—by the uprising (Figure 2.1).

The shock is prompted not only by the violence itself but by the rarity of the scene. Even if the deaths of children constantly set fictional plots in motion, we rarely *see* children being killed in any medium. *Decapitated* children are, needless to say, uncommon. The unusualness of the scene may be one of the reasons Baker positions it as one of the more important frames in the comic by giving this moment a full page.[7] The artist does not shy away from the violence of the rebellion or expressions of rage. While African Americans have often practiced (b)lack humor when representing slavery, some readers found Baker's blend of horror and levity unseemly.[8] Comics scholar Marc Singer, for example, writes that "the sheer graphic overkill" may "leaven the image with a perverse undercurrent of joy."[9]

Francis pushes back against this kind of criticism, as it "suggests a longing for [a] kind of moral certainty, one in which lashing out violently against a pervasive system of dehumanizing and degrading oppression is always wrong."[10] By showing that the violent rebellion was inextricably tied to the violence constantly inflicted upon slaves, and by resisting the "moral center" successfully occupied by nineteenth-century slave narratives, Baker refuses respectability politics by privileging ambiguity instead.[11] Moreover, Singer fails to note that "leavening" violence is a thoroughly accepted American pastime. By evoking the superhero and action comic at many points in the text, Baker seems to suggest that the affects motivating such violence (and the undoubtedly troubling pleasures of retribution) are far from perverse. Violence perpetuated by soldiers, lone avengers, and superheroes in popular culture is expected, treated as reasonable, and even romanticized in many US narratives. In contrast, many antiracists *and* those whose policies often uphold racial inequality, as Francis argues, "demand that the enslaved/oppressed demonstrate their moral superiority at every turn, primarily through denouncing violence."[12]

In the wake of the Black Power movement in the 1960s and 1970s, black people who utilized violence in seeking justice would appear in

FIGURE 2.1. Kyle Baker, *Nat Turner* (New York: Abrams, 2006).

blaxploitation films and other genres, but even a cursory overview of mainstream media discussions of twenty-first-century black responses to racist violence demonstrates that nonviolence and forgiveness are still understood as the ideal path to black equality.[13] In the small pantheon of black heroes celebrated in the dominant discourse of the black freedom struggle—Frederick Douglass, Harriet Tubman, Sojourner Truth, W. E. B. Du Bois, Martin Luther King Jr., Rosa Parks, and Malcom

X post-Mecca—Nat Turner thus poses somewhat of a representational conundrum.[14] On the one hand, most US citizens acknowledge slavery was wrong and also celebrate the archetype of the revolutionary hero. On the other hand, Turner led the largest and bloodiest slave rebellion in US history, and *black* violent resistance is not celebrated in mainstream US culture.

I am not suggesting that violence is a moral good. But Baker calls attention to the racially variable denunciation of the violent, revolutionary hero in US culture. Will's act is horrific, but many lives of innocents are lost when soldiers representing the nation perpetuate warfare.[15] The reality and cost of that violence are often erased in the idealized caricature of the soldier (as opposed to the demonized violent African American) fighting for a good cause as an ideal. And for those concerned with the ways in which depictions of violent African Americans are typically destructive caricatures and stereotypes, that representation of Will may seem simply to replicate white supremacist frameworks that they fight to resist. The discomfited affects produced by this image challenge the caricatured nature of generic models of cultural heroes, and the specific problem of scripting ideal African American heroism as nonviolent, forgiving supplication. Those representations serve to perpetuate what Priscilla Wald would call "official stories" about citizenship, specifically about white heroism and black supplication, while they also regulate possibilities for more progressive frameworks for understanding activism in the present.[16] Regulation occurs because these caricatures continue to hold discursive power in US discourse, still framing what good black activism should look like today.

Comic and cartoon art were important sites for circulating the citizenship ideal of the supplicating black body. Abolitionists established this convention, with cartoonists such as Thomas Nast making distinctions between good and bad emancipated African Americans. The black supplicant also featured prominently in civil rights movement discourse, in which activists arguably made better use of various media for activism than ever before in social movement history. In that context, comic and cartoon art often functioned as more of a reflexive commentary on the discourse of black citizenship circulating in more popular media.

In different ways, both *Nat Turner* and another twenty-first-century graphic biography, Ho Che Anderson's *King*, reflexively call attention to the disciplinary work of heroic black iconography in US culture and the ways in which it idealizes the nonagentic black male subject.

Baker's narrative, like other neo-slavery texts, is in conversation with both historical representations of slavery and the present. The temporal mash-up of the twentieth-century superhero and action-hero comic with the drawings that evoke nineteenth-century representations of slaves unsettles the complex relationship contemporary readers have to representations of slavery. He uses pastiche to bring present-day representations of heroism to the past, and the past to the present, drawing affective connections between heroic iconography in different eras. Anderson also uses pastiche, calling attention to how King became a simulacrum in the popular public sphere. The heavily circulated representations of King in various media—sound, photograph, film, even his monument—have all moved through history to produce a very narrow representation of the civil rights icon. In various ways, King has often been depicted as frozen—either as a hero at a particular moment in his activism or incapable of moving forward.

This chapter examines how Baker and Anderson's graphic biographies reflexively contest historical representations of black heroic citizenship during slavery and the civil rights movement. Employing an identity hermeneutic helps us explore the ways in which the history of idealized and demonized racial caricatures is central to the narrative construction of these texts. I place Baker in conversation with the nineteenth-century representations of slavery in cartoon art—particularly the work of Nast. In Nast's cartoons, ideal African Americans were supplicating, and they were dangerous when attempting to participate in the work of running the state. Baker's representations of heroic and dangerous blackness are the antitheses of Nast's. His representations of revolutionary black bodies using violence to fight for freedom challenge historical treatments of African Americans in US visual culture. I also place Anderson's work in conversation with editorial cartoons in order to construct a different genealogy of public representations of King. While representations of King in film, photography, text, and sound recordings constantly circulate, editorial cartoons are not a prominent part of the archive of public memory. In looking at the archive of editorial cartoons at the time, we can see how King was often depicted as nonagentic and an unsuccessful political actor. More recent cartoons evoke the idea of King as frozen to describe the incompleteness of the black liberation project. By placing caricatures of the "good slave" and King in conversation with these graphic biographies, I explore how these cartoonists attempt to disrupt the narrow discursive frameworks for what kinds of African American leadership can be celebrated.

THE AESTHETICS OF THE "NOT YET" CITIZEN

The origins of African American citizenship are infamously partial (three-fifths a person) and formally nonexistent, a foundation of both "counting" and *not* that inaugurates a definitional crisis in a national discourse characterized by contradictions. Slavery and colonialism have been foundational to the project of modernity, and yet black people have been positioned outside of history and described as outside of the modern.[17] Black life is thus often defined by temporal shifts—before and after emancipation, the civil rights movement, and colonialism. These temporal divisions are both significant and somewhat obfuscating of the past's continued presence in the era of the "post," and the reconfiguration of power relations meant to mimic previous forms of domination. Temporality also plays a role in "waiting," a continued position for black people to occupy. Because they have been both forced and asked to wait for rights and resources that dominant groups receive first, African Americans demonstrate, as Michael Hanchard states, how "human vitality" can be "harnessed because of racial time."[18] In other words, racialized time is a means of keeping African Americans from participating in the traditionally mandated project of nation building through self-determination.

Waiting and patience have thus been essential to majoritarian configurations of good black citizenship in the United States. When in his "Letter from a Birmingham Jail" Martin Luther King Jr. famously criticized the frequent counsel that black people wait, he was not only responding to the demands that movement protesters be patient in addressing Jim Crow laws, but also speaking to the "340 years" that African Americans had been waiting for "constitutional and God-Given rights."[19] After a staggering list of racial injuries never experienced by the people demanding that African Americans be patient, King writes, "When you are forever fighting a degenerating sense of 'nobodiness' then you will understand why we find it difficult to wait."[20]

Comics and cartoon art are well situated to explore the waiting black body because of the ways in which temporality works in the medium. The editorial cartoon depends on a temporality of the present, hinging on contemporary readers being able to situate the content. Panels in sequence, as Hillary Chute argues, depend "on the way temporality can be traced in complex, often non-linear paths across the space of the page."[21] In both cases, situating the body in time is essential to comprehension. The discursive configuration of the black body as waiting

thus intersects with the structure of the comics medium to facilitate a temporal distortion of the African American citizen.

In the years preceding and during the Civil War, the waiting black body would be the sympathetic ideal during a moment in which white men were understood to be taking action. Differences between depictions of white and black citizens can be seen in the hybrid commemorative illustrations/editorial cartoons in *Harper's Weekly* that were progenitors of later cartoons in the United States. Founded in 1857, the periodical was the most-read publication during the Civil War. Most of its illustrations during the war focused on white lives and depicted African Americans infrequently. However, we can see the importance of temporality (and black waiting) in the work of celebrated cartoonist Thomas Nast. His work constantly focused on the relationship between the past, present, and future, and his treatment of slaves demonstrates the ways in which he could not fully imagine them as within the nation-state.[22]

Like other contributors to *Harper's*, he frequently excluded black people from the predominant narrative he presented in his cartoons about the Civil War and the home front. In 2005, Kara Walker produced *Harper's Pictorial History of the Civil War (Annotated)*, a book project that overlaid the collection of images from *Harper's* with black silhouettes and collages of black bodies.[23] One of her interventions was a commentary on the remarkable absence of black people from the story *Harper's* told about a war caused by a conflict over slavery. The relative underrepresentation of black people from this, a popular source of information about the war, is illustrative of how black people can be left out of narratives in which they are central. We can see this exclusion in the genre of cartoons produced during that period, particularly in a number of what I term *panoramic cartoons*, which suggest an almost omniscient gaze on various actors in the war. Segregation in regiments and social life might produce predominately white images, but the move from home life to battlefield to Liberty herself crying over what was lost in the war suggests the cartoonist is producing a scene about American life more broadly. While it might be tempting to categorize these works as illustrations, we should see many of them as editorial cartoons and comic art. The editorial cartoons feature a tension between word and image to call attention to an issue, while the panoramic images are pictures in sequence in a single panel.

In an editorial cartoon criticizing the possible compromises of the Chicago Convention in 1864, Nast depicts the costs, primarily, to

FIGURE 2.2. Thomas Nast, "Compromise with the South," *Harper's Weekly*, September 3, 1864.

suffering white people. Emancipation is listed as one of the things that would be overturned by the compromise, signified by it being written on the upside-down northern flag. The title, "Compromise with the South," and the caption, "Dedicated to the Chicago Convention," produce the triangulated structure that evokes irony (Figure 2.2). The primary sense of what is lost is white liberty. Some commentators have read the solider on the right in chains as African American, but what is interesting about that interpretation is that Nast had very clear aesthetic practices in depicting black people. If this soldier and his family, including a woman with long, flowing hair are African American, it is unlike representations of black people he has in other images.[24] He either fails to include slaves in his discussion of the compromise's costs or depicts a black family in ways that are consistent with the representation of the black family popularized by Harriet Beecher Stowe's famous abolitionist novel *Uncle Tom's Cabin*, in which the people most unsuited to subjection are those closest to whiteness. Either way, the cartoon is illustrative of Nast's discomfort with seeing African Americans as full citizens.

Black exclusion facilitated a temporal narrative about the country that black people would complicate. The binary positions represented

were North and South, and the war disrupted an idealized narrative of a unified national past. While slavery marked a clear difference between the North and the South in most regions, African Americans were still not equal citizens in the North. Thus, in Nast's narrative about the war and the future, the configuration of just and unjust regions focuses on white citizens. His ambivalence about black citizenship would become even more transparent in the cartoons he produced during Reconstruction.

One of Nast's more famous cartoons during the war that did depict African Americans is "Emancipation" (1863/1865), a panoramic cartoon that celebrates the Emancipation Proclamation and presents many of the standard tropes of slavery representations on the left side of the image—the auction block, a master or overseer whipping a slave, and captured runaways (Figure 2.3). As the eye moves toward the right side of the image, we see images of freedom—labor, school, and a post-emancipation domestic scene. The images of African Americans are largely realistically drawn, and they are positioned in scenes of everyday life. In the central, smaller circle at the bottom, Father Time holds the New Year's baby, and he appears to release the shackles binding the

FIGURE 2.3. Thomas Nast, "Emancipation," *Harper's Weekly*, 1865.

slave. After his assassination, Lincoln's visage would replace this image in a reprint, signifying his agency in liberating African Americans. But in this first iteration, Nash suggests a teleological progression—that freedom was inevitable for African Americans as the nation moved toward fulfilling its promise of democracy. At the same time, the largely racially homogenous scene does not depict integration. It is a scene of black progress both central to the nation's progress and strangely outside of it.

Nast makes use of the standard trope of the supplicating slave multiple times in the panoramic cartoon, a representation firmly established with Josiah Wedgeworth's "Am I Not a Man and a Brother" medallion (Figure 2.4). The early abolitionist emblem became fashionable for people to wear.[25] Later the image would appear frequently in abolitionist publications, and the image of the slave in the original bent-knee pose, almost in prayer, was prolific, but so were modified versions in which the slave is still subjected, knees bent, hands up, looking up for salvation. A striking characteristic of the African American futures in the Nast cartoon is that none of the figures are ever standing tall. All the figures in the past are bent or prostrate. Emancipated, their heads are still slightly bowed, even if just to commune with each other in domestic scenes. While not on their knees, black men are slightly hunched over when getting paid or in tipping their hats to a white man on a horse in Nast's vision of the future of black labor. They even have slightly bowed heads at home.

That African Americans are still bowed down after emancipation in Nast's imagination is illustrative of the temporal resilience of black subjection as a preferred image of African Americans in the nineteenth century. Such representations do not suggest that African Americans cannot move forward. On the contrary, the images proffer that even when African Americans move forward, their development is still somewhat arrested, and they are to some extent stuck in place.

Graphic storytelling as a medium facilitated the representation of black subjection in *Harper's*, perhaps never more so than with the drawings based on the photography of "Gordon," arguably

FIGURE 2.4. Anti-Slavery Society, "Am I Not a Man and a Brother?" Woodcut, 1837.

|A TYPICAL NEGRO.|

WE publish herewith three portraits, from photographs by M'Pherson and Oliver, of the negro GORDON, who escaped from his master in Mississippi, and came into our lines at Baton Rouge in March last. One of these portraits represents the man as he entered our lines, with clothes torn and covered with mud and dirt from his long race through the swamps and bayous, chased as he had been for days and nights by his master with several neighbors and a pack of blood-hounds; another shows him as he underwent the surgical examination previous to being mustered into the service—his back furrowed and scarred with the traces of a whipping administered on Christmas-day last; and the third represents him in United States uniform, bearing the musket and prepared for duty.

This negro displayed unusual intelligence and energy. In order to foil the scent of the blood-hounds who were chasing him he took from his plantation onions, which he carried in his pockets. After crossing each creek or swamp he rubbed his body freely with these onions, and thus, no doubt, frequently threw the dogs off the scent.

At one time in Louisiana he served our troops as guide, and on one expedition was unfortunately taken prisoner by the rebels, who, infuriated beyond measure, tied him up and beat him, leaving him for dead. He came to life, however, and once more made his escape to our lines.

By way of illustrating the degree of brutality which slavery has developed among the whites in the section of country from which this negro came, we append the following extract from a letter in the New York Times, recounting what was told by the refugees from Mrs. GILLESPIE's estate on the Black River:

The treatment of the slaves, they say, has been growing worse and worse for the last six or seven years.

Flogging with a leather strap on the naked body is common; also, paddling the body with a hand-saw until the skin is a mass of blisters, and then breaking the blisters with the teeth of the saw. They have "very often" seen slaves stretched out upon the ground with hands and feet held down by fellow-slaves, or lashed to stakes driven into the ground for "burning." Handfuls of dry corn-husks are then lighted, and the burning embers are whipped off with a stick so as to fall in showers of live sparks upon the naked back. This is continued until the victim is covered with blisters. If in his writhings of torture the slave gets his hands free to brush off the fire, the burning brand is applied to them.

Another method of punishment, which is inflicted for the higher order of crimes, such as running away, or other refractory conduct, is to dig a hole in the ground large enough for the slave to squat or lie down in. The victim is then stripped naked and placed in the hole, and a covering or grating of green sticks is laid over the opening. Upon this a quick fire is built, and the live embers sifted through upon the naked flesh of the slave, until his body is blistered and swollen almost to bursting. With just enough of life to enable him to crawl, the slave is then allowed to recover from his wounds if he can, or to end his sufferings by death.

"Charley Sloo" and "Overton," two hands, were both murdered by these cruel tortures. "Sloo" was whipped to death, dying under the infliction, or soon after punishment. "Overton" was laid naked upon his face and burned as above described, so that the cords of his legs and the

GORDON AS HE ENTERED OUR LINES.

GORDON UNDER MEDICAL INSPECTION.

GORDON IN HIS UNIFORM AS A U. S. SOLDIER.

FIGURE 2.5. "A Typical Negro," *Harper's Weekly*, July 4, 1863.

the most enduring image in the history of US slavery's visual representation (Figure 2.5). The picture of Gordon's scourged back circulated widely in abolitionist texts and as a carte de visite before being replicated as a drawing in the 1863 *Harper's* story of "A Typical Negro."[26]

His name was not actually Gordon, and the story *Harper's* tells is false, but I am less interested in historical accuracy than in the work the representation of Gordon performed.[27] The three images of Gordon functioned as a triptych in *Harper's*; this is less familiar to contemporary audiences, who often see only the image of his scarred flesh.[28] The images function as an illustration for the story, but by reading the images alone as sequential art we can see the temporal claims being made about black citizenship. He appears in rags, is examined by doctors, and then dons a uniform. But the larger-sized image of his scarred back in the middle of the triptych continually draws our eyes back to the wounded slave, casting our attention to what preceded his arrival at the Union front lines and drawing our eyes away from his transformation into a soldier. Our gaze cannot quite move on, and the image lingers on the representation of wounding. The defining aspect of his identity in

this triptych is not that he has become a soldier, but that he was a slave who was whipped, and he carries the legacy of rent flesh. The history of reproduction of this image—there were many more reproductions of the scarred black back than the other two—illustrates the ways in which he is frozen as a wounded subject.[29]

This temporal tension in bodily transformation runs through the broad range of illustrations and cartoons depicting slavery in *Harper's*. The typology of African Americans fits roughly into three types in the periodical: the helpless victim needing protection from white supremacy, the pre-citizenship subject who is a respectable figure on the cusp of liberty, and the coon citizen post–Civil War, not fully human, and not quite ready for full participation in the state. African Americans are rarely full citizens in these images; the best they can aspire to is potentiality. Moreover, *Harper's* does not necessarily "progress" in its visual depiction of African Americans. After they are freed, they may still be helpless victims or coon citizens who threaten the nation with their incompetence. Thus, while sympathetic to suffering African Americans, Nast does not go so far as to see them in roles of governance. Suffrage was the limit for black citizenship for Nast. Black victimization should not be tolerated, but neither should full participation in governance or equality (Figure 2.6). That African Americans lacked the capacity for full citizenship was a given to him, and he used caricature to demonstrate their alleged limitations. Citizenship, for Nast, was often written on the body and the face.

Part of what made slaves worthy of freedom was their supplication and lack of threat. While Nast would continue to recognize that white supremacy was crushing African Americans, with the dawn of Reconstruction the largely pro-Union Nast consistently represented black voters and black governance as dangerous. African Americans are constructed as at a precipice—on the verge of freedom or causing state destruction, perpetually gesturing toward a future but also frozen in a moment prior to citizenship. In nineteenth-century visual discourse African Americans signify the "not yet" through their bodies. They are free and yet never ready.

Representations of African Americans in *Harper's* highlight tropes that are familiar to anyone who has encountered a history of black representation in the United States—the bent, supplicating body and animalistic, grotesque phenotype. Cartoon art was one site that established a framework for reading these bodies temporally. Even when moving forward politically, the treatment of their bodies suggests that they remain in place. Racist caricature is also a means of speaking to the past

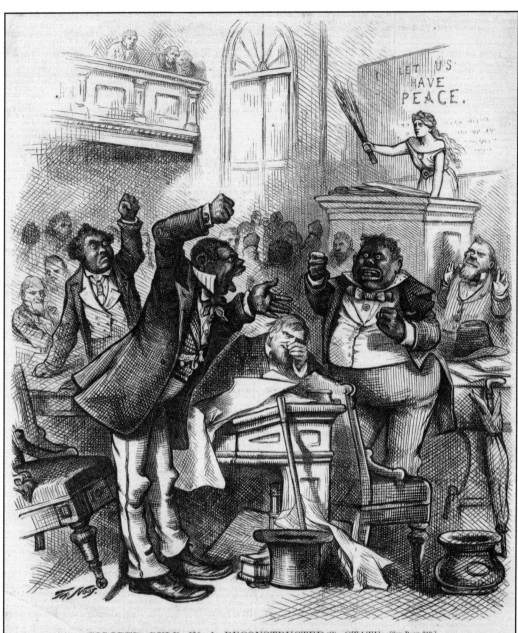

COLORED RULE IN A RECONSTRUCTED (?) STATE.—[See Page 242.]
(THE MEMBERS CALL EACH OTHER THIEVES, LIARS, RASCALS, AND COWARDS.)
COLUMBIA. "You are Aping the lowest Whites. If you disgrace your Race in this way you had better take Back Seats."

FIGURE 2.6. Thomas Nast, "Colored Rule in a Reconstructed(?) State," *Harper's Weekly*, March 14, 1874.

and future at the same time by evoking the idea of arrested development. Rather than engaging in the antiracist and postcolonial tradition of *writing* back to the empire, then, Kyle Baker is *drawing* back to these representations, constantly referencing the nonagentic form, the grotesque caricature, as well as romanticized white caricatures to defamiliarize the affect attached to African American and white citizenship ideals.[30]

REDRAWING AFFECTIVE HISTORY

Kyle Baker's *Nat Turner* (2005) quickly became one of the most important comics in the burgeoning canon of African American comic and cartoon art. Baker is arguably the most successful and prolific cartoonist I discuss in this book. Born in 1965 in Queens, New York, he began his career as an intern at Marvel Comics in high school.[31] Thus unlike many of the other cartoonists I discuss, he began not with independent publishing or a niche black press but with major companies. After some penciling and inking work in the 1980s, his first major work was the comic adaptation of *Howard the Duck: The Movie* (1986–1987). While he has also done some work in Hollywood, he has worked on many superhero comics. His first independent comics, *The Cowboy Wally Show* (1988) and *Why I Hate Saturn* (1990s), are not focused on black characters and I would not argue that blackness is a primary concern in most of his work. His artwork for the black Captain American comic *Truth: Red, White & Black* (2003), which I will discuss in the next chapter, and his collaboration with cartoonist Aaron McGruder and writer Reginald Hudlin, *Birth of a Nation* (2004), are arguably his first major works focused on antiblack discrimination. *Nat Turner* is a capstone in a period of his career focused on African American life.

Scholars have addressed the graphic narrative's relationship to other narratives about Turner. They have debated William Styron's controversial 1967 novel *The Confessions of Nat Turner*, described its largely wordless comics approach as a resistance to existing texts, explored its complex treatment of violence and morality, and positioned it within a tradition of neo-slave narratives.[32] As a neo-slave narrative it constructs accounts of black subjectivity that fill in the gaps of the archive. These texts, as Ashraf H. A. Rushdy explains, "assume the form, adopt the conventions, and take on the first-person voice of the ante-bellum narrative" while also engaging "in dialogue with the social issue of its moment of origin."[33] Neo-slave narratives also produce an affective history that disrupts the highly mediated voices of the original slave texts. While

historians of slavery have done extraordinary work in building archives of primary and secondary sources, slave historiography, like many other kinds of histories, has had to contend not only with absences in the archive, but also with abolitionist and pro-slavery representations of slavery that obfuscate slave experiences. Various genres and media have thus tried to get at the experience of slavery in different ways.

Jonathan W. Gray makes a case for the specificity of the comics medium in how Baker addresses issues people often have with the slavery archive: "Baker supplements the archival text with images designed to call attention to perspectives the archive cannot represent," and thus imposes a "narrative as well as an ethical order on the archive of slavery via his juxtaposition of citation and image."[34] For Gray, Baker "'solves' the problem of interpreting the archive of slavery by composing a historical graphic novel whose illustrations simultaneously advance the narrative and demand a reinterpretation of the archival text when such is present."[35]

I center Baker's play with genre and caricature even more in unpacking his reflexive attentiveness to archive. Much of the difference between the documentarian function of many histories and neo-slave narrative fictions may best be described as a difference between the "true" and the "real." As Hayden White explains,

> Historical discourse wages everything on the true, while fiction discourse is interested in the real—which it approaches by way of an effort to fill out the domain of the possible or imaginable. A simply true account of the world based on what the documentary record permits one to talk about what happened in it at particular times and places can provide knowledge of only a very small portion of what "reality" consists of. However, the rest of the real, after we have said what we can assert to be true about it, would not be everything and anything we could imagine about it. The real would consist of everything that can be truthfully said about what could possibly be.[36]

Neo-slave narratives address and complicate the tropes of slavery in narrative and representations, filling in gaps of the archive, representing what could "possibly be," an enterprise that sometimes relies on the fantastic to do its work—texts such as Octavia Butler's *Kindred* and Toni Morrison's *Beloved* being prominent examples.[37] Neo-slavery texts often focus specifically on the black *body* as a mechanism for

communicating the ways that black bodies are marked by temporality—haunted by history, poised on the precipice of a future that can never escape the past. Baker not only uses the body to get readers to rethink slave history, but quite specifically utilizes depictions of the face to redress historical treatments of black and white citizens in US history.

Scot French argues, "To accept Nat Turner and place him within the pantheon of American revolutionary heroes is to sanction violence as a means of social change. He has a kind of racial consciousness to this day that troubles advocates of a racially reconciled society. The story lives because it's relevant today to questions of how to organize for change."[38] Beginning on August 21, 1831, revolting slaves led by Turner killed approximately fifty-five men, women, and children in Southampton County, Virginia, over the course of two days.[39] Most of the rebels were executed, including those who were only suspected of participating. Turner escaped capture for over two months but was eventually caught and executed. He was the slaveholders' worst fear come to life, and afterward southern states passed even more laws, termed "slave codes," to try to prevent slaves from organizing and rebelling again.[40]

Thomas Gray's *The Confessions of Nat Turner* is the principal written text that Baker responds to, quoting it extensively. From its first appearance, people have questioned the "voice" and diction of the work—albeit for different reasons.[41] As someone who had owned slaves, Gray had a vested interest in producing a pro-slavery narrative.[42] But scholars largely agree that there are many details in the account that could have come only from Turner, even as we must believe that in telling his story the amanuensis impacted content and the delivery.[43] It is the most important account of the rebellion.

Nonetheless, Baker's images often go beyond what readers see in the text, and he adds few additional words. This signals his interest in functioning in tension with the historical narrative. Michael Chaney speculates that the wordless structure of the comic reflects Baker's interest in commenting on white historians' failure to say much about Turner, as "the silenced, abbreviated nature" of the rebellion "becomes its own narration in most historical accounts."[44] A difference between illustration and comics is that comics, as Charles Hatfield argues, often "depend on recognizing word and image as two 'different' types of sign, whose implications can be played against each other—to gloss, to illustrate, to contradict or complicate or ironize the other."[45] Thus Baker's text invites us to think about how the black body and *writing* about black people

function both similarly and dissimilarly. Baker's depictions of bodies disrupt racial scripts, as the bodies are consistently evidence of something beyond Gray's text.

Gray stages his encounter with Turner as a means of making sense of a slave whom he sees as inexplicably noncompliant with the subject position he occupies. "Public curiosity," he writes, "has been on the stretch to understand the origin and progress of this dreadful conspiracy, and the motives which influences [sic] its diabolical actors."[46] Those opposed to slavery can clearly see the cruelties of slavery as a fairly transparent reason to revolt, but for Gray this was an irrational act by slaves who lacked the intellectual capacity of whites. Far from seeing Turner as an exception, even if what he did was exceptional, he argues that the narrative is a lesson about "operations of a mind like his, endeavoring to grapple with things beyond its reach."[47] Gray evokes the idea that we see in *Harper's* of the black subject who paradoxically reaches but will always be in the same place. The stagnation is suggested by the idea of a "mind like his," an essentialist construction of black identity in arrested development. The abolitionist framing of black subjects is consistently the "not yet" and ironically compatible with the pro-slavery rhetoric that treats the slave body as perpetually and uselessly reaching. Visually, *there is much similarity between representations of bodies reaching and bodies supplicating.*

By using the conventions and representations of action and superhero comics, Baker moves away from the perpetually reaching body and makes the character an active body who can, indeed, grasp "things."[48] Casting Turner in a superhero mold, Baker gives him a superhero origin story through his genetic ties. Baker provides an elaborate back story for Turner's mother in issue 1, "Home," crafting a tale of his mother's capture, crossing of the Middle Passage, and experience of the slave auction, now definitive characteristics of the story told about the experience of slavery. "Home" begins with a scene in an African village, and he challenges traditional nineteenth-century visual representations of "natives" as wholly other with scenes of casual intimacy, depicting his mother flirting with a young man in the village.[49] But their lives are disrupted when slave catchers come with horses and guns. Turner's mother throws dirt in the face of one attempting to capture a boy, hides him in a frantic chase through the jungle, captures one slave catcher with a rifle, and shoots another in pursuit (Figure 2.7).[50] Eventually becoming trapped, she dives off a cliff to the ocean, and the panel in which she briefly takes flight, arms and legs extended, head looking up

FIGURE 2.7. A fantastic origin story for Turner's mother. Kyle Baker, *Nat Turner* (New York: Abrams, 2006).

joyously to the sky, mimics images of flying superheroes.[51] But she is brought back to earth when her ankle is caught by a lasso.[52]

Baker's evocation of the generic conventions of action narratives brings Nat Turner's story affectively into the present. His creative rendering of the Turner origin story also allows Baker to make the story more universal in one other way—by focusing on women. In "Home," he also tells the story of a woman who chooses to throw a baby born on the ship to sharks rather than allow the child to be taken into slavery. Historians have shown that black women used a vast arsenal of resistance methods during slavery, including infanticide.[53] But only one woman, Lucy, is known to have participated in the Southampton rebellion.[54] Other accounts generally suggest that a number of women either did not join or actively assisted the families that owned them.[55] While this was primarily a rebellion carried out by men, Baker clearly depicts a traditional "mammy Figure" with a rifle roaring with rage.[56] He thus recasts representations of both "good" motherhood and the mammy archetype. He also crafts a profoundly different representation than the whipped or supplicating slave woman in abolitionist texts. Far from what Hortense Spillers has called the pornotropic representations that eroticized black suffering in slavery, the affect of black women—however briefly depicted—is primarily rage.[57] Even if the scenes of the mother's actions are clearly fictional, representing black rage nonetheless fills in a historical

affective gap in abolitionist texts. Thus, the fiction can be more "real" than the historical record. The angry black woman now resonates as a popular racist caricature, but here anger and rage are contextualized as not only reasonable but heroic. The angry black woman's face thus becomes a progressive caricature, even as they are almost singularly represented this way in the comic.

This is just one of the ways that Baker has chosen to depart from what people know of the historical record, even as he uses *Confessions* to organize the text. By not imagining dialogue, Baker avoids addressing the question of language in accurately depicting black history and affect. Nineteenth-century representations of slaves' voices are notoriously problematic, be it pro-slavery depictions or the conventions of abolitionist discourse. In Baker's *Turner*, the reader is forced to read the body and the sometimes-confusing sequence of events without the often-linear conventional framework of *Confessions*. If not totally outside of the Western language African Americans utilized to claim their humanity, African American agency is depicted almost entirely through black bodies in action. The text provides contextual support for the images, but the images do not serve as illustration—the graphic narrative is clearly what dominates the text. Words are used as sound effect, but "Run, Daddy, Run" are the only speech bubbles Baker adds, as a young Nat tries to keep his father from being captured.[58] With words—other than the *Confessions*— functioning as jarring moments in the text, he emphasizes the uselessness of speech in this context for disrupting the course of events.

Yet the tyranny of a racist visual imperialism has proven just as hard to overcome as language, perhaps more so. Various African American writers have made Western language their own, blending standard English with black vernacular and elaborating on the challenges of being hybrid subjects in the West. But the black visual artist has often struggled to escape the overdetermined nature of black caricature in which the wider lips, nose, and smile on an African American can all too easily reference the ape or coon that dominates the history of visual representations of blacks. Like Thomas Nast and Sam Milai, Baker uses caricature to depict some African Americans' unfitness for citizenship. But in contrast, Baker uses racist stereotype in *Nat Turner* to mark a difference between the heroic and nonheroic African Americans by rendering the black revolutionary with realistic phenotype and muscular forms, while the black men who do not join the resistance and warn their masters are depicted as small, emasculated, and coonish (Figure 2.8).[59] As opposed to rejecting the history of black stereotypical

FIGURE 2.8. Coonish slaves betraying the rebellion. Kyle Baker, *Nat Turner* (New York: Abrams, 2006).

images, he utilizes these images to represent bad black citizens. And his understanding of "bad" is the antithesis to what the "bad" slave was in the white imagination. Short stature suggests arrested development, as the complicity with white supremacy is what marks them as less than full men. These caricatures stand in contrast to a moment earlier in the text when Baker depicts Turner hiding his reading from his master. He crosses his eyes, contorts his face, and performs a loose-limbed, Jim Crow–like dance.[60] Turner's dissemblance immediately ends when his master leaves, and he stares angrily into the distance, his face briefly

hidden from white surveillance.[61] Young Turner demonstrates how self-caricature has sometimes been a tool in black resistance.

Facial expressions are also essential to Baker's intervention into how black male violence is caricatured, exemplified by Will's transformation over the course of the insurrection. In the depiction of the insurrectionists' violence, Baker historicizes black rage through the face. Seeing Will's smiling face initially before the act of violence means that violence framed in the text cannot be read in isolation—and so often, black violence *is* read in isolation. As is often noted in discussions of aftermaths of violence, black offenders' lives are narrated as pathological histories leading to inevitable crime while criminal behavior is often seen as a disruptive or surprising act in the lives of nonblack perpetrators. Because readers see both disruption and history, they are encouraged to understand the affective complexity of black history in a way that can also push readers to think in more complicated ways about how black violence is read. Will's changed face later in the text allows readers to explore the interpretive possibilities of the slave's greeting to the child. The gesture can be read as the performance of intimacy and as real affection. These things are not necessarily mutually exclusive. The first face of the slave, depicting a gentleness designed to make whites comfortable, could also be a real part of the slave's identity. As the text progresses, his face is unmade by violence; its elegance gives way to broken lines and fractured features.[62] Set upon by many guns, he explodes in rage and is taken down by gunfire, a jumbled and confused mass of lines. Baker ends Will's story with a silhouette of his last scene, a grotesque parody of the nineteenth-century silhouette, the ugly shadow of civility and the domestic (Figure 2.9).

Will's smiling face may not be only performance, but could be his "real" face; and when his face devolves in the act of violence, this blackness is not necessarily more "real" than our first encounter with his visage. Given discussions of the "crisis" of black men—higher mortality, incarceration, and their stigmatization in US culture—Baker's text points to the unmaking of many black men of the past, illustrating how unmaking can happen in the present and future. In an interview about *Nat Turner*, Baker references the idea of the black holocaust, a phrase used to emphasize the genocidal devastation of slavery and the trauma of its after effects.[63] As many pundits and theorists discuss the deaths and thwarted opportunities of black people and explore black violence in the twenty-first century, *Nat Turner* resonates as it illustrates how black men have been unmade by violence, a process of unmaking that

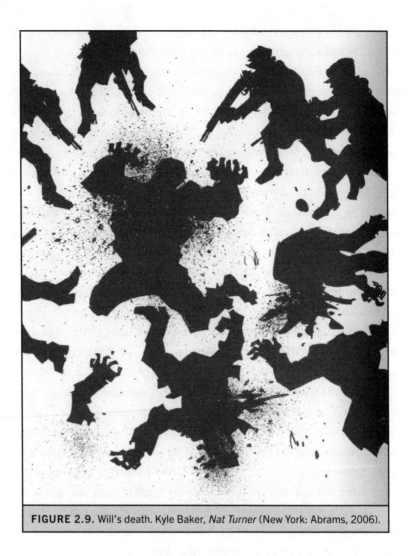

FIGURE 2.9. Will's death. Kyle Baker, *Nat Turner* (New York: Abrams, 2006).

may not have left us. The abstraction of the slave's dead body and the grotesque silhouette thus register in ways that are tied to history but nonspecific enough to speak to history's continued presence. The black silhouette surrounded by guns in this context is clearly the slave, but it could just as easily be one of the many African Americans—armed and not armed—killed by police.

Baker's interest in deconstructing the face of villainy and heroism does not end there. He also depicts a golden-haired, classically handsome white hero in the comic whom we first see holding a young girl in his arms, petting a dog, when the alarm sounds about the insurrection (Figure 2.10). He loads his shotgun and races to engage the slave rebels.[64] We see his horror at white death and masterful subduing of slaves. One of the rebels is drinking while he is pointing a gun at the white hero,

who easily dispatches him.[65] In another frame he shoots the rifle one handed.[66] What should strike the reader is his clichéd perfection, whose violence people are taught to cheer. This is the idealized caricature of a white revolutionary citizen who is Turner's opposite. After the rebellion, many blacks—including those not involved—were decapitated, their heads a warning to other slaves who might be contemplating rebellion. If people condemn the violence of the slaves, should they also condemn the massacre that followed, perpetuated by golden-locked heroes with cute toddlers and dogs?

Baker does not depict this aftermath, but the decapitation scene has a different register for someone with knowledge of this history. Putting heads on pikes is a grisly way of constructing a three-dimensional character study. Caricatures comment on character and moral failure. These bodiless heads reduce the black men and women to the crime warranting this injury, the complexity of their cause and their lives, gone—an indictment inscribed on flesh. The decapitation of the child read in isolation can be seen as an act of unforgivable cruelty, but if other beheadings were markers of who they were and what others could be, the white child is also being punished for his inevitable identity. Before sanctioning the death of a white baby, Turner thinks

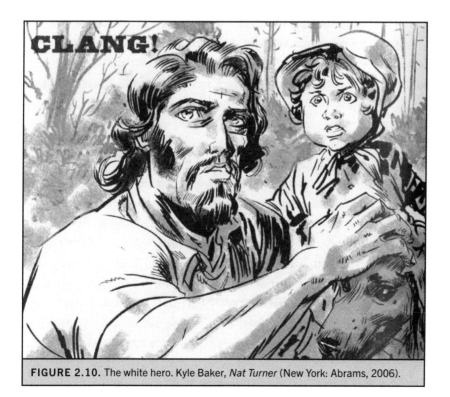

FIGURE 2.10. The white hero. Kyle Baker, *Nat Turner* (New York: Abrams, 2006).

of the slave mother committing infanticide on the slave ship (he says in *Confessions* that God has allowed him to witness things before his birth). Baker crafts a hermeneutic to read the white children in the same affective economy in which black children and adults are read, in which they are always already guilty. The complex affective response invited by the scene thus requires recognition of the wrongness of violence to black children through the wrongness that they feel at the scene of white death.

Baker's last commentary on reading character through the face is through his treatment of Turner himself. In part 4 the text comes closest to directly illustrating *Confessions*. Questioning Turner about his claim that he was a servant of God and a prophet, Gray asks, "Do you not find yourself mistaken now?" Presuming that he would change his mind since he was caught and now faced execution, Gray was probably shocked when Turner responded with, "Was not Christ crucified?"[67] Baker depicts Turner looking earnestly and solemnly at his interrogator, and when he walks off to face the lynching, he is depicted in profile, with a strong silhouette, and at peace (Figure 2.11). It is the white audience whose faces are contorted and grotesque.[68] Turner reportedly did not react conventionally to being lynched, and this disconcerted the audience.[69] Confronted with serenity, their smiles are wiped away.

Baker's attentiveness to the face is an intervention into traditional slavery representations because the iconography was never about the face. The whipped back, the supplicating body, and other unindividuated representations contribute to a discourse that fails to see black people as individuated subjects. Frederick Douglass utilized photography in the nineteenth century to define himself as a free man and citizen, and in contrast to caricature. He spoke of being depicted in a newspaper as a "little Figure, bent over and apparently in a hurry, with a pack on his shoulder going North."[70] Even when depicting him as escaping to freedom, he was drawn as unimpressive. Douglass was deeply interested in political caricature in pursuing slavery abolition, but he became the most photographed person in the nineteenth century to demonstrate his importance and humanity as an individual.[71] Baker, however, sees caricature as something that can be important in humanization. He imagines a representational history that disrupts slave iconography and heroic white iconography. Bodies can often be used to depict action, but in the case of slaves, representations of the body often depict passivity. Baker makes not only bodies but faces active, highlighting a dynamic and complex affect that stands in contrast to the singularity of visual

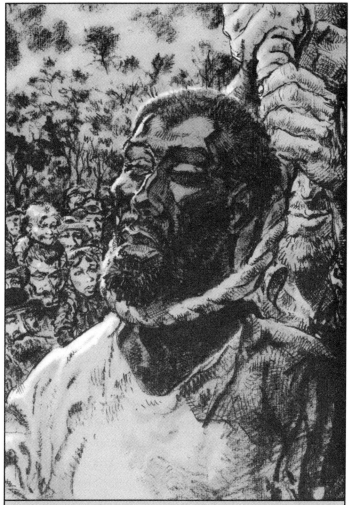

FIGURE 2.11. Nat Turner's death. Kyle Baker, *Nat Turner* (New York: Abrams, 2006).

representations of slave feelings. By not resisting these representations with alternative *words*, he calls attention to the representational logic in US culture that embraces the language of caricature as a mechanism for crafting ideal citizen typologies in the nation.

MARTIN LUTHER KING JR. AND FROZEN AESTHETICS

If immobility is a trope of abolitionist representation, that moment would theoretically have little in common with the most prominent visual representations of black liberation—the civil rights movement. As Sasha Torres, Leigh Raiford, and others have detailed in their

histories of the movement's use of media, activists were agents in these representations, carefully crafting representations of themselves to garner national and international sympathy.[72] Cameras were the primary tools, revealing white brutality and respectable black protesters. Civil rights movement activists are literally represented as marching forward and moving the country toward a more equal future. This is a representation that has increasingly come under pressure because of the evidence that many black people have struggled to thrive despite legal and social changes since the movement. Just as the official narrative of slavery depicts it as a horrible sin eventually vanquished, Jim Crow is treated similarly, even as debates about its efficaciousness since the end of what Bayard Rustin called the "classical period" of the movement linger.[73] Debates about progress and stagnation are as important to understanding the "post"–civil rights era as they were to understanding the status of African Americans in slavery, Reconstruction, and the nadir.

If Nat Turner disrupts representations of the ideal slave, Martin Luther King Jr. would seemingly be the ideal representation of the civil rights activist, even as King is a figure that perfectly captures the tension between black progress and immobility. Nat Turner's and King's relationships to the black archive vary widely. Turner is a figure who has inspired people to imaginatively fill in the gaps of not only his life but the slave experience and our contemporary relationship to it, but King is an icon with an abundance of archival material constructing his legend,[74] so much so that he has become somewhat of a simulacrum.[75] That King was a real person of tremendous national impact is unquestionable, but even in the civil rights period, he was transformed into *King*, a strategic move that resulted in his complexities and the multi-actor intricacies of the movement being erased or sublimated. Both his visage and the phrases most associated with him have become memes, available to people who sometimes reference only a shadow of his broader frameworks or even misrepresent his practices.

Not only does he float around US culture as a signifier for varied uses, but "I have a dream" and "judged not by the color of their skin, but by the content of their character" are phrases that people have made use of in ahistorical ways that are counter to policies that can lead to African American progress. Notably, President Ronald Reagan and other conservatives have used King's legacy to argue that equal opportunity has already been achieved and to support a neoliberal individualism that

sees the path to black people's progress as solely through self-reliance, not by state remedies to discrimination.[76] Affirmative action opponents like Ward Connerly have used "content of our character" to suggest that King would never want the state to base polices on skin color in an attempt to address continued inequality.[77] This reading of King depends on freezing him in 1963, giving his "I Have a Dream" speech, without broader context.[78] As Jacquelyn Dowd Hall argues about the "long civil rights movement," King is the "defining Figure" in a narrative of the movement that treats 1965 as the "moral clarity" of the struggle and confines the story to the South:

> [He is] frozen in 1963, proclaiming "I have a dream" during the march on the Mall. Endlessly reproduced and selectively quoted, his speeches retain their majesty yet lose their political bite. We hear little of the King who believed that "the racial issue that we confront in America is not a sectional but a national problem" and who attacked segregation in the urban North. Erased altogether is the King who opposed the Vietnam War and linked racism at home to militarism and imperialism abroad. Gone is King the democratic socialist who advocated unionization, planned the Poor People's Campaign, and was assassinated in 1968 while supporting a sanitation worker's strike.[79]

His commitments to antipoverty, labor, and antiwar activism are never at the center of the most popular representations of who he was.

Hall's description is what has been described as "King in popular memory."[80] Many scholars and people who knew him have criticized the way he has been flattened to represent localized activism—Jim Crow in the South—as opposed to also addressing his concerns with interrelated social justice issues such as antiwar activism and poverty that make it harder to ignore his broader condemnation of America's foundational inequalities. While research on King as the "face" of the civil rights movement is extensive, I would like, quite literally, to explore the importance of his face in both maintaining reductive narratives of the movement and contributing to a narrative of frozen black activism in general. Film and photography are undoubtedly the predominant ways that King circulated in visual culture, but the editorial cartoons in this period often focus on his face and provide a visual record of the conflicts during the movement that historians have carefully traced. If newspaper and documentary photography are often used to depict a

serene King in order to construct a simplified heroic narrative, the editorial cartoon used that same well-known, stoic expression to suggest ineffectualness and failure.

Here I focus on the visual depiction of stillness and its political and discursive uses. King is often caricatured in our public discourse as in stasis in various ways—non-action as a form of stillness that produces movement, frozen in time, as an immovable force because of his character, and, with the completion of the Martin Luther King National Memorial on the National Mall in 2011, as a motionless, moral testament to progress (although editorial cartoons often use the monument to signify the nation's failure). As sequential art is about the tension between movement and stillness, and editorial cartoons often endeavor to capture the affect of a particular moment in time, King is an interesting figure to trace because of the role of stillness in the ways that he is caricatured. Cartoonist Ho Che Anderson reflects on King as a simulacrum and uses a frozen and stilted aesthetic in the comic, preventing a feeling of movement or action in his text. Thus, like Kyle Baker, Anderson helps us rethink not only issues of black progress in US history, but the uses of King in popular memory.

As I argue throughout this book, white and black cartoonists both use racist caricature to make distinctions between good and bad black political actors. But an interesting aspect of King in caricature is that mainstream newspaper cartoonists who criticized him rarely resorted to traditional racist caricature in drawing him. The satire required that the lines of his face remain the same, for excesses would have made him unrecognizable. The lack of expression, his supposed unchanging expression in the face of chaos, was part of the critique of him as ineffectual. We consistently see this treatment of him in the last few years of his career.

King has been, as political theorist Kevin Bruyneel argues, "haloed" after his death, and part of angelic construction involves containing him in time and space.[81] If one of the problems with framings of southern slavery was the lack of acknowledgment of northern racism, similar reductive historical claims have been made with the civil rights movement. Locating racism in the South aids in containing the impact of racism in national discourse and memory. One way King has been frozen in the popular imagination is through his location in the South. While King's identity had certainly become not only national but global, part of the work of containing the meaning of civil rights abuses involves making the South the primary location of racial injury.

The end of his career disrupts his temporal and historical placement in historical memory. On July 10, 1966, he held a rally, "Freedom Sunday," at Chicago's Soldier Field—an event reportedly attended by forty-five thousand people. On July 12, the police shut off an open fire hydrant in an African American neighborhood. Given the heat, children's limited access to a public swimming pool, and the tradition of kids playing in front of open fire hydrants to cool off, residents reopened it immediately. Police shut the hydrant again, and the neighborhood exploded. Arson, looting, and violence took place over the next few days, and the National Guard was brought in to end the disturbance.[82] White newspapers attributed the urban unrest to King and the Chicago Freedom Movement, but clearly the amount of tension that produced the unrest was caused not by a fire hydrant nor by King's nonviolent plan of action. The depth of race and class inequality that prompted his shift to Chicago was the source of the tension. Moreover, activists committed to Black Power and a more aggressive form of confrontation were already doing work in Chicago when he arrived, and he was greeted with anger and ambivalence.

We can trace this ambivalence in the black press. Members of the black community could be deeply critical of King, a factor that is often excluded in the popular imagination. If the white press was accusing King of starting the riots, the *Chicago Defender*, one of the most important black newspapers in the country, criticized the approach of the Student Nonviolent Coordinating Committee (SNCC) as too moderate. The cartoon in Figure 2.12 by Tom Floyd (the creator of *Integration Is a Bitch!*), published on August 16, 1966, demonstrates a respect for King's philosophy while satirizing him as diminished and ineffectual. He is on his knees, felled by a bottle that has struck his head. His protest sign, promoting "love," is upside down. The caption states, "You're a better man than I, Dr. King," the tension lying in the question of whether or not being a "better

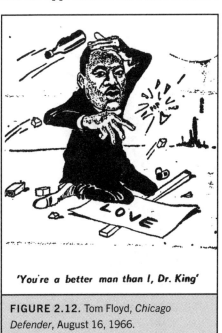

'You're a better man than I, Dr. King'

FIGURE 2.12. Tom Floyd, *Chicago Defender*, August 16, 1966.

man" necessarily means more effective. But again, the construction of his face is not exaggerated—caricatures of him depend on the immobility of his serene visage. Floyd draws King fairly consistently, rarely with any affect (Figure 2.13). The most affect we see in Floyd's cartoons of King is after the unrest in 1966, as King is depicted holding Chicago violence back at the door, sweat popping from his face, skid marks beneath his shoes as he tries to keep the violence from bursting in (Figure 2.14). But his face is not animated.

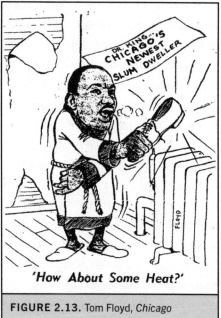

'How About Some Heat?'

FIGURE 2.13. Tom Floyd, *Chicago Defender*, January 20, 1966.

As King moved attention to Vietnam, he received more criticism about stepping outside of his box, another attempt to freeze his location. King was continually constructed as an "outside agitator" throughout his public career[83]—in various places in the South, outside of Chicago politics when the Southern Christian Leadership Conference was sup-

FIGURE 2.14. Tom Floyd, *Chicago Defender*, July 25, 1966.

posedly only about "regional" southern politics, and intervening in international politics when his focus allegedly should be African American rights. For example, in a *Kansas City Star* cartoon by progressive white cartoonist Bill Sanders, the cartoonist is less respectful of the serene caricature of King, depicting the civil rights leader leaning against a bar, drinking bottles labeled "Anti-Vietnam" and "100 Proof." His face is bloated, and he would not be recognized as King without the

briefcase by his ankle that bears his name. As is often the case in editorial cartoons from the period, the movement is gendered female. A little African American girl wearing a dress bearing the words "civil rights movement" tugs at his jacket's coattails, crying. The caption is her voice, pleading, "Father, dear Father, come home with me now!"[84]

This depiction of King as a derelict father is an indictment of a man who has left before his work is done. As increasing numbers of young African Americans grew dissatisfied with the language and tactics of nonviolence and "loving" your enemy, some critics described King as having lost control of his movement and his people.[85] But such a perception also ignored the variety of local activists who directed projects without or in partnership with his leadership. The desire to construct him as "Father" of the movement also ignores the long years of struggle that began in Reconstruction. But the patriarchal model was appealing—even to progressives.

By the time of his death, King was diminished in the public imagination. Even Sam Milai, who was strongly invested in respectable representations of black leadership and greatly admired King, describes King's "shrinking image" in 1967 as someone both soldiers and the press find insignificant.[86] It was thus his death and martyrdom that fixed him in the public imagination and froze him in a different way, erasing the negative press he received from the record that his family, many civil rights activists, the press, and political parties chose to preserve in holding him up as the sign of racial progress. As Edward P. Morgan has argued in his tracing of King's legacy, the "iconic King" serves "mainstream ideological assumptions" that fit into mythologies of the United States.[87] The cartoons that followed his death did not reference the critique, the tension, or the blame, and he solidified into an angel and ideal.

Ho Che Anderson intervenes with *King* by evoking this legacy of static representation. Originally released as three different issues and completed in 2005 after ten years of labor, Anderson's *King* is an ambitious, challenging graphic biography that departs from educational comic depictions of King's life, such as *The Montgomery Story*, that simply celebrate the official narrative of his "fathering" of the movement.[88] Organized around significant events and moments in his life, labeled by location and date, almost every section of *King* begins in the middle of a conversation. Anderson does not give exposition other than through dialogue, and he depends somewhat on the reader's prior knowledge of King's life to follow the narrative. Born in London to a Guyanese mother and a Jamaican father, raised in Toronto, and named

FIGURE 2.15. Six of a nine-panel grid. Ho Che Anderson, *King* (Seattle: Fantagraphics, 2005).

after Vietnamese and Cuban revolutionaries, Anderson approaches King as someone everyone already knows. The text suggests that readers knew the conversation even as its density adds complexity to the story. At various points he uses a traditional nine-panel grid to produce viewpoints from "the witnesses" to King's life (Figure 2.15). These witnesses fill out a typology of people in the period—an older African American who saw him as a troublemaker, a man challenging the idea of King as a messiah, a woman attracted to his charisma, a person moved and transformed by his presence, and someone scarred by white supremacy who feels hate for white people. This block of talking

heads immediately demonstrates the complexities of discourses surrounding King, and yet the heteroglossia is not what shapes King in popular memory.

The multiple perspectives as presented through the comic form—often in a nine-grid block—nonetheless contribute to a feeling of stasis in the work. While visually complex, it is also text-heavy. The text often overpowers the page, producing a reading experience that slows the act of reading so the reader can absorb the minutia of details about the movement, and it often dominates the frame so that we follow speech bubbles more than faces or bodies. If *Nat Turner* intervenes in the existing narrative circulating about Turner through "drawing back to" the written historical record in *Confessions*, the overwhelming amount of text in *King* speaks back to representations of King and the movement by functioning as an image. "Mythical speech," as Roland Barthes has theorized, "is made of material which has already been worked on so as to make it suitable for communications," and the reworked, often circulated representations of speech and photographs are what have allowed King to move forward in history as myth.[89] When Anderson combines the well-known representations and discourse with polyphony and pastiche, the overwhelming sensory experience of the text blends myth with a complex discursive record. The result is not a feeling of movement forward; instead, it encourages a meditative relationship to the still King (Figure 2.16). This story could have been represented with much more action—King's life was filled with protests and danger. The three-volume memoir of civil rights movement activist John Lewis's life, *March*, illustrates this contrast.[90] But Anderson chooses to evoke stillness and immobility of King's representations, which invites readers to reflect on how his image has circulated.

The three volumes of *King* present different periods in his life, and throughout the text Anderson depicts King's face and body in a few different styles. After a brief opening that gives us a scene from his childhood with a heard but not seen Daddy King, part 1 introduces us to him while he is a student at Boston University in 1952, tracing his early career until he is stabbed by a mentally unbalanced Izola Curry in 1958. Part 1 is predominately in black-and-white, evoking a stark woodcut style sometimes reminiscent of proto-graphic novelist Lyn Ward's work in the 1920s and 1930s. Sometimes this black-and-white King is rendered in a slightly looser style—but we do not need to see him clearly to know he is King. Grainy reproductions of photographs of

FIGURE 2.16. A still King and his iconographic speaking persona. Ho Che Anderson, *King* (Seattle: Fantagraphics, 2005).

King—the second style—are sometimes interspersed with Anderson's images, reminding readers that these images and this narrative are mixed in with popular memory.

Part 2 spans his life from 1960 to the March on Washington on August 28, 1963. While this section is also predominately in black-and-white, the end of the section more fully integrates reproduced photographs with the drawings. This is the moment that is King's most famous in popular memory; his "I Have a Dream" speech is one of the more well-known speeches in US history. Anderson draws King on top of a collage of digitized photographs of the event, signifying the creation of King on top of the photographic record (Figure 2.17).[91] The next pages are also filled with the words of his speech surrounded by images of the period—Kennedy, the Klan, and boycotts. At the end we finally have his third mode of representing King with the first full-color pictures of his face.[92]

Anderson has said that he shifted to color somewhat organically over the course of the project, but the predominance of color nonetheless marks a tonal shift in the text (Figure 2.18).[93] The last section, to which we

FIGURE 2.17. King collage/pastiche. Ho Che Anderson, *King* (Seattle: Fantagraphics, 2005).

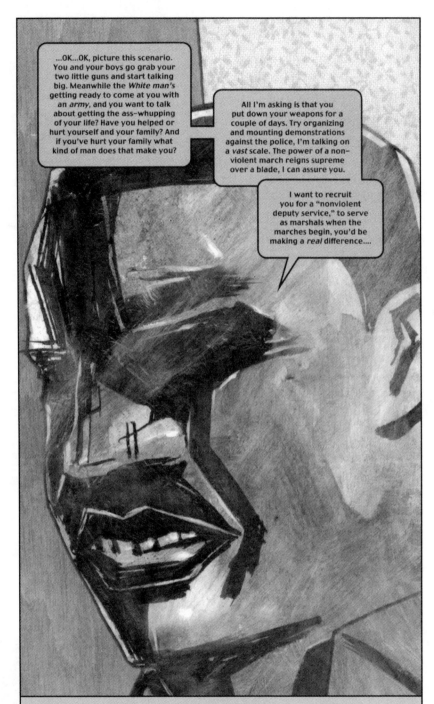

FIGURE 2.18. King in color. Ho Che Anderson, *King* (Seattle: Fantagraphics, 2005).

transition with two splash pages featuring an American flag splattered with blood, states, "Truth or Myth—None of that matters. All that matters is the legacy."[94] This is the period in which the myth has been made, but is also waning. In this final section we see a looser, colorful, impressionistic drawing style and fewer speech balloons.[95] Not coincidentally, other than his speech in Memphis before his assassination and the assassination itself, few moments of this period are part of the King myth. Martin Luther King Jr. is a more animated figure in this section, when the myth is not in conflict with the complexity. The "witness" sections still simulate a documentary style of talking heads, but King is depicted as having less success with his message. At one point he states, "I'm starting to feel like those of us who adhere to nonviolence should just step aside, let the violent forces run their course, which would be brief because you can't conduct a violent campaign once everyone's dead. Maybe violence is the way to go, what makes me think I'm such an expert? Lord knows I'm just as tired of being jailed and beaten as everyone else. Maybe it's time to start hitting back."[96] Such a sentiment would never be permitted in the discourse of King the myth. A King with doubts, who acknowledges the appeal of responding to violence with violence, a King in despair, is absent from the way he circulates in popular memory.

A few pages later, Anderson depicts him delivering his famous "Mountaintop" speech, having passed through his moment of pessimism—at least in public. This is Anderson's most expressive depiction of King speaking. Here, he captures the preacher's cadence of King's speech pattern with the movement of his body. Without the words it might seem like he was singing. Anderson shifts to a close-up of King's gaze, as he delivers the speech's closing and states that he is not "worried about anything" or "fearing any man," as his "eyes have seen the glory of the coming of the Lord."[97] Soon after King would be assassinated. In the last few pages Anderson depicts a young King staring out the window toward the sun and a cross with chains hanging from it. Like Baker, Anderson evokes Christ imagery in his last representation of his biographical subject. But while Turner's Christ-like affects disconcerted white gazes, King's association with Christianity and Christ is a powerful tool for integrating King into the national imagination. The "haloing" of King is part of what makes his legacy less threatening. However, Anderson employs juxtaposition in order to push against a reading of King that focuses on the end of his life. Here, the promise and vulnerability of young King blend with icon King to emphasize the incompleteness of the revolutionary project.

FIGURE 2.19. Dave Granlund, January 9, 2017. Courtesy of Dave Granlund.

Attempts to redress the flattening of King's legacy have sometimes produced tension. This was profoundly seen in the conflicts surrounding the memorial, in which his face and pose became a source of debates. The US Commission of Fine Arts, which had approved the sculpture, interpreted the result as stiff, static, and "'confrontational in character.'" An African American consultant who had approved it, as had King's son, said that this was intentional—he was a "warrior" and "confrontational" in fighting for equality.[98]

The standard caricature of King as depicting noble stasis resonates even more as his monument has been used to represent him in twenty-first-century editorial cartoons. When the monument was first completed in 2011, more than one cartoon commented that its unfinished look also signified King's incomplete struggle for racial justice (Figure 2.19). In 2014, as the national Black Lives Matter movement gained prominence, a number of cartoonists used King, but also his monument, not only to reference the incomplete project for racial justice but to align the idealized representation of King with the protesters' project to end excessive force by the police.

Over the years, King has also often been depicted weeping, commenting on not only the continued existence of racism, but protests and urban uprisings that did not follow nonviolent practices. He is often used as a symbol of absence, of failed or nonexistent black leadership. The popular archive has so solidified his perfect leadership that

the lessons to be learned from his conflicts and disconnects with various groups are erased. Some of the more profound lessons of King's legacy lie in the incomplete struggles against not only racism, but war and poverty, struggles that resulted in his being pilloried and sometimes reviled. The absence of these representations in the popular archive functions as a weapon against black citizens and leaders who voice rage, disappointment, and uncertainty. By way of example, after the Ferguson protests more than one white acquaintance said to me that the problem is that "there's not a Martin Luther King." They either ignored or did not know that just like the Ferguson protestors, King was accused of being an outside agitator, lacking direction, and causing violence.

The ideal black hero who can be assimilated into mainstream American imagination has evolved since the nineteenth century. But he (and he is often a he in public discourse) is still supplicating, never acts in anger, using words and not fists, and follows a certain moral path. Leaving us with a King that is frozen in perfection, instead of struggle, deprives us of a model for the present. The present requires a roadmap for false starts and complexity, not an untouchable ideal. Even cartoons critical of King can provide affectively compelling narratives that recognize the dialectical relationship between hope and despair.

On the day of King's murder, the *Christian Science Monitor* published a cartoon depicting him as Don Quixote, hunched over a tired nag.[99] One attendant looks to him in hope, while the other puzzles over a broken Humpty Dumpty representing "Non-Violent Control." The pastiche of the cartoon blends the Cervantes novel with the nursery rhyme and drives home the idea of King existing in the realm of the fantastic—but not as an ideal. Instead, he is depicted as delusional, holding court over a mythical kingdom and pursuing an impossible quest. Don Quixote, of course, is famous for the "madness" of his dream, and then waking from it after abandoning his journey. Does cartoonist Guernsey LePelley wish to see racial equality as a dream? Or is he only mocking the idea of King's control? Should King wake up? Or is the madness worth fighting for? The indeterminacy is generative and made even more ironic by the timing of its production.

Both Kyle Baker and Ho Che Anderson explore the ways in which the public has been uncomfortable with constructions of black heroism that do not conform to popular representations of the static black subject. And the editorial cartoon archive provides a complex affective popular archive often missing from mainstream discussions of these

moments in history. Often by focusing on the face, these artists high-light the preponderance of troubling models of black subjects who are subjected. Both contemporaneous and reflective representations of black heroes in these texts add so much to more visible discourse and archives about black citizenship. These comics and cartoons archive the messiness of political struggle. In the often-fantastic excess of these representations, depicting rage, the indecipherable, and stasis, these representations contribute to an affective real, lost in popular represen-tations of what it has meant to be a black hero.

3

WEARING HERO-FACE

Melancholic Patriotism in

Truth: Red, White & Black

The rich inheritance of justice, liberty, prosperity and indepen-
dence, bequeathed by your fathers, is shared by you, not by me.
The sunlight that brought life and healing to you, has brought
stripes and death to me. This Fourth [of] July is yours, not mine.
You may rejoice, I must mourn.
—Frederick Douglass, "What to the Slave Is
 the Fourth of July?," July 5, 1852

At the same time that the reductive representation of Martin Luther King
Jr. was being solidified as the ideal model of black respectability, the
image of black men sporting Afros and dashikis emerged as a represen-
tation that signified black nationalism; or at the very least, something
other than representative Americanness. At the height of this aesthetic
in the late 1960s and 1970s, adoptions of such signs were populist acts of
resistance to the ideals of whiteness.[1] Despite or, more likely, because of
this antiestablishment aesthetic, in 1972 this image was embraced by the
US Navy as a recruiting tool during the waning years of the Vietnam War
just as the United States transitioned into utilizing an all-volunteer mili-
tary. In one recruitment poster (Figure 3.1), two men in dashikis and short
Afros gaze seriously at the viewer, while black typeface states, "You can
be black, and Navy too."[2] Similar navy posters from that year hail black
audiences with images and slogans that ironically try to contain revo-
lution within a state-sanctioned frame. One poster features an African
American woman (not with natural hair) and states, "We'll take you as
far as you can go," while another depicts a young man standing in front
of a fighter jet who appears to be looking up at the words, "join the Navy
and see the world change."[3] While the woman's recruitment poster seems
strangely limiting, the conjunction "and" in two of the slogans hailing

FIGURE 3.1. Recruitment poster, Department of the Navy, 1972. US Naval Historical Center, stock no. RAD 72792.

African American men acknowledges that military service and revolution are not automatically linked but challenges discourses that distance a black revolutionary body from serving the state.

These recruitment posters simultaneously suggest that rebellion will be contained and promise political transformation. The dialectical movement between containment and political promise within them is a microcosm of the nature of democratic citizenship; in return for willing containment, a citizen receives rights and the promise of greater economic or political liberation. But the creators of the poster recognize that blackness can seem opposed to service in the US military, and this is not an idea that emerged only from supporters of Black Power in the post–civil rights era. Blackness historically showed the fissures in what the American solider signified. Because the uniform did ostensibly function as the thing that enabled American democracy and soldiers were the principal sign of it, the black solider was for many years threatening to American democracy because he demonstrated both the promise of equality and systemic hypocrisy and failure. Many whites were anxious about the former, while African Americans were understandably angry because of the latter. The military uniform is the most dramatic signifier of this containment and promise. In the national mythos, the soldier's own containment and participation in the containment of others is part of the sacrifice given for the state, and the solider ensures political possibility for himself and for all citizens, even as he may facilitate the oppression of others. A black identity hermeneutic makes hypervisible the duplicity of what the American solider represents in general, and not only the problem of the African American solider in particular. Quite simply, how often does the idealized representation of the American solider sell lies about democracy?

In the medium of comics, perhaps no solider has struggled with what the uniform represents like Captain America. Beginning its run shortly before the bombing of Pearl Harbor in 1941, the comic *Captain America* was a wartime invention, and its issues told the World War II story of a weak, New York City everyboy named Steve Rogers who became a supersoldier through an experimental military serum.[4] His emaciated frame was transformed into a bulky supernatural body of overwhelming musculature. On the inaugural issue's cover, his flag-clad arm delivers a roundhouse punch that sends Hitler sprawling and promises a US transformation from observer to dangerous world actor.[5] The fictive hero reached the height of his popularity during the war and never surpassed it because he was truly a hero of the moment, replicating the superhero prototype established by the Superman creators as an average man who can become an idealized first citizen, identifying and vanquishing clear enemies to the state, and, clad in red, white, and blue, making explicit the nationalist trinity of state, soldier, and flag. He fictively stood in for real-world nationalist struggles, and the villains doing violence to Steve Rogers were doing violence to the abstract ideals of truth, justice, and democracy purportedly represented by his symbolic perfection.

Captain America has more recognition in the twenty-first century because of the popularity of films in the Marvel Cinematic Universe. As portrayed by the handsome Chris Evans, he represents the idealized nobility of the comic book character and his eventual distrust in national and multinational state agendas. As J. Richard Stevens explains, his character has embodied the politics of various political moments, but his "essential character" has not changed. He began as a "jingoistic war hero," then a "liberal crusader in the late 1960s," a representative of "Cold War morality" in the Reagan era, conflicted *and* neoconservative in different runs after 9/11, and "a frustrated symbol of the Obama administration optimism that struggled to define the role of government in regulating the new world order."[6] "Cap" has often questioned what the United States represented and what it meant for him to represent it. In 1974, he briefly became "Nomad," a man without the country, a post-Vietnam story critical of Nixon and American politics.[7] He questioned the relationship between US imperialism and conflicts with the Middle East in the "The New Deal" story arc.[8] In the 2006–2007 "Civil War" comics crossover event inspired by the PATRIOT Act, Cap rejects the "registration act" for superheroes, but loses, cast as a villain by a nation that prefers their safety over the possible civil rights threats to a

minority of superpowered humans.[9] A 2010 storyline in which Cap and his African American partner in crime fighting, Sam Wilson (the Falcon), take on a white supremacist terrorist group made national news when someone in the production process crafted a sign in a protest scene that evoked rhetoric of the Tea Party. Marvel was accused of "making patriotic Americans into its newest super villains."[10] Despite the public record of racist language that had emerged from various media personalities, politicians, and everyday citizens supporting the Tea Party, Marvel apologized for the issue and said the sign would be eliminated in the reprint, erasing the social commentary from the record.[11] Some people condemned Marvel for allegedly politicizing the always political Captain America when the company announced in 2014 that Sam Wilson would become Captain America.[12]

But the first black Captain America—initially outside of the continuity of the character—offered one of the most powerful examples of Captain America's introspection about his role. It is in one of the few runs of the series written and drawn by men of color: *Truth: Red, White & Black*. Rogers is a secondary character who enters the story late, having discovered that whiteness was the necessary state prerequisite for wearing the superhero uniform. Building on the history of the Tuskegee syphilis experiment in which the US Public Health Service withheld treatment from approximately four hundred African American men suffering from syphilis from 1932 to 1972, Marvel editor Axel Alonso suggested that a feasible origin story for Captain America was that military scientists would more likely have experimented on black bodies before allowing a white man to be endangered.[13] The eventual result of this brainstorm was the seven-issue *Truth* series, created by writer Robert Morales and artist Kyle Baker. The series illustrates that the African American soldier is an ambivalent figure that contains the contradictory discourses of containment/freedom and imperialism/democracy propagated by law, propaganda, and nationalist common sense in the United States.

As the superhero genre increasingly embraced the antihero in the last decades of the twentieth century, creators increasingly challenged the inherent contradiction between representing the law and vigilantism. Black superheroes historically have highlighted another inherent contradiction, not only representing a nation-state as ideal when it often fails to represent ideals, but representing a state that refuses to recognize their rights as citizens. That is doubtlessly why the first black superheroes with their own comics were outside of this

paradigm—Black Panther was not a US citizen, and Luke Cage explicitly stated he was a "hero for hire" and not an altruistic servant. Superheroes are caricatured representations of idealized citizen soldiers, with propaganda and pop cultural productions constantly propagating the romance of the clear alignment of the soldier with the state. African American superheroes have traditionally made hypervisible the contradictions in the superhero role, just as the real-life black soldier has placed pressure on idealized representations of the nation and the soldier's affirmation of its ideology through force. This has never been as much the case as with World War II, the "Good War," which also saw heightened activism from African Americans calling attention to the hypocrisy of the United States in confronting a racist, genocidal regime partially inspired by the US eugenics movement.

This chapter places *Truth* in conversation with editorial cartoon representations of the black solider in World War II, highlighting the contemporaneous and, with *Truth*, a retrospective examination of the struggle of African Americans to represent the citizen-soldier ideal in this period. As I explored in the last chapter, the nationalist heroic ideal in the United States is often violent, but it is a valorized violent subjectivity that excludes black citizens (and arguably women and most nonwhite men). The superhero comic is this ideal on steroids, and *Truth* is a comic that explores what happens when an excessive ideal caricature merges with an excessively denigrated body that is ironically also a mechanism for propping up the ideal. This state-produced dissonance produces the first black Captain America, an inherently ambivalent figure. If the idealized soldier is a form of patriotic caricature that citizens have been asked to embody, some African Americans have responded with an affective mode I term "melancholic patriotism." Patriotism consists of formal and informal contractual obligations and affective attachments to the state and what it purports to represent, and *Truth* reflects on the history of African American soldiers, who both have invested in the ideals of democracy and have experienced an affective disconnect resulting from its phantasmagoric nature for them despite their service. Continued attachment to the democratic ideals the state represents and promises is what produces melancholia—full citizenship is a lost love object that both never was and is continually chased. While the black Captain America is betrayed by the US government in *Truth*, there are signs in the text that he does not abandon a belief in the possibility of the United States or what the flag represents—he is neither an antihero nor unpatriotic. Scholarly discussions of African

American attachments to nation typically evoke discussions of black nationalism, and while that is an essential history in the story of African American challenges to mainstream US political discourses, it is not the only story that can be told about African American citizens' nationalist attachments in the United States.

As Kimberly L. Phillips recounts in *War! What Is It Good For?*, African Americans have long criticized the hypocrisy of the US government's discriminatory treatment in the military and the economic and social circumstances that make the military one of the most viable options for some citizens.[14] And yet it has not been uncommon to hear African American World War II veterans who experienced horrific discrimination and violence from their own country state, "I am a patriot." This perspective invites the question: what forms might patriotism take when the government has historically denied your rights and those of people like you? An identity-based nationalism is one answer, as is a universalist form of patriotism that erases racial identity, privileges American citizenship, and resists the label of "black" or any other modifier that some would claim is a qualifier in describing citizenship. However, the kind of patriotism that Morales and Baker present in *Truth* describes an African American patriotic identity founded on an investment in democratic principles promised by the state and mourning at the impossibility of having full access to the rights guaranteed by the state or the mythology of the American Dream. To a certain extent, the patriot is the caricature of the everyday citizen, and the black citizen exposes that excess. Despite the failure of the United States to create equality for all citizens, there is a kind of black patriot who still has a melancholic attachment to its possibilities and takes pride in the black citizen's role in working toward equality and justice.

THE VISUAL WAR

US propaganda during World War II—posters, photographs, advertisements, recruitment films, Hollywood melodramas, and comic books—presented idealized caricatures of soldiers as tall, muscular, and affectively stoic with their resolute commitment to the battle but smiling in other contexts.[15] Women were represented as helpmates to the men in the fight. Ideal soldiers were also invariably white. Black soldiers were largely excluded from media except in the black press. Until the release of *The Negro Soldier* (1944) late in the war, the War Department did not embrace the idea of showing images of black men training to

white viewers in newsreels or photos released to newspapers. It also did not want black citizens to know about the constant violence perpetrated against black soldiers.[16] African Americans countered this exclusion with their own circuits of information, sending stories and photographs home and to the press, creating a record the military wished to erase or suppress.

"Photography," Maurice Wallace and Shawn Michelle Smith explain, "served not only as a means of self-representation but also as a political tool with which to claim a place in public and private spheres circumscribed by race and racialized sight lines."[17] For Frederick Douglass, pictures were an important counter to racist representations, allowing whites to see black people the way they saw themselves, but they also functioned as aspirational representations. From Louis Agassiz's scientific racism to unflattering and often stereotypical photographs of African Americans that circulate in the press after they have been killed by the police, photographs have also been tools of racism.[18] Family photographs are a way that African Americans spoke back to representations of themselves that they could not control.

One of these men was my grandfather. Like many African Americans, my mother's family took countless photographs in the first half of the twentieth century. She has a number of pictures of my grandfather during the Second World War, always smiling (Figure 3.2). He died when I was very young, and by all accounts he was a joyous man. And yet my mother told me that in one letter to his sister Helen he revealed that a white commander told him, a medic, that he must treat wounded white men before wounded black men. He told my uncle that a commanding officer explained to white soldiers that if they caught their black comrades with white women, they could shoot them with impunity. None of these pictures, showing him handsome and dashing in his uniform, tell stories of the discrimination he faced in the war. While you can see a hint of the segregated military in pictures where he is surrounded by black soldiers, the battles at home and abroad fought by black troops are not captured in our family photographs or the photographs of many others. These photos demonstrate the sameness, as opposed to the difference, of black soldiers.

FIGURE 3.2. Author's grandfather, David L. Wanzo, in uniform in World War II. Courtesy of Margaret Wanzo.

Such images tell a story of their worthiness for citizenship by combatting the invisibility and lies told about black soldiers in the white press.

Civil War carte de visite portraiture of African American men in uniform inaugurated this tradition. Deborah Willis explains that one of the first acts of newly enlisted black soldiers was to be photographed: "The wartime photographic experience" was "designed to communicate with and engage the viewer in ideas of citizenship and self-representation. For the soldiers, the very act of having their portraits made both represents and embodies freedom."[19] But as Maurice Wallace argues, such photographs established their suitability for citizenship as emancipated men but also masked historical wounds and the continued challenges to black futurity in the nation.[20]

The cartoon medium did not have the same representational limitations. With its elasticity as a medium it could provide more of an imaginative and discursive framing to the black soldier's body. While cartoonists did comment on the treatment of African American soldiers after the Civil War and World War I, it was not until World War II that a robust black press produced a substantial body of nonphotographic African American–created visual representations to speak back to the erasure and disparagement of the black soldier. Claims about what comic art uniquely does are inevitably essentialist discussions of the medium, but I included this brief discussion of photography to illustrate the importance of multimedia approaches to combating visual imperialism that, in different times and spaces, do different work. Black activists during the civil rights movement and the Black Lives Matter movement in the twenty-first century have made good use of photography to show violence perpetuated by the state and fellow citizens against black bodies. During World War II, the black press showed heroic representations of African Americans in film and photography. Cartoonists also depicted black heroism, but editorial cartoons were uniquely situated to represent the subjected affective experience of African Americans during the war.

The *Chicago Defender*'s Jay Jackson was particularly inventive and relentless in visually representing black subjection and US hypocrisy during the war. Jackson produced work for the *Defender* and its short-lived illustrated magazine, *Abbott's Monthly*, in the 1920s. He joined the staff formally in 1933.[21] A commercial artist as well as a prolific cartoonist who produced a number of comics strips in the black press, he produced the satirical slice of life cartoon *As Others See Us* (1928–1934) that

condemned issues such as colorism and financial reckless in the black community. In 1942, he created *Speed Jaxon* to depict a heroic black spy who had to deal with racial discrimination on his missions. This strip worked in concert with his editorial cartooning during World War II, which called attention to the discrimination black soldiers faced at home and abroad.

A black solider lays face down in "Democratic America," stabbed in the back by "Hitlerism in the U.S. Armed forces."[22] Another black soldier writes a letter to Santa asking for protection at home so he can protect the nation abroad, his downcast face peering up at Uncle Sam.[23] Uncle Sam is more actively abusive when he casts a black solider into the lion's den of segregated units, and the modern Daniel appears quite fearful as he nears the waiting mouths of lions representing "humiliation" and "resentment."[24] A black soldier desperately reaches for a gun labeled "democracy," as the "Dixie gremlins" attack him at every angle with "menial labor," "limited advancement," and other obstacles to his success (Figure 3.3). These representations of the affective experiences of subjection would not be accomplished in that era through

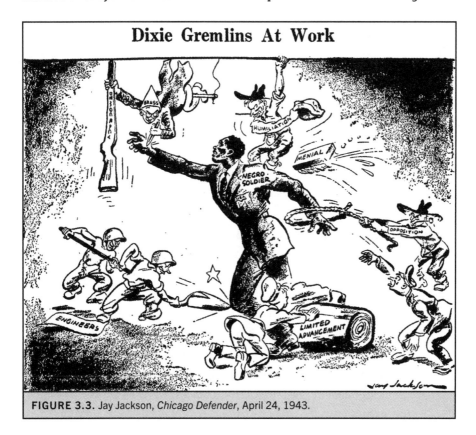

FIGURE 3.3. Jay Jackson, *Chicago Defender*, April 24, 1943.

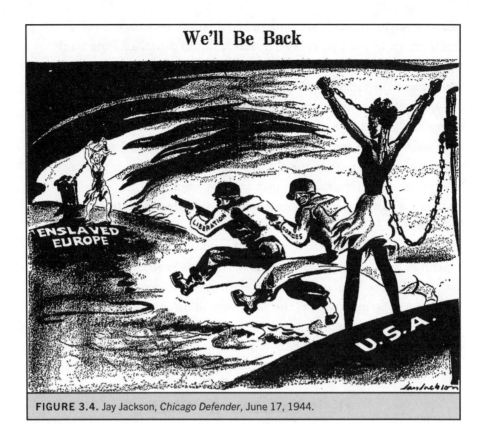

We'll Be Back

FIGURE 3.4. Jay Jackson, *Chicago Defender*, June 17, 1944.

the photograph. Moreover, as images that circulated in the black press, these expressions of melancholia were in-group expressions of affect. White audiences could see the images if they sought them out, but these representations largely functioned to reinforce and affirm a collective group identity and critiques of the nation during the war. Shortly after the attack on Pearl Harbor in 1941, the *Pittsburgh Courier* called for the "Double V" campaign—victory at home and abroad.[25] This would become a constant refrain during the war, and the representational work of the black press gave language to soldiers and citizens who wished to see their despair, rage, and condemnation of the nation represented.

A recurring theme of the editorial cartoons, as opposed to photographs or *The Negro Solider* (1944)—a propaganda film that marked one of the few efforts of the War Department to produce positive representations of African American soldiers that would be seen by nonblack audiences—is that the cartoonists showed the injurious effects of the state on black bodies, as opposed to black soldiers unaffected by oppression.[26] Like a number of other cartoonists, Jackson shows less

than ideal images of black people to demonstrate how the nation sees, treats, and transforms African Americans. In a 1944 cartoon (Figure 3.4), he employs the convention of representing the nation as female and depicts two soldiers running toward an "enslaved Europe," signified by a scantily clad blonde woman chained to a post. One solider looks back with a distressed look on his face to the United States, where a black woman is also chained. Like Milai, Jackson uses a black woman to represent the black nation. She is topless, stranding straight and powerfully despite her bondage, her arms thrust straight over her head as if calling attention to their neglect. The cartoon's caption is "We'll Be Back," an attempt to speak into existence an intervention that would not necessarily be forthcoming. The black woman represents not only the black nation but the entire United States, which had to be judged by how it treated black citizens. Like other prose and images throughout the war, Jackson's cartoon makes treatment of African Americans the principal sign of what the nation is. The topless black woman, a nativistic stereotype standing in contrast to the Fay Wray representation of Europe held captive by brutes, suggests that the "uncivilized" representation of the black woman reflects the lack of "civilization" in the United States, despite its claims to be upholding Western civilization and democracy in the war.

He makes the phantasm of progress and inclusion a constant theme; the perfection in photographs is dismantled in images that represented how ideology and violence acted on black bodies and spirits. Months before the United States would officially enter the war, Jackson depicts a bedraggled man who appears to be a castaway on a deserted island, running and desperately attempting to grasp a variety of things out of reach (Figure 3.5). These things—an anti-lynch bill, government promises, equal treatment in the military—are mirages. Illusions created by challenging weather conditions, mirages are nonetheless often presented as fantasies that highlight the desperation of the person fooled by the image. Popular representations of castaways tricked by mirages typically depict them as figures of pathos and despair. The audience usually knows better, aware that the fantasy of water or shelter is a trick of the light. There is something pathetic about the delusion, even though the hopeless people exiled from the rest of the world are often in such circumstances through no fault of their own. Jackson hints at an indictment of the figure, as there often is in the idea of chasing mirages, even if the person may be blameless. People often judge those who reach for unrealities that, despite their desperation, they must

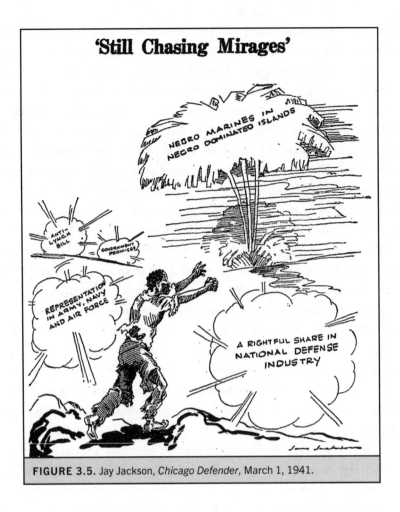

FIGURE 3.5. Jay Jackson, *Chicago Defender*, March 1, 1941.

know are not there. It is the fruitlessness of the desire, at war with the attachment to that which has been promised and should be a right, that creates the conditions for the melancholic black citizen to emerge. It is within those affective interstices that Morales and Baker created *Truth*.

TRUE BELIEVERS? SUPERHERO COMICS AND PATRIOTISM

Morales and Baker reimagine the U.S. military's supersoldier project that made Steve Rogers Captain America by telling a tragic story about black soldiers both chosen for experimentation and disavowed because of their race.[27] The story begins by introducing three possible black Captain Americas, who illustrate different kinds of possibilities for African American male inclusion in US citizenship. All three become part of the military experiment, and we observe the abuse their whole black platoon endures

and their deaths as the military uses them as guinea pigs. The few who survive the experiment to become supersoldiers are secrets, while Steve Rogers becomes the Captain America icon. When Isaiah Bradley is the sole black supersoldier remaining, he completes a mission in Germany, only to be imprisoned by the army for stealing the white Captain America's uniform. Rogers uncovers the story and seeks out Bradley, who, like many icons in the black community, is well known among black people even though he has been excluded from mainstream media and history. Rogers returns the "stolen" uniform to Bradley, now mentally disabled because of the side effects of the early serum. Isaiah Bradley, the last one standing, is not even given the privilege of hero status as blackness makes his publicly wearing the Captain America uniform a crime. If Rogers's transformed body represents US democracy's ability to transform its citizens into ideals, black Captain America Isaiah Bradley epitomizes not only the failure of US democracy to work equally for all citizens but also the ways in which the fantasies of US democracy can be built on the backs of those it uses and then discards.

The first cover of *Truth* features a silhouette with markedly black features and a do-rag—a style worn by some African American men—tied at the back of his neck (Figure 3.6). The black silhouette is framed by the red and white stripes in the flag, while the star that is traditionally at the center of the Captain America uniform reads as either a stark emptiness or a glowing beacon at the black figure's center. The double readings possible from the cover art—counterrevolutionary and patriot, shining representative or a citizen coping with a void—immediately situate the comic book miniseries into the real history of African Americans' uneasy fit as representatives of patriotism in Western states and the superhero comic's move from featuring idealized national heroes to depicting troubled icons. This is thus a revision of the soldier silhouette that is always already white, and should be read in relationship to the reams of black propaganda posters that made the black silhouette antithetical to representing the United States, and not just in relationship to the history of superhero comics and how patriotic discourse undergirds the genre.

The superhero is a natural place for conflicts around citizenship to play out, for the superhero—invented by Jewish immigrants constructing narratives about the ideality of citizen outsiders—typically depicts outsiders assimilating and coming to embody model citizens.[28] The first run of Captain America was, as creator Joe Simon explained, "consciously political."[29] Captain America was the most popular comic during

World War II, but was published intermittently in the following decades. Not as popular as Superman or Batman, he nonetheless, as Jennifer Ryan argues, "served as a barometer of the American cultural and political climate for the next sixty years."[30] Some fans suggest that something in the character has gone wrong when there is clearly political content in the comic, but it is intrinsic to the character. Internet message boards reveal that several fans were concerned with the turn Captain America took after 9/11. "The New Deal" (2002) story arc depicted a Captain America devastated by 9/11 and critical of the way that any military action creates a space in which hatred and violence can flourish. Conservative film critic Michael Medved critiques the story for being "hidden within star-spangled, nostalgic packaging of comic books aimed at kids" in an essay for *National Review* called "Captain America, Traitor?"[31] He simplistically reads the story as presenting a "conspiracy theory" that the CIA sanctioned attacks on US citizens and arguing that the United States should feel guilty for World War II. What "The New Deal" really does is frame the story with well-documented evidence that the US government does have an unfortunate history of supporting groups who then become dangerous regimes and then presents the destruction of life in any war—even in a romanticized war like World War II—as traumatic. Medved, perhaps echoing the views of others, ahistorically views comics as uncomplicated, cartoonish romances about nation, conflicts, and heroism, when many comics after Vietnam have been self-reflexive and critical of simplistic stories of caped crusaders and national salvation.

Many comic book superheroes are now antiheroes, struggling with a morally ambiguous state of affairs. After the work of writers Frank Miller and Alan Moore, who revolutionized the genre, the antihero, while not new, became common. Miller revises Batman in *The Dark Knight Returns* (1985–1986), offering a critique of Batman as an embittered vigilante. Moore radically transformed the genre with *Watchmen* (1986–1987), which depicted caped crusaders as human beings who all too easily could be destructive tools of the state. The rise in film adaptations of these creators' works in the midst of the twenty-first century explosion in superhero films has made the conflicted superhero more commonplace. As Mila Bongco writes, the "reassuring" binaries have shifted and "often, the superheroes themselves question their role in upholding the law in a world where those in powerful and institutionalized positions have debatable intentions and morality. . . . This present world of uncertain directions and kaleidoscopic and contradictory images is increasingly reflected both textually and visually in comic books."[32]

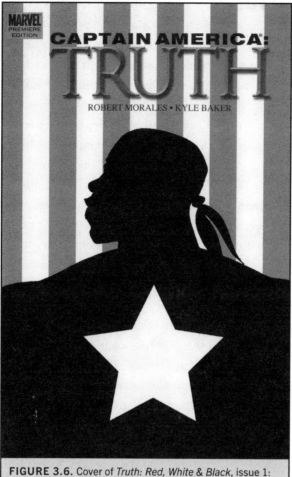

FIGURE 3.6. Cover of *Truth: Red, White & Black*, issue 1: "The Future." Courtesy of Marvel Comics.

Visual dissonance and contradiction is a tool in Kyle Baker's artwork for the series. Baker's use of the simple line, round-headed characters, flat color, and undetailed landscapes stands somewhat in contrast to more detailed superhero bodies, shadows, and contrasts often used by superhero comic artists that might seem to some to be closer to a "realist" (if excessive) style often used to depict tragic superhero narrative arcs.[33] However, the contrast between the tragic narrative and an aesthetics often used to depict stereotypical images of black characters is more sharply realized with Baker's artwork. A skilled illustrator capable of more complex renderings of black characters—perhaps most evident in *Nat Turner*—Baker chooses to visually tell the story by blending the cartoonish and the tragic. He thus emphasizes the possibility of reading tragedy even in stereotypical renderings of the black body.

For several decades, racist depictions of black characters filled super-hero comics. They were often clueless buffoons or lesser citizens in relationship to white heroism. As Marc Singer has argued, black super-heroes have often been "marked purely for their race" and "absorbed into the generic ideology of the superhero, in which exotic outsiders—and few are so exotic in the comics as black superheroes—work to preserve America's status quo."[34] Black superheroes began to represent more pro-gressive possibilities in the wake of the civil rights and the Black Power movements, and characters such as the Black Panther and the black Green Lantern often exhibited black rage, social critique, and a desire to help the African American community.[35] However, many represen-tations have been problematic, and despite the social critiques that per-meated a number of the comics, the racism of a genre that often relies on stereotypes and glorifying citizenship affected representations of blackness. In terms of mainstream superhero comics, black characters arguably came into their own with the short-lived Milestone imprint of DC Comics, in which politically complex characters (and occasionally didactic stories) were at the center of comics produced by creators of color.[36] Black superhero comics became increasingly sophisticated over time as creators and writers constantly addressed the alleged incommen-surableness of blackness with the superhero. Morales and Baker present a meta-commentary in *Truth* by showing the black soldiers reading the white *Captain America* comic book, and later showing Rogers learning of a suppressed black Cap history parallel to his own. The different contexts in which the stories circulate and how they learn about each other mirror the segregated discursive structures during the war.

Just as the character represents blackness and universalism, the black Captain America comic also addresses varied models of patriotism that emphasize either one's identity or universal principles. Many superhero comics address multiple models of the patriot. While a basic definition of patriotism is love of one's country, it has also been defined as a kind of nationalism, love for one's own community or group, and cosmopolitan-ism. Qiong Li and Marilynn B. Brewer draw a distinction between patrio-tism and nationalism, arguing that the former connotes "pride and love for country" while the latter is "associated with authoritarianism, intoler-ance" and a "chauvinistic arrogance and desire of dominance in interna-tional relations."[37] Ramzi Fawaz makes a case for superheroes becoming popular fantasies of internationalism after World War II.[38] Their otherness and freakishness—particularly in Marvel Comics—became a site for cre-ators and alienated youth to engage imaginatively with a variety of late

twentieth-century progressive projects. While Fawaz is right to the point to the leftist principles and idealization of freakishness in the comics, the centrality of whiteness in relationship to racial others demonstrates the limitations of the comics' progressiveness in imagining who can truly be at the center. These heroes are often cosmopolitans, what Martha Nussbaum describes as a "person whose allegiance is to the worldwide community of human beings," but the emphasis on the galactic and the world deflect attention from local inequalities.[39]

The black Captain America's investment in the nation pushes against the idea of cosmopolitanism as an ideal when there is injustice at home. He can represent the possibility of the ideals of constitutional patriotism being upheld and be an advocate for similarly situated compatriots, but also be an ideal cosmopolitan citizen as a product of the black diaspora who illustrates the stakes of legacies of war, slavery, and imperialism. Anthony Appiah argues that "the cosmopolitan patriot" both is rooted at home and takes pleasure in others. This patriot envisions an ideal world of "migration, nomadism, and diaspora" and "the result would be a world in which each form of human life was the result of long-term and persistent processes of cultural hybridization: a world, in that respect, much like we live in now."[40] The comic book superhero is often an immigrant story, and the narrative makes the superhero valued and at home in his adopted country, modeling a wish fulfillment acceptance of the many immigrants who created comic books in the early days of the industry.[41] But many black citizens continue to be, to borrow Michelle Wright's language, "Others-from-Within" in Western nations.[42] African American patriotism is about negotiating this status, suggesting a patriot not fully explained through these other definitions, one attached to the American Dream but unable to access it.

"THE DREAM OF EQUALITY FOR A WHOLE DAY": BLACK MANHOOD AND VARIED RESPONSE MODELS TO INEQUALITY

This explicitly African American patriot—one who keeps black identity in his understanding of agency and mourns the lack of access to equality—is not politically homogenous. In *Truth*, Morales and Baker represent different kinds of black male citizens who have varied responses to their lack of access to the American Dream. Following the model of many comics, the text explores masculine models of citizenship and the discussion of patriotism in *Truth* must be read in relationship to these

varied kinds of masculinity. Even though women can also experience the affect associated with insufficient access to citizenship, *Truth* clearly focuses on patriotism in relationship to emasculation of black men. The three types of African American manhood featured in this text—the revolutionary, the nihilist, and the family man—are overlapping types, but one archetypal identity is privileged in each of the three characters. *Truth* lacks a "true believer" who expresses belief in the promises of the American Dream and that he has achieved it or could, but the American Dream ideal haunts *Truth* as the black soldier's principal attachment.[43]

In the first issue of *Truth*, "The Future," we are introduced to these three archetypes. Maurice Canfield of Philadelphia is a talented-tenth Negro and organizer.[44] He is a wealthy revolutionary as opposed to a poor or working-class radical, but is committed to working for progress and rejecting a family fortune "based on Negroes that are compelled to lighten their skins and straighten their hair."[45] Maurice is an atheist and socialist, and his response to oppression is both intellectual and violent; in our first encounter with him, we see that his handsome, patrician face is damaged from an encounter with white workers. He is conscripted into the military for expressing his anger through violence when he is attacked by others.

Luke Evans, the second main character, is disciplined and rarely directs his anger outward, but the weight of racism has caused him to direct it inward. Previously a captain in the army, he was demoted because he shoved a commanding officer who found the racist murder of a black soldier a trifling issue. As he plays pool, he states that he has learned that the pool table "is the only place I get to shove whitey around."[46] Alone in his room with a bottle and a revolver, he is about to put a bullet in his head when he hears of Pearl Harbor. Suddenly having a purpose again even in the highly conflicted space that has contributed to his unhappiness, he chooses not to end his life.

The third soldier we follow is Isaiah Bradley, a young husband who chooses not to respond with physical violence when a white worker at the 1941 World's Fair refuses to allow him and his wife to see performers. Isaiah's wife, Faith, who we later discover is the narrator for most of the series, prevents him from responding with violence. While his anger is apparent, Isaiah is the one of the three who chooses not to act upon it. His round and wide-eyed face appears the youngest and most happy as he goes off to war, promising to return to his pregnant wife.

These three types—the revolutionary, the nihilist, and the family man—all face moments when they are called to violence and the

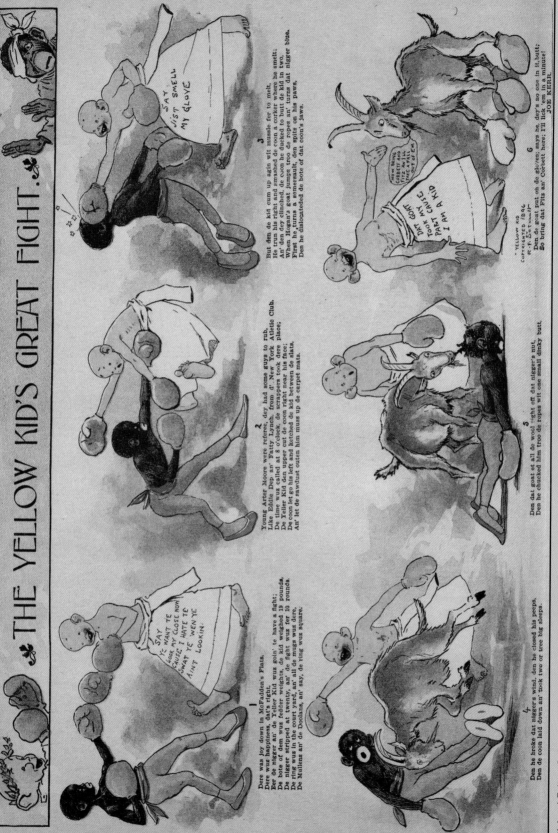

Richard Felton Outcault, "The Yellow Kid's Great Fight," *New York Journal*, December 20, 1896. Courtesy of the Library of Congress, Serial and Government Publications Division.

Kelly Sue DeConnick (author), Valentine De Landro, Robert Wilson IV, et al. (illustrators), *Bitch Planet, Vol. 1: Extraordinary Machine* (Portland, OR: Image Comics, 2015).

Kelly Sue DeConnick (author), Valentine De Landro, Robert Wilson IV, et al. (illustrators), *Bitch Planet, Vol. 1: Extraordinary Machine* (Portland, OR: Image Comics, 2015).

Jeremy Love, *Bayou, Vol. 1* (Burbank, CA: DC Comics, 2009).

Thomas Nast, "Emancipation," *Harper's Weekly*, 1865.

King in color. Ho Che Anderson, *King* (Seattle: Fantagraphics, 2005).

Recruitment poster, Department of the Navy, 1972. US Naval Historical Center, stock no. RAD 72792.

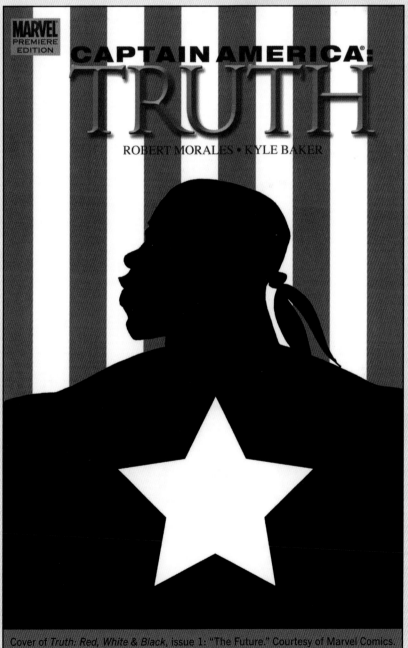

Cover of *Truth: Red, White & Black*, issue 1: "The Future." Courtesy of Marvel Comics.

The End

In loving memory of
JUNE JORDAN,
1936-2002.

The black Captain American pictures with the white Captain America 3.7 Final Fame of Truth.

Dwayne McDuffie (author), M. D. Bright (penciller), *Icon* no. 19, November 1993.

White Whore Funnies, issue 2, 1978, cover. Courtesy of Larry Fuller.

Dwayne McDuffie (writer), Mark Bright (penciler), *Icon* no. 13, May 1, 1994.

physical responses are rational choices in these contexts. In response to the wounds inflicted by racism, they choose revolutionary action, despair, or a focus on the familial, and Morales directs readers to understand that their roles are shaped by circumstance and choice. All their reactions are compensatory, a result of overdetermined destinies in the United States.

Even though the text does not give the reader a true believer in the nation-state, the specter of entitlement to full citizenship haunts these characters, who, in choosing to believe in political progress, the sense of purpose offered by the army, and the joys found with a wife and child, respectively, have directed their energies to the local and extrapolate from these attachments a larger sense of personal responsibility and identity. The title of the issue, "The Future," is thus indicative of not only the specific paths of radicalism, nihilism, and family chosen by the characters but also the ways in which these archetypes exemplify the possibilities for black citizens as the second half of the twentieth century approaches. As prospective black superheroes, these characters demonstrate double identities that go beyond the classic superhero dual identity of ordinary and supernatural man. These men are, as John Cawleti argues of hero archetypes, figures "marked, at least at the beginning of the story, by flawed abilities and attitudes presumably shared by the audience," and they are also scarred by the kinds of injuries that mark average men who suffer above-average traumas because of racism.[47] If the superhero narrative is about the possibility of heroism in every individual, then seeing the extraordinary in the typical is even more apparent in the superhero narrative told by *Truth*'s creators.

However, these characters are not allowed to follow the classical superhero trajectory as black superheroes. Mila Bongco suggests that "a nonwhite person, even if male, is too marginal to be THE superhero for the mainstream comic book consumer," and Morales treats the white Captain America as a figure within the text of *Truth* who would have to be invented even if black versions already existed.[48] Isaiah discovers a *Captain America* comic book that was released the year before he and other black soldiers are experimented on and puzzles over the fact that a narrative so like theirs is produced for the United States before their experiences. Luke explains, "If the Army determines they need a Steve Rogers, they're going to move heaven and hell to get one, the poor bastard."[49] Steve Rogers is needed to publicly wear the uniform, but as one superior officer argues, "Your kind could never be good enough to wear that sacred uniform!"[50] They cannot function as Captain Americas in

terms of the romance the military wants to demonstrate, and in the brutal logic of the comic they cannot survive to be the triumphant heroes of traditional superhero comics. Morales hints at the impossibility of narrative on the very first pages. The first issue of *Truth* opens with the narrator, Faith, saying that when she and Isaiah went to "Negro Week" of the World's Fair, "a whopping seventy-five cents admission could buy you the dream of equality for a whole day . . ." and on the very next page she amends, "that is until somebody decided it didn't."[51] This opening is an ironic foreshadowing for the entire series, as the dream of equality offered by the conventions of the classic superhero narrative offers the dream of equal superheroes for the readers, but the fantasy is disrupted by historical realities that burden the narrative with the impossibility of any of these men being embraced as ideal patriots wearing the Captain America uniform.

"KILL ME SOME WHITE MENS": DESIRE, REVOLUTION, AND BLACK AGENCY

Historical realities are a key obstacle to romantic patriotic narratives because they often depend on nostalgia, which is an inadequate ideological base for many citizens in the United States. Given the number of legislative, judicial, and cultural transformations designed to improve the rights of women and people of color since *Captain America's* inception, nostalgia is problematic grounds for common affective attachments. In his work on comics, Jarret Lovell argues that nostalgia not only represents a cultural practice of "coping with contemporary voids by revisiting historical periods" but also represents a cultural practice of ignoring historical voices—like the willful erasure of historical discrimination in favor of constructing romantic narratives about a golden age.[52] In the absence of an ability to build a patriotic attachment to the United States and a response to a global sense of community with people of African descent, black nationalism—an ideology simultaneously articulating black desire and mourning—was born.

While *Truth* is not a black nationalist text, we can read the black Captain America as functioning partially as a black nationalist hero. According to Wahneema Lubiano, black nationalism "functions as a utopian narrative—a rallying cry, an expression of desire."[53] Readers are told that all black people have heard of the black Captain America, and it becomes clear that he stands for an expression of an African American desire to create a nostalgic object in the US imaginary, a desire to form

a viable and valued model of citizenship.[54] If black nationalism also "functions as a utopian narrative—a rallying cry, an expression of desire" and an "ongoing, ever-renewed critique of black existence against white racial domination,"[55] then we can read this black nationalist hero as an embodiment of black desire and cultural critique. His body and this story express a desire for full citizenship and ask an ongoing question in the United States: how does one construct oneself as a self-determining black citizen within the state despite white hegemony?

The first issues of *Truth* confront this question. If "The Future" introduces us to three different models of responding to racism, the second issue, "The Basics," explores how the characters struggle to assert themselves as citizens. As black soldier-citizens, the characters are clearly on the losing end of any discourse about citizenry that the military will protect. African American soldiers are a hypervisible example of the ways in which people are made into objects in the military, and Morales draws on the documented history of military experimentation, the habitual practice of ignoring the significance of race riots, and institutional discrimination to look at the "math" the military uses to fulfill its goals as well as the math of citizenship in which black citizens clearly lose.[56] As the slogan of the forties argued, they fought for democracy abroad and received none at home. Maurice attempts to communicate the political possibilities of "Double V for victory at home and abroad," arguing that they should "fight for the right thing." He models a black citizenship model that many of his peers mock because of his "Li'l Lord Fauntl'roy" background and the "foolishness" of symbols for combatants on the ground. Embracing and fighting for the symbols of the nation are treated by his peers as an impossibility.

What some of his peers view as possible often fits into the acceptable parameters of US nationalist ideology—a specific black agency permitted by the state. For example, one soldier, Larsen, sees resistance as killing white men. However, killing white men in this context is allowed only by white domination, and thus it is resistance that is contained. As their leader, Luke Evans, states, "Killing white men is a gift you only get from other white men." Unlike Maurice, he cannot believe in the larger possibilities of citizenship, and his focus is on individual pleasures that he reads as an act of resistance. Similarly, the meaning of war is mapped onto more local foci. When Isaiah receives a picture of Faith and his daughter, one of the other soldiers says, "Guess that's what we are fighting for, huh?" Protecting one's family and "killing white men" could be read as personal choices, but they are mapped onto national

discourses, and national discourses are also mapped onto local attachments. The conflation of personal desire and state-sanctioned rhetoric and action can muddy a clear articulation of a specific black agency or any other identity that citizens attempt to pose as resistant to the state.

Nevertheless, resistance cannot be fully contained. The military is not entirely sure of their control in *Truth*, and they recognize that just placing the men in a situation where they might be in the position of revolting or where the black family or soldiers could be read as national representatives threatening ideological narratives that exclude full black citizenship. Anxiety about containing revolution may have propelled the military leaders to massacre hundreds of fictional black troops in the text. Morales bases this story on an urban legend about black soldiers who were massacred in Mississippi for being agitators.[57] But while this story speaks to specific black mythology and history, it is nonetheless a story of all soldiers for Morales:

> Black soldiers in WWII were more devalued than black soldiers in the first World War. It was a complete bureaucratic decision. They have less standing. They weren't thought of as people. It's not hard for institutions like the military to avoid thinking of people as people. If you look at the history of U.S. military experimentation, they've killed a lot of people. It's really staggering [if you] go to the website and look at how many people have been experimented on in the course of 50 or 60 years. Essentially, I used that group as a microcosm for the greater experience.[58]

Morales is performing what the white military hierarchy in his texts, numerous comic book producers, and many people in power have resisted doing—challenging the containment of the black superhero into boxes and allowing the black soldier to stand in for universal struggles. "For a black citizen," Morales argues, "it's not as jarring a transition for you to be placed in a position where you have no institutionalized power."[59] His intervention into superhero rhetoric thus goes beyond mere inclusion of the rare black body into the superhero pantheon. He demonstrates how the specifics of the black experience can tell an audience something universal in a more pronounced way than a white body can in this context.

This last factor demonstrates one of the models of US citizenship—that individual biography demonstrates both American exceptionalism and representativeness. The ideal US citizen is both like every American

and above them all; his suffering is excessive but still functions as a proper sign of what all great citizens overcome in their path to success. Stories about citizens of color can be even more dramatic examples of this duality because race functions as the exception that is both a burden and a key to proving worth.

Even as they demonstrate their worth as citizens in the text, they are still read as easily sacrificed. The few supersoldier survivors begin focusing on the work they need to do to get home, even as their situation and the hormonal imbalances produced by the serum escalate their anger. When only the initial three characters are left, Maurice is blinded by anger after a confrontation with a racist white soldier and kills Luke Evans when he is attempting to restrain him. In turn, Maurice is shot by the racist white soldier. By the end of the fourth issue, only Isaiah Bradley has survived, and he fights to save his family from what seems like the greater of two evils: Nazi Germany.

While both the United States and Germany are enemies to Isaiah, he gains a greater sense of solidarity with all victims in the war on his mission. When Morales and Baker move Isaiah and the story into Germany, they can position Isaiah as a global citizen. They make the black Captain America into a cosmopolitan citizen in two moments in the text, and both are highlighted by dead bodies surrounding those with whom they should have a cultural or political link. In an earlier issue, "The Passage," the creators harken back to the Middle Passage by scripting mythical African Warriors into the frame while one of the black soldiers dies through the army's use of the experimental superserum. The warriors stand near his bed while Luke talks about one of the race riots of 1919 and the dying character joins the warriors after he has passed. This passage places him in a history of black struggle and locates him in the diaspora with a home to which he can pass. While the configuration of Africa as original and future home gestures to the black nationalist impulses of the text, it also places him as a world citizen and not only in a US context.

The second moment highlighting the cosmopolitanism in the series is also a situation when foreign bodies surround the African American hero. This scene, more than the first, demonstrates the black Captain America's cosmopolitan status. The cover of the issue features a black head inscribed with numbers. Called "The Math," the cover and issue concern "the math" of the military that sacrifices citizens while also more specifically alluding to the inscription of numbers on concentration camp members' bodies. The numbers signify the similarities between

Isaiah and the victims of the Holocaust. In a suicide mission in Germany, Isaiah is confronted with evidence of Nazi experimentation and Holocaust victims. He is required to destroy a crematorium and places dynamite on the burned and mutilated corpses of victims with tears running down his face. In the magical realist moment of the issue, he is attacked by women in gas chambers, and the women are both real and specters of themselves. These victims of violence do not recognize the similarities between them—as either real bodies or projections of Isaiah's guilt. With their mutual history as objects of military experimentation and their similar objectification during the war, Isaiah and the Holocaust victims share a similar status as citizens—they are global victims. But as Isaiah is trapped in a gas chamber, the women's bodies evaporate and the numbers on their bodies are all that are left of their presence.

The glowing numbers surround Isaiah, and while the "math" of the situation would position them in solidarity with each other, it also demonstrates that he cannot save them. They are tools of the people in control of their bodies, and there is little space to maneuver a revolution. Isaiah Bradley is rescued but is then imprisoned in solitary confinement for years because he took the Captain America costume before he left on the mission. Echoing the results of some survivors of the Tuskegee experiment, Morales inflicts mental deterioration caused by the serum on his hero and Isaiah spends the remainder of his life at home as a shadow of the man he had been. He is betrayed in every way by the military he served, but it is this betrayal that produces his status as a legendary black Captain America, unknown to Steve Rogers and most other white citizens but well known in the black community through "The Blackvine," the title of the final issue of the series. The US military deemed him unfit to represent the ideal patriot, but in their betrayal of his service he can represent the ideal black patriot—forged in anger, wounded, and leaving a legacy that white America attempts to erase.

THE MELANCHOLIC PATRIOT

The complexity and ephemerality of what Isaiah mourns when he grieves the loss of the nation/uniform that he never truly possessed make him a melancholic subject. The melancholic is, as Anne Anlin Cheng describes it, "psychically stuck."[60] The melancholia of racialized people is more specifically the condition of coping with one's status as "an 'object,' a 'loss,' an 'invisibility,' or a 'phantom.'"[61] This certainly describes Isaiah's status in the military. He was an object subjected to

military power and suffered perpetual grief because of his loss of family and compatriots. He was not allowed status as a real person in the military, and his deeds and identity were invisible except in circuits of black communication. Cheng describes racial melancholia as illustrating how "complex psychological beings deal with the objecthood thrust upon them, which constitutes how they negotiate sociality and nationality. Within the reductive notion of 'internalization' lies a world of relations that is as much about surviving grief as embodying it."[62] *Truth* is a rich example of a text depicting racial melancholia. The black soldiers in the text had to negotiate their objecthood as tools used to preserve the nation-state. Isaiah's story must be read as a tragedy, and he embodies loss. With his friends and mind lost, his survival is a constant testament to the suffering he has experienced. Even though he embodies loss, he also represents heroism and possibility. His embodiment of loss and heroism is clearly depicted at the end of the series. In some of the last pages of the comics, we see Rogers examining a wall of pictures of Isaiah with numerous black luminaries: among them Malcom X, Richard Pryor, Nelson Mandela, Muhammad Ali, Alex Haley, Spike Lee, and a slightly troubled-looking Colin Powell. Isaiah's face tends to innocently mimic or respond to the faces next to his; he performs mimicry as children often do. We see him saluting Powell, laughing at Pryor, and singing with Marvin Gaye. While complex intellectual processing has been lost to him, he has gained a mythic stature in black culture that endlessly signifies the complexities of black patriotism. If constitutional patriotism for the abstracted universal citizen is represented by the flag or the uniform, attempting to erase what it has been used for or what it could mean, then the last image of *Truth* is the paradigmatic representation of the black patriot.

Steve Rogers returns the tattered uniform that Bradley had taken and been imprisoned for because his wearing it had represented stealing not only US property but also the property of whiteness and white citizenship. Rogers returns this uniform to Isaiah Bradley, and it is only a rag now—a tattered and threadbare garment. Isaiah does not speak when he meets Steve Rogers. He looks solemnly at the man in the Captain America uniform for several panels. Then an expression of shock turns to joy as he holds the tattered uniform of red, white, and blue, and he drapes it over himself for a picture with the pristinely clad white Captain America at his side. The image of the tattered sign of patriotism draping the smiling and mentally impaired Isaiah Bradley likely fills many readers with a deep ambivalence. In what is left of Isaiah

Bradley's shattered consciousness, what is the source of the smile? Is it mere mimicry of the smile of the man by his side, the kind of man he was told he has no right to be? Is it a trickster-like pleasure informed by his possession of an identity and property denied him by the state? Or is it pleasure in draping himself in a symbol of his accomplishments in the name of the abstract principles in which he believed?

We do not know the answers to these questions, and Robert Morales would suggest that the answers would lie in whatever we project onto the suit: "Cap is a propaganda symbol. You have a powerful symbol; most people tend not to look at what the symbols are. In comics, you don't have symbols as much as fetishes, and fetishes are imbued with all sorts of weird power . . . not Freudian, they're in love with certain costumes, etc. . . . and fetishes are conservative. [The fetishistic fans] don't want to see their love object belittled and changed."[63]

The character of Captain America is a popular generic object to which many fans are attached. Cap stands in for the flag, the United States, and the idea of patriotism, and the United States as an ideal. Vocal fans accused Marvel of "trying to 'PC-up' Captain America" and that *Truth* "was an affront to everything that Captain America stood for."[64] The vitriol leveled at Marvel, Morales, and Baker was a defense against attacks on their love objects. The black Captain America thus makes visible the racial melancholia of white subjects as well, their attachment to a love object—the ideal nation-state—that was never truly there. *Truth* constructs an African American love object, a black Captain America whose ambivalent figure represents a threadbare version of the American Dream to which not only African Americans but other Americans cling (Figure 3.7).

In 1943, a man calling himself a "Loyal Negro Soldier" wrote a letter to the civilian aide to the secretary of war to protest his treatment in the military. He was sent to a camp in Louisiana and describes going to the post exchange and being told that Negroes would not be served. The saleswomen, he writes, "knew not the way of a true democracy." But they were not alone in their ignorance, and he was prepared "to fight for a country where" he was "denied the rights of being a full-fledged citizen."[65] As a soldier, he explains, he fights "for a mock Democracy," but he is nonetheless "a loyal Negro soldier."

World War II veterans have often given accounts of being "loyal" and "patriotic." Some statements were doubtless performances. Some statements should doubtlessly be read as real and as an attachment to the America that could be, as opposed to the one that was. This attachment

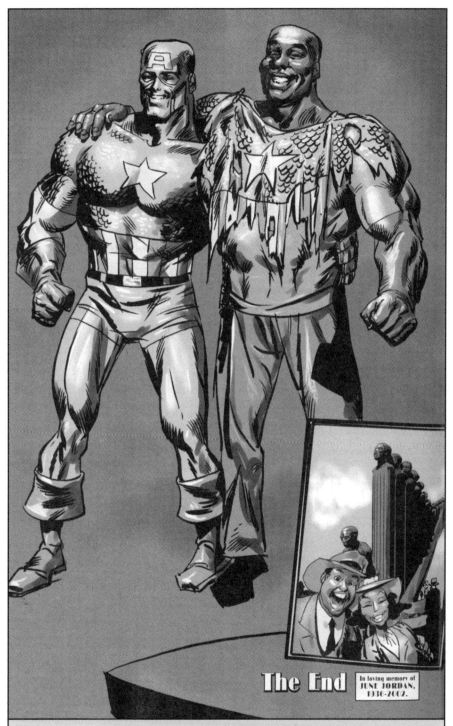

FIGURE 3.7. The two Captain Americas in the last frame of the series. *Truth: Red, White & Black*, issue 7: "The Blackvine." Courtesy of Marvel Comics.

to a troubled nation that damages its citizens and in so doing damages itself is what makes the last image of Isaiah Bradley such a magnificent articulation of a Cap that truly represents America.

The African American patriot seen here is indelibly a postrevolutionary body: his uniform in tatters, he stands next to a representative of the establishment that denied him full citizenship. The excessive representation of his brokenness is what allows him to signify not only black citizenship. Mentally wounded, he can no longer articulate a protest or ask questions. Produced after 9/11, in an era when the military was desperately trying to fill a volunteer army in never-ending war, *Truth: Red, White & Black* seemed a cautionary tale not only for African Americans but for all citizens. Stories about soldiers' inadequate gear and protection for combat and poor treatment after coming home would continue to fill the media in the twenty-first century, thus Isaiah Bradley's tragically wounded character seems an appropriate Cap for this moment. The African American patriot in *Truth* demonstrates the characteristics of many US soldier-citizens represented in the media: melancholic, wounded, and inadequately provided for by the nation. Some soldiers produce justifiable anger at the nation, but others still take pleasure and pride in the uniform. Taking pleasure in building up what has broken you is a pride that we might easily name as pathological. But it is pathology that runs through a black nation that often calls attention to the violence and suffering masked by a heroic ideal.

4

"THE ONLY THING UNAMERICAN ABOUT ME IS THE TREATMENT I GET!"

Infantile Citizenship and the Situational Grotesque

Just as the African American hero has been antithetical to construc-
tions of white, masculine citizen ideals, black children have been a
binary other to romanticized depictions of white children. American
visual culture history is filled with this binary, with perhaps Topsy and
Eva from Harriet Beecher Stowe's *Uncle Tom's Cabin* being the most
explicit examples of a black "pickaninny" caricature functioning as
opposite to a white angelic girl child. As we saw with the Yellow Kid
comic strip, black children are often represented as outside of inno-
cence and something other than children. But some African American
cartoonists have turned this caricature of white innocence on its head,
marking the universal, idealized childhood as suspect given the mate-
rial realities facing many children.

Few cartoonists were better at making the white child caricature
the Other than Brumsic Brandon Jr. His comic strip *Luther* (1969–1986)
was one of the first nationally syndicated comic strips created by an
African American featuring black characters outside of the black press,
following Morrie Turner's *Wee Pals* and Ted Shearer's *Quincy*. Luther
and his friends attended an inner-city school and dealt with poverty,
hunger, unseen teacher Ms. Backlash, and a white classmate who stood
in for blithe ignorance to black suffering and passive resistance to the
black freedom struggle. The unfortunate timelessness of his comic
strip is on full display in a 1970 four-panel strip (Figure 4.1) in which
Luther and his friend Pee Wee discuss police shootings. Brandon's
strips frequently employ incongruity to produce the joke in the last
frame. Here, Pee Wee asks Luther why "so many black people get hurt
when . . . the police say they were shooting over their heads?" "Well,"
Luther speculates, "a lot of policemen think all black people are BOYS."
In the last frame a close-up of Luther's wide, innocent eyes, and round

FIGURE 4.1. Brumsic Brandon Jr., *Luther*, 1970. Printed with permission of the Brumsic Brandon Jr., Art Trust and the Billy Ireland Cartoon Library and Museum.

face in his hands delivers the punch line: "So I guess the cops don't shoot HIGH enough!"

These black children embody a racial melancholia springing from lost objects they cannot quite place—a mourning and confusion at the violability of black bodies that speaks to the fact their personhood should be cherished and is not. And for readers, grotesquerie lies in the liminality of these cute children's knowledge of monstrous facts. Nineteenth- and twentieth-century discourse about the "child" has mandated that children be innocent but suggested that adults should work to maintain that innocence. But class and race always complicated who was allowed to be a "child" in national discourse.

Regardless of how much we might want to complicate these constructions, we can still express dismay that young African American children know or must be taught that black boys and men are disproportionately shot by the police in the United States. These child characters are in between adult consciousness and childhood innocence, which is a characteristic of the precocious child in the comic strip. The seriousness of the issue puts a twist on the characteristic child persona in the funny pages. The dissonance produced by the nexus of blackness and childhood is produced by both their struggle as children dealing with serious issues and the nature of the "funny pages" as a space with recognizable and predictable content in their depiction of children.

For all the breadth of innovation in comic strips such as *Little Orphan Annie*, *Peanuts*, and *Calvin and Hobbes*, children in comic strips, as Michael Chaney explains, "romanticize youth's vistas and vicissitudes to affirm the enduring appeal of" sentimental children. He argues that the child is "the face of American comics."[1] Little Orphan Annie faced real perils but was famously optimistic. Charlie Brown's melancholia is existential and thus not grounded in something that might require action on the part of adults. But just as blackness places pressure on the nationalism modeled by superheroes, young African American

characters place pressure on the innocence that the cute "child" models in the American comic strip.

Brandon's characters could nevertheless be read as caricatures of black children, and he was well aware of that fact. One of the ways in which blackness can be caricatured is not only through the rendering of the face and body, but through situational context. Artists and writers displace excesses from the body onto circumstances the body inhabits. Juxtaposition thus produces the sense that the black body is being car-icatured in a situational grotesque. Representations of suffering slaves have thus been described as caricature because of the history of rep-resenting black abjection.[2] Any representation of an African American performing a crime risks being called caricature or stereotype because of the association of African Americans with criminality. However, the fact that black bodies are overburdened by a history of representation that can somewhat overdetermine readings of them as caricatures does not foreclose the kind of antiracist critiques that can spring from the inevitability of such readings. The expectation of what the black body is or will be can indict the causality *that shapes* the black body and not the body itself. And in Brandon's comic strips, the black child in pov-erty shapes the triangulated structure of the humor by indicting the structures that produce the circumstances. The "child"—configured as innocent and carefree in the national imaginary—should not be a wounded black body. Because the "child" carries dominant ideological national scripts, these poor black children call attention to their being out of place, and thus challenge the discourse of the child citizen itself.

Luther and Pee Wee's cherubic faces are framed by the trash can, the rickety-looking bannister, and their words. While there is a long history of the "cute" impoverished child in popular culture, the introduction of violence directs the reader to be less sanguine about the American ragamuffin archetype, perhaps best signified by Harold Gray's *Little Orphan Annie* (1924–2010). In ways that the black superhero is similarly disruptive to nationalist fantasies in *Truth*, African American children in comics are disruptive figures who resist nostalgia and hopefulness. Instead, the affective center of these comics across genres is founded in melancholia and dissonance between the grotesque circumstances of structural racism and the cuteness of the child. This chapter explores how a number of African American cartoonists have taken up the cute black child as a pessimistic figure, often by reframing the discursive role of what Lauren Berlant has called the "infantile citizen"—the widely circulated, romanticized, and unknowing figure of the child that can

represent national innocence.[3] The difference race makes to cuteness is evident across genres. Ollie Harrington's editorial cartoons, Brumsic Brandon Jr. and Aaron McGruder's comic strips, Dwayne McDuffie and artist M. D. "Doc" Bright's superhero comic *Icon*, and Jennifer Cruté's autobiographical work all play with the situational grotesque, idealized fantasies about the (white) American child's futurity, and black out-of-placeness in the national imaginary. When read against a history of comic strips like Gray's *Little Orphan Annie*, in which the idea of looking "through the eyes of a child" calls the audience to participate in fantasies about American exceptionalism, these comics contest racialized discourses that imagine children as untouched by the world. These cartoonists unpack the idealized representations of the everyday life of the child, and use the black child's vulnerability (and wisdom) to uncover injuries perpetuated by the state and other institutions that deny black children care.

THROUGH THE EYES OF THE CHILD: CUTE AESTHETICS

Part of the layered context of the black difference to reading the child is that the figure of the child is already slightly incongruous. In his 1992 takedown of cuteness and a cultural embrace of the infantile, Daniel Harris makes a case for seeing the cute aesthetic as artificial, almost inherently attached to consumerism and the grotesque. The "grotesque is cute," he argues, "because it is pitiable, and pity is the primary emotion of the seductive and manipulative aesthetic that arouses our sympathies by creating anatomical pariahs like Cabbage Patch Dolls or even E.T." For Harris, cuteness "creates a class of outcasts and mutations" that are lovable because of "a quality it lacks, a certain neediness and inability to stand alone."[4] Neediness and an inability to stand alone, of course, are characteristics of children, and he believes that cuteness is something adults do to children to mask the dreariness of child rearing. Cuteness stands opposed to "harsh realities" like "the latch-key kid, the two career-family, the single-parent household, the crack baby, the less-than innocent, drug-running sixth-grader with a beeper in one pocket and a 44 Magnum automatic pistol in the other."[5]

Almost every example he gives of "realities" of the anti-cute are representations typically attached to black children. He does not address the frequently racialized construction of cuteness in the United States. Children vulnerable to the "inner city" are often described in a racialized, grotesque language and do not invite as much care because the state

suggests their circumstances are produced by their families or themselves. As Sianne Ngai argues, the "'cute' designates not just the site of a static power differential but also the site of a surprisingly complex power struggle."[6] "Cuteness" is one of the reasons the (white) child warrants state attention. The post–civil rights era would certainly see a rise in cute black children in popular culture. Most notably, African American child actors Emmanuel Lewis and Gary Coleman suffered from conditions that caused arrested physical development, enabling them to star in 1980s televisions shows where they would never grow up and become threatening representations of black masculinity.[7] But at the same time that we had such commercially successful examples of black cuteness, discourses about allegedly monstrous black children—the "crack baby" and future "superpredators"—began filling news reports.[8] These alleged monstrosities supposedly burdened the state and threatened its futurity.

Black children are often framed as threatening the future or not having much of one. Fatalistic framing sets them apart from how white children or the idea of children writ large are positioned in US culture. Lee Edelman has argued that the "child remains the perpetual horizon of every acknowledged politics," as the a priori innocence of children is presumed to engage the sympathy and concern of all citizens.[9] But one of the many absences in his influential argument is attentiveness to children who are consistently designated as lacking a future, or whose futures are considered destructive for the state. Youth touched by drugs, crime, and teenage pregnancy—often imagined as children of color—are children that the conservative state fights for in a paradoxical way. Conservatives fight for a decline in teen pregnancy while reducing options for birth control and sex education, declare a war on drugs while penalizing mothers for substance abuse and cutting health care, and want kids to choose alternatives to crime while reducing educational opportunities. Which is to say they "fight" for some youth by pushing these disadvantaged children and their advocates to engage in battles that are very hard to win. These children's ability to survive the disconnect between care and an alleged tough-love advocacy is what proves their worth. Children who are gifted with such abusive state concern thus have a tendentious relationship to "cuteness" and innocence in the history of discourses about children in the United States.

"Neediness and inability to stand alone" is thus how the pathologized African American child can be read, but they nevertheless often mark some kind of difference, or limit, in the logic of the strange nexus

of the child, the cute, and the grotesque in the United States. Part of what makes children "cute" is often their channeling of adulthood—preciousness, "acting grown"—a slippage between child and maturity. Slippage between categories is a means of delineating the grotesque; it is also a means of categorizing the other. Both Mary Russo and Leonard Cassuto have explained that constructing women and black people as grotesque is a mechanism for categorizing them as other than human.[10] It emerges, as Cassuto explains, from conflicts in categories and fundamental boundaries. The in-between is at the heart of the affective grotesque, but Daniel Harris's intervention allows us to see the aberrant pleasures of the grotesque as well. People can be drawn to and repelled by the grotesque. How else to explain white attachment to "contemptible collectibles" of black people, the "pickaninny" eaten by alligators, or the monstrous darky with the watermelon smile?[11] The grotesque is uncanny. It is recognition of something familiar but often *made* "not right" in order to establish normative categories.

Child bodies engender various and conflicting affects from adults as they become what Robin Bernstein describes as "credible vessels" for adults to perform, deflect, and embody various ideas.[12] In particular, a "constantly replenishing obliviousness" does work for a nation that wants to absolve itself from blame. As Lauren Berlant observes, the trope of the "infantile citizen" constantly produces narratives where the child's innocence and disappointment about the nation's failures is a discursive mechanism that allows the state to acknowledge that the nation does not live up to its ideals while the child stands for what the nation now is and (allegedly) will be. The child's idealized persona masks continued injury.

Little Orphan Annie arguably speaks to Berlant's paradigm as well as any comic strip in US history. Mischievous children such as the Yellow Kid and the Katzenjammer Kids established an affective precedent for the child on the comics page. Other common tropes of children on the funny pages that were influential but not constitutive of all strips are absent adults (*Peanuts*), precociousness (*Dennis the Menace*), elaborate fantasy lives (*Little Nemo*, *Calvin and Hobbes*), and the relationship between the child and the city (Yellow Kid). *Little Orphan Annie* was syndicated around the country for decades, adapted into a popular radio show, Broadway musical, and three films. First appearing in 1924 and running for years after Gray's death until 2010, it followed the adventures of an impoverished and much-abused orphan who continued to be optimistic despite her decades of extraordinarily bad luck.

Gray's strip is an ideological descendant of Horatio Alger's popular stories in the nineteenth century about poor boys able to lift themselves up through their strong moral character. Lifting oneself up by one's bootstraps is clearly easier with millionaires lending a hand, but the prosperity gospel propagated by these stories was that they received such help from on high because they deserved it (and would have been fine without it).[13]

Annie would perpetually receive and lose the reward of being adopted by her rich benefactor. She was often separated from her wealthy adopted father, Daddy Warbucks, and the absence of the parent—in the way of many children's narratives—allowed her to perform as a "mature adult inhabiting the body of an adorable child."[14] Annie was a caricature of wide-eyed innocence with round eyes that literally held nothing within, suggesting blindness, and she failed to see structural inequality. Annie remarked frequently that she had everything she needed despite having nothing, becoming the perfect embodiment of the obliviating function of the American child. Modeling optimism in the Great Depression and beyond, she provided a conservative counterpoint to Franklin Delano Roosevelt's New Deal.

Little Orphan Annie was arguably the first transparently and unapologetically political comic strip in mainstream US newspapers, but it would not be the last. Nor would Annie be the only child in comics to embody possibility for struggling citizens in the first half of the century. In the black press, Jackie Ormes's *Patty-Jo 'n' Ginger* was a very popular single-panel comic that depicted a precocious young African American child named Patty-Jo and her young caregiver. Ormes's characters were the antithesis of abjection, always well-dressed, stylish, and cute as dolls. Patty-Jo would, in fact, be a doll.[15] Patty-Jo's precocious and wry commentary on national and world events never seemed to leave her discomfited. While a radical intervention into traditional comics by allowing a young black girl to be a brilliant political commentator, the persona of Patty-Jo herself was not designed to leave the reader affectively uncomfortable about the precocious black child's vulnerability. Ormes's commentary on the grotesque work of the state does not touch the pristine cuteness of Patty-Jo, and thus stands in contrast to the work of some other African American cartoonists after the civil rights era. While Ormes used the child's gaze to speak to the politics of the period and explore how black children were often abandoned in policy frameworks, some other cartoonists showed how the state's treatment produced abject black bodies.

THE GROTESQUERIES OF CHILD POVERTY

Born in 1912, Ollie Harrington was a contemporary of Harold Gray and Jackie Ormes, and he worked until his death in 1995. He stated that one of his desires in cartooning was to change the representations of African Americans, who "were always represented as a circle, black with two hot dogs in the middle for a mouth . . . it was a conscious effort on my part to change that at least in my drawing. The black had to disappear. The rubber lips had to disappear."[16] He was a celebrated cartoonist and friends with many leading black literary lights in the first half of the twentieth century. Harrington began publishing comic strips, single-panel gag cartoons, and editorial cartoons in African American newspapers such as the *National News*, *New York State Contender*, *Chicago Defender*, *Pittsburgh Courier*, and *New York Amsterdam News* in the early 1930s. He continued to contribute work to the black press even after he moved to France in 1951 because the House Un-American Activities Committee was targeting him for this antiracist activism. He moved to East Germany in 1961 and remained there until his death.

Harrington's style transformed over time. A 1933 comic strip in the *Baltimore Afro-American*, "Scoop," depicts a loosely drawn child figure who is in keeping with the cute typology of the period. At one point, Scoop is hit and chained up by his stepmother, who believes he has been left some money by his deceased father. The last frame ends with a cliffhanger: "Poor Scoop—mistreated by his stepma—not a friend in the world. But—has Scoop got the dough hidden away or is it only the vision conjured by the drink befogged brain of a fiendish woman?"[17] The character has a round cherubic face, wears an oversized coat, and employs black dialect. In one strip, he forgets what he is supposed to tell the super in the apartment building, but after the apartment is flooded he remembers that his mother told him that they needed a repair.[18] This strip is very consistent with the serialized travails that child heroes encountered in 1930s media, and seems less a particular commentary on African American life. His very popular single-panel gag cartoons *Bootsie* (1936–1974) and *Dark Laughter* (1938–1956) were more culturally specific and employed slice-of-life humor set in Harlem. He was sometimes accused of perpetuating stereotypes for depicting black people acting with common foibles such as laziness or false bravado.[19]

Many of his depictions of children were also slice-of-life cartoons, and the situational irony called attention to their vulnerability. These works lay in the nexus between gag cartoons and the editorial cartoons

depicting children focused on the foibles of the state, and the children were vulnerable victims of it. In his work in the black press, the black face stayed fairly consistently "cute" and the situational grotesque produced the ironic humor of the commentary (Figure 4.2). Over time, he would begin to show the impact of the state on their bodies. In a genre that so diligently showed romantic and ideal types of children—including, in her own fashion, Jackie Ormes's trailblazing *Patty-Jo 'n' Ginger*—Harrington places children in a situational grotesque that invites the reader to be uncomfortable not only with the idea or criticism in the punch line but with the vulnerability of the black child. In the situational grotesque, the body would not be grotesque in itself without the conditions that either act on the body or provide a jarring contrast to it.[20]

FIGURE 4.2. *Dark Laughter.* "Now I ain't so sure I want to get educated," September 21, 1963. An example of Harrington's early "cute" black child aesthetic. Original drawing. Published in the *Pittsburgh Courier*. Courtesy of Dr. Helga Harrington, Library of Congress.

Harrington often deployed a triangular structure in his editorial cartoons that depended upon the tension between the suffering black body, the realist image, and the invisible state causing the injury. His realistic aesthetic becomes a perverse twist on stereotypical representations of the black child. Representations of poor black children would be familiar to readers, which is one of the reasons that Ormes and other cartoonists created a wide set of representations that did not replicate a narrative of black poverty. Arguably, these visual representations practiced a representational politics of respectability.[21]

These representations shifted over time as he began working for communist newspapers. His children increasingly appeared old, and showed his interest in using children—and black children in particular—to signify the state's failure. In one single-panel *People's Daily World* cartoon (Figure 4.3), two young boys are sitting in what appears to be an urban setting, surrounded by filth. One child sits on an abandoned oven and the other on a box, with old tires and overflowing trash foregrounded in the frame. Their clothes are torn and patched, and one child's teeth need work. Eyes appear tired in their small faces. The caption reads, "Well natcherly I know whut I wanna be when I grow up but statistics say I aint gon' git to grow up!" Readers are directed to look

"Well natcherly I know whut I wanna be when I grow up but statistics say I aint gon' git to grow up!"

FIGURE 4.3. Oliver Wendell Harrington, *Dark Laughter: The Satiric Art of Oliver W. Harrington*, ed. M. Thomas Inge (Jackson: University Press of Mississippi, 1993), 37. Originally published in *People's Daily World*, ca. 1986–1990. An example of the cute marred by the grotesque common in his later works depicting children. Courtesy of the Walter O. Evans Collection.

outside the frame by the hint of the open mouth indicating speech and a hand gesture. Without these signs the images would stand in themselves as pictures of black abjection. The triangulated structure directs the reader to critique the state because the critical voice emerging from the black body directs the criticism to causality outside of blackness. "Statistics" are descriptive and, to many people, predictive. His desires are pitted against an empirical force framed as outside of his body, but the visual representation of his body also indicts the allegedly all-knowing nature of the empirical. The idealized futurity of children is

transparently treated as doubtful for African American children. More-over, "statistics"—some of which are undoubtedly supported by the state—can contribute to the state's abdication of responsibility for their most vulnerable citizens.

Reframing causality and how we might view statistics has been essential to black intellectual interventions into poverty discourse. Afri-can American poverty had long been associated with moral and cul-tural failures. Lyndon B. Johnson declared a "war on poverty" in 1964, inaugurating a set of social safety net programs designed to address long-standing inequalities. In 1965, Daniel Patrick Moynihan produced *The Negro Family: The Case for National Action* as part of his role as assistant secretary of labor. While acknowledging the long history of racism and discrimination that had impacted black people, he infa-mously argued that black poverty was the result of a "black matriarchy" that emasculated black men. While recognizing that discrimination had a large impact on black lives, he saw discrimination as transforming black character and creating a "tangle of pathology."[22] Black culture, in this logic, produced a structure of pathology and subsequently the pathological child.

When Harrington was producing cartoons for the *Daily World*, the Reagan era's policies of trickle-down economics, and their continua-tion under George Bush, were not making the lives of black children better. Johnson's war on poverty had clearly been lost. Debates over the numbers of children in poverty have hinged on the question of the government's categorization of poverty. The percentage of children in poverty rose for much of the 1980s, somewhat explained by the change in the categorization of the poverty line.[23] This change reflected the reality of the resources required for basic needs. The intractability of poverty and hunger in a country as wealthy as the United States would preoccupy many intellectuals and policy makers for decades to come. While Harrington had many different foci in his editorial cartoons, he would return to the child body again and again, showing a dissonance between the ideal futurity that children allegedly represented and cir-cumstances under which many of them lived.

Harrington's nuanced joke in one cartoon (Figure 4.4) indicts insti-tutions that fail to prepare for the future. Two boys are at the dump where they are foraging for food. One tells the other, "Ya can find a lot'a eatable scraps out here if you can remember what they was supposed to teach you about germs in the biology class!" "Supposed to" indicts the schools, and yet the failed education is nonetheless necessary for

"Ya can find a lot'a eatable scraps out here if you can remember what they was supposed to teach you about germs in the biology class!"

FIGURE 4.4. Oliver Wendell Harrington, *People's Daily World*, 1986–1990, c8. *Dark Laughter: The Satiric Art of Oliver W. Harrington*, ed. M. Thomas Inge (Jackson: University Press of Mississippi, 1993), 45. Courtesy of the Walter O. Evans Collection.

their survival. The size of the figures, the reference to school, and the situational context of black boys talking lead us to read them as children. As in many of his cartoons, the child on the right has an old man's face. Emaciated arms, visible ribs, and bloated stomach evoke the representations of starving children typically seen in charity solicitations to help children in the Global South. The relationship between the old face and the gaunt frame defamiliarizes the typical large-eyed image of the starving child, reminding the reader that the vulnerable child becomes the vulnerable adult in the fast-approaching future.

While these editorial cartoons were produced after the "classical" period of the civil rights movement, his representation of black children

did not depict an integrated world. Harrington's work was always in African American or leftist papers, whereas the first African American cartoonists in white newspapers demonstrate different models of integrating the white funny page. Morrie Turner's *Wee Pals* (1965) was the first comic strip by an African American cartoonist to receive national syndication outside of the black press. His multiracial cast of characters emphasized "Rainbow Power!" and celebrated the possibility of interracial intimacy among youth, thus forecasting the possibility of such camaraderie among adults. *Wee Pals* is a joyous comic, but made many explicit statements about political issues. Consistently, Turner emphasized the need for people to abandon tribalism in favor of solidarity politics.

Ted Shearer's *Quincy* became nationally syndicated in the 1970s, and his strip provided yet another model of integration. The group of children in his strip also demonstrated a great deal of camaraderie, but poverty was a frequent topic. Like Turner, Shearer placed Quincy within the same representational structure of the cute white child in comics. With his smiling, cherub face and quips, he made the impoverished inner-city child capable of conveying the same cute aesthetic as carefree white children. His poverty was constantly announced, but was not an impediment to his experiencing joy in childhood. One of the possible interventions into the statistical framing of black youth is intervening into a narrow framework that conceptualized the black child solely as a problem. Shearer's *Quincy* encouraged readers to see poor black children as children. By illustrating the stories, experiences, and wit of inner-city black youth, Shearer presents a black youth culture that contains the "innocent" experiences of childhood even in disadvantaged circumstances. These comics strips offered varied ways to integrate the funny pages in the white press. Brumsic Brandon Jr.'s approach, however, was slightly more radical because the serious themes in his strips were resistant to the traditional affect of the funny pages. He received letters from both black and white readers suggesting that the tone of the issues in his strip was inappropriate:[24] "The very first letter I received from a reader, after *Luther* broke into print, was from a young white woman who said, in no uncertain terms, that the problems to which I was addressing myself were far too serious to have fun with. She stated further that if I were white, I was sick, and if I were Black I was crazy. . . . A letter from a Black inmate in a Philadelphia prison stated that a particular strip was 'quite true,' and that 'being black,' he saw no humor in it."

Brandon began his professional cartooning career in 1945, and none of the strips he had submitted to syndicates were successful until

Luther. His earlier work focused on white characters or animals because there was allegedly "no market" for a strip featuring black characters.[25] He saw his comic strip as doing the work of the editorial cartoon, and understands how essential caricature is to the medium:

> A cartoon is a "drawing, often in caricature, made as a commentary on current events, or to illustrate a joke or narrative"; therefore, automatically built into a cartoon is the pointing of an accusative finger. If there is a joke, there must also be a butt of that joke. We Blacks have been either the butt of those jokes in the comics or totally ignored until recently. With the advent of the few Black comic strips that exist today, we have taken a giant step away from being the butt of the joke and another giant step into the position of pointing an accusative finger.[26]

After the "repulsive images of Smokey, Abestos, and Ebony White," he, too, saw "cute little black children as an antidote to the history of these representations."[27] He thought about calling the strip *The Inner City Kids*, as reframing the perception of urban black children was a primary concern, but the title was rejected for not being commercial enough.[28] Brandon wanted to create positive representations, but part of what makes Luther and his classmates "positive" representations is that their affect rarely is. Brandon was intent on producing positive images that veered far away from the history of black representation in comics (and elsewhere), but he was well aware that his depiction of poor black children could function as a caricature to some readers that would stand for all black children. "There are those," he writes, "who feel that because there are four other kids sleeping in the same bed at the same time as Pee Wee that this is universally true." Representations of white characters are not burdened by the representational logic that afflicts subjected groups. Most strips depict them puzzling through racist issues with a child's logic—albeit children who have been introduced to discrimination at young ages. He remembered "wondering why 'Skippy' and other children in comics were never concerned with the things that concerned" him most.[29] If one of the conventions of the child in comics is the combination of naïveté and wisdom that produces the obliviating function for adults, it is the impoverished, black difference that disrupts the construction of the child as modeling what the nation is in its best version.

Pee Wee's constant hunger is one of the most poignant sources of humor in the comic. In a 1970 strip he asks the little girl, Oreo, why

teachers say that he has an empty head. She replies that it because his answers are so often wrong. "But that's not because my head is empty . . ." he protests. "It's because my stomach is!" The penalties of hunger are both their inability to perform well and the invisibility of the knowledge they glean as poor children. As Pee Wee says in another strip in a discussion of another character's low score on a test, the things they ask "ain't the kind of stuff" they know.[30]

In a 1971 strip (Figure 4.5), a white classmate announces in the first frame that "It's stupid to blame hunger on the war!" As the Vietnam War continued, many people contested the resources used to fight as so many in the country were economically struggling. And as is often the case in the strip, the white child evokes his father (who is for civil rights as long as nothing changes), stating that he thinks the "country is rich enough . . . to have both guns and butter!" The boy has clearly started to walk off after his lecture, only to look back in surprise as Pee Wee, always starving, looks up with wide eyes and asks, "What's butter, Luther?" The dissonance between what Pee Wee knows and does not know produces the power in the punch line. The urban child knows guns, but not a very common kitchen staple. White infantile citizens typically cause hopefulness in the adult because they know what society should do and be and are ignorant or disappointed in its failures. In contrast, the black infantile citizens in *Luther* expect little to nothing from the state because they know its failures and are ignorant of the gifts it bestows on a chosen few.

The war on poverty is thus constantly depicted as not working. "What happened to the war on poverty?" Pee Wee asks. "I guess they called a cease fire," Luther responds.[31] And of course, if the war does not succeed they are transparently the victims, treated as refugees in their own country. The affect of the comic strip often invites nostalgia for the sense of possibility and imagination in childhood, but Luther reminds readers of how material inequality impacts the lives of children.

FIGURE 4.5. Brumsic Brandon Jr., *Luther*, 1971. Printed with permission of the Brumsic Brandon Jr., Art Trust and the Billy Ireland Cartoon Library and Museum.

FIGURE 4.6. Brumsic Brandon Jr., *Luther*, March 2, 1971. Printed with permission of the Brumsic Brandon Jr., Art Trust and the Billy Ireland Cartoon Library and Museum.

Idealized, infantile citizens model the possibilities for the nation, but black infantile citizens illustrate that the future shows no signs of transforming possibilities for the most vulnerable citizens.

In one strip (Figure 4.6), Luther asks a particularly dispirited-looking Pee Wee what he's thinking about. "My future!" he responds, with a downcast face. "Well, what makes you look so sad?" Luther asks. The title character rarely looks nonplussed in the strip, but even he cringes with wide eyes when Pee Wee responds, "My present!" Luther's eyes are a stark contrast to Little Orphan Annie's iconographic, vacant orbs. His wide eyes—with pupils—are forced to see. Brandon calls attention to the impossibility of extricating a child's future from their present, an impossibility often glossed over in policy discourses about personal responsibility and individual character. It is one of a number of strips in which the children demonstrate anxiety when reflecting on their futures. The poor urban child some people often feel sympathy for quickly becomes the sign of black pathology sans traumatic history. Comic strips featuring children can be for adults nostalgic representations of an idealized past that simultaneously models an affect about childhood and the nation in the present. But when the child's strip problematizes what adults remember or know about the child, it displaces the nostalgic underpinnings of an idealized America.

If one cartoonist is affectively closest to Brandon Jr.'s legacy on the funny pages, it is Aaron McGruder, whose comic strip *The Boondocks* (1996–2006) used a child to embody condemnation of the state. Other African American strips that followed the early pioneers included Ray Billingsley's *Curtis* (1988), Rob Armstrong's *Jump Start* (1989), and the strip of Brandon's daughter, Barbara Brandon-Croft's *Where I'm Coming From* (1989–2004), the first syndicated strip produced by an African American woman. However, none of these strips were as popular as

McGruder's. In its short ten-year run it came to be read by many people who did not read comic strips and inspired conversations and think pieces because of its controversial content.[32]

Aaron McGruder began the strip in 1996 while an Afro-American studies major at the University of Maryland. Only two years after he graduated in 1997, the strip was picked up by Universal Press Syndicate and nationally syndicated. Born after 1968, he benefitted from the civil rights movement and produced a very different black child for the funny pages. McGruder's characters live in an integrated world, and his commentary on contemporary life reflects mainstream cultural obsessions (like Star Wars) as well as a black radicalism that Huey attempts to bring into a predominately black space. He adapted the comic strip for the Cartoon Network but left the show after the third season, suggesting that he made the choice because the young audience for the show restricted the work he desired to do because "it was important to offend, but equally important to offend for the right reasons."[33]

McGruder was often accused of racist caricatures, but critics of the comic often elided the difference between satire and perpetuation of stereotypes.[34] The strip featured the radical ten-year-old Huey, who moves to the suburbs with his grandfather and "thug" little brother, Riley. Huey is constructed as the rational subject who gazes on unreason. As it progressed, McGruder more often had a national focus. Huey is a progressive black nationalist, critiquing the sins of Black Entertainment Television, the black celebrities worthy of his "Most Embarrassing Black Person" award, and the foibles of the two-party political system. While many readers expressed offense at what they viewed as stereotypes of African Americans, the strip's creator became a national star after 9/11.[35] McGruder did not shy away from criticizing President George W. Bush or his administration after the event, and a number of newspapers pulled his strip when they deemed it too offensive.[36]

Huey is positioned as a fairly powerless citizen-subject, but he utilizes some of the traditional methods of visibility. Letters of protest, phone calls, speaking out against ideological indoctrination, and educating family and friends are his means of protest. Mirroring a pose we often seen in Garry Trudeau's *Doonesbury*, a common image is of Huey lounging in an armchair watching television, taking in the absurdities of US politics and popular culture. But because he is a child and not an adult, he is an atypical national critic in a space that typically presents children as precocious or awkward youngsters challenging adults in the domestic sphere. While the children in *Luther* still use a child's

gaze, Huey appears to be a child genius, preternaturally gifted with his political commentary. He embraces a role in the public sphere, but a recurring source of the comic strip's humor is the depiction of Huey fruitlessly sending protests into the void—venting to family and friends or making protests through the phone, Internet, or letters. As he is ten years old, his invisibility and voicelessness are heightened, and yet the child's voice also illustrates the toothless power of many citizens. As in many other cases, the child functions as a universal sign. However, the strip makes Huey visible—he is a markedly black body and loud radical voice in a space that has traditionally lacked such a presence. McGruder constructs Huey as a heroic figure fighting against national absurdity and totalitarianism. The humor sometimes emerges from his exhausted radicalism that cannot change the world. Evoking the black nationalism of the late 1960s and 1970s, he also destabilizes the construction of idealized child futurity. He is a sign of the failures of future plans.

In his first strip after 9/11 (Figure 4.7), McGruder challenges the notion of black bodies as objects of humor, as well as the question of comedy after such a national trauma, a common question in the entertainment industry in the weeks after the attacks. These frames represent a common sequence in *The Boondocks*, depicting Huey in contemplation, moving to a moment of silence in shadow before the punch line of the strip. The moment of silence mimics the moments of silence that the nation took in mourning after the terrorist attacks. But with the assertion that Huey "never" laughed or smiled before the attacks, McGruder calls attention not only to the character's aesthetic difference from other representations of blackness but also to narratives that suggest that laughter and smiling were easy for the nation before 9/11. There was terror and struggle before the events, and Huey's innocence was not disrupted by the attacks—he was never allowed innocence.

FIGURE 4.7. Aaron McGruder, *The Boondocks*, September 24, 2001 (New York: Three Rivers Press, 2003), 168.

The kind of strips that resulted in *The Boondocks'* removal from some papers were scathing attacks on the logic of patriotism after the events. McGruder suggested that the administration encouraged fear and also called attention to long histories of US support of groups that then would engage in terrorist activities. Huey, as a black infantile citizen, refuses the national oblivion encouraged by the nation. He

was often depicted screaming to those who would not listen. Some papers reacted by placing the strips on the editorial page, while others removed them entirely.

In response to the strips being pulled, McGruder created the characters Flagee and Ribbon (Figure 4.8). Flagee and Ribbon are both interesting doubles for Huey and the desired recipients of his politics. Huey, despite being a child, plays the role of elder statesmen, wise in the ways of the nation-state (albeit often to the cluelessness or derision of those whom he addresses). Ribbon is the child Huey is not, soaking in the knowledge that Flagee produces. Flagee's movement also connotes jauntiness, mov-

FIGURE 4.8. Aaron McGruder, *The Boondocks*, October 19, 2001 (New York: Three Rivers Press, 2003), 168.

ing in ways foreign to the serious protagonist of *The Boondocks*. Flagee and Ribbon exhibit a kind of inherent joy that Huey never possesses. At the same time, the strokes that convey jauntiness also connote Flagee's and Ribbon's rage and fear, respectively. When Ribbon tells Flagee, "[I] heard someone say on radio that if we kill innocent people, we're not better than the terrorists," Flagee leans threateningly down on Ribbon, stating that he would drag Ribbon out to the street and shoot him if he said anything like that again. The line between patriot and fascist, joy and fear, is thin.

Flagee's and Ribbon's "joy" can be conveyed only by a reified patriot; the flag is the signifier of a particular kind of ideal subject. McGruder constructs the ideal citizen-subject in the post-9/11 imaginary as disembodied. Not only is there no room for Huey's body in the ideal construction of US citizens; all citizens get displaced under the weight of ideology. This ideal US citizen mindlessly parrots jingoistic phrases, incapable of recognizing that the construction of citizenship that they perpetuate depends on disregarding real bodies, exhibited by the actual erasure of Huey and the characters who usually fill McGruder's strip. Replacing bodies with the trappings of patriotism suggests that the path of post-9/11 national discourse romanticizes neither real bodies nor real minds but instead ideas that ignore some citizens' expressions about what truly places them in harm's way. The world does not make room for Huey. It silences him, desires his erasure. In erasing him, McGruder shows what is left: Flagee and Ribbon; jingoism and his sidekick, parrot.

The metacritique produced by "The Adventures of Flagee and Ribbon" also poses the question of what the possibilities for humor are in such

a climate. The idea of Flagee and Ribbon is funny, but only through the delivery of lines that are decidedly not. McGruder has been accused of stereotyping, but this devolution of bodies into the tools of US national-ist discourse illustrates another kind of erosion of complex differences: the desired homogeneous subjection in the world of the PATRIOT Act.[37] In that world, there is little room for humor or any other kinds of intel-lectual production that fail to match the script disseminated by Fox News broadcasters.

Huey's silence, invisibility, and incongruity in relationship to US narratives of citizenship are examples of widespread erasures of diverse citizenship models and problems in US culture. The black child is simultaneously not taken seriously and treated as a pathological sign. Huey is not the pickaninny, eating watermelon or smiling with wide eyes. The fact that Huey never smiles in the strip is one of the sites of visual resistance. As he is never the smiling pickaninny who cannot be taken seriously, by presenting a serious image in the comedic frame, he challenges traditional representations of black children—from the nameless black babies eaten by alligators in early twentieth-century material culture to late twentieth-century black sitcoms that treat lazy and back-talking black children as a source of laughter. While other representations of black children treat them as a source of threat, Huey also challenges the ways in which black children can be dangerous. He is an intellectual menace and not a physical one.

VULNERABLE GIRLS

Reframing the threat of black youth by making the threat intellectual is also the work of the comic book *Icon*. Raquel Ervin / Rocket is the fifteen-year-old protagonist of the comic book *Icon* (1993–1997), cre-ated by writer Dwayne McDuffie and artist Mark D. Bright. She is the sidekick but actual brains behind the construction of the title charac-ter. As Raquel Ervin, she meets the superpowered Augustus Freeman III when she accompanies her boyfriend and his friends in an attempt to rob Freeman's house. Freeman, like Superman, crashed in a field and was adopted by the family that found him. Unlike Superman, the alien had lived many years as an adult on his home planet before his crash and adapted by taking on the infant form of the people who found him. He was found by southern slaves in the nineteenth century and, immortal on Earth, lived for many years, periodically leaving where he lived and returning as his own son. After living through slavery and

Jim Crow segregation, he believed that African Americans were not tak-
ing advantage of the gains of the civil rights movement and became
a black conservative. Raquel witnessed Freeman's superpowers during
the thwarted robbery and subsequently returns to convince Freeman
that he has an obligation, as an African American with such gifts, to be
a role model for others. Throughout the series, the teenager constantly
reminds him through her words and material circumstances of the
realities of structural racism in a post–civil rights culture. Raquel is the
heart of the series, the character who invites the reader's identification.

Making Raquel a point of identification is a radical departure from
most superhero comics given what the creators do to her character and
body. While her body is chiseled when in uniform, outside of the cos-
tume Raquel does not have a muscular superhero frame. In fact, writer
Dwayne McDuffie and the artists quickly transform her body into one of
the most abject in US culture—the teenage, black, unwed, single mother.
In the 1990s, the idea of "babies having babies" made the unmarried,
black teenage mother one of the principal signs of a black grotesque
in US culture. And in a genre of hyperembodiment, her pregnant body
would appear the ultimate counterideal to the US citizen. Raquel per-
sonifies all that cannot possibly be read as heroic in US culture. While
teenage single mothers are sometimes read as admirable after they have
overcome their status, Raquel, perhaps because of the limited run of
the series, continued to personify someone of limited opportunity. She
is bright but living in housing projects, struggling to balance school,
motherhood, and work; Raquel's melancholy at not only her subjection
but that of the other inhabitants of Paris Island, a low-income section
of the fictional city of Dakota, informs much of the comic. But it is a
melancholia about class and race relations that is cut by optimism and a
satirical gaze on what the impossibility of being able to imagine Raquel
means in the context of the heroic citizen-making imaginary of the
United States.

In a critique of black superhero comics, Anna Beatrice Scott claims
that there is "absolutely nothing new" about *Icon*: "an alien who falls
to earth and takes on the form of an African slave, . . . a black Republi-
can brought out of the closet, so to speak, by a soon-to-be unwed teen-
age mother, who is also his sidekick."[38] While I have not run into many
black single-mother teenaged superheroes, let alone those who create
the heroes they assist and read Toni Morrison, I do take her point that
"black bodies are already stories, mythological beasts with epic powers
and tragic presaged endings in the faulty perspectivism of the white

supremacist world" and, moreover, that "an artist's perception of a necessity of representing the 'real' when rendering a black body as fiction character almost always reveals the creator's intention of getting it right or righting a wrong, but rarely writing a story."[39] Scott's criticism suggests, yet again, a catch-22 for creators of black representation. But the hyperawareness of these representational conundrums are a powerful creative force in *Icon*.

The wry and peppy cover of issue 31 is an explicit double of an early Batman comic book cover depicting Batman and Robin, the most iconographic superhero and sidekick in the history of comics. It features a jaunty yellow background with Batman and Robin soaring through the air over the rooftops. They look at each other, with Robin clearly smiling, and the cover informs us that we will be treated to the "THE ALL BRAND NEW ADVENTURES OF THE BATMAN AND ROBIN, THE BOY WONDER." Issue 31 of *Icon* signifies the original cover, down to the shape of the title on the page, but the visual humor is made explicit by the combination of duplication and the subtle difference in images and text. On the cover of *Icon*, we see black bodies and are told that we will be rewarded with the "ALL BRAND NEW ADVENTURES OF ICON AND ROCKET, THE UNWED MOTHER!" The dissonance between "the boy wonder" and "the unwed mother" draws attention to the incongruity of the old-fashioned frame with the new-fashioned girl heroine. This refashioning of conventions is common in *Icon*, which produces dramatic or situational irony in relationship to both comic book conventions and common narratives about African American subjects.

At the end of the inaugural issue of *Icon*, Icon and Rocket rush in to save a group of hostages, and this scene plays simultaneously on historical representations of superheroes, the role of black characters in comics, and the relationship between African Americans and the police. As they begin their adventure, Rocket says to Icon, "Let's go set a positive example for the downtrodden"—the situational irony lying in Rocket's consciousness of the problematic, hyperbolic role of the hero and the fact that this is, in fact, what Raquel asked Augustus Freeman to do. Raquel's critical race humor is based on her knowledge of the incongruity of their bodies in scripts of heroism, and recognition that these scripts will challenge their attempts to make political interventions. She evokes the status of older black sidekicks to white heroes when she questions Icon's belief that he can "land in the middle of eighty bazillion cops and ask if they need a hand." She exclaims, "Hey I'M the sidekick. I'M supposed to be the naïve one!" A younger Raquel would have been at

home with *Luther* and his friends, and like other critical black children in comics who preceded her, she is an infantile citizen who expects little from the nation. She is the antithesis of the white infantile citizen because she constantly reminds people of racist histories. As the sidekick who created the ideological purpose of Icon, she draws attention to the ways in which the sidekick often stands for the consciousness and hopes of the everyday citizen, a consciousness that stereotypical black sidekicks such as Ebony White to the Spirit were often denied. Raquel has knowledge of the limitations of black citizens having iconic or heroic status. She asks, "You think the cops are sitting around waiting for a flying nigger to drop out of the sky and do their job for them?" Icon is distant from the real challenges facing black citizenship and resists the idea that there will be a racial reading of their bodies. But of course, when they enter the fray they find themselves confronted by the gun barrels of countless police officers. Wryly commenting on how illegible they are as saviors and how easily they are read as enemies of the state, Rocket declares, "I bet this never happens to Superman!" She is satirizing their status as objects of abjection; they are radical Others who challenge white citizens' visions of themselves as the only possible source of true heroism. Like many other heroes, her humor reflexively gestures toward the history of black bodies as the antithesis of national heroes.

But one of the more powerful interventions of *Icon* is the exploration of the nexus of race and gender. Readers have fewer affective connections to Icon in his very Superman-like perfection. Embodying self-determination and selfless virtue, he illustrates how the iconographic ideal might not be the ideal representative of real citizens. Rocket must teach him about the material reality of black existence at the end of the twentieth century. Living in the projects, her story and body are thoroughly of the present, resisting conservative narratives that suggest that African Americans do not experience structural racism in contemporary culture. As the sidekick, she is the voice that checks the conservatism that Icon embodies. Icon represents the state, and Raquel is the black infantile citizen who challenges the romanticization of black possibility within it. The incongruity between the conservatism embedded in superhero iconography and real citizenship is illustrated in issue 8, when Icon gives her the full story of his origins. Rocket exclaims, "I think I just Figured out how a black man could be a conservative Republican—You're from OUTER SPACE!"[40] While writer McDuffie rejected the idea that Icon is a black double of Superman, the narrative

of immigration, adoption, and iconographic and straight-laced status holds many parallels to the Superman story. And in the invocation of Rocket as the true heart and ideological conscience of the construction of the superhero narrative, her character challenges not only Icon but the traditional comic book narrative that frames the Superman model as the ideal and fantastic representative of the United States. Raquel's body stands as the real body in the frame that must deal with the material constraints of her heroic labor. As she struggles to get her costume on before going on maternity leave, the realness of her body does not prevent her from using the energy-absorbing utility belt that protects her from harm and allows her to direct the force used against her (Figure 4.9). However, it *does* make it more difficult. Rocket thus is never an idealized fantasy.

This visual humor in the scene of the pregnant Raquel putting on her utility belt is a radical variation on traditional panels depicting superhero activity—the mysterious or heroic silhouette, the costume change, and physical labor. Because the chiseled musculature of the superhero is so iconic, the image of Raquel's slight form and protruding belly is a radical visual challenge to the source of heroic power. The source of her *physical* power is not inherent—it is the belt—and thus reminds the reader of the fact that what produced a space for Raquel Ervin's heroism was outside the traditional stories about inherent power or skill sets produced by accidents. Her work as a superhero is very much shaped by her own specialized labor—her ability with words to convince Freeman of his responsibilities and her compassion, energy, dedication, and cynical optimism that comes from her living in the projects. As she huffs and puffs in an effort to fasten her belt, showing the everyday labor of her work, her face mimics the expression that she would actually have giving birth. When this form of labor (giving birth) entails the same signifier as heroic labor, it challenges the naturalization of chiseled masculinity as the only kind of heroic body. Most importantly, the comic does not confine her heroism to the romance of childbirth, suggesting that the domestic is the most important place of women's heroism for girls and women. Instead, the creators displace a signifier of heroic labor (the pregnant face that huffs and puffs) and situate it in the public sphere. In placing the everyday in the heroic sphere, the creators invite identification as well as humor.

Teenage black girls were rare protagonists in superhero comics in the 1990s, and in the twenty-first century they are still not plentiful, but there are more representations of them. However, one area in which

FIGURE 4.9. Dwayne McDuffie (author), M. D. Bright (penciller), *Icon* no. 19, November 1993.

black producers are notably absent is the life narrative, which is inar-
guably the genre of comics with the most respect in academic and
critical circles.[41] Works such as Marjane Satrapi's *Persepolis* (2000) and
Alison Bechdel's *Fun Home* (2006) are arguably the most high profile but
a mere sampling of critically acclaimed life narratives about children.
Jennifer Cruté's two-volume *Jennifer's Journal: The Life of a SubUrban
Girl* thus entered something of a void in publishing. And as this book
has shown, texts by and about African American girls and women are
even more rare, and very few make use of the black grotesque or abject
aesthetic that is the focus of this book. She claims she "wanted to keep
absolute control" of her characters and shift "the way African American
girls and women have been portrayed in the media." Cruté frequently
encountered commercial arts clients who wanted black women shaped
into either Western standards or stereotypical ones, and saw it as a "dis-
service to readers when your own life story is edited into the fabricated

life of a stereotype."[42] And yet even if she rejects treating the body in stereotypical ways, she is an artist interested in black abjection created by situational contexts.

In crafting a coming-of-age narrative, Cruté uses what Hillary Chute has described as the "inbuilt duality of the form—its word and image cross-discursivity—to stage dialogues among versions of the self, underscoring the importance of an ongoing, unclosed project of self-representation and self-narration."[43] In Cruté's narration through a cartoonish caricature, she subverts some of the conventions of the black life narrative. Evolving from the slave narrative tradition, the African American life narrative has often contained a double form of narrative address. Early African American autobiographies reveal the humanity and complexity of black identity to white readers, proving their humanity as black people and exploring double consciousness as black subjects in a white nation; the white reader has often been an implied reader of the text. African American readers may experience recognition, value the ability to represent autonomous black subjects in print, or be exposed to narratives of heroic black subjects. However, African American women's narratives may, as scholars such as Valerie Smith have noted, represent more of an authorial "we" than individual-istic, heroic "I."[44] Cruté's *Jennifer's Journal* joins the ranks of coming-of-age narratives by African American women such as Lorene Cary's *Black Ice* and Margo Jefferson's *Negroland* that complicate narratives of blackness and class in the United States.[45] Such narratives explore a black out-of-placeness in both black and white communities.

Qiana Whitted argues that with Cruté's use of "round expressive black and white cartoon figures," her "characters appear to come from a charmed world where 'ridicule or attack on any religious or racial group is never permissible.'"[46] The cartoonish representation would suggest that her book is for children, but Jennifer's narrative double appears on the cover to warn that the text is "NOT recommended for children." Cute functions as a mechanism for dissonance between what the child's nar-rative should be in the logic of children's fiction and nonfiction, just as poor children, black children, and any children who problematize idealized universal types can create cognitive dissonance about what childhood is in the United States.

The narrative begins as if it might be a narrative appropriate for children, as she discusses inheriting her artistic talent from her mother. Even moments of racialized dissonance, such as when her brother wins an award and there are no black dolls to give him as a

prize ("they said they ran out of black ones" when it does not appear that they have any), is well within the confines of the trope of recognition of black difference in black coming-of-age narratives.[47] Dead pets, childhood concussions, and exposure to too-mature-for-children television are the everyday traumas of childhood. Then the word "nigger" is introduced, starred out, transforming the "universal" childhood narrative into a narrative of black identity (Figure 4.10). As they encounter racist children, the comic still feels within the confines of children's literature, but also invites the question—at what age should children read about the thing they have already encountered? The artificial construction of childhood innocence when children both experience and inflict racist harm destabilizes the idea of what a child's narrative should be.

The story quickly movies into a depiction of her parents' unhappy marriage. The cute aesthetic of not only Jennifer but her parents is in tension with their conflicts and the representation of her father's infidelity. In one frame Jennifer reflects on the fact that she's "not sure how they got together" but might understand why. She envisions the two smiling on their wedding day, with her father thinking of a hamster on a wheel and her mother thinking, "He doesn't hit me."[48] The children's section of the bookstore now includes some books to help youth cope with trauma, but in the cross-discursivity between adult and child Cruté suggests some narrative slippage when she actually processed these experiences. This slippage exists for children, as consuming narratives of nonideal childhoods can be treated as an injury in itself. Such content absences, as in the case of *Luther*, can suggest that troubled children are unimaginable bodies in the nation. Or more specifically, people know these children exist, but to represent the reality of children is often treated as contaminating the minds of the only kind of children the state wishes to address.

Cruté's cute aesthetic also challenges the representations of childhood and sexuality. Cruté shows her specific upbringing in the black church and how religious teachings made her desires for masturbation, while not a particularly raced prohibition, seem sinful. Children begin masturbating at a very young age, but the prohibition against speaking about sex, let alone drawing sex, means that this childhood experience is unrepresentable. Cruté's claim that *Jennifer's Journal* is "not recommended for children" is consistent with what the market and societal norms would find appropriate but also calls attention to a representational regime that disavows representing real childhood experience.

FIGURE 4.10. Jennifer Cruté, *Jennifer's Journal* (Greenbelt, MD: Rosarium Publishing, 2015), 29.

In volume 2, Cruté turns more specifically to ways in which blackness marks her as out of place, both within the white suburbs and among black people. The comic opens with the common black childhood experience of white rejection of intimacy with black skin and proximity. The cute aesthetic aids in producing a white childhood grotesque, as their doll-like faces mask racist monstrosity. Her family had fewer economic resources than many of her classmates; she thus faced ridicule for that as well. African American classmates also stigmatized her as a teenager

for her love for heavy metal, and she was called a "sellout" or someone who "thinks she's white." Her "favorite" insult was made by a girl with a clear nineties black style aesthetic, sporting an asymmetrical haircut and clothes. Speaking from the authority of culturally sanctioned authentic blackness, she declares that Jennifer's "parents was at Woodstock when they Shoulda Been at Motown."[49]

Jennifer could also be read as not authentically black because of her experience with depression. Depression is the mechanism for relaying the situational grotesque in her work. One consistent representation of African American women is strength, or "the strong black woman,"[50] attaching stigma to receiving mental health care.[51] Cruté's acknowledgment that black people are not supposed to be depressed is contested by her representation of despair. Knowing that people think "black people don't get depressed," she provides a family portrait, of her mother,

FIGURE 4.11. Jennifer Cruté, *Jennifer's Journal* (Greenbelt, MD: Rosarium Publishing, 2015), 27.

grandparents, aunts, and uncles who were depressed for various reasons. Cruté does not ascribe a biological rationale to what appears to be a high number of family members who experienced mood disorders. She attributed depression largely to physical abuse, with some family members experiencing anxiety and seeming "down" without an apparent reason. The line between depression and racial melancholia is nonetheless thin here. While it would be wrong to attribute all of their depression to being shaped by racial injury, part of what shapes and perpetuates the injury is its invisibility—that black people are not depressed.

Cruté describes her depression as first emerging from observing her parents' arguments, conflicts that caused her to experience anxiety. She experienced constipation, anxiety from unpaid bills, and decreased academic performance. The cute aesthetic produces a useful dissonance between the perception of a child and her suffering. In drawing a failed suicide attempt, she depicts her tongue hanging out after she has taken twenty-three iron pills, a standard cartoonish representation of poisoning (Figure 4.11). Cruté's non-comics work shows she can draw in other styles, and in the frame preceding this one she shows herself drawing because she "felt that if I put my depression on paper, I wouldn't hurt myself." She uses a realist aesthetic of images on her wall that notably appear to be of white subjects, while her representation remains cartoonish. The range of representations of despair and self-injury that she hangs on the wall are indicative of the other ways people represent depression. Button eyes and the rounded face defamiliarize representations of depression that might be seen as comical with this aesthetic. Cuteness masks injury.

And indeed if the child has traditionally been used to mask the nation's abuse and failures, the black infantile citizen disrupts this representational regime. Utilizing genres tied to nationalist, masculine, and escapist histories, these cartoonists' use of conventional frames may offer the most challenges to them. As opposed to announcing their representations are revisions and other to the narratives that are supposed to be mainstream and representative of the nation's desires, these cartoonists revise from within traditional frameworks. Instead of suggesting that they are counter to the representative, these texts suggest that their characters are also representative, replacing one set of ideal bodies with other kinds of bodies.

The melancholia and situational grotesque are produced by the incongruity at the idea of such a replacement. And the humor that the creators of these comics evoke when gesturing to the incongruity is

grounded in topics of deadly seriousness. These are comics asking for action or commenting on invisibility and voicelessness. Actual laughter may not be the response people have to many of these comics. But the work lies in between conventional affects. The "awww" at the cute, the laughter at the transgressive joke, the grimace at a disturbing representation, and the chuckle at the visual or linguistic surprise all blend in these comics to imagine subjects in between reader expectations. As canaries in the comic coal mine, they craft a new space for children in the popular imagination. They are black infantile citizens that push audiences to remember, as opposed to improbable white child ideals that encourage the nation to forget.

FIGURE 5.1. *White Whore Funnies*, issue 2, 1978, cover. Courtesy of Larry Fuller.

5

RAPE AND RACE IN THE GUTTER
Equal Opportunity Humor Aesthetics and
Underground Comix

The models of ideal citizenship in comics are normative because citizenship is a normative construction. While citizenship status is the foundation for making most rights claims, many theorists have imagined models of belonging that eschew the kinds of masculinist, nationalist, conservative, and universalist fantasies perpetuated by the nation and various comic genres. If one genre of comic art has been more consistently resistant to normativity it is "underground comix," which emerged in the 1970s and can only loosely be understood as a genre. And yet certain principles undergirded much of the work that came out of this revolution in alternative comics publishing, including a parodying of many classic comics genres. We might imagine that African American cartoonists could flourish in that publishing environment, and yet racist scripts also had a place among countercultural movements.

Larry Fuller, one of the few African Americans creating and publishing in the underground comix scene, is very careful to say that he mostly attributes his failures as a publisher to his lack of business acumen. But "some experiences," he recalls, "bordered on the absurd":

Once, while seeking to gain any kind of insight whatever into publishing comics, I made an appointment with a then rather well known and white underground publisher. Meeting him in his office, he told me to my face that he never in his life thought of colored people as creative enough to do something like comics and thought they may be more suited to being comedy relief, then pointing out to me the likes of the "Yassuh boss" types in old movies. Another time at a convention, a so-called reporter came to my booth and asked about the forces behind *White Whore Funnies*

no. 1. When I told him I was "the force" he insisted on meeting the "boss." When I told him I was "the boss" he got angry and said he wanted to meet the "man who put up the money." When I told him I was that man, he fumed and stormed away, muttering something like "Goddamn uppity nigger," no doubt meant for my aural consumption. This stuff wouldn't fly at all today—I think.[1]

Fuller's anecdote demonstrates that some whites in the underground community saw black people as the perpetual objects of the joke and more capable of minstrel-like comedy than the ironic humor that became popular in many underground comics and *Mad* magazine in the 1960s and 1970s. The irony in this context is that creators in the underground comix movement often prided (or defended) themselves as exploding representational taboos and became signs of a progressive counterculture. No one was more representative of this contradiction than Robert Crumb. His work in *Zap Comix* no. 1 in 1968 was seen as ushering in the rise of transgressive underground comics for the next two decades.[2] At the same time, Crumb infamously made use of racist and sexist stereotypes in his work. Crumb and Harvey Kurtzman—founder of *Mad* magazine, the most high-profile response to the censorship produced by the Comics Code in 1954—exemplified and inspired much of the comic art that emerged in response not only to the code but to social movements, drug culture, and more accessible print technologies.[3]

Of all the genres of US comics I have discussed in this book—editorial cartoons, graphic biographies, superhero comics, and child-centered comic strips—underground comix were most associated with a certain kind of citizen. Counterculture citizens articulated an ideology they would see in "alternative publications" like comics, which "explicitly rejected the mainstream values of the parents" and "had a different value profile" from "mainstream culture."[4] For some of the target market, consuming these comics made a statement about not only who you were, but the kind of countercultural citizen you desired to be, not because there was a one-to-one identification between readers and characters, but because the pleasure in the text signified the consumers' irreverent readings of a wider cultural landscape. Given its diversity, it may be difficult to call underground comix a "genre," but these works did interpellate citizens coming of age in the midst of social justice movements and who were resistant to the nationalist, idealist, and romantic claims about America. At the same time, the counterculture aesthetic

was clearly not necessarily progressive, perhaps best exemplified by the white supremacist and sexist ideology propagated by Charles Manson, who wore the garb of hippies but had a reactionary worldview.

These cartoonists took up the underground charge of perverting— which I do not mean pejoratively—Americana. Comix were somewhat paradoxically associated with a counterculture embrace of both nonengaged nonconformity and the activism addressing oppressed groups. Some comics focused on identity groups less represented in underground comics production. This industry was predominately a boys club, but female cartoonists such as Trina Robbins, Roberta Gregory, and Phoebe Gloeckner created a strong body of feminist underground work.[5] Some of them also participated in the gay comics scene as well, a development that aligned with a post-Stonewall rise in gay and lesbian political activism and "out" creative production.[6]

Gay comics gloried in sexual explicitness by recognizing the transgressive nature of queer pleasure everywhere. Feminist comix, some queer, did this work but also embraced subversion as an opportunity to privilege women in narratives about women's power and pleasure. These artists recognized the power of representing what people feared, had not seen, and desired. But African American cartoonists' relationship to underground conventions would inevitably turn slightly differently, as the transgressive black body is hypervisible because the black grotesque is embedded in the American imaginary. In other words, the most transgressive representations of black people in allegedly counterculture texts would be the images that people knew very well. The hypervisibility and always already transgressive nature of black representations can make the project of visibility more fraught than for subjects who struggle with invisibility or wish to make their transgression a representational ideal.

A number of representations that I have discussed in this book are designed to comment on the white racist gaze. But an interesting characteristic of a cartoonist like Robert Crumb is that the cartoonist not only comments on the white racist gaze, but very explicitly interpellates a reader who is "in on the joke" being told. This makes his work different from anti-racist cartoons, as the humor turns on pleasure at the transgressive joke. It is an early version of what has been called "equal opportunity offender" humor. In his discussion of the comedian Don Rickles as marking the emergence of this form of humor, Raúl Pérez defines it as a form of "ridicule that was conscious of diversifying the targets of ridicule," and treating the "insults as carrying, more or less, equal weight

in the eyes and ears of the audience."[7] One of the characteristics of "equal opportunity offender" humor is that the teller and audiences are "in on" the joke of discrimination. Because the audience knows that it is wrong, the replication of the stereotypes allegedly allows them either to laugh at the representation as holding enough truth to be funny or to laugh at people who do believe it. This stands in contrast to humor that is purely abject and self-focused or based on the superiority of the joke teller over the derided object. Humor based on superiority nonetheless creates the condition for equal opportunity offender humor. At the same time that equal opportunity offender humor emerged, self-deprecatory comedians grounding their comedy in autobiographical abjection also rose to prominence.

Both forms of humor would be characteristic of some underground comics, although they were only sometimes present together.[8] When producing equal opportunity offender humor, the teller/creator makes a caricature of herself through self-deprecation and abjection. Because humorists producing the humor make fictions of themselves, the jokes are done by characters who believe things the teller allegedly does not. The humorist's double provides cover for both the teller and the audience who laughs. The triangulated structure of the joke is complicated here: the object of the humor is ostensibly the abject and grotesquely insulting humorist, but the object of the character's joke is still ridiculed.

But what difference does race make when African Americans are simultaneously the offensive joke tellers and objects of the joke? Underground comix would seem tailor-made for many African American cartoonists to find a home in the community. But there was not a plethora of African American cartoonists or comics representing a distinctive black underground voice in the era. Larry Fuller and Richard "Grass" Green were the two most notable but not widely known African American cartoonists of the period, and they also utilized equal opportunity offender humor in their pornographic and, in Green's case, autobiographical comics. They craft abject and black masculine grotesque subjects to participate in equal opportunity offensive humor or, more specifically, what I term an equal opportunity offensive humor *aesthetic*. Some of their comic stories featured nonverbal black Sambos with big black dicks or black male rapists, but they are well aware of the injuriousness of these representations for black men. When Fuller's comic book, *White Whore Funnies* (Figure 5.1), depicted a large, black, somewhat grotesque male hand grabbing a white woman between the legs, he was well aware he was trafficking in stereotypes about white

women who have sex with black men and the specter of the black male rapist. Giving the omnipresence of this stereotype of black men, its evocation is inescapable when viewing the image, and the offensiveness of "white whore" and "black rapist" is equally available to the gaze.

A survey of their work demonstrates differences between Crumb's humor and the kind of work that Fuller and Green do, and in this chapter I explore the ways in which their black counterculture subjects in underground comics are strong representations of the genre with a difference. One of the questions that structures this book is whether or not a formalist analysis of comics yields clues to what, if anything, reframed stagnant racist or sexist stereotypes might help us see differently. Offensive jokes are often just offensive jokes that dwell in a space of taboo with no object other than titillation or injury. But the temporal complexity of racist and sexist caricature as something that is past but still psychologically present invites an interrogation of what kinds of offenses encourage a reframing or confrontation of a derided subject. Humor often depends on inequality. The a priori assumption of equal opportunity offensive humor in comics, however, depends on a set of aesthetic conventions. Through visual and narrative structure, these aesthetic practices position objects of jokes as the same in some way. I demonstrate how Fuller and Green sometimes employ a triangulated structure of interpretation that works with the visual joke to reframe readings of black subjection. This configuration of similarity—both that anything and everything can be a humorous object and that there are few ethical distinctions in whom the objects of humor are—shape the logic behind the idea of equal opportunity offensiveness. In seeing the ridiculous, ugly, and grotesque in everyone, equality opportunity humor aesthetics in offensive jokes depend on somewhat of a dystopian affective mode. Creators of such humor see pathology everywhere.

I caution readers that most of the comics I discuss in this chapter will offend many people. But I believe that seeing offense as the *only* possible affective end of a racist caricature forecloses our ability to understand what it means to navigate a world in which our affective incommensurability with others is ever present. This is not to say that all examples of offensive humor are the same. Comparing and contrasting Crumb's use of this aesthetic—which I would describe as a conventional use of underground equal opportunity offensive humor aesthetics—with that of Green and Fuller's comics suggests some structural differences in how the visual jokes work. The structure of being "in on the joke" when not only you but everyone like you always is the

joke often complicates identification in African American cartoonists' work. All of these artists are, to some extent, referencing a national id of race and gendered psychosis. By implicating themselves in stereotypical representations of black masculinity, they see no one as outside the national "joke" of perverse racialized, gendered mythologies that have an atemporal hold on the national psyche.

R. CRUMB AND FETISHIZING RACIST ENTRENCHMENT

Underground comix, also known as "alternative comix," emerged in the late 1960s as an ironic genre of representation and storytelling that satirized American identities, institutions, and narratives. As Charles Hatfield explains, while Crumb's *Zap* is identified as the birth of the underground comic book, the origin of these comics is not easily confined to a particular comic and date, as many of the creators began with or were inspired by fan publications, other kinds of zines, college humor magazines, underground newspapers, and rock posters.[9] Patrick Rosenkranz explains in his foundational overview, *Rebel Visions*, that the origins of underground comix were "about both action and reaction—advocating revolution in the streets and sexual freedom, but also springing from post-war suburban angst and fatalism steeped in atomic bomb drills; drawn in a pictographic language that reflected the shared rites and customs of American youth mid-century."[10] They changed the industry by encouraging not only transgressive content but independent publishing and circulation. Many cartoonists took pleasure in the profane and sexually explicit. Often employing self-deprecatory autobiographical storytelling, underground comix inaugurated the independent and alternative comics scene today.[11] As obscenity laws pushed comics from newsstands in the early seventies, the underground comics scene also facilitated the growth of a specialized group of fans in a comics industry already much diminished from its popularity in the middle of the twentieth century.[12]

No cartoonist's work was more representative of a white masculine ethos at the center of underground comix than that of Robert Crumb. Race is central to his work—specifically whiteness. One of his characters is literally Whiteman, a repressed and uptight man always on the verge of explosion. Crumb has consistently argued that some readers are incapable of recognizing that his representations of women and black people are clearly satire because the images are so excessive.[13] At the same time, he has argued it is "all there in the culture" and he has "just

combine[d] his personal experience with classic cartoon stereotype"—suggesting that the stereotypes are ones he carries himself.[14] Such a defense is less about targeting oppression than embracing the idea of making public unpopular, hidden desires. Crumb has been described as transplanting the id to the page, and it is an id that is simultaneously individual and representative of a white everyman citizen ethos.[15]

If Crumb is id on the page, the diegetic logic of his comics resists the superego and ego's influence, leaving those psychological roles for the reader encountering the text. Part of what these comics do is hail readers that take pleasure in unregulated representations, even as the presumption of these comics is that the implied reader condemns some of the racism and sexism in real life. In a discussion of his infamous comic strips "When the Niggers Take Over America!" and "When the Goddamn Jews Take Over America!" Crumb states that the "strips were never not going to happen—they even freaked me out, but I had to do them."[16] The temporality of the racist image takes on an odd valence here, as he suggests that the racist images were always there, waiting to be produced again. When Crumb argues that these representations are simply "always there" and part of what he grew up with, he is taking the underground sensibility of recasting Americana, but he does not actually revise the representations. The afterlife of racist representations may make them fairly intractable in many contexts, but he seems to embrace the idea that they never leave or transform in the psyche.

Critics have commented on the racist representations in Crumb's work, but "race," as Corey Creekmur argues, "remains a blind spot in critical discussions of underground comics."[17] Understanding how race functions in Crumb's comics requires understanding how white masculinity interacts with or erases blackness in his work. Sometimes, as is the case with Robert Crumb's famous five-panel "Keep on Truckin'" comic strip (Figure 5.2), which quickly became a sign of white counterculture, the blackness is present through erasure. In *Zap Comix* no. 1, Crumb depicts various white men walking toward something with oversized feet, their long strides not necessarily marking a move toward a goal. The accompanying blues song lyrics narrating the panels are from Blind Boy Fuller's "Truckin' My Blues Away," a song about sexual desire emptied of romantic and erotic content in Crumb's work with only "keep on truckin' / truckin' on down the line / hey hey hey / said keep on truckin' /truckin' my blues away!'" providing the text for decidedly nonsexy representations. The men in four of the frames are Americanized revisions of the flaneur and depict various forms of

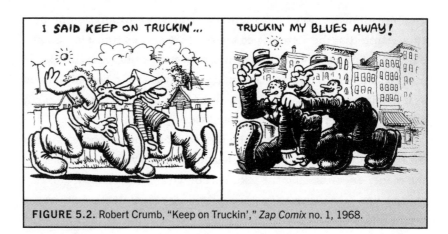

FIGURE 5.2. Robert Crumb, "Keep on Truckin'," *Zap Comix* no. 1, 1968.

conventional white male workers, mostly in business attire, with the exception of one frame showing a couple of men walking around the neighborhood wearing hats so low it is doubtful they can see where they are going. Such aimlessness is suggestive of the pleasures of not being forced to have direction in life.

Crumb's caricatures of white masculinity are dressed for the work-force as they "keep truckin'" despite the daily grind and make use of a black blues song to narrate white survival. These (mostly) smiling men do not seem to have the blues or to be channeling the complex working-class ethos that merged misery, pleasure, and humor in early twentieth-century blues music.[18] Most of the men are illustrative of normative white masculinity whose productivity as workers and repro-ductivity mark their good citizenship—while the desire to escape those things would mark a countercultural citizenship. "Keep on Truckin'" is a signifier emptied of the erotic, racial, and class contexts that informed the source material but still depends on the racial affective association with the blues to produce humor and counterculture associations. That the men in business suits and hats have the blues is what produces the affective disconnect between what white masculinity should desire and what they experience, a disconnect that shaped the countercul-ture movement. Arguably, black culture was stylistically as important to the counterculture as drugs, as an affiliation with blackness—always outside the normative—could mark the height of "cool" otherness for white subjects.[19]

Crumb is also known for his abject, autobiographical comics with uncensored salaciousness, but an uninhibited approach to desire is important to much of his work and famous characters like Fritz the Cat and Mr. Natural.[20] One of the principal objects of perversion in

underground comics is the normative life trajectory for white men. Thus this approach to desire crafts an id on the page that is beyond the individual and plays with a white masculine inner desire, freed by the political struggles shaping the late sixties and seventies—particularly feminism and the sexual revolution—but that at times seems somewhat hostile to it.

Women are arguably most often the target of offensive humor in his comics, through what Freud might have called the tendentious, aggressive joke. Tendentious jokes, Freud argues, require three people—the person who makes the joke, the object of the humor, and "a third on whom the joke's aim of producing pleasure is fulfilled."[21] His example focuses on verbal "smutty" jokes in which a man tells a dirty joke in front of a woman whose "inflexibility" in responding to the humor is a condition of the smutty joke's performance. A third person looking could serve an inhibitory role, but in witnessing the exchange the listener becomes the recipient of the smutty joke, making the woman an object of ridicule and shame.

Aggressive jokes are a way of addressing an enemy. They make the "enemy, small inferior, despicable or comic," thus the joke teller can "achieve in a roundabout way the enjoyment of overcoming him—to which the third person, who has made no efforts, bears witness by his laughter."[22] The joke can then "evade restrictions and open sources that have become inaccessible."[23] While the cultural revolutions of the sixties invited white masculine subjects to free themselves from social scripts of racial masculinist protection of women, the latter also became highly visible targets of criticism. Feminist activism was frequently ridiculed. The movement for black equality could be a source of humor, as were age-old stereotypes of African Americans. If some of the aggressive humor directed toward women was shaped by a shift in their representations, the humor toward black people depended on very old stereotypes. Crumb argues that he has done such comics because "America is a country just *filled* with racist thoughts." When he "was growing up, the image of the status quo was based pretty much on what white guys from the South thought, I just had to expose all the myths people have of blacks and Jews in the rawest way possible to tilt the scale toward truth."[24]

He is arguing that the white masculinist imagination is the object of the joke, but unlike the Barry Blitt *New Yorker* cartoon, which had a title (albeit displaced to the inside of the magazine), "The Politics of Fear," that directed the reader to see a white racist gaze as producing the representations of the Obamas as plotting against America, Crumb

FIGURE 5.3. Robert Crumb, "Angelfood McSpade" (1967), in *The Complete Crumb Comics*, vol. 5, 4th ed., ed. Gary Groth, Robert Fiore, and Robert Boyd (Seattle: Fantagraphics, 2013).

does not have a triangulated structure in the comic itself. "When the Niggers Take Over America!" and "When the Goddamn Jews Take Over America!" infamously circulated (without Crumb's permission) in white supremacist spaces because the representations speak to racist fantasies about African Americans and Jews. But nothing indicts white racism other than implied readers outside of the cartoon who are supposed to understand the excesses as clearly racist. While some of Crumb's work could be dismissed, Brandon Nelson suggests, as "sick humor that has no purpose," the cartoonist has claimed that his comics can be read as embedding antiracist critique because the representations are so transparently egregious.[25] His most racist and sexist representation, Angelfood McSpade, would seemingly fit into this category.

Angelfood originally appeared in the *East Village Other* in 1967 but made her first comic book appearance in *Zap Comix* no. 2 (Figure 5.3). A very tall and thick black woman, with pitch-black skin and the minstrel's mouth, she "has been confined to the wilds of darkest Africa" because "civilization would be threatened if she were allowed to do whatever she pleased!"[26] The first frame introduces her as the "Zap Comix Dream

Girl of the Month," gesturing toward the clear difference between her body and that of the traditional men's magazine model. This point is highlighted even more with traditional pornographic atomization of her body—the second frame shows only her torso and her hand clasping her large breasts, with a speech bubble in place of where her head should be, stating, "Ah gots de biggest tits in town." That statement is simply followed by word as sign, "PANT, PANT," introducing the desire of the small, nerdy white man with a big nose and big feet, typical of many of Crumb's characters. He tracks her large footprints in the jungle, as she is an "extremely elusive creature," and imagines her walking down the street in "native garb," bare-chested, on the arm of a business man, because "she's the kind of chick a guy would be proud to walk down the street with."[27] Police arrest white men who try to capture her, and only "officially sanctioned researchers are allowed near the dark-skinned sex bomb" because "those creeps can't hardly ever get one up!" But "when she flexes the muscles in her powerful thighs, it's just too atrocious," and "men would quit their jobs if they had a chance to see ol' Angelfood shake that thing."[28]

This is incontrovertibly a racist depiction of black womanhood. Crumb, however, would argue that the comic strip is not. Angelfood is a conglomeration of every negative stereotype of black women: masculine, oversexed, not quite human features, living in the jungle and thus animalistic, and only desired, it seems, by men whose masculinity is in question. We could read it as expressing antiracist sentiments, but that reading, while perhaps counterintuitive, depends upon whether or not we read the comic as a criticism of a white male fetish for phantasmagoric blackness. One man hunts her and "dreams of glory," and one "very sneaky Jewish character" parachutes into the jungle on top of her supine figure before being taken away by officers who are inexplicably keeping men from her. An antiracist reading would require that the viewer read the representations trafficking in anti-Semitic and antiblack stereotypies as repugnant fantasy not referencing real black women or Jewish men and see white fetish for and the excesses of this fantasy as the object of the joke.

It is possible to see white men who desire such fantasies as objects of humor, but the comic also structurally treats real black women as a referent. Darieck Scott would describe this scene more specifically as "phantasy," following theorists Jean Laplanche and Jean-Bertrand Pontalis, as not just "whimsy and triviality" attached to fantasy but suggestive of how the work of imagination makes desire possible and

recognizable.[29] The desires that are recognized here are ones at home with what Moya Bailey terms misogynoir representations.[30] With the exception of some of Crumb's blues music illustrations, black women are consistently depicted in his work according to old, racist scripts. Realist depictions of black womanhood are not referents that would then focus the satire—if we read the comic in a satirical mode—on condemning the gaze for being racist as opposed to simply desire for an undesirable object. Reading it as antiracist would require a belief that the audience all understands that the representation is not a satire directed at black women as well.

Another of his comic strips that could be read as criticizing a white gaze that is undermined by the caricature of black womanhood is his 1976 comic "Mr. Snoid in 'Once I Led the Life of a Millionaire.'"[31] One of Crumb's recurrent (and possibly alter-ego) characters, the grotesque Snoid, is depicted on the toilet, struggling to pass a bowel movement in the first few frames. After this inauspicious introduction he calls for his maid, Beulah, the name of a woman character on radio and television in the 1940s and 1950s. "Beulah" has become a stereotypical referent for black womanhood in servitude.[32] She comes to him and wipes his anus, before picking him up like a baby in her arms and carrying him upon his command. Her degradation continues when he puts a costume horse head on her and rides her back. We also learn he has her under video surveillance.

These are some of the most demeaning representations possible, and the repugnant Snoid's treatment of her is also an indictment of him. That reading is facilitated by his comeuppance in the story. He decides to "have some fun with that simple creature," and puts on blackface, an Afro, and sunglasses and pretends to be a Black Panther–style revolutionary. Speaking to her from her television, he calls out to all the "beautiful black women out there," telling her that "the revolution has come." He claims black folks have overthrown the government, and calls on all black people, "especially beautiful black women who have to work in the rich houses of honky white motherfuckers," to "rise up." He ends with "GIT WHITEY," imagining that Beulah will provide entertainment for him, his arrogance not allowing for the possibility that she could be a true threat. But a newly bare-chested and freed-hair Beulah attacks him with a knife and fork, the black domestic stereotype replaced by the tribal archetype. He is nonetheless vindicated in his belief that she cannot best him, as he is able to overcome her despite her superior size and strength, leaving her literally tied up in knots.

In a sudden plot twist, the People's Liberation Army breaks into the house, frees her, and introduces her to Marxist philosophy. She keeps asking to "Kill Whitey," and does not seem to grasp the principles well, suggesting, as does a racist caricature of a black member of the army who looks befuddled but loves "to hear [the] story," that African Americans are incapable of understanding the ideology undergirding the movement. Beulah thus seems simply like a dupe when she goes to Snoid, who outsmarts attempts at resistance again by burning down his house rather than allow the revolutionaries to claim his property. When he jumps out of the window Beulah catches him and he fears injury, but she decides she does not want to kill him after all. Instead, in the last panel we see him trussed up with a "profiteer" sign, and she is similarly elevated but carried on the shoulders of her comrades. "Aftuh dis," she says, "yo' gone hafta clean toilets fo' 'bout five years, an' den mebbe you git t'do sum farm work!"[33]

An antiracist reading could interpret the Beulah caricature as how Snoid and a larger white imagination not only see African Americans, but also see someone with so many deficits triumphing over him as illustrative of his inadequacies. Many groups are objects of satire: Snoid, Beulah, the Black Panther Party, the People's Liberation Army, and thus 1970s radical political groups in general. If humorous caricature focuses on excess, the "radical" is an easy target because speech, aesthetics, and acts are by definition outside of normative models of politics.

Because there are so many objects of ridicule, it is an example of an equal opportunity humor aesthetic, with everything worthy of mockery. And yet is the implied reader one of the groups depicted? Countercultural citizens can bond over treating Left political projects as objects of humor because of the public performance affect in pursuit of revolutionary goals.

Crumb's technique in crafting an equal opportunity offensive humor aesthetic in this comic depends on him drawing caricatures with different identities similarly and positioning them similarly in the narrative and frames. Both Snoid and Beulah are grotesque physically. With his constipation and then with the act of Beulah wiping his anus, they are both associated with feces and thus abjection. He understands himself as clever but is not; Beulah's blank look and the easy way in which she is fooled suggest that she lacks intelligence. As Beulah looks at Snoid in blackface on the television, they are somewhat mirror images of each other (Figure 5.4). The shapes of Beulah's mouth, cheeks, and eyes in anger are the same as Snoid's in anger. Her larger size would suggest

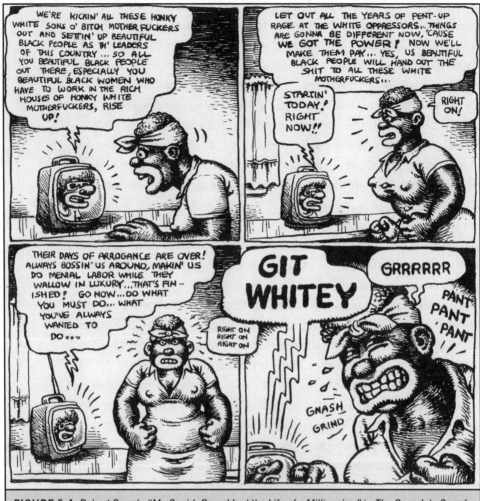

FIGURE 5.4. Robert Crumb, "Mr. Snoid: Once I Led the Life of a Millionaire," in *The Complete Crumb Comics*, vol. 11 (Seattle: Fantagraphics, 1987).

her greater power, but her inability to best him on her own demonstrates that she is inadequate despite her size, while his smaller size, despite his besting her, suggests his inadequacies despite his whiteness. As the two of them are elevated above the crowd, sitting, they are finally equal in stature.

The equal opportunity humor offensive aesthetic and the alleged dependence on readers functioning as the indicting eye are now characteristic of equal opportunity humor in an alleged "post"-feminist or "post"-race era. Crumb offers an early form of allegedly "post-race" humor to his implied comics reader, one who is a white subject outside of these political passions and the seriousness of revolutionary politics. But what happens when underground cartoonists interested in the

comics of offense insert a hint of political sincerity into a genre of comics that often resists such affects?

I have spent what may seem like an inordinate amount of time reading Crumb in a book about black comics because the idea of equal opportunity offensive humor is a frequent topic as people debate the politics of offense in media. Humor has become a topic in political debates about political correctness, identity politics, "free speech," and markers of "American" or "un-American" tastes. And part of what I want to explore here is what it means to be "in on the joke," and if there are different ways of being both *in* and *in on* it. We live in an era when even online dating questionnaires ask if you like offensive jokes, a query that allegedly tells people not only what the responder likes but who the person is. The supposition is that all offensive humor is the same, and all tellers have the same purpose in telling the joke. Even if Snoid and the Angelfood-desiring subjects can be read as stand-ins for Crumb, there is not equal vulnerability in the typology. While not always completely different from Crumb's work, the use of triangulated structure in the work of Green and Fuller sometimes produces more complex accounts of desire and humanity *through* flat and more narrow constructions of character.

"WHITE WHORES," BLACK DICKS, AND PORN POLITICS

"Complexity" can be an analytical placeholder when more specific claims are required, but complex personhood is what caricature can sometimes offer even if simplification is what organizes the form. I take "complex personhood" from Avery Gordon, who reminds us that "all people (albeit in specific forms and whose specificity is sometimes everything) remember and forget, are beset by contradiction and recognize and misrecognize themselves and others."[34] Misrecognition—and commenting on it—is central to the cycle of caricature as injury and critique. The flatness may belie the ways in which caricature may address not only the gaze but relationships formed by simplistic readings of subjected groups. In other words, the shared experience of misrecognition can produce the conditions for mapping relationships and political and social recognition.

This is not to say that black cartoonists Larry Fuller and Richard "Grass" Green described their goal in making comics as political. Fuller, born in New Orleans in 1944, describes himself as a dreamer who "believed in the importance of dreaming." Comics such as "Nancy and Sluggo, Popeye, and Tarzan" "got into" his "bloodstream" and he

"wanted to make comics for a long time." He was discharged from the Air Force in 1968 and subsequently created the comic book *Ebon* (1969) after being encouraged by Gay Arlington, owner of San Francisco Comic Book Company. Fuller never thought *Ebon* was very good, but his initial move into adult comics was designed to help him gain entry into the superhero comic book industry. He also produced some gay comix. Fuller and his friend Thomas "Raye" Horne would become collaborators with this goal in mind, but eventually lost interest in moving to Marvel and DC.[35] Fuller was very active in the 1970s but produced quite a bit of unpublished material after that with Grass Green, publishing his last comics story in 1992.[36]

Green published work in Fuller's comics, but they never actually met. Richard "Grass" Green was born in Fort Wayne, Indiana, in 1939 and became known as an artist for fanzines, crafting superhero stories and parodies. His work with superheroes can be seen in anthology comic books such as *Super Soul Comics* (1972), various *Megaton* comics, and most notably his stories about *Xal-Kor the Human Cat* (1980).[37] He self-published some work and also produced work for adult underground comic books such as *Bizarre Sex* (1972).[38] Eros Comix would publish his adult, urban-themed comics such as *Ghetto Bitch* (1991), and in 2002 Hamster Press and TwoMorrows published the final story of Xal-Kor. Historians of comics sometimes mention *Xal-Kor* and *Ebon* and are arguably their best known works, but I am less interested in their superhero comics than in the political provocations in their sexually explicit comics. These texts blend black revolutionary political commitments with the play, taboo, and pornography of the underground. If one kind of white caricatured subject in underground comics is abject sexually, the turn to sex comics highlights the role of racial anxieties in the construction of white American subjects. By integrating black male abjection with white desire, these cartoonists craft black fantastic subjects who can overcome the ways in which white people control racial and sexual narratives.

The kind of black subject crafted by these comics is a fantastic one. The aesthetic politics at work in black superhero and porn comics featuring black men are thus not unrelated. As Darieck Scott argues in his discussion of African Americans in gay pornographic comics, "The presentation of the characters as objects of desire as well as figures with whom to identify—sites for the reader to sexually fantasize, like porn in any medium—renders them, within the terms of the genre, analogous to the hero in superhero comics. While the references to the superhero

genre can be located in visual codes and construction in narrative of some of these cartoons, the visual strategy of black beauty and sexual desirability as power comes into particular focus where the black male character is explicitly a superhero or hero."[39] In Scott's discussion of cartoonists who make the Big Black Dick the object of phantasy in gay porn comics, he suggests that readers are configured as "separated from blackness" whether or not they are black. Blackness is constructed as a consumable object for those who fantasize about possession of it. All of the readers are "positioned as nonblack desiring blackness in these strips."[40] The structural work of these comics has a similarity to Crumb's comics even as they have opposing affective ends. Crumb's work clearly hails nonblack readers with excessive caricature of the grotesque that may produce laughter in some readers but always repels. Green and Fuller's work, in contrast, may be of interest to nonblack audiences, but clearly hails a black gaze.

Fuller and Green often depend on this black male caricature for the logic of joke. The Big Black Dick and blackness itself is still an object, but functions also as a subject, positioning readers as black or as subjects who identify with a black gaze. Some of this is done through an aesthetic of equal objectification, and some by a conventional heteronormative pornographic gaze that objectifies women while calling attention to the always raced nature of American porn. As many theorists have noted, one of the primary modes of subversiveness in pornography can be the turn to humor.[41] Thus the most important aspect of encouraging identification with a black male gaze in their pornographic narratives is the reflexivity that makes black humorists both the object and the subject of the joke as the tellers.

While various scholars have contested the idea of the "implied reader," many underground cartoonists' constructions of authorial selves and implied readers are essential to engaging their texts. As Wayne Booth argues, "The most successful work is one in which the created selves, author and reader, can find complete agreement."[42] By this logic, if readers object to the terms of the text, they reject the text as bad and fail to enjoy it. Many underground cartoonists are meant to engage taboo, and the creators know some people will be offended. But like all producers of commercial work, they depend on a group of consumers who will return. Underground comics clearly interpellate readers who already understand themselves as countercultural citizens, but the comics can also push the readers' traditional identifications and affective pleasures. Given existing markets for these works, Green and Fuller knew the market was

predominately white. Thus their configurations of black countercultural subjects were different from the revolutionary subjects who were satirized in Crumb's work and unusual authorial voices for the audience.

Larry Fuller and his collaborator Horne quite transparently create a satirical black authorial subject in *White Whore Funnies*. Their nom de plumes, Wiley Spade and A. Christian Black, are winks to black readers, referencing scripts about black masculinity that the comic will challenge. "Spade" is a racial epithet, but "Wiley" suggests the trickster figure, a joke on those who hurl the epithet as well as an insider cultural framework. In contrast, A. Christian Black represents the good black citizen, one who would not be producing or consuming the pornographic content found within these pages. The names position the trickster as author, thus casting an authorial representation that encourages identification with or at least admiration for the trickster's wit and ability to prevail. In centering black male subjects in the comics, they challenge not only the centrality of the white countercultural citizen but their alleged politics. As Fuller explains,

> I grew up in the Deep South of course, so no blindfold was ever over my eyes, but it was also around this time that I began to really, REALLY appreciate how much certain segments of society resented things like [him and Horne picking up a lot white women], even in a so called liberal (over used, misused word of late) post hippie paradise like the West Coast in general and San Francisco in particular. I tell you, with influences like Richard Pryor and Evelyn Waugh, to name but a few, Raye and I determined and decided that we could at once bring our own particular vision to the underground scene, with blatant send ups and skewering of every point of view about said subject, all the while supplying the target audience with the scandalous, scantily clad babes in interracial situations.

Fuller explains that he never "thought of white women as a group or demographic as whores, then or now," but saw such representations as challenging even the supposed, progressive white readers in the West Coast underground scene. If Crumb's representations imagined readers "in on" the joke of racial discrimination, Fuller imagined the "target audience" as possessing unstated limits to their progressivism.

Because Fuller understood that interracial sex could be a limit to white liberalism, employing caricatures of interracial desire and framing it though the black trickster's voice positions the reader as an

admirer of the black trickster's ability to sexually conquer women—particularly white women. Many of their texts present the stereotypical narrative of black men always desiring white women (and vice versa). In, for example, "Some Tight White Ass," drawn by Larry Davis and written by Fuller, the pornographic limericks tell the story of a "young Nigger" who "had a cock bigger than most" and "wanted hisself some tight white Ass!" The tightly framed, black-and-white images of sexual penetration, fellatio, and black hands on white flesh throughout using a stippling technique create an effect of both abstraction and a newspaper photography verisimilitude (Figure 5.5). The sexual humor gestures toward racist pathology that can still be present in interracial sexual intimacy as well as fantasies about what white women bring:

> She screamed, yelled and called him *the* name
> But kept wanting more just the same.
> She craved his big dick that never went South
> And purified it with her tiny White mouth
> And he just kept gittin' her tight white ass![43]

The name is unclear but the utterance was clearly derogatory and probably "nigger." Despite (or perhaps because of) the epithet, the next lines suggest that she still desired him. The pun on a "big dick that never went South" suggests not only an indefatigable erection but one that

had not ever gone "South" to a place where black men (and penises) were castrated metaphorically and, at times, literally as threats to white womanhood. White supremacists have long seen miscegenation as a threat to the nation. The notion that her mouth purifies is obviously ironic—in committing prurient acts with black men she would not be considered "pure" by those who have established an ideological framework that configures white women as pure, thus the act that contaminates whiteness cannot purify. Both "tight white ass" and "Big Black Dick" reduce identities to body parts, but through the tension between word and image the comic destabilizes what we think the representation is doing when we first encounter it.

She screamed, yelled and called him *the* name.
But kept wanting more just the same.
She craved his big dick that never went South
And *purified* it with her tiny White mouth.
And he just kept gittin' her *tight white ass!*

FIGURE 5.5. "Some Tight White Ass," *White Whore Funnies*, issue 3. Courtesy of Larry Fuller.

Another caricature destabilized in a couple of stories—to varied success—is that of the black male rapist. The three issues of *White Whore Funnies* mostly depict consensual sex between black men and white women, but many of the comics suggest some anger toward constructions of white womanhood and white women who harbor racist beliefs. In Green's case, one of his comics stories depicting rape problematizes narratives of white womanhood and white purity in relationship to blackness, but also replicates sexual violence scripts. "Maniac on the Loose" is an eleven-page comic story that is the longest in issue 3 of *White Whore Funnies*. The cover of the issue is tied to the story, with a fake news article from *The Inkwell Revealer*, a paper whose motto is "The Truth in Black and White." Truth in "black and white" is a nod to both the racialized "truth" produced by the news and the Manichean binaries embedded in racial narratives and that in association with the title of the comic *White Whore Funnies* position the reader to see the irony in the ensuing content (Figure 5.6). The cover also produces an equal opportunity humor aesthetic by juxtaposing excessive stereotypes of whiteness and blackness. The headline screams "Black Maniac Assaults, Rapes Innocent White Lass." Captions accompanying the images of the victim and suspect describe her as "sweet, innocent, wholesome, virginal," and him as "mean, nasty, vicious, and niggardly." The buxom blond with glasses is depicted looking back over her shoulder in question as the black rapist smiles while running down the street.

The article beneath the headlines describes the events in which the police shot and killed the suspect "Willard Coon" in the act of raping the unnamed victim. The other article, "White Women 'Go for Lusty' Sexy Black," describes a survey "by the little known, hardly respected and definitely biased Jive Niggers of America (JNA)" indicating that "all three members of the organization" have done well in pursuing sex with white women. Descriptions of the organization satirize a black braggadocio about white conquests. Readers are informed at the end of the article that it is incomplete because Spade was arrested for statutory rape. Both stories depict black rapists, but because of the tongue-in-cheek humor neither of the stories could be transplanted easily into a white supremacist framework. The joke is on black people, but on white people as well.

The cover image is a more successful critique of the black male rapist trope than is the story it accompanies. Green's "Maniac on the Loose" is structured much like Crumb's racist and sexist comic work, as nothing in the comic itself points to a criticism of the discourse. It is an

𝔚𝔥𝔦𝔱𝔢 𝔚𝔥𝔬𝔯𝔢 𝔉𝔲𝔫𝔫𝔦𝔢𝔰

SEXTRA!! Read all about it!

"The Truth in Black and White"

𝔗𝔥𝔢 𝔍𝔫𝔨𝔴𝔢𝔩𝔩 � 𝔯𝔢𝔳𝔢𝔞𝔩𝔢𝔯

★ ★ ★ ★ FINAL ONLY $2.00

Black Maniac Assaults, Rapes Innocent Young White Lass

Community Members Outraged, Demand Action
You Must Be An Adult To Buy This!

White Women 'go for lusty, sexy' Blacks

SAN FRANCISCO, Ca. - According to a recent survey by the little known, hardly respected and definitely biased **Jive Niggers of America (JNA)**, a recently formed lodge whose members are dedicated to, in the words of co-founder and *vice*-president **Wiley Spade**, "ketchin' all de White pussy we kin," all three members of the organization have done "**sextremely well in their** pursuit of that best of all possible things, **White ass!**" Spade himself was only just recently the proud recipient of "summa de best **17 year ole, blue-eyed, blonde haired stuff** money kin buy!" He went on to say that the party in question had smooth, creamy skin, big hefty thighs and one of the finest 240 lb female figures he had ever seen.

While conceding that the **JNA's** present membership is still somewhat limited consisting to date of two other members with the unlikely names of *Larry Fuller* and, even farther out, *Grass Green*), **Spade** maintains that they have already received inquiries from such diverse geographical opposites as Pocatello, Idaho, Rome, Georgia, Down Heah, Texas, and Kampala, Uganda. Of the last locale, **Spade** chuckles and says, "Man, they got some real jive niggers over theah."

*The writer regrets being unable to finish this extremely interesting interview as some local police arrived with a warrant for Mr. Spade charging statutory rape. We will, however, keep (chuckle) **abreast** of the trial proceedings.*

The Victim - "Sweet, innocent, wholesome, virginal"

The Suspect - "Mean, nasty, vicious, niggardly"

Police apprehend, kill rapist

FT. WAYNE, Ind. - Police today shot and killed one **Willard Coon**, notorious rape suspect who had escaped from the **Fremont Sanitarium**. According to **William (Billy) de Liar**, shyster mouthpiece for the national chain, the **Blankety Blank Sanitoriums/Camps for Recalcitrant Negro Offenders**, said Coon's escape wasn't discovered until the 8 pm bedcheck. Coon's long record of **demented, sadistic, psychotic, homicidal behavior and sexual aberration** included 16 cases of sexual slayings. Police were notified and at approximately 11:39:48:05½ pm last night, Coon was discovered leaving the scene of a suspected rape. *"Suspect some shit!"* says rookie policeman **Marshall Law**, first officer to arrive at the scene. *"I caught the fuc--er*, **suspect, bare-ass--er, red-handed."** When Coon disobeyed an order to *"HALT, ASSHOLE!"*, **Officer Law** drew his service revolver and "blew the Black bastard to Kingdom Cum."

Police were apprised of the suspect's possible whereabouts by a young couple that was stopped for excessive speeding. They informed the officer who made the traffic stop that they had heard the radio reports about Coon's escape and were on their way to check the well being of a young female friend, the rape victim, who was working overtime and had no knowledge that a dangerous criminal had escaped custody.

FIGURE 5.6. *White Whore Funnies*, issue 3, December 1979, cover. Courtesy of Larry Fuller.

extended, nasty rape joke, the aggression targeting the virginal victim, Myrtle, attacked by a black man named Coon. The constantly drooling, grinning black rapist evokes the nightmare of Gus chasing Flora in D. W. Griffith's *Birth of a Nation*. He is a horrific caricature of black masculinity in pursuit of white women to defile.[44] This, like Crumb's text, makes identification with characters within the comic unlikely. The drooling maniac rapist is grotesque and is killed for his crime. But the police officer who kills him is not a hero, and his focus after shooting the rapist is on the size of Coon's penis. Myrtle does appear to be truly hurt during the assault, and we should not read it as a fake performance of pain. But Green doubles down on the aggressive joke, depicting her in the last frame as daydreaming about her assault.

White women are a fetish in many of these stories, standing in for white supremacist phantasms that have both compelled and castrated black male subjects. But "Maniac on the Loose" is not a comic story to recuperate or defend. It is nasty and disturbing, even if it is also illustrative of how we can imagine an aggressive joke containing content coming from a place of real political grievance—here constructions of the black male rapist. Such work is illustrative of how often criticisms from people who are progressive on race issues sometimes use sexism as a mode of attack.

The representation of Coon, like many representations of black men in their comics, also gives rise to questions of what it means to be "in on the joke" of this story. The grinning, drooling, barely verbal rapist is, like Angelfood, so preposterously excessive he is other to real men, but he is nonetheless a referent to ideas about black men. Green is not Coon, but Coon is a referent for him and other black masculine subjects. The Black Rapist is a sign that is larger than its referent—real African American men who have sexually assaulted women but more specifically the myth of all African American men as potential rapists. Green is satirizing the discourse of the Black Rapist, but the tendentiousness of this joke does not land only on Myrtle. We are invited to read Myrtle's assault as a manifestation of her id, and she is a placeholder for white women who would struggle to acknowledge desire for black men. But the rape script of the victim who enjoys her assault is not an offensive joke that gestures to affinity between any of the groups depicted.

In contrast, Larry Fuller crafted a nonconsent fantasy story in *White Whore Funnies* with a nonverbal black male aggressor, and it is more illustrative of the triangulated structure that renders a more complex narrative about racialized sexual scripts. By placing the representation

specifically in the realm of a nonconsent fantasy that a white woman brings to a psychoanalyst, the text makes the role of racialized sexual fantasies explicitly the primary object and a meditation on the nature of fantasy in itself. Drawn by Larry Davis, "The Wild Sex Fantasy of Mrs. White!" opens with this prologue: "We all have our fantasies. Those sporadic but gratifying secret musings in which our every whim or desire is utterly fulfilled. Fantasies don't need to justify themselves. They ask no questions and tell no lies. Primarily products of the fun loving id, they exist solely to please their master, the always demanding ego."[45] Whether intentional or not, this inaccurate description of how the id functions in relationship to the ego makes a fascinating statement about the ways in which interracial desire can function in the US imaginary. The id, which operates according to the pleasure principle, does not serve the ego. On the contrary, with help from the superego the ego mediates between the fantasies and irrational desires of the id and the world. The ego must manage the strength of the id. If the ego is the reality principle, the idea that fantasies serve reality invites exploration of what fantasies allow in the negotiation of the real world. In the case of Mrs. White's story, an erotic fantasy about encountering a large, chained, and naked black man in her house, part of what the story invites is that the fantasy of the black man serves whiteness and, in particular, white femininity.

In the story Mrs. Patina White—an expression of whiteness that calls attention, as Richard Dyer has argued, to the impossibility of white femininity being as white as is demanded by the cultural imaginary—goes to a psychoanalyst, Dr. Dumpsit.[46] She recounts dreaming of a door in her house that does not exist but that she sometimes looks for, although she is afraid her husband "will find it and learn what's behind it."

Indeed, he doubtlessly would not be pleased. Behind it is a nude black man with a chain around his neck attached to the floor. He looks at her, and she "rakes her eyes over him." Here, the look—her statement of desire—gives her some agency in the fantasy. However, her look at a black man in chains also replicates the pornographic gaze embedded in the history of slavery. As Mireille Miller-Young argues in her discussion of black women in pornography, "If the function of slavery was to guarantee the use of enslaved black bodies for the needs of the master, part of the power of the master's imperial gaze was the assurance of visual pleasure, and of owning the right to look."[47] They were pathologized through this gaze that became intertwined with a variety of disciplinary gazes that simultaneously made them objects of desire and deviance.

FIGURE 5.7. "The Wild Sex Fantasy of Mrs. White," *White Whore Funnies*, issue 3. Courtesy of Larry Fuller.

Patina compares her feeling to what she experienced once at a zoo "in front of the tiger cage!" She teases "this naked black giant" as she "did that tiger, dangerous as it might be," and throws the key. "The giant buck nigger" unchains himself, charges her, looking like a black Frankenstein's monster, "and snarling like a hurt gorilla" (Figure 5.7). As with the "Maniac on the Loose" story, her clothes are ripped off by a barely verbal black man, but that is where the similarities between the stories end. It then becomes a fairly straightforward pornographic comic, with sexually explicit prose and images describing penetration, her performing fellatio on him, and his performance of cunnilingus on her. As she is the narrator, White's pleasure is the focus, which makes it a story that might not be out of place in the genre of erotic comics created for women. Framed as a dream, it is not presented as a story of real threat or risk; it does not ostensibly suggest the same aggression toward white women as the "Maniac" story.

Mrs. White is nonetheless somewhat indicted in the narrative, as the story calls attention to the white gaze not only on the second page, which focuses on it, but in the premise of the fantasy itself. That she calls her lover a "big, ugly, black, big lipped, wooly headed, stinking black nigger mule" as she commands him to pleasure her is, as with "Some Tight White Ass," an illustration of interracial sexual desire not being conterminous with antiracism. Readers are looking at her desire, and thus placed in a position where they are aligned with her pleasures because the erotic prose encourages identification. At the same time, they will note that the black man is an unreadable cipher and mere tool for her. Even if the pleasures are more voyeuristic, the profound nonhumanism of the black man with his barely verbal utterances, such as "me fuck white lady!" and "Koondah," which she describes as "some nameless forgotten crap," makes him other to the audience. Identification and pleasure are complex, thus White's conventional Western beauty can still encourage alignment with the perspective of the black cipher, turning us all into people who desire her. And pornography can obviously be nonindexical, with pleasure in being the mindless sexual tool, as pornography's focal point can be sex organs, producing the possibility of nonscripted identifications shaped by involuntary arousal. The images emphasize not only his penis and strong muscular body but close-up representations of her aroused clitoris and vagina, allowing for multiple points of identification. Such images thus work with and to some extent against the text, which firmly aligns the reader with (W)hite racist sexual desire.

White Whore Funnies consistently plays with the *fantasy* of interracial sex, and not the *reality* of it. Sex between white women and African American men is real, but the space of the racialized fantastic is one in which the *idea* of sex between black men and white women does a different kind of work than representations of sex in a realist mode. Black men and white women have been socially constructed in the United States as incompatible sexual partners—a prohibition that produces the very kind of subjects society wishes to disallow and disavow. The impossibility of their desire—as something that will lead to disastrous consequences, destroys the purity of white womanhood, or cannot be real—shapes constructs of black male citizenship and white female citizenship. With the bait and switch of the unconscious, white women are both objects of desire and not. If the subject is constituted through desire, the actual object of desire in the play of the narrative can be more amorphous than sex with the racial other. Caricatures of both black men and white women are a mechanism for crafting more desires than an indexical sexual desire for an other.

At the end of White's narrative her analyst declares that she is a masochist, stating that her "neurosis" is "associated with a deep rooted desire to be pleased and punished simultaneously!" He then proceeds to unbuckle his pants, telling her to put her issues aside as he wants to "tell" her about his fantasies, with his apparently magically speaking penis. But then the figure from her "dream" breaks into the office and rescues her from sexual molestation from her doctor, and White walks out happily arm in arm with the barely verbal black lover, smiling over her shoulder at the doctor who is shocked that it was not purely fantasy. The dream, and fantasy, is the black lover's existence but also their ability to escape the confines of a narrative that marks her desire as neurotic and his "winning" over affluent and emasculated white masculinity impossible. White women are clearly the currency in the exchange here, reminiscent of what Eve Sedgwick has described as a homosocial negotiation "between men."[48] And yet in the logic of the joke, white women are participants in pleasure and the win over white masculinity. One reading might suggest that the black body is the item of exchange, but the peripheral positions of the husband and therapist make them narratively significant as the vanquished but insignificant as so little action happens with them. Fuller wrote the end of the story first, which suggests that comeuppance of the white male analyst and alliance between White and her lover was always the goal.

Fuller confesses he often thought of the story as "a shit job," given his intentional utilization of "cheap paperback porn" and "60s and

70s sitcoms as a template." But he has received "countless letters from comic porn fans about it over the decades."[49] White wives cuckolding their husbands with Black Bucks is a traditional porn trope, but as porn scholars have argued, there is often a transgressive politics at play in these pornographic fantasies. All of them are butts of the joke, but black men and white women are to some extent "in" on it. If we read this as simply a pornographic fantasy in the "(white) slut wife/black cock" genre, then male readers are privileged subjects of the fantasy. But in the triangulated structure of the joke, neither her invisible husband nor the analyst is central to the relationship. The husband is absent, and the analyst's desire is thwarted. While the story could be seen as a traditional porn story for a white male gaze, her narration when combined with the end makes the analyst a tool for her ability to speak sexual desire. The alliance between Patina White and her wordless black lover decenters the typical gaze in pornographic representations. If subjects are located by desire, white women and black men are situated here as escaping the parameters that position them as always responding to or serving white male subjects. They are constituted not only by sexual desire, but by the desire to escape racialized gendered scripts.

In their discussions of African American women and the pornography industry, Mireille Miller-Young and Jennifer Nash have explored why black subjects might wish to replicate these stereotypical representations. They make a case for the mechanisms by which African American women performers articulate sexual agency through erotic play with stereotypes and, at times, in spite of it. The conditions of production for comics are different as these creators have full creative control over what they create and thus are not beholden to white producers in determining the content. Both of these black feminist frameworks can nevertheless still be instructive. Many of the claims Miller-Young makes about how black women function in pornography can be equally true of black men. Black men and women are "both desirable and undesirable objects: desirable for their supposed difference, exoticism, and sexual potency, and undesirable because these very same factors threaten or compromise governing notions" of "heterosexual relations and racial hierarchy."[50] These comics creators may be using the representation of black male hypersexuality to "contest it from within."[51] There is "illicit eroticism" in the desire for black men, which Miller-Young describes as the ways in which "cultural workers enact a repertoire of skills and theories—including appropriating or manipulating certain stereotypes." Following the work of José Esteban Muñoz, she argues that they do so

to "'negotiate a phobic majoritarian public sphere that continuously elides or punishes the existence of subjects who do not conform to the phantasy of normative citizenship.'"[52] And Nash makes a case for "reading for ecstasy rather than injury," to explore what kind of pleasures "racialized pornographies can unleash."[53] How, she asks, "can black pleasures" include "sexual and erotic pleasures in racialization, even when (and perhaps precisely because) racialization is painful"?[54]

For Nash, racialization is potentially productive. Blackness is a "fraught, complex, and potentially exciting performance for black subjects, as a *doing* which can thrill, excite, and arouse, even as it wounds and terrorizes."[55] And it is not difficult to see why African Americans would take pleasure in the stereotypical framing of the well-endowed black man with extraordinary sexual prowess. In the films Nash discusses, race humor can "implod[e] racial fictions and entrenc[h] them, sometimes simultaneously."[56] These are clearly comics that replicate racial fictions, but the irony makes the uncritical consumption of the scripts challenging. But if the underground comix aesthetic as practiced by Crumb is sometimes shaped by a refusal to take anything seriously that undercuts the political subversiveness of the work, the refusal to take the racist representations of black masculinity seriously might read as resistance.

CARICATURE AND SOLIDARITY: THE COMICS OF RICHARD "GRASS" GREEN

While their uses of Big Black Dick and black male rapist stereotypes disrupt the racist gaze (at their best), they do not encourage identification and recognition with the authorial voice. Grass Green's autobiographical comics employ caricature in ways that complicate stereotypical representations of black identity and encourage readers to read *through* the caricature. In the most substantial scholarship about Grass Green's work to date, Brian Cremins argues that self-published comics like his *Un-Fold Funnies* "provide the autobiographical, self-published counterpoint" to his genre comics.[57] The nineteen issues of the *Un-Fold Funnies* were photocopies of double-sided 8.5 × 11 short comics, shaped by a trifold structure. Green discussed topics such as sexuality, his everyday life, money troubles as a working artist, and his love of legendary Marvel artist Jack Kirby. Cremins is right to point out that Green's work "provides a unique opportunity to explore the relationship between genre work and more intimate narrative forms such as autobiography and memoir," given the slippage in Green's storytelling and his reflection on

being a comics producer.[58] A few comics depict him being interviewed by himself or a friend and reflecting on how people read his work and the industry in general.

Cremins, however, does not discuss the role of sexuality in his comics, which is a consistent theme. "Maniac on the Loose" is not the only fictional comics story Green published with discussions of sexuality and representations of sexual violence. And he focuses on sexuality in almost half of the autobiographical *Un-Fold Funnies*: "Life with Elmo," "Down with a Cold," "Drawin' Chix," "Questions and Answers Part Two," "Grass and Oren Chat," "Grass vs. Love," "Horny Talk," and his version of a sex education comic called "Thesis on Sex."[59]

A major part of Green's autobiographical persona is his sexual desire. One of the ways in which fantasy and reality speak to each other in his works is that some of his comics treat the "Big Black Dick" as "real" in the realm of fantasy, but in his autobiographical narrative he makes a point of stating "unlike a lot of the stereotypes that we have ALL heard about" he is "NOT superbly endowed" and he struggles with sexual conquests.[60] In the 1981 comic "Life with Elmo," his penis, named Elmo, suddenly begins speaking to him because of his failure to consistently secure sexual partners. Elmo berates him for constant masturbation and encourages him, when practicing the withdrawal method, to ejaculate on his partner's stomach (because women apparently love it) instead of running to the bathroom to reach orgasm. Green is depicted as a fairly mindless desiring subject led by his penis, but in contrast to the mindless criminality of "Maniac on the Loose," he cares about issues such as his partner's pleasure, unplanned pregnancy, and consent.

Despite the rape fantasy that appears in "Maniac," he makes a point of emphasizing the importance of consent in the "Thesis on Sex" (Figure 5.8). He insists it is not "chauvinisitical shit" and that "PERSONS" who "like to fuck" might "learn something too," the reference to "persons," most likely a gibe at the call for gender-neutral language that was becoming more of an issue through feminism. He nonetheless emphasizes the importance of pleasing a partner and foreplay, a practice he acknowledges he failed to do when he was younger. He states that unless "yer some kind of some dumb-ass JERK, you should ENJOY making your mate come!" He also instructs them to read women's magazines and think about porn as a means of instruction: "Look BEYOND all the fuckin' and suckin' and oo's & ah's—study what's being done and HOW it's being done. Then try it with your woman (IF she's game; don't FORCE it)." This panel depicts his enraptured face and tongue in between a woman's

FIGURE 5.8. Richard "Grass" Green, *Thesis on Sex*. Courtesy of the Billy Ireland Cartoon Library and Museum.

legs, her hairy vagina (in an era before shaving was standardized as ideal) treated as a source of delight. This stands somewhat in contrast to "Questions and Answers Part Two," in which he addresses the violence and subjection of women depicted in his comics.[61]

In one of the issues of his self-published comic *Un-Fold Funnies*, Richard "Grass" Green addresses the violence against and subjection of women depicted in a number of his comics (Figure 5.9). He draws himself responding to the accusation, with an angry, contorted face, or

sometimes signaling a lack of perturbation by coolly smoking a ciga-
rette. Acknowledging that he is not the "most understanding mu'fuggah,"
he describes his comics as "FUN READING FOR ADULTS."[62] Part of the "fun" for
Green lies in the normative scripts for women as "having pussies" that
are used for "pleasure, reproduction, or both." While supporting equal
pay, he believes "women's lib" can "exploit" everything, "almost as if they
are trying to become men." He expresses certainty about the immuta-
bility of "woman" as a category, positioning his head as leering behind
two representations of fragmented women, one of a torso with large
breasts and the other featuring a woman's prominently displayed vagina.
Framed under a lengthy screed declaring "a woman is a woman," Green's
authorial persona is intentionally and excessively pugnacious. Glaring at
a woman smoking a cigar who is apparently a women's liberation pro-
ponent and "wants to become a man," he naturalizes his chauvinism and
the propensity of these images, as does Crumb, because of the entrench-
ment of stereotypical representations in culture. It is unlikely that he
would explicitly argue that the same logic should excuse racism.

And yet an early issue of *Un-Fold Funnies* suggests that chauvinism
should also be an object of ridicule. "Speakin' Out" opens with another
black man telling Green that "the whole world is prejudiced," and the
statement is met with hearty agreement. Green's companion complains
that in the sixties it appeared as if black people would advance until
feminism came along and white men began ignoring black men in
favor of supporting white women. All the blacks are men and all the
women are white in his logic. Women were doing things like "getting

FIGURE 5.9. Green discusses his depiction of women in some of his comics. Richard "Grass" Green, *Un-Fold Funnies.* Courtesy of the Billy Ireland Cartoon Library and Museum.

promotions," making "tv shows," wearing pants, and working two jobs. All this change and hard work is offensive to Green's companion, who calls for everyone to "go back to helping ta' black." Green affirms him until the punch line in the closing panel, in which the chauvinist grouser calls for all the "sucker—er—nice folks" to send money to him so he can buy a Cadillac, furnish his house, and restock his liquor store. As opposed to some of his other comics, Green stands in for the slightly implicated reader who might be agreeing with the sexist claims. Black chauvinism and white feminists are targets in the same comic, suggesting an equal opportunity humor aesthetic, and calling into question how to read the sexual representations in relationship to fairly consistent commitments to economic equality and respect for women in other contexts.

Like many underground cartoonists, Green often operates in a self-deprecatory and self-parodying space. But autobiographical comics are not the only place where he uses fictional caricature to address the sexist gaze and embrace reading *through* caricature to see complex black subjects. Despite the emphasis on "fun," some of his comics reference real injury and harm in the midst of the joke. The shadow of injury in relationship to the sexual joke is perhaps nowhere more apparent than in his comic *Ghetto Bitch* (1993).[63] "Ghetto Bitch vs. JJ. The 'Jesus Freak'!" ostensibly presents another conventional porn scenario. A religious man and prostitute encounter each other, and in an attempt to "save" her both physically and spiritually, he is seduced by her. Over forty panels depict their sexual encounter, but prior to this the "ghetto bitch," Lisa, describes how she was groomed by a pimp at age sixteen when searching for a father who abandoned her. After finding him dead in the gutter, she "died" a little too, and Green depicts her subsequent sexual abjection and use by men. The transformation of Lisa's face throughout the comic—from innocent to grotesque and back again—is a means by which Green refuses to confine the caricature of the "ghetto bitch" prostitute to a singular type, and thus Lisa to a reductive stereotype (Figure 5.10). In a number of his works Green makes the face look monstrous in orgasm, the body literally coming undone. Lisa, however, comes undone multiple times, particularly experiencing despair. Her face becomes unrecognizable when she fears JJ will reject her. She experiences rage, joy, fear, despair, pleasure, and hope throughout the comic (Figure 5.10). While the grotesque crying at sexual rejection is a joke, the variety of affects go far beyond either porn scenarios or the affects attached to the stereotype of urban black women who work the street.

FIGURE 5.10. Richard "Grass" Green, "Ghetto Bitch," *Erox Comix* (Seattle: Fantagraphics, 1993). Courtesy of the Billy Ireland Cartoon Library and Museum.

Confessing her inability to orgasm with any of her johns, she asks JJ to have sex with her and for them to touch each other with real intimacy. He has his own, unexplained traumas in his past, but some previous unreligious history before his conversion is alluded to by his ability to physically triumph over her pimp. *Ghetto Bitch* presents many clichés, but the porn story troubles the very category of the "ghetto bitch." While a frequently denigrated object of jokes, Green rehabilitates her, cutting the sentimentality with the pornographic. The idea of the wounded girl with daddy issues groomed into sex work may be a stereotypical convention, but the reality of such injury for many women is still true. More importantly here, the reality of the pornographic fantasy of the "ghetto bitch" is disrupted by framing the sexual fantasy with the religious man with the story of her traumatic history. In the end, her decision to leave prostitution and return to her mother places pressure on the sustainability of such fantasies. The "ghetto bitch" has a future outside of that label, and the utopian possibilities modeled by some pornographic fantasies—that life can be changed by transformative sex—humanize often dehumanized representations of black womanhood. No such narrative and transformative possibilities exist for Angelfood McSpade.

Green's work depicting sexuality thus varies widely. Some of his sexually explicit comics can be seen as examples of the aggressive joke, directed at feminists who are cultural enemies, thwarting pleasure, taking up space, threatening the limited gains African American men have been able to make in terms of the currency offered by normative masculinity in the post–civil rights era. And yet close readings of the structure of his comics, in which black men are also stereotypes, foolish, and cultural outliers, could encourage us to see the cartoonist as undercutting the narrative of women's subjection by rendering black men as abject or ridiculous chauvinists and thus poor points of identification for readers. His autobiographical self-deprecatory comics challenge stereotypes of black masculinity, even as he performs chauvinism, which readers are, by turns, asked to find amusing or ridicule. And in *Ghetto Bitch* there is also a strain of sincerity in his comics, addressing injury through caricature, that places pressure on racist and sexist scripts.

We must understand the whole body of his work to understand the complexity of his black underground authorial voice. Recognition that Crumb, Fuller, and Green's comics make a case about cultural pathologies invites us to think about which, if any, make interesting interventions into how readers are implicated in these narratives. While Crumb seems to imagine a white subject somewhat outside of this logic, "not"

the southerner who propagated the images or white subject in on the joke, the black cartoonists know that they are always objects even as they also imagine black subjects and readers as creators.

I have placed all of these comics under the rubric of "offensive" because much of their content intends to offend or because the explicit content would be offensive to many, but all of the work is not equally offensive. We can certainly focus on Green's less controversial work, humorous comics that are clearly antiracist and comment on inner cities or diversify representations of superheroes. Excluding offensive work from the archive of admired artists is always easier. But the offensive work is part of a larger genealogy of equal opportunity offensive humor that continues to create conflicts between those who tell people not to take offense at the clearly offensive and those who cannot imagine anything valuable in aggressive and ugly humor. If we wish to imagine conversations that move beyond this impasse, perhaps we must meet in the gutter, traversing the space between the pain of derogatory representations and the meaning some people find in the abject and transgressive, asking uncomfortable questions about the pleasures—and humanity—that people find there.

TO CARICATURE, WITH LOVE

A *Black Panther* Coda

I end this book with what will seem to some like fighting words. The foundation of the most financially successful black film of all time is based on a white caricature of blackness, and reductive caricature is essential not only to the generic pleasures it offers, but to the political debates it has evoked. Released in 2018, *Black Panther* became one of the most successful films in the Marvel Cinematic Universe and shattered expectations for its success. Building from the work of various artists and writers who transformed the character over the course of fifty years, it tells the story of an African king, T'Challa, who is the ruler of a techno-logically advanced fictional country called Wakanda. The country masks its assets for fear that outsiders would seek to pillage its major resource—vibranium—a result of a meteor that hit the country many years ago. Over the course of the film T'Challa must regain his throne after a venge-ful cousin raised in the United States usurps his position. In advance of the Marvel film's opening, black people were heralding the "peak black-ness" of the film and the revolutionary potential of its content.[1] But I was skeptical of the revolutionary potential of a comic book adaptation that was not only an attempt to respond to black social movements, but tempered by the *containment* of black revolutionary politics for popular consumption. Indeed, some critics have condemned the film for being conservative, reactionary, regressive, and stereotypical.[2]

And what if everyone is right? Part of the project of this book has been an attempt to challenge simplistic binary readings of racist cari-cature. Usually, a racist caricature is just a racist caricature intending to denigrate people of color. But as I hope I have demonstrated, sometimes they do other kinds of work. This does not mean that the caricature is not there. Celebrated Kenyan political cartoonist Patrick Gathara—who knows a thing or two about African caricatures—criticized *Black Pan-ther* for depicting a "nation with the most advanced tech and weapons in the world" that "nonetheless had no thinkers to develop systems of

transitioning rulers that do not involve lethal combat or *coup d'etat*."[3] He sees Wakanda as "very like the usual portrayals of Africa, right down to her invisible residents":

> Other Marvel cities are peopled by many Ordinary Joes, from policemen to high school students to retirees and the super-rich, all of whom, at least theoretically, have some chance of becoming superheroes. Wakanda, on the other hand, is about royalty and warriors. Its wealth does not come from the ingenuity of its people but from a lucky meteor strike and the benevolence of its all-wise rulers.
>
> This is a vision of Africa that could only spring from the neocolonial mind. It is really telling how close a black "redemptive counter-mythology" sails to the colonial vision of a childish people needing a strong guiding hand to lead them. Despite their centuries of vibranium-induced technological advancement, the Wakandans remain so remarkably unsophisticated that a "returning" American can basically stroll in and take over, just as 19th-century Europeans did to the real Africa.[4]

These are, indeed, stereotypes of Africa. But a large number of African Americans and Africans have loved the film. Should we read such love as simply false consciousness? Are they loving the film despite the caricatures? Or might there be some kind of work the caricatures do that also inspires love?

An exploration of the film's comics origins—more specifically the challenges and interventions proffered by caricature in *Black Panther*'s history—might intervene in what can be a reductive framework for interpretation. It can help us, as some black media critics have continually suggested we do, move beyond positive and negative binaries and recognize that the comic and film hold progressivism and conservatism simultaneously, representing ongoing conflicts over black liberatory practices. It can also help us see why black comics creators can become attached to representations with flawed origins, as the heroic archetypes often give people denied such representations access to fantasies reserved for whites.

Ambivalence is in the DNA of *Black Panther*, created in the wake of civil rights struggles. And I mean "in the wake" in the rigorous sense provided to us by Christina Sharpe, the condition of constantly dealing with the afterlife of slavery and the longue durée of black liberation struggles.[5] T'Challa, the Black Panther, originally appeared in an issue of the *Fantastic Four* in 1966. By this time the news was filled with stories of real

black heroes risking death and facing down real masked and unmasked villains in order to make the United States a place in which principles of justice of freedom were a reality. Nothing created for the comics pages could possibly match the heroism of black people who had nothing supernatural to protect them. But Stan Lee and Jack Kirby gave it a try.

While he first appeared in a superhero comic, Black Panther later was featured in "Jungle Comics," a genre that was strongly derivative of Edgar Rice Burroughs's Tarzan and used white protagonists to support Western imperialism.[6] Jungle comics origins clearly informed his introduction narratively and visually. In Black Panther's initial appearance, the Fantastic Four are invited to Wakanda, and find themselves hunted. Even as they marvel at the technological advances of the country and "superior intellect" of their adversary, the roommate of Fantastic Four team member Johnny Storm easily overcomes the Black Panther. Native American Wyatt Wingfoot accompanies them and rescues the Fantastic Four by drawing on the "blood" of his ancestors, "the greatest scouts of all time."[7] On the one hand, Wingfoot's skill may seem to suggest the superiority of people of color. But on the other hand, the long history of the "vanishing American" discourse in popular fiction in the United States has constructed white people as the inheritors of Native American skills. Constructing themselves as the rightful descendants of original Americans has been a complex narrative mechanism for claiming white superiority.[8] This issue vacillates between showing white amazement at the intelligence and sophistication of Africans and giving readers American leadership in the form of an idealized caricature of the Native American hunter, serving to undercut the representation of foreign, black heroism.

Readers come to learn that T'Challa, the Black Panther, has lured the superheroes there to test them and himself. Ben—the Thing— functions as the Western gaze on Wakandans, expressing disbelief or racism throughout their encounter. Lee reflexively references the comic's problematic predecessors: Ben wonders how a "refugee from a Tarzan movie" could have access to sophisticated technology. One of the conventions of Black Panther comics over the decades would be to comment on white Western readings of Africanness, critiques of the imperialist gaze that would grow more sophisticated over time. A number of my friends have been very critical of the role of the Central Intelligence Agency in the film, in which a CIA agent works with T'Challa and his small group of supporters in a civil war incited by Killmonger. The treatment of a CIA agent as a hero working for the salvation of Africa and the world can be read as a perverse yet predictable

Hollywood treatment of white heroism, an evocation of a white savior narrative. Given the well-documented abuses of the CIA in Africa and the Global South more broadly, this is a very reasonable criticism.

However, CIA agent Ross was one of comic writer Christopher Priest's primary interventions into colonialist discourse when his run began in 1998.[9] For Priest, the white CIA agent Everett Ross serves a comical role as the marveling "handler" of T'Challa who often voices the perspective of white masculinity out of its depth in the face of the Shaft-like Black Panther. Ross is the first character we see in Priest's run on the series. Priest and artist Max Texeira depict him as squatting pantless on a toilet and describing himself as "Emperor of Useless White Boys." The formal structure of the narrative when integrated with the content enables a set of discursive reversals. Ross is how we are introduced to T'Challa. Traditionally, this is a means of decentering African subjectivity in all fictions about the continent—not only comics and fantastical adventure narratives but public policy discourse. But by Ross's framing we see that he, himself, is the one being framed. The reader is directed to gaze on white abjection in relationship to Black Power. The film was less successful and arguably less interested in the extent of this anti-imperialist critique. But the remnants of it are still there. The white presence must be in the film in some way to stay true to the foundations of *Black Panther* as a comic, specifically the triangulated interpretative structure not only that comments on the white gaze but in which white characters are forced to acknowledge their inadequacies. The question of what black diasporic art is without whiteness extends to black superhero comics in a more specific way—what is the black superhero without imagining the white hero as its Other? In the Black Panther's origins, he quite quickly became a hero whose mission was determined by whiteness, and it is hard to imagine a Black Panther narrative that is not in some way responding to the constant presence of Western imperialism.

Priest's interventions were part of a long history of revisions that invest in black liberatory politics. The second issue of Black Panther's debut ends with T'Challa having defeated his nemesis Klaue with the help of the Fantastic Four, and finding himself without a purpose. The Fantastic Four tell T'Challa that people will need someone with his abilities, and he appears in one frame almost to receive a revelation about the possibilities for his future as they all lay hands on him. Ramzi Fawaz has a lovely utopian reading of artist Jack Kirby's panel, seeing the Fantastic Four as turning their "broader cosmopolitan commitments" toward "an African nation and its revolutionary leader, while the Black

Panther's local commitments to tribe and country are turned outward, toward the world." Fawaz argues that "in this double movement, the comic book depicted cosmopolitan encounter as mutually transformative in its capacity to scale upward and downward through varied valences of political and ethical commitment."[10]

My reading of this moment is a little more cynical. I see the move toward cosmopolitanism and the universal as a move *away* from black revolutionary politics. That an African hero would suggest that he lacks purpose and must be directed by white Americans to see his utility in struggles for justice in *1966*, a political moment marked by global black decolonial and civil rights struggles—undercuts the Black Panther's intelligence and heroism yet again. And this is part of the caricature of Africans that Gathara takes issues with—a "colonial vision of a childish people needing a strong guiding hand to lead them."

In addressing a paternalistic racial representation, I am not devaluing the progressivism of the invention of the Black Panther, his importance in the history of comic book storytelling, or the fairly radical gesture of creating a black hero in a United States in which so many Americans unquestionably believed in black inferiority. As I have argued, racist and imperialist origins do not foreclose more progressive political futures. Binaries of positive and negative or good and bad often have limited analytical value in tracking the complex work of racially problematic representations, nor does it explain why African Americans can be interested in rehabilitating them. The rehabilitation of black representations is foundational to African American cultural production, so much so that we must understand the shadow of black racial caricature as haunting all African American representations. Even ones, such as Ryan Coogler's celebrated adaptation of *Black Panther*, that some people claim are revolutionary.[11]

But the reality is that *Black Panther* and other recent adaptions of black comic book representations that emerged out of the civil rights era, such as *Luke Cage* and *Black Lightning*, are post-racist caricatures. My use of "post" should be understood in the tradition of acknowledging the impossibility of it. Just as postcolonialism marks a neocolonialism, "post"–civil rights era and "post"-blackness note the end of what Bayard Rustin termed the "classical period" of the civil rights movement but do not suggest the end of the black freedom struggle. That we are not post-identity or post-discrimination is so clearly empirically true that it may seem trivial to mention it. But if black cultural production is, as Michelle Wright has argued, always a counter to "originary discourses that posited

the Black as other to the white subject," then we must understand any liberatory black aesthetic practice as responding to negative representations.[12] Moreover, many black aesthetic practices are responding to and revising previous black liberatory aesthetic practices.

In *Icon*, a comic that is very much "post"–1970s black comics and indebted to them, writer Dwayne McDuffie made the attachment to and need for revision of these characters clear. The character Buck Wild is a double for Luke Cage (Figure C.1). Like Cage, Buck Wild is a mercenary for hire, whose dialect cannot escape tortuous linguistic caricature. His first phrase is "Alright, you mother-lovin', finger licking, chicken pluckers. You done messed up now! Cause I'm Buck Wild, Mercenary Man!" He is introduced via Rocket's narration: an "old played-out record" that she cannot escape. We see frames illustrating his "belief defying strength" and his struggles with Lysistrata Jones in hip huggers, mastering him with the P-Whip. As Buck Wild's adventure unfolds, Rocket's narration goes on to say that "the record's played out, alright, but nothing ever came along to take its place. . . . It ain't much. It ain't even good. But it might be all there is. And that's better'n' nothin' ain't it?" Buck Wild stands for the compromised possibilities offered by black images in comics, a stagnation of production that has been facilitated by mainstream comics publishers. He stands for "psychically stuck" representations. McDuffie suggests that rather than try to revamp the old stereotype, it is time to develop new paradigms. At the end, Buck Wild says, "Seein you two taught me a lot. Lookin at you makes me think, mebbe if I hadn't been frozen, I wouldn't have to be like this. Mebbe I can Still be more than What I is now." But Rocket humorously rejects the idea that he can be productively reimagined: "I wouldn't count on it, Buck. You are what you is. And 1972 was a long time ago. Maybe it's just time to move on."

McDuffie is nonetheless respectful of the role that such stereotypical heroes played. Buck Wild dies and has a funeral, and the creators evoke many prominent black characters in superhero comics of that era—from Black Goliath to Brother Voodoo. In delivering Buck Wild's eulogy, Icon delivers a melancholic meditation on black representation in the midst of the satirical evocation of this history: "He spent his life fighting for what is right, all the while struggling with questions of identity and public perception that we STILL do not have answers for. He reinvented himself time and again, searching for a comfortable way to present himself to the world. And while we winced on occasion at his embarrassing speech and demeaning behavior, more often we cheered him on. Because whatever

FIGURE C.1. Dwayne McDuffie (writer), Mark Bright (penciler), *Icon* no. 13, May 1, 1994.

else he was, he was always a hero. A hero for those of us who had no heroes. Were it not for him we would not be here today."[13]

The "issues of identity and public perception that we still no have answers for" have been playing out with *Black Panther*, *Luke Cage* (2016), and *Black Lighting* (2018), twenty-first-century adaptations of black superheroes that blend the racial uplift and blaxploitation aesthetic practices of the 1970s. And yet the desire to revise them as opposed to create new characters demonstrates the continuous drive to hold onto these imperfect popular black love objects. The challenge posed by the temporally fixed nature of these black caricatures produced a slightly messy mash-up in the 2016 Netflix television series adaptation of *Luke Cage*, which uneasily moved between not only the past and present, but *fantasies* and desires of the past and present. The comic book tells the story of a wrongly incarcerated man experimented on in prison; the bullet-proof Luke Cage was described in some media following the show's release as a hero for a "black lives matter moment."[14] But he was initially a blaxploitation hero with attire, speech, and urban genre clichés that marked his seventies origins. The continued salience of his incarceration storyline nevertheless demonstrates the atemporality of so many representations of black suffering. The possible pleasures and injuries are also atemporal. On the one hand, the black man who cannot be hurt is an old fantasy of black monstrosity, the same fantasies police officer Darren Wilson evoked in 2014 when he described eighteen-year-old Michael Brown as a "demon" in offering an excuse for shooting him six times.[15] On the other hand, the idea of a strong black man impervious to white supremacy is a resistance fantasy that many people have enjoyed in the past and present, even as it is tied to ideas of racialized masculinity that can be injurious.

The show often visually winked at the depiction of Cage in the seventies. Space is also strangely out of time in the show. Both *Daredevil* and *Luke Cage* were set in a Hell's Kitchen and a Harlem that are pregentrification, and the shows try to evoke that moment even as they attempt to reflect the urban politics of the present. The dissonance in space-time has implications for both the narrative and the character, as the antagonists' relationship to white supremacy and white supremacy's role in shaping the black quotidian inform what we understand as the black superhero's raison d'être. Luke Cage is illustrative of a black representation that had to progress, but at the same time some of the aspects of this character had to remain to be meaningful as a representation grounded in a particular location and time. Part of the sameness is, not surprisingly, tied to caricature.

Another challenge posed by representations of black urban conflict is the accusation that the absence of white antagonists masks the workings of racism. People invested in the binary of positive and negative representation can treat all depictions of black criminal behavior as racist caricature, a reading that can ignore a black quotidian that must negotiate the nexus of state violence and intraracial injury. While discussing the Salim and Mara Brock Akil adaptation of *Black Lightning*, one of my very thoughtful white friends criticized the show's focus on a black gang called "The 100," seeing the depiction of black criminality as a deflection from state violence and other racist injuries. Such a criticism, however, heard in discussions of shows like *The Wire*, invites a question of what the right way to depict *intra*racial conflict is. Given the nexus of state violence and intimate violence, discussions of intimate violence between subjected people often discuss state influence. Racialized caricature is often a sign of how the state and other communities ignore the complexities that can shape crime and injury and read black bodies. But caricature can also sometimes offer an opportunity to see *through* the caricatured representations of black crime. Part of what it means to be "post"-racist caricature can be to redeploy—perhaps master—these representations to different ends.

Intraracial conflict in narrative also invites us to think about the formal principles that refocus how we read a representation in relation to the context in which it is produced. This question is at the heart of some of the debates after the release of *Black Panther*, in which the primary conflict is between an African man and his African American cousin. Many writer and artist contributions influenced the film, but a key part of the plot is Ryan Coogler and Joe Robert Cole's reworking of a famous Black Panther storyline by Don McGregor. The 1973 story arc, "Panther's Rage," was a somewhat radical intervention in the comics industry. It is credited as being the first long story arc in superhero comics, but McGregor also had the audacity to craft a story arc set in Africa with all black principal characters, believing that white principal characters were unnecessary. Given the challenges black producers had breaking into the ranks of superhero comic writing, it is perhaps not surprising that a white writer had the ability to convince Marvel to accept this move. African American artist Billy Graham, however, brought new realism to the physical depictions of the African characters. The primary antagonist was Killmonger, a Wakandan angry with T'Challa's father for the treatment of his parents. In a famous set of panels replicated in the film, Killmonger defeats T'Challa in battle, hurling him over a waterfall to a probable death.

One could argue that the situation produces caricature. But McGregor could have told a story focused on battling colonizers. Instead, he chose to tell a story with all black characters that focused on intraracial relationships. The broader context of racism and colonialism is a theme in the story, but we can also recognize that part of McGregor's narratalogical intervention was telling a story about black conflict without white bodies or speech. The revolutionary aspect of the story might, then, have had less to do with the content read in isolation than with the genre intervention that makes black people (and mostly Africans) the only characters of importance. Just as naturalized caricatures have narrowed the possibilities of black representation, progressive mandates for what resistance to histories of representation should look like can similarly restrict the possibilities for black storytelling. African American creators have long recognized the value of stories focused on more intimate conflicts in communities, but one strand of racial representational politics might interpret "Panther's Rage" and Coogler's *Black Panther* as regressive because the villain is not the colonizer.

Philosopher Christopher Lebron voices this criticism, seeing Killmonger as a "receptacle for tropes of inner-city gangsterism." He gestured to the multiple black villains in the Luke Cage adaptation in his critique as well, questioning the framing of black poverty that is "partly tied to institutional racism but more closely tied to the greed expressed by two of its big bad black baddies"—inner-city crime bosses Black Mariah and Cotton Mouth. And the Netflix series ends, as does *Black Panther*, with black brother fighting brother. Why, Lebron asks, didn't Coogler make Klaue the villain, thus offering the opportunity to have a "white villain imbued with the sins of racism." Instead, he argues, "the bad guy is the black American who has rightly identified white supremacy as the reigning threat to black well-being; the bad guy is the one who thinks Wakanda is being selfish in its secret liberation; the bad guy is the one who will no longer stand for patience and moderation—he thinks liberation is many, many decades overdue. And the black hero snuffs him out."[16] Lebron's sense of affinity with Killmonger's politics is similar to that of many audience members. It prompted the hashtag "KillmongerWasRight" as well as many think pieces condemning the film for neoliberalism and antirevolutionary politics. The extensive debates about the character arguably suggest that writer-director Coogler succeeded in crafting a film that complicates the infamous binary affinities characteristic of many superhero narratives. For at least three decades, superhero comics have interrogated these binaries.

Villains with complexity have a long history in crime genres in particular, a trend that bothered psychiatrist Frederic Wertham so much that it was part of his rebuke of the comic book industry in *Seduction of the Innocent*, a study that influenced the Comics Code of 1954.[17] Superhero films have increasingly embraced the wounded villain—particularly in films springing from Marvel Comics. Thus if the villain is traditionally a caricature of evil, the sympathetic villain might just be seen as a new caricature type.

The challenge of black representational politics is that the history of racist representations inevitably shapes readings of characters, so any "black" version cannot be read *only* as a generic convention that remains untouched by the difference race makes. In this case, an identity hermeneutic can make the caricature of the sympathetic villain richer, just as it has in other contexts. Before "#KillmongerWasRight" people asked if Magneto was right.[18] A major antagonist in the X-Men series—also created by Lee and Kirby in 1963—Magneto believed that mutants had to fight those without powers or risk extermination because human beings constantly attack and seek to destroy difference. Some fans have suggested that the comic was playing in the dark: Magneto was an allegory for Malcom X and Professor X, the mutant who believed in living peacefully with non-mutants, represented the perspective of Martin Luther King Jr.[19] Stan Lee has not denied this; at the same time, people have doubted that he was making such an explicit political allegory in *X-Men*'s origins.[20] The comic series, like many superhero comics, became much more transparently political over time. But racism was nonetheless a clear allegory throughout *X-Men*. Magneto was later given an explicitly Jewish background, with a family murdered in the Holocaust. As Kathrin M. Bower argues, this "origin story inserts the Holocaust in to the conventional comic book formula" in which a superhero or supervillain is created by a "traumatic childhood experience," but the "appeal to the Holocaust complicates this convention, rendering Magneto's rage and mistrust toward humanity more comprehensible to the reader while destabilizing his categorization as a supervillain."[21]

As I have argued, identity hermeneutics make a difference in genre—transforming narratives by placing underrepresented characters at the center. At the same time, if part of the pleasure of the genre is its narrative fulfillment of what is expected, women and racial, ethnic, sexual minorities place pressure on the narrative's ability to adhere to its traditional patterns without alteration. Not adjusting for the difference

that identity makes risks accusations of—and this is an irony to be sure in the case of the speculative or fantastic—a lack of realism and cultural specificity. Changing it to reflect the difference identity makes risks a different set of criticisms, namely the conventional narrative pleasures that are important to specific genres.

Recognizing that Killmonger's character and desires mark a foundational challenge to the principles of the superhero and supervillain while remaining consistent with some other characters in the US superhero comics helps illustrate that some of what might be marked as exceptional in *Black Panther* is representative of an ongoing strand of antiracist, misanthropic politics by some creators in the superhero genre. We can accept Christopher Lebron's claim that Killmonger could be read as a caricature of inner-city black masculinity, but also recognize that it is that very caricature that invited the heated and complex debates around black politics that the film inspired. As I hope I have demonstrated, the flatness attached to caricature can sometimes invite complex readings, as opposed to reductive ones. It is the excess that crystallizes not character but political position and the circumstances that create the conditions for caricature's construction. So much of the criticism has been around why the film is revolutionary or why it is conservative, why it is "just entertainment" or why people miss its radical importance. But if we refuse the tendency toward binary oppositions and explore how all of these things can be true, it offers an opportunity to think anew about the conditions of production for black creators in popular culture and the ways in which negotiations with historical representations always offer an opportunity for exploring black ontology and varied ways to be black citizens.

I have been interested in helping people rethink why African Americans might play with caricature for critique, not only in a humorous mode, which is perhaps where we may be most accustomed to encounter it, but in various genres of comics and cartoon art. As I have argued, African American artists have often utilized caricatures of blackness—or what might be understood as such—to comment on the white gaze. They do it to comment on the fact that white people literally and figuratively create black subjects that are left out of the nation. They have done it to criticize African Americans whom they see as failing to assimilate. They do it to render the grotesqueries of the state that shape black bodies. The do it to talk about how we are haunted by the legacy of racist violence. They do it to call attention to alleged white progressivism. And they do it to show how the body that whites might read

as undesirable can be embraced as the ideal body for revolution. *One way of representing black experiences and political claims can be an absence of complexity that acknowledges the denial of black human-ity in real life.* The reductive representation can carry history as much as complexity, but because these depictions are so historically tied to injury they can inevitably be read as essentialist.

Killmonger can be read in terms of complexity, or we can do a sur-face reading that understands him as a caricature. Support for the latter reading would focus on the narrative conventions of African American urban masculinity. He is a fatherless black male child, who grew up to embrace violence and kill without conscience. And it is the rending of his flesh—he scars his flesh to mark each of his kills—that produces a black grotesque, each mark a sign of murders he has committed. His education and intelligence, some critics suggest, are not reflected in his speech or behavior.

While Jordan's skill as an actor can allow us to read for complexity, it is the very broad representation of his political position that has been read as a caricature that articulates sharp division in black liberation projects. Black people are constantly negotiating questions of assimila-tion, separatism, violence, and nonviolence. As Patrick Gathara argued, T'Challa can also be read as a reductive caricature. A surface reading of this fantastic representation allows us to see the black desire mapped onto his body as well—the embrace of "great men" and black messiahs who carry black cultural specificity and tradition with them simulta-neously. Complexity is written on the black body because of how the collective past and possible futures are always written on black subjects. Unable to be read as individuals, because there is little room in the black political imagination, as Hortense Spillers has argued, for "the one," they carry multiplicity.[22]

Collectivity written on the body is part of what renders the black body fantastic, and by the same token the gesture toward something other is a speculative enterprise. *The black fantastic is thus a site of the "real," because black people are always already fantastic.* We might understand that the primary characteristic of the real and experiential in black representation, or the thing that makes it register as real expe-rience, is *recognition*. Recognition as a dominant characteristic of how black cultural productions become legible as "black." One of the values of focusing on recognition is that its fluid meaning gives it utility in a variety of approaches to studying media. For those still concerned with positive and negative representation, "recognition" is a prevalent

characteristic of their affective and historical readings of an image. Recognition is essential to the process of describing the relationship between subjects and objects. The fictions inherently at play in the process of recognition produce a greater fluidity in what people say they desire in black cultural production. Recognition of blackness cannot be encapsulated by the ideas of the "real" and "experience."

The foundation of black representation is the popular. We cannot understand black representation without acknowledging the ghost of representations past haunting the possibilities of the present and foreseeable futures. It is why, even if many critics and producers justifiably and necessarily move beyond a preoccupation with positive and negative representations in their work, this binary haunts reception and reading practices. Rather than treating the impossibility of exorcising such ghosts as a limitation, we can treat caricature as manifesting the struggle to escape history, a referent for the need for revolution.

Sociologist Avery Gordon moves between a variety of media to describe the critical work attentiveness to haunting can do. Exploring the relationship between presence and absence is the "paradox of tracking through time and across all those forces that which makes its mark by being there and not there at the same time."[23] What if part of the work of recognition in black representation is making visible what is not there, has not been there, what is remembered or known but not seen? That would seem to suggest that the "real" always has the speculative and the fantastic as part of its configuration in black cultural productions. Black cultural productions are always sparring with ghosts.

Black caricature always deals in pain because historically it has been a way of inflicting injury. But in the hands of those interested in justice, it can be a *manifestation* of injury. It is for this reason that when I encounter what can be read as black racist caricature, I temper the jarring affect of encountering essentialist depictions of blackness with a question of whether or not the narrative and visual structure that shapes it may be doing work other than, or something more than, the injury. I cannot imagine a time free of some version of black representation that can be read as caricature. Because on some level, its absence will always be a sign of forgetting the monstrosity crafted by historical injuries, a weight carried by all black people perpetually in the wake— and on the brink—of real political change.

Acknowledgments

I did not grow up reading comics. I watched my share of cartoons, television shows, and movies adapted from superhero comics and enjoyed a few comic strips in the newspapers. Like any number of girls born in the United States in the 1970s, I loved Lynda Carter and my Wonder Woman Underoos. But I never identified myself as a fan. That changed when I began buying comics in graduate school in an effort to still read for pleasure when studying for my comprehensive exams left me unable to consume any non-work-related novels for a while. Then two things happened that transformed my research trajectory forever— Marvel published *Truth: Red, White & Black* and I began work at Ohio State University.

The story of the black Captain America showed me the kind of thoughtful, challenging work that could be done in comics and cartoon art about race. I interviewed writer Bob Morales for my first article about comics, and that experience inspired me to work through a rich archive of comics and cartoon art created by artists of color. We occasionally emailed over the years, until Bob passed away in 2013. I am grateful for the brilliant work he created with Kyle Baker, which was the impetus for this project.

Ohio State University has the biggest archive of comics and cartoon-related materials in the world. This book would not have been possible without the knowledge, help, and support I received from Lucy Shelton Caswell, Jenny Robb, Susan Liberator, and Marilyn Scott. I am particularly grateful to Lucy for introducing me to the work of Sam Milai, and to Susan and Jenny for how generous they always were with their time. The English Department at Ohio State was so supportive as a place to do comics work, but Jared Gardner deserves special praise for mentoring me at every turn in my development as a comics scholar.

The world of black comics scholarship is very small. But even within that small group, a few people deserve special shout-outs: Qiana Whitted has been my biggest cheerleader. Her friendship and intellectual

gifts have been a blessing. John Jennings, the hardest working man you'll ever meet and the Kevin Bacon of the black comics world, still found time to connect me with people and offer support in the midst of all his world building. Jonathan W. Gray always offers insights that have made my work better.

Since I cannot seem to complete a book in under a decade, more people have given me useful feedback about my work than I can possibly name. I apologize to anyone I've omitted here: Michael Chaney, Angela Rosenthal, Frederick Luis Aldama, Corey Creekmur, Brian Cremins, Andrew J. Kunka, Maurice Stevens, Frances Gateward, Anitra Grisales, Darieck Scott, Paige McGinley, Katrina Thompson Moore, Rhaisa Williams, Linda Nicholson, Cynthia Burack, Michael Gillespie, Leigh Raiford, Emily Lutenski, Ramzi Fawaz, Peter Coogan, Deborah Elizabeth Whaley, Carol Stabile, Glenda R. Carpio, Courtney Baker, Charles Hatfield, Stanford Carpenter, Jonathan Gayles, Damian Duffy, Olubukola Gbadegesin, Glenn Hendler, Scott Poulson Bryant, William Maxwell, Evie Shockely, Noah Berlatsky, Aaron Kashtan, Julian Chambliss, Dawn Durante, Richard West, and Gerald Early. I was honored beyond measure that Henry Jenkins was excited about this project. And Nic Sammond has been kinder about my work than I deserve.

My support in St. Louis has been extensive. The College of Arts and Sciences at Washington University offered me significant financial support in writing a book with many images. Sarah Martin and Hannah Wier provided much-needed research assistance. Mary Ann Dzuback and Donna Kepley offered up help at exactly the right times. My mother, Margaret Wanzo, was always understanding when I had to take archival trips to Columbus when I was home for the holidays. I appreciate Heidi Ardizzone for always gifting me with wisdom, tea, and sympathy; Colin Burnett for both offering unflinching critique and expressing the belief that I might produce something useful; Diane Wei Lewis for last-minute proofreading; and Adrienne Davis for always having my back.

A version of chapter 3 was previously published as "Wearing Hero-Face: Black Citizens and Melancholic Patriotism," in *Journal of Popular Culture* 42.2 (2009): 339–362, and some of chapter 4 appeared in *The Blacker the Ink: Constructions of Black Identity in Comics and Sequential Art*, edited by John Jennings and Frances Gateward (New Brunswick, NJ: Rutgers University Press, 2015). I thank Eric Zinner, Dolma Ombadykow, and the production team for shepherding this project through NYU Press.

I've followed fair use principles in showing very small portions of people's work. But I owe a great deal to people who have allowed me to

reprint editorial cartoons or full strips. Dave Granlund and Barry Blitt graciously gave me permission to reproduce their editorial cartoons. Barbara Brandon-Croft, Kim Milai, and Helma Harrington gave me access to the artwork of family members. And I am particularly grateful not only to Bob Morales for talking to me but also to Larry Fuller, who took the time to write up a priceless oral history of his time working in the underground comics industry.

It is my hope this monograph will be an introduction to some extraordinary work that few people know well. This book is dedicated to the black cartoonists of yesterday, today, and tomorrow.

Notes

Introduction

1 See Annette Gordon-Reed, *The Hemingses of Monticello* (New York: Norton, 2008), for a history of the Hemings family and the children of Thomas Jefferson and Sally Hemings.

2 Andrew J. Kunka, "Intertextuality and the Historical Graphic Narrative: Kyle Baker's 'Nat Turner' and the Styron Controversy," *College Literature* 38.3 (Summer 2011): 169.

3 Kunka, "Intertextuality and the Historical Graphic Narrative," 169.

4 Christopher John Farley, "On the Beach with Dave Chappelle," *Time*, May 15, 2005, http://content.time.com/time/arts/article/0,8599,1061415,00.html.

5 Will Kymlicka and Wayne Norman, "Return of the Citizen: A Survey of Recent Work on Citizenship Theory," *Ethics* 104 (January 1994): 353.

6 Richard Bellamy, *Citizenship: A Very Short Introduction* (Oxford: Oxford University Press, 2008), Kindle location 276.

7 Bellamy, *Citizenship*, Kindle location 296.

8 Laurence D. Bobo, "An American Conundrum: Race, Sociology, and the African American Road to Citizenship," in *The Oxford Handbook of African American Citizenship, 1865–Present*, ed. Henry Louis Gates Jr., Claude Steele, Laurence D. Bobo, Michael C. Dawson, Gerald Jaynes, Lisa Crooms-Robinson, and Linda Darling-Hammond (Oxford: Oxford University Press, 2012), 20.

9 Constance C. McPhee and Nadine M. Orenstein, *Infinite Jest: Caricature and Satire from Leonard to Levine* (New York: Metropolitan Museum of Art, 2011), 4.

10 McPhee and Orenstein, *Infinite Jest*, 3.

11 See David Kunzle, *Father of the Comic Strip: Rodolphe Töpffer* (Jackson: University Press of Mississippi, 2007).

12 Several people are understood as having invented stereotype in the eighteenth century. It involved the "indirect transfer, either in the form of a plaster mould or a papier-mache matrix in place of a metal one." It was cheaper and lighter and made it easier to transfer as a single unit. Dennis Bryans, "The Double Invention of Printing," *Journal of Design History* 13.4 (2000): 295. Stereotyping was a neutral printmaking practice, but over time the word became associated with derogatory representations, particularly in relationship to race, ethnicity, gender, and sexuality.

13 See David Bindman, *Ape to Apollo: Aesthetics and the Idea of Race in the 18th Century* (Ithaca, NY: Cornell University Press, 2002). See Michael Chaney's discussion of Frederick Douglass's use of the satirical magazine *Punch* in making a case for abolition, recognizing the value of both distortion and self-caricature in his emancipatory project. "Heartfelt Thanks to Punch for the Picture: Frederick Douglass and the Transnational Jokework of Slave Caricature," *American Literature* 82.1 (2010): 57–90.

14 Sheena Howard and Ronald L. Jackson, eds., *Black Comics: Politics of Race and Representation* (New York: Bloomsbury, 2013); Frances Gateward and John Jennings, eds., *The Blacker the Ink: Constructions of Black Identity in Comics and Sequential Art* (New Brunswick, NJ: Rutgers University Press, 2015); Deborah Elizabeth Whaley, *Black Women in Sequence: Re-inking Comics, Graphic Novels, and Anime* (Seattle: University of Washington Press, 2015); Brannon Costello and Qiana Whitted, eds., *Comics and the U.S. South* (Jackson: University Press of Mississippi, 2012).

15 This is such a frequent claim that the popular online satirical magazine the *Onion* joked about it with the fake story "Comics Not Just for Kids Anymore, Reports 85,000th Mainstream News Story," July 10, 2012, www.theonion.com.

16 Matthew P. McAllister, Edward H. Sewell, and Ian Gordon, eds., *Comics and Ideology* (New York: Peter Lang, 2001); and Ariel Dorfman and Armand Mattelart, *How to Read Donald Duck: Imperialist Ideology in the Disney Comic* (New York: International General, 1975).

17 I point to Wikipedia because it is one of the first places a general audience may look ("Thomas Nast," Wikipedia, https://en.wikipedia.org). See also the Billy Ireland Cartoon Library and Museum (https://cartoons.osu.edu) and other sites that always mention Tammany Hall immediately as one of his primary contributions to American cartooning.

18 Bart Beaty contests the "Blackbeard thesis" (from legendary comics historian and archivist Bill Blackbeard) that *Hogan's Alley* was the first comic with a recurring character, arguing that the

claim is "rooted in American chauvinism that seeks to claim comics as a national cultural form, tying comics to the democratic, pluralist, and family-oriented values that are held to exemplify the American character." *Comics versus Art* (Toronto: University of Toronto Press, 2012), Kindle location 526.

19 The comic had multiple names over the course of its run.

20 David Kunzle, *The History of the Comic Strip, Vol. II: The Nineteenth Century* (Berkeley: University of California Press, 1990), 4.

21 Kunzle, *History of the Comic Strip*.

22 Christina Meyer, "Urban America in the Newspaper Comic Strips of the Nineteenth Century: Introducing the Yellow Kid," *Image TexT: Interdisciplinary Comics Studies* 6.2 (2012).

23 People often read the Yellow Kid as Chinese. The idea of the Yellow Peril of dangerous Chinese invaders was well ingrained in the US imaginary by the late nineteenth century. Outcault would correct this misreading of the character with the 1896 comic "Li Hung Chang Visits Hogan's Alley." Mickey's thoughts/speech often appeared on his yellow dress shirt, and he typically looked out to the audience so that his speech served as commentary to the reader. He and Li are "a big hit wit each oter," and Mickey appears to realize in the process of saying this that his success with him is because Li may think they share an identity: "Say! He Tinks I'm a Chinaman—Don't say a woid!" Outcault's corrective to the misrecognition of Mickey's racial identity suggests that the cartoonist believed that it was important that the character be seen as white, even as his passing with "yellow face" could be a joke and source of pleasure. In the tradition of minstrelsy, such "play" with other racial identities was an important part of leisure in working-class white communities.

24 Robin Bernstein, *Racial Innocence: Performing American Childhood from Slavery to Civil Rights* (New York: New York University Press, 2011).

25 There have been riots throughout US history for all kinds of reasons. While in popular media today riots are mostly associated with urban black populations, white men were the primary participants in urban riots until the twentieth century (and if we start to include sporting events, they arguably still are). See Paul A. Gilje, *Rioting in America* (Bloomington: Indiana University Press, 1996), for a discussion of riots since the founding of the United States.

26 Bernstein, *Racial Innocence*, 30–68.

27 While all scholars who discuss Jack Johnson focus on the racial stakes of his matches, Theresa Runstedtler talks about his racial signification globally. See *Jack Johnson, Rebel Sojourner: Boxing in the Shadow of the Global Color Line* (Berkeley: University of California Press, 2013).

28 For a discussion of the development of the sports cartoon, see Amy McCrory, "Sports Cartoons in Context: TAD Dorgan and Multi-genre Cartooning in Early Twentieth-Century Newspapers," *American Periodicals: A Journal of History, Criticism, and Bibliography* 18 (2008): 45–68.

29 McCrory, "Sports Cartoons in Context."

30 See Runstedtler, *Jack Johnson, Rebel Sojourner*.

31 I see Toni Morrison's claims about canonical American literature as also being true about the canon of American comics. This book, as that work was, explores "whether the major and championed characteristics of our national literature— individualism, masculinity, social engagement versus historical isolation; acute and ambiguous moral problematics; the thematics of innocence coupled with an obsession with figurations of death and hell—are not in fact responses to a dark, abiding, signing Africanist presence" (5). Toni Morrison, *Playing in the Dark: Whiteness and the Literary Imagination* (Cambridge, MA: Harvard University Press, 1992).

32 See Peter Maresca's beautiful collection of early comic strips, *Society Is Nix: Gleeful Anarchy of the Dawn of the American Comic Strip 1895–1915* (Palo Alto, CA: Sunday Press Books, 2013).

33 "Early in the century, the comics abounded with racial and ethnic diversity; a few mainstream comics even featured blacks as their chief characters. . . . As comics became such big business, they needed a broad, national appeal, so they de-emphasized controversial topics such as race and ethnicity" (43). "In the comics immediately following World War II, then, race disappeared" (47). Bruce Lenthall, "Outside the Panel— Race in America's Popular Imagination: Comic Strips Before and After World War II," *Journal of American Studies* 32.1 (1998): 39–61.

34 Michael Barrier, "Charles M. Schulz: An Interview with Michael Barrier," originally published in *Comics Buyers Guide*, no. 1473 (February 8, 2001), www.michaelbarrier.com.

35 Clarence Page, "A 'Peanuts' Kid without Punchlines," *Chicago Tribune*, February 16, 2000, http://articles.chicagotribune.com.

36 It is useful to compare Schulz's use of Franklin with Walt Kelly's treatment of a black character named Bumbazine in the celebrated strip *Pogo*. Bumbazine was also somewhat idealized, and to actually address issues of inequality, Kelly moved to using animals. See Brian Cremins's reading of race in *Pogo* in "Bumbazine, Blackness, and the Myth of the Redemptive South in Walt Kelly's Pogo," in Costello and Whitted, *Comics and the U.S. South*.

37 Page, "'Peanuts' Kid without Punchlines."

38 Barrier, "Charles M. Schulz."

39 Barrier, "Charles M. Schulz."

40 As Jared Gardner and Ian Gordon argue, "The themes we read about in *Peanuts*—the profound existential concerns about loneliness, love, faith, and grief—are there for the taking. No advanced degree or theoretical apparatus is

required." *The Comics of Charles Schulz: The Good Grief of Modern Life* (Jackson: University Press of Mississippi, 2017, 5).

41 See Michael E. Miller, "Peter Parker, a.k.a. Spider-Man, Should Be Straight and White, Says Co-creator Stan Lee," *Washington Post*, June 25, 2015, www.washingtonpost.com; Noah Berlatsky, "The Incoherent Backlashes to Black Actors Playing 'White' Superheroes," *Atlantic*, February 20, 2014, www.theatlantic.com; Mark Peters, "Superhero Switch-Ups: A History of Race and Gender Switches in Comics," *Salon*, July 19, 2014, www.salon.com; Andrew Wheeler, "Radioactive Blackness and Anglo-Saxon Aliens: Achieving Superhero Diversity through Race-Changing," *Comics Alliance*, June 27, 2014, http://comicsalliance.com; Reggie James, "Why Comics Creators Need to Stop Changing Characters' Races," *REAXXION*, April 22, 2015, www.reaxxion.com; Jill Pantozzi, "Hey, That's My Cape! Comic Books, Race, Change, & Hate," *Newsarama*, August 3, 2011, www.newsarama.com; Scott Beggs, "But Spider-Man Can't Be Black," *Film School Rejects*, May 7, 2015, http://filmschoolrejects.com.

42 Umapagan Ampikaipakan, "That Oxymoron, the Asian Comic Superhero," *New York Times*, December 25, 2015, www.nytimes.com.

43 Steven L. Piott, "The Right of the Cartoonist: Samuel Pennypacker and Freedom of the Press," *Pennsylvania History: A Journal of Mid-Atlantic Studies* 55 (April 1988): 78–91.

44 See Amy Kiste Nyberg, *Seal of Approval: The History of the Comics Code* (Jackson: University Press of Mississippi, 1998).

45 Some examples of events that made the mainstream press are Superman's "death" in 1992, black Latino Miles Morales replacing Peter Parker as Spider-Man, and the resignation of the writers for *Batwoman*, who quit when DC would not allow the lesbian title character to get married to her partner in 2013.

46 On January 7, 2015, two terrorists associated with a branch of the Islamic fundamentalist group al-Qaeda went to the *Charlie Hebdo* office in Paris and shot and killed Stephane Charbonnier (Charb), Jean Cabut, George Wolinski, Bernard Verlhac, Bernard Maris, Phillipe Honoré, Michel Renaud, Elsa Cayat, Frédéric Boisseau, Mustapha Ourrad, Ahmed Merabet, and Franck Brinsolaro. The ostensible motive for the horrifying murders of cartoonists, staff, and officers was the cartoonists' representation of the prophet Muhammad in the cartoons. For contrasting debates about the cartoons, see Mark McKinney, "The Meanings of Charlie Hebdo and the Value of Scholarship on Comics and Cartoons," *Berghahn Press Blog*, January 16, 2015, http://berghahnbooks.com and Jeet Heer, "The Aesthetic Failure of 'Charlie Hebdo," *New Republic*, May 8, 2015, https://newrepublic.com.

47 Jim Rutenberg, "Deconstructing the Bump," *New York Times*, June 11, 2008, http://thecaucus.blogs.nytimes.com.

48 Rachel Sklar, "Yikes! Controversial *New Yorker* Cover Shows Muslim, Flag-Burning, Osama-Loving, Fist Bumping Obama," *Huffington Post*, July 21, 2008, www.huffingtonpost.com.

49 Jonathan P. Rossing, "Comic Provocations in Racial Culture: Barack Obama and the 'Politics of Fear,'" *Communication Studies* 61 (September/October 2011): 422–438; Craig O. Stewart, "Strategies of Verbal Irony in Visual Satire: Reading the *New Yorker*'s 'Politics of Fear' Cover," *Humor* 26 (May 2013): 197–217; Linda F. Selzer, "Barack Obama, the 2008 Presidential Election, and the New Cosmopolitanism: Figuring the Black Body," *MELUS* 35 (Winter 2010): 15–37.

50 Stephen Best and Sharon Marcus, "Surface Reading: An Introduction," *Representations* 108.1 (Fall 2009): 9.

51 Quoted in Evan McMurry, "Michelle Obama: I Was Knocked Back by Race Perceptions," *Guardian*, May 11, 2015, www.theguardian.com.

52 Tristan A. Bekinschtein, Matthew H. Davis, Jennifer M. Rodd, and Adrian M. Owen, "Why Clowns Taste Funny: The Relationship between Humor and Semantic Ambiguity," *Journal of Neuroscience* 31 (June 2011): 9665–9671.

53 Richard Iton, *In Search of the Black Fantastic: Politics and Popular Culture in the Post–Civil Rights Era* (Oxford: Oxford University Press, 2008), 17.

54 Scott McCloud, *Understanding Comics: The Invisible Art* (New York: Harper Perennial, 1994), 9. See also Bart Beaty's discussion of the genealogy of definitions of comics in chapter 2 of *Comics versus Art*.

55 Other scholars have talked about editorial cartoons in relationship to sequence. Beaty challenges the division in *Comics versus Art*; McAllister, Sewell, and Gordon's *Comics and Ideology* includes editorial cartoons in their discussion of what counts as comic art; Jeet Heer and Kent Worcester also consider editorial cartoons part of comic art and make that claim in their edited collection, *A Comics Studies Reader* (Jackson: University Press of Mississippi, 2009), xiii.

56 Phillip Brian Harper, *Abstractionist Aesthetics: Artistic Form and Social Critique in African American Culture* (New York: New York University Press, 2015), 2.

Chapter 1. "Impussanations," Coons, and Civic Ideals

1 W. E. B. Du Bois, "Criteria of Negro Art," *Crisis* 32 (October 1926): 290–297.

2 Du Bois, "Criteria of Negro Art."

3 Matthew Arnold, *Culture and Anarchy: An Essay in Political and Social Criticism* (London: Smith, Elder, 1869), viii.

4 Michael Tisserand, *Krazy: George Herriman, a Life in White and Black* (New York: HarperCollins, 2016), 91.

5 Tisserand, *Krazy*, 92.

6 M. Thomas Inge, "Was Krazy Kat Black?," in *Drawing the Line: Comics Studies and Inks*, ed. Lucy Caswell and Jared Gardner

(Columbus: Ohio State University Press, 2017), 45.

7 Inge, "Was Krazy Kat Black?," 45.

8 Tisserand, *Krazy*, 154.

9 See Miriam Petty on the idea of constrained African American performers in the early twentieth century "stealing the show." *Stealing the Show: African American Performances and Audiences in 1930s Hollywood* (Oakland: University of California Press, 2016). I talk about overdetermined readings of roles seen as stereotypes in "Beyond a 'Just' Syntax: Black Actresses, Hollywood, and Complex Personhood," *Women and Performance* 16.1 (2006): 135–152. See also Louis Chude-Sokei on Bert Williams in *The Last Darky: Bert Williams, Black on Black Minstrelsy, and the African Diaspora* (Durham, NC: Duke University Press, 2006), 21, 179.

10 Richard J. Powell, *Black Art: A Cultural History* (1997; London: Thames and Hudson, 2002), 15.

11 Paul Taylor, *Black Is Beautiful: A Philosophy of Black Aesthetics* (Hoboken, NJ: Wiley Blackwell, 2016), 12.

12 Michel Foucault, "The Ethics of the Concern of the Self as a Practice of Freedom," in *Ethics: Subjectivity and Truth*, ed. Paul Rainbow, trans. Robert Hurley et al. (New York: Penguin, 1997), 281–301.

13 Racquel Gates, *Double Negative: The Black Image in Popular Culture* (Durham, NC: Duke University Press, 2018), 17.

14 Gates, *Double Negative*, 19.

15 Dana Villa engaged with the concept of alienated citizenship in *Socratic Citizenship* (Princeton, NJ: Princeton University Press, 2001) but explores the concept from the perspective of people who choose to be alienated, as opposed to focusing on citizens whom the state alienated from the national body.

16 Jeet Heer, "Krazy Kat's Colors: The Shadings of George Herriman's Black and White World," *Lingua Franca* 53 (September 2001): 52–58.

17 Ian Dahlman, "The Legal Surrealism of George Herriman's Krazy Kat," *Law, Text, Culture* 16.1 (2012): 35–64; Jesus Jiménez-Varea, "Surrealism, Non-Normative Sexualities, and Racial Identities in Popular Culture: The Case of the Newspaper Comic Strip *Krazy Kat*," *Revista Comunicación* 1.11 (2013): 51–66; M. T. Inge, "*Krazy Kat* as American Dada Art," in *Comics as Culture* (Jackson: University Press of Mississippi, 1990); Keith L. Eggener, "'An Amusing Lack of Logic': Surrealism and Popular Entertainment," *American Art* 7.4 (Autumn 1993): 30–45.

18 Tisserand, *Krazy* 3–4.

19 Inge, "Was Krazy Kat Black?"

20 This question is a riff on Stuart Hall's famous essay, "What Is This 'Black' in Black Popular Culture?," *Social Justice* 20.1–2 (1993): 104–114.

21 Heer, "Krazy Kat's Colors," 53.

22 Jared Gardner, "Becoming Krazy," in *Scenes of My Infint-hood: Celebrating the Birth of* Krazy Kat (Columbus: Ohio State University Libraries, 2010), 34.

23 Houston Baker, *Modernism and the Harlem Renaissance* (Chicago: University of Chicago Press, 1987), 17.

24 For a discussion of the ways in which black performers have complicated and added complexities to blackface performance, see Chude-Sokei, *Last Darky*.

25 Alain Locke, "Art or Propaganda?," *Harlem* 1.1 (November 1928).

26 Du Bois, "Criteria of Negro Art."

27 Theresa Runstedtler, *Jack Johnson, Rebel Sojourner: Boxing in the Shadow of the Global Color Line* (Berkeley: University of California Press, 2013).

28 Jean Lee Cole, "Laughing Sam and Krazy Kats: The Black Comic Sensibility," *Canadian Review of American Studies* 47.3 (2017): 373–402.

29 See Jeet Heer, "The Colors of Krazy Kat," in *Krazy and Ignatz, Komplete 1935–1936* (Seattle: Fantagraphics, 2005), 12; and Eyal Amiran, "George Herriman's Black Sentence: The Legibility of Race in Krazy Kat," *Mosaic: An Interdisciplinary Critical Journal* 33.3 (September 2000): 63–64.

30 Matthew P. McAllister, Edward H. Sewell, and Ian Gordon, eds., *Comics and Ideology* (New York: Peter Lang, 2001).

31 Edward A. Shannon, "That We May Mis-Unda-Stend-Each Udda," *Journal of Popular Culture* 29.2 (1995): 212. This follows a quote from David Kunzle's magnum opus on the history of comics and is, I think, a misreading of Kunzle's claim that the "caption is content to remain subordinate to the picture; indeed, in point of quantity we make this part of a necessary definition of the comic strip as a genre to distinguish it from illustration" (David Kunzle, *The History of the Comic Strip: The Nineteenth Century* [Berkeley: University of California Press, 1990], 374–375).

32 Locke, "Art or Propaganda?"

33 Locke, "Art or Propaganda?"

34 Armistead S. Pride and Clint C. Wilson, *A History of the Black Press* (Washington, DC: Howard University Press, 1997), 13.

35 Martha Banta, *Barbaric Intercourse: Caricature and the Culture of Conduct* (Chicago: University of Chicago Press, 2003), 21.

36 Banta, *Barbaric Intercourse*, 25.

37 Patrick S. Washburn, *The African American Newspaper: Voice of Freedom* (Evanston, IL: Northwestern University Press, 2007), Kindle location 246.

38 Billy Ireland Cartoon Library and Museum, Sam Milai Archives, Ohio State University, http://ead.ohiolink.edu.

39 Andrew Buni, *Robert L. Vann of the Pittsburgh Courier: Politics and Black Journalism* (Pittsburgh: University of Pittsburg, 1974), 325.

40 See Richard L. Kaplan, *Politics and the American Press: The Rise of Objectivity, 1865–1920* (New York: Cambridge University Press, 2002), particularly the first chapter, which discusses political partisanship and representations of African Americans.

41 Buni, *Robert L. Vann of the Pittsburgh Courier*.

42 Amy Helene Kirshcke, *Art in Crisis: W. E. B. Du Bois and the Struggle for African American Identity and Memory* (Bloomington: Indiana University Press, 2007), 2.

43 Editorial cartooning emerged from a Western tradition of satirical art, and it is fundamentally a genre of protest. The *Crisis* would thus have a tone respectful toward African Americans but not to white people or the state. Racist caricatures of black people rarely appeared in the *Crisis*, even as black cartoonists would occasionally use them in the black press. A notable exception is that sometimes Du Bois reprinted cartoons from Europe to demonstrate European knowledge of American racism, but the marked difference between their art and that of the other work in the *Crisis* demonstrated how dominant racist caricature is in the visual vocabulary of the West. Kirshcke, *Art in Crisis*, 57, 203.

44 Larry Neal, "The Black Arts Movement," *Black Theater* 12.4 (Summer 1968): 28–39, 29.

45 Neal, "Black Arts Movement."

46 For more on this idea, see Tanisha C. Ford's discussion of clothing and style, *Liberated Threads: Black Women, Style, and the Global Politics of Soul* (Chapel Hill: University of North Carolina Press, 2017); and Leigh Raiford's discussion of a black power aesthetic in photography in *Imprisoned in a Luminous Glare: Photography and the African American Freedom Struggle* (Chapel Hill: University of North Carolina Press, 2013).

47 Emory Douglas, *Black Panther: The Revolutionary Art of Emory Douglas*, ed. Sam Durant (New York: Rizzoli, 2007).

48 Carolyn R. Calloway, "Group Cohesiveness in the Black Panther Party," *Journal of Black Studies* 8.1 (1977); Erika Doss, "'Revolutionary Art Is a Tool for Liberation': Emory Douglas and Protest Aesthetics at *the black panther*," *New Political Science* 21.2 (1999): 245–259.

49 Roland Barthes, *Mythologies*, trans. Annette Lavers (New York: Noonday Press, 1972), 115.

50 See Fae Brauer, "'Moral Girls' and 'Filles Fatales': The Fetishisation of Innocence," *Australian and New Zealand Journal of Art* 10 (2011): 122–143.

51 Robert D. Loevy, *The Civil Rights Act of 1964: The Passage of the Law That Ended Racial Segregation* (Albany: State University of New York Press, 1997).

52 "Civil Rights: Dirksen's Defection," *Time*, May 13, 1966.

53 For a discussion of the "Mrs. Murphy" exemption, see James D. Walsh, "Reaching Mrs. Murphy: A Call for Repeal of the Mrs. Murphy Exemption to the Fair Housing Act," *Harvard Civil Rights–Civil Liberties Law Review* 34 (Summer 1999): 605–634.

54 Martin Luther King, "The Other America" (speech, Stanford, CA, April 14, 1967), YouTube, www.youtube.com/watch?v=m3H978KlR2o.

55 Thelma Golden, "Freestyle" exhibit, Studio Museum in Harlem, New York, April 28–June 24, 2001.

56 Huey Copeland, "Post/Black/Atlantic: A Conversation with Thelma Golden and Glenn Ligon," Studio Museum in Harlem, New York, September 28, 2009, www.liverpool.ac.uk.

57 Mark Anthony Neal, *Soul Babies: Black Popular Culture and the Post-Soul Aesthetic* (New York: Routledge, 2001).

58 Matt Santori, "Game Changers: Valentine De Landro on Bitch Planet," *Comicosity*, April 28, 2015, www.comicosity.com.

59 Santori, "Game Changers."

60 Kelly Sue DeConnick (author) and Valentine De Landro, Robert Wilson IV, et al. (illustrators), *Bitch Planet, Vol. 1: Extraordinary Machine*, issue 3 (Portland, OR: Image Comics, 2015).

61 Susan Bordo, *Unbearable Weight: Feminism, Western Culture, and the Body*, 10th anniv. ed. (Berkeley: University of California Press, 2003), 192.

62 Josh Hogan, "Jeremy Love's American Style," *Graphic Reporter*, www.graphicnovelreporter.com.

63 Neal, "Black Arts Movement."

64 Scott McCloud, *Understanding Comics: The Invisible Art* (New York: Harper Perennial, 1994), 31.

65 McCloud, *Understanding Comics*, 30.

66 Paige Tutt, "Apple's New Diverse Emoji Are Even More Problematic Than Before," *Washington Post*, April 10, 2015.

67 McCloud, *Understanding Comics*, 42.

68 Bertha Upton (author) and Florence K. Upton (illustrator), *The Adventures of Two Dutch Dolls and a Golliwogg* (London: Longmans, Green, 1895).

69 Thierry Groensteen, *The System of Comics*, trans. Bart Beaty and Nick Nguyen (Jackson: University Press of Mississippi, 2007).

70 Georg Wilhelm Friedrich Hegel, *The Philosophy of History*, trans. J. Sibree, preface by Charles Hegel (Kitchener, Ontario: Batoche Books, 2001), 117.

71 Richard Iton, *In Search of the Black Fantastic: Politics and Popular Culture in the Post–Civil Rights Era* (Oxford: Oxford University Press, 2008), 16.

72 There's a great deal of scholarship on the effects of stereotypes on public policy. But see, for example, Jon Hurwitz and Mark Peffley, "Public Perceptions of Race and Crime: The Role of Racial Stereotypes," *American Journal of Political Science* 41.2 (April 1997): 375–401.

73 Koritha Mitchell, *Living with Lynching: African American Lynching Plays, Performance and Citizenship, 1890–1930* (Urbana: University of Illinois Press, 2011), 7.

74 See, for example, Saidiya Hartman's discussion of representations of violence toward slaves in *Scenes of Subjection: Terror, Slavery, and Self-Making in Nineteenth-Century America* (Oxford: Oxford University Press, 1997), and Elizabeth Alexander's discussion of the Rodney King video in "Can You Be BLACK and Look at This? Reading the Rodney King Video," *Public Culture* 7 (1994): 77–94.

Chapter 2.
The Revolutionary Body

1 For discussions of imperialist aesthetics, see Catherine E. Anderson, "A Zulu King in Victorian London: Race, Royalty and Imperialist Aesthetics in Late Nineteenth-Century Britain," *Visual Resources* 24.3 (2008): 299–319; Shelly Jarenski, "Delighted and Instructed: African American Challenges to Panoramic Aesthetics in J. P. Ball, Kara Walker, and Frederick Douglass," *American Quarterly* 65.1 (2013): 119–155.

2 On August 9, 2014, a white police officer shot eighteen-year-old African American Michael Brown multiple times and killed him in Ferguson, Missouri. Protests ensued, with many debates over whether or not Brown had just committed a "strong arm" robbery at a convenience store and whether or not his hands were up when he was shot. He was unarmed. Protests ensued, the first of many after police shootings of African American men in what came to be known as the Black Lives Matter movement. "MLK III: Riots Would Disappoint Father," CNN, November 25, 2014, www.cnn.com; Alexandra Jaffe, "Huckabee: Michael Brown Acted Like a 'Thug,'" CNN, December 3, 2014, www.cnn.com.

3 Ronald Takaki's *Violence in the Black Imagination: Essays and Documents* (New York: Oxford University Press, 1972) examines how Douglas, William Wells Brown, and Martin Delany explored the importance of violence in expressions of black masculinity in early African American literature. Simon Wendt argues that the emphasis on nonviolence was actually a deterrent against some African Americans joining the civil rights movement in the South because of the "connotations of effeminate submissiveness" (544). Wendt, "'They Finally Found Out That We Really Are Men': Violence, Non-Violence and Black Manhood in the Civil Rights Era," *Gender and History* 19.3 (2007): 543–564.

4 Craig Fischer opens his essay "Provocation through Polyphony: Kyle Baker's Nat Turner" by commenting on its importance to his memory of the text: "When I think of Kyle Baker's graphic novel *Nat Turner* (2008), I immediately recall, in detail, the book's splash page of a big, bald slave named Will swinging his axe and beheading a cherubic white child. What does this image mean?" (255). In *The Blacker the Ink: Constructions of Black Identity in Comics and Sequential Art*, ed. Frances Gateward and John Jennings (New Brunswick, NJ: Rutgers University Press, 2015), 255–273.

5 Kyle Baker, *Nat Turner* (New York: Abrams, 2008), 108.

6 Consuela Francis, "Drawing the Unspeakable: Kyle Baker's Slave Narrative," in *Comics and the U.S. South*," ed. Brannon Costello and Qiana Whitted (Jackson: University Press of Mississippi, 2012), 113–137.

7 Francis, "Drawing the Unspeakable," 135.

8 Glenda Carpio, *Laughing Fit to Kill: Black Humor in the Fictions of Slavery* (Oxford: Oxford University Press, 2008).

9 Marc Singer, "Week 8: Kyle Baker, Nat Turner," *I Am NOT the Beastmaster* (blog), March 18, 2010, http://notthebeastmaster.typepad.com.

10 Francis, "Drawing the Unspeakable," 118.

11 Francis, "Drawing the Unspeakable," 118.

12 Francis, "Drawing the Unspeakable," 117.

13 This became a major source of discussion in the wake of the protests following the shooting of Michael Brown in Ferguson, Missouri, in August 2014.

14 See Charles Burnett's documentary *Nat Turner: A Troublesome Property* (California Newsreel, 2002) for a discussion of representational debates around Turner.

15 Baker has also called attention to this treatment of violence in an online game, *Mass Murderer of Steel*, that he produced after the release of Zach Snyder's film *Man of Steel* (2013). In the climax of the film, Superman and the antagonist Zod destroy half of the city Metropolis in their fight, undoubtedly killing thousands of people. Baker's game addresses a criticism that several people had about this depiction of Superman's character: he would do everything possible to avoid such mass violence. Moreover, he would be shown mourning the loss of so many people. Instead, he mourns when he kills Zod. To highlight the film's indifference to mass violence, in the game *Mass Murderer of Steel* the player gets points each time Superman and Zod hurl themselves into another building and kill screaming people. www.mtv.com.

16 Priscilla Wald, *Constituting Americans: Cultural Anxiety and Narrative Form* (Durham, NC: Duke University Press, 1995).

17 Georg Wilhelm Friedrich Hegel infamously described Africans as outside of history in *Lectures on the Philosophy of History*, trans. H. B. Nisbet (Cambridge: Cambridge University Press, 1975), 176. See Paul Gilroy's *The Black Atlantic: Modernity and Double Consciousness* (New York: Verso, 1993) for a discussion of how integral people of African descent are to modernity.

18 Michael Hanchard, "Afro-Modernity: Temporality, Politics, and the African Diaspora," *Public Culture* 11.1 (1999): 256, 264.

19 Martin Luther King, "Letter from a Birmingham Jail," in *The Radical King*, ed. Cornel West (Boston: Beacon, 2016), 131.

20 King, "Letter from a Birmingham Jail," 132.

21 Hillary Chute, "Comics as Literature? Reading Graphic Narrative," *PMLA* 123.2 (2008): 454.

22 Richard West, email, April 1, 2016.

23 Kara Walker, *Harper's Pictorial History of the Civil War (Annotated)* (offset lithography/silkscreen, LeRoy Neiman Center for Print Studies, 2005).

24 "Compromise with the South," Cartoon of the Day, *HarpWeek*, www.harpweek.com, "Thomas Nast Portfolio," https://cartoons.osu.edu.

25 Zoe Trodd, "Am I Still Not a Man and a Brother? Protest Memory in Contemporary

Antislavery Visual Culture," *Slavery & Abolition* 34.2 (2013): 338–352, 340.

26 David Silkenat, "'A Typical Negro': Gordon, Peter, Vincent Colyer, and the Story behind Slavery's Most Famous Photograph," *American Nineteenth Century History* 15.2 (2014): 169–186.

27 Silkenat, "'Typical Negro,'" 169.

28 Silkenat, "'Typical Negro,'" 174.

29 Silkenat, "'Typical Negro.'"

30 On writing back to empire, see Bill Aschcroft, Gareth Griffiths, and Helen Tiffin, *The Empire Writes Back: Theory and Practice* (New York: Routledge, 1989).

31 M. Keith Booker, ed., *Encyclopedia of Comic Books and Graphic Novels*, vol. 2 (Santa Barbara, CA: Greenwood, 2010), 44.

32 Michael Chaney, "Slave Memory without Words in Kye Baker's *Nat Turner*," *Callaloo* 36.2 (Spring 2013): 279–297; Andrew J. Kunka, "Intertextuality and the Historical Graphic Narrative: Kyle Baker's 'Nat Turner' and the Styron Controversy," *College Literature* 38.3 (Summer 2011):168–193; Jonathan W. Gray, "'Commence the Great Work': The Historical Archive and Historical Violence in Kyle Baker's *Nat Turner*," in *Afterimages of Slavery: Essays on Appearances in Recent Films, Literature, Television, and Other Media*, ed. Marlene D. Allen and Seretha D. Williams (Jefferson, NC: McFarland, 2012), 183–200.

33 Ashraf H. A. Rushdy, *Neo-Slave Narratives: Studies in the Social Logic of a Literary Form* (New York: Oxford University Press, 1999), 3, 5.

34 Gray, "Commence the Great Work," 189.

35 Gray, "Commence the Great Work," 190.

36 Hayden White, "Introduction: Historical Fiction, Fictional History, and Historical Reality," *Rethinking History* 9.2–3 (June/September 2005), 147.

37 Toni Morrison, *Beloved* (New York: Knopf, 1987). Other examples include Octavia Butler's *Kindred* (New York:

Doubleday, 1979) and Phyllis Alesia Perry's *Stigmata* (New York: Anchor, 1999).

38 Felicia R. Lee, "Nat Turner in History's Multiple Mirrors," *New York Times*, February 7, 2004, www.nytimes.com.

39 See Appendix E, "White Victims," in David F. Allmendinger Jr., *Nat Turner and the Rising in Southampton County* (Baltimore: Johns Hopkins University Press, 2014).

40 See Herbert Aptheker, *Nat Turner's Slave Rebellion: Including the 1831 "Confessions"* (Mineola, NY: Dover, 1966, 2006), 57–107.

41 David F. Allmendinger Jr., "The Construction of The Confessions of Nat Turner," in *Nat Turner: A Slave Rebellion in History and Memory*, ed. Kenneth Greenberg (Oxford: Oxford University Press, 2003), 37.

42 Allmendinger, *Nat Turner*, Kindle locations 196–197.

43 Scholars believe some of the account could only have come from Turner.

44 Chaney, "Slave Memory," 281.

45 Charles Hatfield, *Alternative Comics: An Emerging Literature* (Jackson: University Press of Mississippi, 2005), 37.

46 Nat Turner, *The Confessions of Nat Turner, the Leader of the Late Insurrection in Southampton Virginia*, ed. Thomas R. Gray (Chapel Hill: University of North Carolina Press, 2011), 10.

47 Turner, *The Confessions of Nat Turner*, 10.

48 "Kyle Baker," *Comic Vine*, http://comicvine.gamespot.com.

49 Baker, *Nat Turner*, 11.

50 Baker, *Nat Turner*, 18–19.

51 Baker, *Nat Turner*, 27.

52 Baker, *Nat Turner*, 28.

53 See Dorothy Roberts, "Reproduction in Bondage," in *Killing the Black Body: Race, Reproduction, and the Meaning of Liberty* (New York: Pantheon Books, 1997).

54 Mary Kemp Davis, "'What Happened in This Place?': In Search of the Female Slave in the Nat Turner Slave Insurrection," in Greenberg, *Nat Turner*, 169.

55 Davis, "'What Happened in This Place?'"

56 Baker, *Nat Turner*, 149.

57 Hortense Spillers, "Mama's Baby, Papa's Maybe: An American Grammar Book," *Diacritics* 17.2 (Summer 1987): 64–81. See also Saidiya Hartman's discussion of slavery and the pornotrope in *Scenes of Subjection: Terror, Slavery, and Self-Making in Nineteenth-Century America* (Oxford: Oxford University Press, 1997).

58 Baker, *Nat Turner*, 82–83.

59 Baker, *Nat Turner*, 130, 132, 136.

60 Qiana Whitted notes that this representation is not far from the character Ebony White, created by legendary cartoonist Will Eisner. "'And the negro thinks in hieroglyphics': comics, visual metonymy, and the spectacle of blackness," *Journal of Graphic Novels and Comics* 5.1 (2014): 79–100.

61 Baker, *Nat Turner*, 90.

62 Baker, *Nat Turner*, 172–175.

63 In an interview with Ed Mathews for *Pop Image*, Baker notes, "It's a Holocaust book." Meryl Jaffe, "Using Graphic Novels in Education: Nat Turner," CBLDF, February 19, 2014, http://cbldf.org.

64 Baker, *Nat Turner*, 144–145.

65 Baker, *Nat Turner*, 157.

66 Baker, *Nat Turner*, 167.

67 Baker, *Nat Turner*, 189.

68 Baker, *Nat Turner*, 193–195.

69 He "remained poised during the proceedings. According to the *Herald*, 'he betrayed no emotion,' and 'exhibited the utmost composure throughout the whole ceremony.'" Patrick H. Breen, *The Land Shall Be Deluged in Blood: A New History of the Nat Turner Revolt* (Oxford: Oxford University Press, 2015), 150.

70 Celeste-Marie Bernier, "A Visual Call to Arms against the 'Caracature of My Own Face': From Fugitive Slave to Fugitive Image in Frederick Douglass's Theory of Portraiture," *Journal of American Studies* 49.2 (2015): 323–357.

71 For a discussion of Douglass's investment in photography, see the introduction and Laura Wexler's chapter in Maurice O. Wallace and Shawn Michelle Smith, eds., *Pictures and Progress: Early Photography and the Making of*

African American Identity (Durham, NC: Duke University Press, 2012); and for a discussion of Douglass's interest in caricature, see Michael Chaney, "Heartfelt Thanks to Punch for the Picture: Frederick Douglass and the Transnational Jokework of Slave Caricature," *American Literature* 82.1 (2010): 57–90.

72 See Leigh Raiford, *Imprisoned in a Luminous Glare: Photography and the African American Freedom Struggle* (Chapel Hill: University of North Carolina Press, 2013) and Sasha Torres, *Black, White, and in Color: Television and Black Civil Rights* (Princeton, NJ: Princeton University Press, 2003).

73 Bayard Rustin, "From Protest to Politics: The Future of the Civil Rights Movement," *Commentary*, February 1, 1965, www.commentarymagazine.com.

74 Rushdy, *Neo-Slave Narratives*, 18.

75 Jean Baudrillard suggests that the postmodern experience is one in which "reality" is shaped by representations that have no relationship to reality—"pure simulacrum." Baudrillard, *Simulacra and Simulation*, trans. Sheila Faria Glaser (Ann Arbor: University of Michigan Press, 1994).

76 See Denise M. Bostdorff and Steven R. Goldzwig, "History, Collective Memory, and the Appropriation of Martin Luther King Jr: Reagan's Rhetorical Legacy," *Presidential Studies Quarterly* 35.4 (December 2005): 661–690.

77 Ronald Turner, "The Dangers of Misappropriation: Misusing Martin Luther King, Jr.'s Legacy to Prove the Colorblind Thesis," *Michigan Journal of Race and Law* 2.1 (1996): 101–130.

78 There are many examples of King described as "frozen": Michael Eric Dyson, *I May Not Get There with You: The True Martin Luther King, Jr.* (New York: Free Press, 2000), 15; Alan Johnson, "Self-Emancipation and Leadership: The Case of Martin Luther King," in *Leadership and Social Movements*, ed. Colin Baker,

Alan Johnson, Alan Johnson, and Michael Lavalette (Manchester: Manchester University Press, 2001), 99. For a discussion of a frozen aesthetic in memorialization, see Thomas H. Kane, "Mourning the Promised Land: Martin Luther King Jr.'s Automortography and the National Civil Rights Museum," *American Literature* 76.3 (2004): 568.

79 Jacquelyn Dowd Hall, "The Long Civil Rights Movement and the Political Uses of the Past," *Journal of American History* 91.4 (2005): 1234.

80 See Francesca Polletta, "Legacies and Liabilities of an Insurgent Past: Remembering Martin Luther King Jr. on the House and Senate Floor," *Social Science History* 22.4 (Winter 1998): 479–512; Kevin Bruyneel, "The King's Body: The Martin Luther King Jr. Memorial and the Politics of Collective Memory," *History & Memory* 26.2 (2014): 75–108.

81 Bruyneel, "King's Body," 77.

82 Mary Lou Finley, Bernard LaFayette Jr., James R. Ralph Jr., and Pam Smith, eds., *The Chicago Freedom Movement: Martin Luther King Jr. and Activism in the North* (Lexington: University Press of Kentucky, 2016), 303.

83 Bruce D'Arcus, "Dissent, Public Space and the Politics of Citizenship: Riots and the 'Outside Agitator,'" *Space and Polity* 8.3 (2004): 355–370.

84 Bill Sanders, *Kansas City Star*, King Center, n.d., https://thekingcenter.org. The King Center no longer makes this image available online, but it can also be found at the Reading the Pictures Blog, January 20, 2014, www.readingthepictures.org.

85 Taylor Branch, *At Canan's Edge: America in the King Years, 1965–68* (New York: Simon & Schuster, 2003), 183, 762.

86 Sam Milai, *Pittsburgh Courier*, April 27, 1967, Billy Ireland Cartoon Library and Museum, Ohio State University.

87 Edward P. Morgan, "The Good, the Bad, and the Forgotten: Media Culture and Public Memory of the Civil Rights Movement," in *The Civil Rights Movement in American*

Memory, eds. Renee C. Romano and Leigh Raiford (Athens: University of Georgia Press, 2006).

88 Qiana Whitted, "Comics and Racial Pedagogy from Martin Luther King and the Montgomery Story to March: Book One" (Ohio State University Festival of Cartoon Art, 2013).

89 Roland Barthes, *Mythologies*, trans. Jonathan Cape (New York: Farrar, Straus, & Giroux, 1972), 108.

90 John Lewis, Andrew Aydin, and Nate Powell (illustrator), *March*, vols. 1–3 (Marietta, GA: Top Shelf, 2016).

91 Ho Che Anderson, *King* (Seattle: Fantagraphics, 2005), 146–147.

92 Anderson, *King*, 149.

93 Tim O'Shea, "Talking Comics with Tim: Ho Che Anderson," CBR.com, March 8, 2010, www.cbr.com.

94 Anderson, *King*, 153.

95 O'Shea, "Talking Comics with Tim."

96 Anderson, *King*, 214.

97 Anderson, *King*, 219.

98 Bruyneel, "King's Body," 87.

99 Guernsey LePelley, *Christian Science Monitor*, April 4, 1968. This image is archived at the King Center.

Chapter 3. Wearing Hero-Face

1 The Black Panthers best represented this aesthetic. Although typically clad in black, they did present what Erika Doss calls a "protest aesthetic" in her discussion of artist Emory Douglas's work promoting the Panther's program. See Doss, "'Revolutionary Art Is a Tool for Liberation': Emory Douglas and Protest Aesthetics at *the black panther*," *New Political Science* 21.2 (1999): 245–259.

2 Recruitment Poster, Department of the Navy, US Naval Historical Center, stock no. NH 78890-KN, stock no. RAD 72791, 1972, www.ibiblio.org.

3 Recruitment Poster, Department of the Navy, US Naval Historical Center, stock no. RAD 71794, 1972, www.ibiblio.org.

4 Bradford W. Wright, *Comic Book Nation: The Transformation of Youth Culture in America* (Baltimore: Johns Hopkins University Press, 2001), 30.

5 Wright, *Comic Book Nation*, 32.

6 J. Richard Stevens, *Captain America, Masculinity, and Violence: The Evolution of a National Icon* (Syracuse, NY: Syracuse University Press, 2015), 2–3.

7 *Captain America* no. 180 (December 1974).

8 John Ney Rieber (writer) and John Cassaday (penciller), *Captain America, Vol. 1: The New Deal* (New York: Marvel Comics, 2003).

9 Mark Millar (writer) and Steve McNiven (penciller), *Civil War* (New York: Marvel Comics, 2007).

10 Warner Todd Huston, "Marvel Comics: Captain American Says Tea Parties Are Dangerous and Racist," *Renew America*, February 9, 2010, www.publiusforum.com.

11 Stephanie Condon, "Tea Party Nation Accepts Apology for Captain America Comic," *CBS News*, February 12, 2010, www.cbsnews.com; Brendan McGuirk, "Why Marvel Owes No Apologies for Captain America's 'Tea Party,'" *Comics Alliance*, February 11, 2010, http://comicsalliance.com.

12 For a look at the debates surrounding the announcement that Steve's longtime partner Sam Wilson would become Captain America, see the message boards following the announcement. Kwame Opam, "Marvel Is Replacing Steve Rogers with the New Black Captain America," *Verge*, July 16, 2014, www.theverge.com.

13 Stanford Carpenter, "Truth Be Told: Authorship and the Creation of the Black Captain America," in *Comics as Philosophy*, ed J. McLaughlin (Jackson: University Press of Mississippi, 2005), 46–62, 51.

14 Kimberly L. Phillips, *War! What Is It Good For? Black Freedom Struggles & the U.S. Military from World War II to Iraq* (Chapel Hill: University of North Carolina Press, 2012).

15 Phillips, *War!*, 26.

16 Phillips, *War!*, 21–22.

17 Maurice O. Wallace and Shawn Michelle Smith, eds., *Pictures and Progress: Early Photography and the Making of African American Identity* (Durham, NC: Duke University Press, 2012), 5.

18 See Brian Wallis, "Black Bodies, White Science: Louis Agassiz's Slave Daguerreotypes," *American Art* 9.2 (Summer 1995): 38–61.

19 Deborah Willis, "The Black Civil War Solider: Conflict and Citizenship," *Journal of American Studies* 51.2 (2017): 287–289.

20 See Maurice Wallace, "Framing the Black Soldier: Image, Uplift, and the Duplicity of Pictures," in Wallace and Smith, *Pictures and Progress*, 244–266.

21 Amy M. Mooney, "Seeing 'as Others See Us': *The Chicago Defender* Cartoonist Jay Jackson as Cultural Critic," *MELUS* 39.1 (Summer 2014): 115.

22 Jay Jackson, "The Enemy Is Still Here," *Chicago Defender*, August 30, 1941, 14.

23 Jay Jackson, "Dear Santa . . . ," *Chicago Defender*, December 19, 1942.

24 Jay Jackson, "The Modern Daniel," *Chicago Defender*, January 25, 1941, 14.

25 See Beth Bailey and David Farber, "The 'Double V' Campaign in World War II Hawaii: African Americans, Racial Ideology, and Federal Power," *Journal of Social History* 26.4 (Summer 93): 817–843.

26 Stuart Heisler (dir.) and Frank Capra (producer), *The Negro Soldier*, April 10, 1944.

27 A note about the "first Captain America" designation: There is serious debate among comics fans about whether Steve Rogers or Isaiah Bradley was first. Editor Axel Alonso stated that the inspiration for the series was that the military would have experimented on black people first. Morales also told me in an interview that because *Truth* was originally outside of the continuity of the Captain America comics, he also began with that idea. Baker explains later that issues 5 and 6 demonstrate that they are not disrupting the Captain America continuity. Isaiah Bradley's grandson, Elijah, would tell people that his grandfather was the first Captain America.

28 Helena Frenkil Schlam, "Contemporary Scribes: Jewish American Cartoonists," *Shofar* 20.1 (2001): 94–112, 98.

29 Wright, *Comic Book Nation*, 36.

30 Jennifer Ryan, "Truth Made Visible: Crises of Cultural Expression in 'Truth: Red, White, and Black,'" *College Literature* 38.2 (Summer 2011): 68.

31 Michael Medved, "Captain America, Traitor?," *National Review*, April 4, 2003, www.nationalreview.com.

32 Mila Bongco, *Reading Comics: Language, Culture, and the Concept of the Superhero in Comic Books* (New York: Garland, 2000), 94.

33 For an example of complaints about the work in *Truth* being too "cartoonish," see Michael Bedford, "*Truth: Red, White, and Black*—An Allegorical Retcon," *Monkeys Fighting Robots*, October 21, 2016, www.monkeysfightingrobots.co; Dave Buesig, "Captain America Reading Order," *Comic Book Herald*, January 23, 2014, www.comicbookherald.com, who discusses "many fans" who find the work "egregiously cartoonish."

34 Marc Singer, "'Black Skins' and White Masks: Comic Books and the Secret of Race," *African American Review* 35.1 (2002): 107–119, 107, 110.

35 For a discussion of concerns with black social issues in comics and black superheroes, see Adlifu Nama, *Super Black: American Pop Culture and Black Superheroes* (Austin: University of Texas Press, 2011).

36 Jeffrey A. Brown, *Black Superheroes, Milestone Comics, and Their Fans* (Jackson: University Press of Mississippi, 2001).

37 Qiong Li and Marilynn B. Brewer, "What Does It Mean to Be an American? Patriotism, Nationalism, and American Identity after 9/11," *Political Psychology* 25.5 (2004): 727–739, 728.

38 Ramzi Fawaz, *The New Mutants: Superheroes and the Radical Imagination of American Comics* (New York: New York University Press, 2016).

39 Martha C. Nussbaum, "Patriotism and Cosmopolitanism," in *For Love of Country?*, ed. Martha C. Nussbaum and Joshua Cohen (Boston: Beacon, 2002), 3–20, 4.

40 Anthony Appiah, "Cosmopolitan Patriots," in Nussbaum and Cohen, *For Love of Country*, 21–29, 22–23.

41 Bongco, *Reading Comics*, 103; Schlam, "Contemporary Scribes," n.p.

42 Michelle Wright, *Becoming Black: Creating Identity in the African Diaspora* (Durham, NC: Duke University Press, 2004), 7.

43 "Cap" is the shorthand characters in the comics and fans use for Steve Rogers. From this point on when I use "Cap," it is a designation of Steve Rogers.

44 W. E. B. Du Bois, "The Talented Tenth," in *The Negro Problem* (New York: James Pott, 1903), 31–75.

45 All citations come from the collected version of the comic book, which lacks page numbers. I designate the name of the issue in parentheses. Issue 1: "The Future" (TF), issue 2: "The Basics" (TB), issue 3: "The Passage" (TP), issue 4: "The Cut" (TC), issue 5: "The Math" (TM), issue 6: "The Whitewash" (TW), issue 7: "The Blackvine" (TBV). Robert Morales (writer) and Kyle Baker (penciller), "The Future," in *Truth: Red, White & Black* (New York: Marvel Comics, 2004), TF.

46 Morales and Baker, "The Future," TF.

47 John G. Cawleti, *Adventure, Mystery, and Romance* (Chicago: University of Chicago Press, 1976), 40.

48 Morales and Baker, *Truth: Red, White & Black*, 118.

49 Robert Morales (writer) and Kyle Baker (penciller), "The Cut," in Morales and Baker, *Truth: Red, White & Black*, TC.

50 Morales and Baker, "The Cut," TC.

51 Morales and Baker, "The Future," TF.

52 Jarret Lovell, "Nostalgia, Comic Books, & the 'War Against Crime!' An Inquiry into the Resurgence of Popular Justice," *Journal of Popular Culture* 36.2 (November 2002): 335–351, 346.

53 Wahneema Lubiano, "Black Nationalism and Black Common Sense: Policing Ourselves and Others," in *The House That Race Built: Black Americans, U.S. Terrain*, ed. Wahneema Lubiano (New York: Pantheon Books, 1997), 232–252, 233.

54 Morales and Baker, "The Whitewash," TW.

55 Morales and Baker, "The Whitewash," 233.

56 In his appendix, Morales discusses his sources on the history of US military experimentation.

57 Morales and Baker, *Truth: Red, White & Black*, "Appendix".

58 Robert Morales, telephone interview, August 2, 2004.

59 Morales, telephone interview.

60 Anne Anlin Cheng, *The Melancholy of Race: Psychoanalysis, Assimilation, and Hidden Grief* (New York: Oxford University Press, 2001), 8.

61 Cheng, *Melancholy of Race*, 14.

62 Cheng, *Melancholy of Race*, 20.

63 Morales, telephone interview.

64 Matt Brady, "Post Mortem-Truth: Red, White and Black," *Newsarama*, November 19, 2003, http://newsarama.com.

65 Christopher Moore, *Fighting for America: Black Soldiers—the Unsung Heroes of World War II* (London: One World/Ballantine, 2004), Kindle locations 2526, 2531, and 2536.

Chapter 4. "The Only Thing Unamerican about Me Is the Treatment I Get!"

1 Michael Chaney, *Reading Lessons in Seeing: Mirrors, Masks, and Mazes in the Autobiographical Novel* (Jackson: University Press of Mississippi, 2016), 57.

2 Dexter Gabriel, "Hollywood's Slavery Films Tell Us More about the Present Than the Past," *Colorlines*, January 9, 2013, www.colorlines.com; Tanya Steele, "The 'Lonely Slave' Narrative Continues to Thrive in Hollywood," *IndieWire*, October 21, 2013, www.indiewire.com.

3 Lauren Berlant, "Theory of Infantile Citizenship," *Public Culture* 5.3 (Spring 1993): 395–410.

4 Daniel Harris, *Cute, Quaint, Hungry and Romantic: The Aesthetics of Consumerism* (New York: Basic Books, 2000), 4.

5 Harris, *Cute, Quaint*, 18.

6 Sianne Ngai, *Our Aesthetic Categories: Zany, Cute, Interesting* (Cambridge, MA: Harvard University Press, 2012), 11. For other discussions of the cute in national discourse, see Lori Merish, "Cuteness and Commodity Aesthetics: Shirley Temple and Tom Thumb," in *Freakery: Cultural Spectacles of the Extraordinary Body*, ed. Rosemarie Garland Thomson (New York: New York University Press, 1996), 185–203.

7 *Diff'rent Strokes*, NBC (1978–1986); *Webster*, ABC (1983–1989).

8 Donna M. Hartman and Andrew Golub, "Social Construction of the Crack Epidemic in Print Media," *Journal of Psychoactive Drugs* 31.4 (1999): 423–433; Michael Welch et al., "Moral Panic over Youth Violence: Wilding and the Manufacture of Menace," *Youth and Society* 34.1 (August 2016): 3–30; John J. Dilulio Jr., "The Coming of the Super-Predators," *Weekly Standard*, November 27, 1995, www.weeklystandard.com.

9 Lee Edelman, *No Future: Queer Theory and the Death Drive* (Durham, NC: Duke University Press, 2004), 2.

10 Mary Russo, *The Female Grotesque: Risk, Excess, and Modernity* (New York: Routledge, 1995); Leonard Cassuto, *The Inhuman Race: The Racial Grotesque in American Literature and Culture* (New York: Columbia University Press, 1997).

11 Patricia Turner, *Ceramic Uncles and Celluloid Mammies: Black Images and Their Influence on Culture* (New York: Anchor, 1994), 12.

12 Robin Bernstein, *Racial Innocence: Performing*

American Childhood from Slavery to Civil Rights (New York: New York University Press, 2011), 40–41.

13 See Jeffrey Louis Decker's chapter on Horatio Alger in *Made in America: Self-Styled Success from Horatio Alger to Oprah Winfrey* (Minneapolis: University of Minnesota Press, 1997); W. T. Lhamon Jr., Horatio Alger and American Modernism: The One-Dimensional Social Formula," *American Studies* 17.2 (Fall 1976): 11–27.

14 Stella Ress, "Bridging the Generation Gap: Little Orphan Annie in the Great Depression," *Journal of Popular Culture* 43.5 (2010): 789.

15 Nancy Goldstein, *Jackie Ormes: The First African American Woman Cartoonist* (Ann Arbor: University of Michigan Press, 2008).

16 Oliver Wendell Harrington, *Dark Laughter: The Satiric Art of Oliver W. Harrington*, ed. M. Thomas Inge (Jackson: University Press of Mississippi, 1993), xi.

17 Ol. Harrington, "Scoop," *Baltimore Afro-American*, April 29, 1933, 21.

18 Harrington, "Scoop."

19 Harrington, *Dark Laughter*.

20 While it is not exactly the same framework I employ, see a discussion of the situational grotesque in James Iffland's *Quevedo and the Grotesque II* (London: Tamesis Books, 1982).

21 A politics of respectability, as Evelyn Brooks Higginbotham explains, is a politics of assimilation that demonstrates black women's ability to model religious, moral, and democratic ideals that were central to what the nation imagined itself to be. Respectability politics, however, clearly crosses gender lines and has enabled black people "to counter racist images and structures" (187). *Righteous Discontent: The Women's Movement in the Black Baptist Church, 1880–1920* (Cambridge, MA: Harvard University Press, 2003).

22 Daniel P. Moynihan, *The Negro Family: The Case for National Action* (Washington, DC: Office of Policy Planning and Research, US Department of Labor, March 1, 1965).

23 Paul A. Jargowsky, *Poverty and Place: Ghettos, Barrios, and the American City* (New York: Russell Sage Foundation, 1997).

24 Brumsic Brandon Jr., "'Luther' and the Black Image in the Comics," *Freedomways* 14.3 (1974): 233. Brandon frequently contributed cartoons to *Freedomways* (1961–1985), a black arts journal that featured the writing of prominent black intellectuals and writers such as Martin Luther King, James Baldwin, Alice Walker, C. L. R. James, and Kwame Nkrumah.

25 Brandon, "'Luther' and the Black Image."

26 Brandon, "'Luther' and the Black Image."

27 Brandon, "'Luther' and the Black Image."

28 They said that strips named after main characters are more successful. Brandon, "'Luther' and the Black Image," 235.

29 Brandon, "'Luther' and the Black Image," 236.

30 Published in 1970.

31 Published in 1970.

32 The show was adapted into a cartoon for Comic Network. In a conversation with McGruder in Columbus, Ohio, he told the author in a public conversation onstage that he was cognizant that children watched the show and changed the tone from the political content of the strip. "Conversation with Aaron McGruder" (30th Annual African American Heritage Festival, Newport Music Hall, Columbus, OH, April 30, 2008).

33 Sergio, "Aaron McGruder Finally Explains Why He Left 'The Boondocks'," *IndieWire*, May 28, 2014; www.indiewire.com.

34 Nancy C. Cornwell and Mark P. Orbe, "'Keepin' It Real' and/or 'Sellin' Out to the Man': African-American Responses to Aaron McGruder's *The Boondocks*," in *Say It Loud! African American Audiences, Media and Identity*, ed. Robin R. Means Coleman (New York: Routledge, 2002), 27–44.

35 Ben McGrath, "The Radical," *New Yorker*, April 11, 2004, www.newyorker.com.

36 Jayson Blair, "Some Comic Strips Take an Unpopular Look at U.S.," *New York Times*,
October 21, 2001, www.nytimes.com.

37 The USA PATRIOT Act was signed into law on October 26, 2001, and was a response to 9/11. Many people criticized the legislation as threatening civil liberties.

38 Anna Beatrice Scott, "Superpower vs. Supernatural: Black Superheroes and the Quest for Mutant Reality," *Journal of Visual Culture* 5.3 (2006): 295–314, 311.

39 Scott, "Superpower vs. Supernatural," 312.

40 Incidentally, Clarence Thomas was a big *Icon* fan, much to the consternation of Dwayne McDuffie, and the writer had a very funny essay about his disconcerted response to Thomas's admiration of *Icon* on his website, called "Here Comes the Judge." McDuffie passed away in 2011, and the website is no longer accessible.

41 Michael Chaney, ed., *Graphic Subjects: Critical Essays on Autobiography and Graphic Novels* (Madison: University of Wisconsin Press, 2011); Hillary Chute, "Comics as Literature? Reading Graphic Narrative," *PMLA* 123.3 (2008): 452–465.

42 Jeff Mays, "Jennifer Cruté: Using Comics, Life Story to Fight Stereotypes," *Newsone*, February 13, 2014, https://newsone.com.

43 Hillary Chute, *Graphic Women: Life Narrative and Contemporary Comics* (New York: Columbia University Press, 2010), 5.

44 Valerie Smith, *Self Discovery and Authority in Afro-American Narrative* (Cambridge, MA: Harvard University Press, 1987).

45 Lorene Cary, *Black Ice* (New York: Vintage, 1991); Margo Jefferson, *Negroland* (New York: Pantheon Books, 2015).

46 Qiana Whitted, "Race and Risks of 'Kiddie Garbage' Cartooning," *Hooded Utilitarian*, October 16, 2013, www.hoodedutilitarian.com.

47 Jennifer Cruté, *Jennifer's Journal: The Life of a SubUrban Girl*, vol. 1 (Self-published, 2005), 5.

48 Cruté, 50.

49 Cruté, vol. 2, 16.

50 Melissa Harris-Lacewell, "No Place to Rest: African American Political Attitudes and the Myth of Black Women's Strength," *Women and Politics* 23.3 (2001): 1–33.

51 Earlise Ward, "African American Men and Women's Attitude toward Mental Illness, Perceptions of Stigma, and Preferred Coping Behaviors," *Nursing Research* 62.3 (May–June 2013): 185–194; Vetta Sander Thompson et al., "African Americans' Perceptions of Psychotherapy and Psychotherapists," *Professional Psychology: Research and Practice* 35.1 (2004): 19–26.

Chapter 5. Rape and Race in the Gutter

1 Larry Fuller, email to author, June 18, 2017. All subsequent quotes from Fuller refer to this interview.

2 Robert Crumb, *Zap Comix* no. 1 (San Francisco: Apex Novelties, 1968).

3 Patrick Rosencranz, "The Limited Legacy of Underground Comics," in *Underground Classics: The Transformation of Comics into Comix*, ed. James Danky and Denis Kitchen (New York: Abrams Comic Arts, 2009). For a discussion of the self-regulating industry comics code in 1954, which changed the direction of EC Comics and limited content in Marvel and DC, see Amy Kiste Nyber, *Seal of Approval: The History of the Comics Code* (Jackson: University Press of Mississippi, 1998).

4 Susan Spiggle, "Measuring Social Change: A Content Analysis of Sunday Comics and Underground Comix," *Journal of Consumer Research* 13.1 (June 1986): 101. See also Jack Levin and James L. Spates, "Hippie Values: An Analysis of the Underground Press," *Youth & Society* 2.1 (1970): 59–73.

5 For a discussion of the "boys club" in the underground scene and feminist comix production in the 1970s and 1980s, see Trina Robbins's introduction to *The Complete Wimmen's Comix* (Seattle: Fantagraphics Books, 2016);

Margaret Galvan, "Feminism Underground: The Comics Rhetoric of Lee Mars and Roberta Gregory," *Women's Studies Quarterly* 3/4 (Fall/Winter 2015): 203–222.

6 *Gay Comix* (1980–1998), initially edited by Howard Cruse and published by Kitchen Sink Press, is probably the most famous example of gay comix.

7 Raúl Pérez, "Don Rickles, the 'Equal Opportunity Offender' Strategy, and the Civil Rights Movement," in *Standing Up, Speaking Out: Stand-Up Comedy and the Rhetoric of Social Change*, ed. Matthew R. Meier and Casey R. Schmitt (New York: Routledge, 2017), 72.

8 See John Limon, *Stand Up Comedy in Theory, or Abjection in America* (Durham, NC: Duke University Press, 2000).

9 Charles Hatfield, *Alternative Comics: An Emerging Literature* (Jackson: University Press of Mississippi, 2005), 8.

10 Patrick Rosenkranz, *Rebel Visions: The Underground Comix Revolution, 1963–1975* (Seattle: Fantagraphics Books, 2008), 221.

11 Hatfield, *Alternative Comics*, x.

12 As obscenity laws pushed comics from newsstands in the early seventies, the underground comics scene also facilitated the growth of a specialized group of fans in a comics industry already much diminished from its popularity in the middle of the twentieth century.

13 B. N. Duncan, *R. Crumb: Conversations* (Jackson: University Press of Mississippi, 2004), 123; Christopher Borelli, "R. Crumb Reflects on 'The Complete Zap Comix,'" *Chicago Tribune*, November 14, 2014, www.chicagotribune.com.

14 Nicholas Barber, "The Sublime Robert Crumb," *Economist*, July 1, 2016, www.1843magazine.com.

15 See Edward Shannon, "Shameful, Impure Art: Robert Crumb's Autobiographical Comics and the Confessional Poets," *Biography* 35.4 (2012): 627–649; and "Something Black in the American Psyche: Formal Innovation and Freudian Imagery in the Comics of

Winsor McCay and Robert Crumb," *Canadian Review of American Studies* 40.2 (2010): 202.

16 Hilton Als, "When Comics Aren't Funny," *New Yorker*, November 1994, 48.

17 Corey K. Creekmur, "Multiculturalism Meets the Counterculture: Representing Racial Difference in Robert Crumb's Underground Comix," in *Representing Multiculturalism in Comics and Graphic Novel*, ed. Carolene Ayaka and Ian Hague (New York: Routledge, 2015), 19–33, 19.

18 In *Race Music: Black Cultures from Bebop to Hiphop* (Berkeley: University of California Press, 2003), Guthrie P. Ramsey agrees with scholars who have cautioned against overemphasizing blues music as the principal sign of authentic black culture but sees some blues songs as helping to shape African American culture, identity, and social reality (46).

19 See Norman Mailer, "The White Negro," *Dissent* 20 (Fall 1957), www.dissentmagazine.org, for an infamous articulation of an alliance between blackness and white hipster culture. See Christopher Gair, *American Counterculture* (Edinburgh: Edinburgh University Press, 2007), in which he argues that the Beats "tended to appeal to what they identified as genuine 'American' values, such as individual freedom of choice, as alternatives to a corporate capitalism that they perceived to be corrupting American ideals." But "the language used to express these views often attempted to mimic the voices of an urban African-American culture largely denied both the freedoms that the Beats saw as epitomizing true American individualism and the spoils of American national prosperity. There is an irony in this appropriation that appears to have been lost on many of the Beats themselves, since their focus on certain forms of African-American cultural production was not paired with much understanding of the historical factors

that had helped to shape black art" (26).

20 Edward A. Shannon argues that characters like Mr. Natural "share Crumb's sexual fixation on and fear of revulsion from powerful women" in "Something Black in the American Psyche," 204.

21 Sigmund Freud, *Jokes and Their Relation to the Unconscious*, trans. James Strachey (New York: Norton, 1990), 118.

22 Freud, *Jokes and Their Relation to the Unconscious*, 122.

23 Freud, *Jokes and Their Relation to the Unconscious*, 123.

24 Als, "When Comics Aren't Funny," 48.

25 Brandon Nelson, "'Sick Humor Which Serves No Purpose': Whiteman, Angelfood and the Aesthetics of Obscenity in the Comix of R. Crumb," *Journal of Graphic Novels and Comics* 8.2 (2017): 139–155.

26 Robert Crumb, *The Complete Crumb Comics*, vol. 5, 4th ed., ed. Gary Groth, Robert Fiore, and Robert Boyd (Seattle: Fantagraphics Books, 2013), 16–19.

27 Crumb, *Complete Crumb Comics*, 5:17.

28 Crumb, *Complete Crumb Comics*, 5:19.

29 Darieck Scott, "Big Black Beauty: Drawing and Naming the Black Male Figure in Superhero and Gay Porn Comics," in *Porn Archives*, ed. Tim Dean, Steven Ruszczycky, and David Squires (Durham, NC: Duke University Press, 2014), 209.

30 I take the term "misogynoir" from Moya Bailey, "New Terms of Resistance: A Response to Zenzele Isoke," *Souls* 15 (2013): 341–343.

31 Robert Crumb, "Mr. Snoid in 'Once I Lived the Life of a Millionaire,'" in *The Complete Crumb Comics*, vol. 5, 2nd ed., ed. Mark Thompson (Seattle: Fantagraphics Books, 2013), 59–72.

32 See Robin R. Means Coleman, *African American Viewers and the Black Situation Comedy: Situating Racial Humor* (New York: Garland, 1998), 63–65.

33 Crumb, "Mr. Snoid," 72.

34 Avery Gordon, *Ghostly Matters: Haunting and the Sociological Imagination* (Minneapolis: University of Minnesota Press, 1997), 4.

35 Fuller email.

36 Larry Fuller, instant message to the author, June 27, 2018.

37 Richard "Grass" Green, *Super Soul Comix* (1972 series), issue 1 (Princeton, WI: Kitchen Sink Press, October 1972); Bill Schelly (writer) and Richard "Grass" Green (penciller and ink), "Xal-Kor the Human Cat," *The Eye Collection (2002 Series)* (Seattle: Hamster Press, June 2002).

38 Richard "Grass" Green and Sam Sorig (pencillers), "Prison of Arab Slavers," *Bizarre Sex* (1972 series), issue 2 (Princeton, WI: Kitchen Sink Press, November 1972); Richard "Grass" Green (penciller), "Wild Man Meets Rubberboy," *Snarf* (1972 series), issue 2 (Princeton, WI: Kitchen Sink Press, August 1972); Richard "Grass" Green (penciller), *White Whore Funnies* (1979 series), issue 3 (Fort Wayne, IN: Inkwell, December 1979).

39 Scott, "Big Black Beauty," 194.

40 Scott, "Big Black Beauty," 209.

41 This is particularly the case with the rise of parody in pornographic films.

42 Wayne C. Booth, *The Rhetoric of Fiction* (Chicago: University of Chicago Press, 1961), 138.

43 Larry Fuller (writer) and Larry Davis (penciller), "Some Tight White Ass," *White Whore Funnies*, issue 3 (Fort Wayne, IN: Inkwell, December 1979).

44 *The Birth of a Nation*, dir. D. W. Griffith (1915).

45 *White Whore Funnies* no. 2 (Larry Fuller Presents, 1978).

46 Richard Dyer, *White* (London: Routledge, 1997), 78: "Whiteness, really white whiteness, is unattainable. Its ideal forms are impossible."

47 Mireille Miller-Young, *A Taste of Brown Sugar* (Durham, NC: Duke University Press, 2014), 27.

48 Eve Kosofsky Sedgwick, *Between Men: English Literature and Male Homosocial*

Desire (New York: Columbia University Press, 1985).

49 Fuller email.

50 Miller-Young, *Taste of Brown Sugar*, 9.

51 Miller-Young, *Taste of Brown Sugar*, 9.

52 Miller-Young, *Taste of Brown Sugar*, 10.

53 Jennifer Nash, *The Black Body in Ecstasy: Reading Race, Reading Pornography* (Durham, NC: Duke University Press, 2014), 2.

54 Nash, *Black Body in Ecstasy*, 4.

55 Nash, *Black Body in Ecstasy*, 87.

56 Nash, *Black Body in Ecstasy*, 111.

57 Brian Cremins, "'A Space of Concentration': The Autobiographical Comics of Richard 'Grass' Green and Samuel R. Delany," in *Reading African American Autobiography: Twenty-First Century Contexts and Criticism*, ed. Eric D. Lamorre (Madison: University of Wisconsin Press, 2017), 156.

58 Cremins, "'Space of Concentration.'"

59 Richard "Grass" Green, Billy Ireland Cartoon Library and Museum, Jay Kennedy Collection, box 60.

60 Richard "Grass" Green, *Thesis on Sex*, Billy Ireland Cartoon Library and Museum, Jay Kennedy Collection, box 60.

61 Richard "Grass" Green, "Questions and Answers Part 2," *Un-Fold Funnies* no. 19, Billy Ireland Cartoon Library and Museum, Jay Kennedy Collection, Box 60.

62 Richard "Grass" Green, *Un-Fold Funnies*, "Questions and Answers—Part Two," no. 19.

63 Richard "Grass" Green, "Ghetto Bitch vs. the 'Jesus Freak,'" *Ghetto Bitch*, issue 1 (Eros Comics—Fantagraphics Books, 1993).

Coda

1 Tre Johnson, "Black Superheroes Matter: Why a 'Black Panther' Movie Is Revolutionary," *Rolling Stone*, February 16, 2018, www.rollingstone.com; Nicholas Barber, "Black Panther: The Most Radical Hollywood Blockbuster Ever?," *BBC*,

February 6, 2018, www.bbc.com; Jamil Smith, "The Revolutionary Power of Black Panther," February 11, 2018, time.com.

2 Paul Bios, "Black Panther Review: This Deeply Conservative Movie Makes Captain America Look Like a Neo-Marxist Stooge," *Daily Wire*, February 19, 2019.

3 Gathara is not only a successful cartoonist whose work is published internationally. He has also produced scholarship on the subject. See Patrick Gathara, *Drawing the Line: The History and Impact of Cartooning in Kenya* (Nairobi: Freidrich Ebert Stiftung, Association of East African Cartoonists, 2004).

4 Patrick Gathara, "Black Panther Offers a Regressive, Neocolonial Vision of Africa," *Washington Post*, February 26, 2018, www.washingtonpost.com.

5 Micah Peters, "The Evolution of Marvel's 'Black Panther': Tracing the Comic Book Origins of a Complex, Exciting Character—and the Series That (Sometimes) Bears His Name," *Ringer*, February 14, 2018, www.theringer.com; Elliot Hannon, "Today in Conservative Media: *Black Panther*'s Wakanda Basically Relies on Real World Conservative Foreign Policy," *Slate*, March 12, 2018, https://slate.com.

6 Bradford W. Wright, *Comic Book Nation: The Transformation of Youth Culture in America* (Baltimore: Johns Hopkins University Press, 2003), 36.

7 Stan Lee (writer), Jack Kirby (penciller), Joe Sinnott (inker), and Sam Rosen (letterer), *Fantastic Four*, issue 52 (New York: Marvel Comics, July 1966).

8 On Vanishing Americans, see Lora Romero, "Vanishing Americans: Gender, Empire, and New Historicism," *American Literature* 63.3 (September 1991): 385–404.

9 Rene Lemarchand, "The CIA in Africa: How Central? How Intelligent?," *Journal of Modern African Studies* 14.3 (1976): 401–426.

10 Ramzi Fawaz, *The New Mutants: Superheroes and the Radical Imagination of American Comics* (New York: New York University Press, 2016), 120.

11 See, for example, Jamil Smith, "The Revolutionary Power of 'Black Panther,'" *Time*, February 11, 2018, http://time.com.

12 Michelle Wright, *Becoming Black: Creating Identity in the African Diaspora* (Durham, NC: Duke University Press, 2004), 4.

13 *Icon* no. 30, Dwayne McDuffie (writer), Mark Bright (penciller). Milestone, 1995.

14 Andy Crump, "More Than a Great Superhero Show: *Luke Cage* Is about Black Identity, or Black Identities," *Paste*, September 28, 2016, www.pastemagazine.com.

15 In an interview with George Stephanopoulos, Wilson said that Brown looked "like a demon." Wilson would not be charged. *World News Tonight*, ABC, November 25, 2014.

16 Christopher Lebron, "'Black Panther' Is Not the Movie We Deserve," *Boston Review*, February 17, 2018, http://bostonreview.net.

17 See Frederic Wertham, *Seduction of the Innocent: The Influence of Comic Books on Today's Youth* (1953; New York: Rinehart, 1954). He was concerned that crime comics often glorified criminals.

18 J. Lamb, "Magneto Was Right," *Nerds of Color*, September 18, 2013, https://thenerdsofcolor.org.

19 Laurence Baron, "'X-Men' as J Men: The Jewish Subtext of a Comic Book Movie," *Shofar* 22.1 (Fall 2003): 44–52, 48.

20 Phenderson Djèlí Clark, "On Malcom, Martin and That X-Men Analogy Thing," February 21, 2015, https://pdjeliclark.wordpress.com.

21 Kathrin M. Bower, "Holocaust Avengers: From 'The Master Race' to Magneto," *International Journal of Comic Art* 6.2 (Fall 2004): 182–194, 189.

22 Hortense Spillers, "'All the Things You Could Be by Now if Sigmund Freud's Wife Was Your Mother': Psychoanalysis and Race," *boundary 2* 23.3 (Autumn 1996): 75–141, 100.

23 Avery Gordon, *Ghostly Matters: Haunting and the Sociological Imagination* (Minneapolis: University of Minnesota Press, 2008), 6.

Index

poverty, 22, 164
 in children's comics, 141,
 139–54
 in civil rights activism, 97,
 109, 128
 in superhero comics, 16, 216
Powell, Colin, 135
Powell, Richard J., 35
Priest, Christopher, 210
Professor X, 217
propaganda, 46, 56
 art as, 31
 Du Bois on, 38, 41, 46
 military, 114–16, 120, 123,
 136
Pryor, Richard, 135, 188
Pulitzer, Joseph, 31
Punch, 225n13

queerness, 17, 173

racial integration, 27, 46, 80
 in comics, 12–13, 15, 28–29,
 59, 151, 155, 186
Raiford, Leigh, 95
Ramsey, Guthrie P., 236n18
rape joke, 27–28, 171–205
Reagan, Ronald, 96, 113, 149
realism, 4, 23, 30, 41, 47, 63, 89
 in editorial cartoons, 7, 10,
 50, 54, 79, 147
 gender and, 168, 182
 magical realism, 134
 sexuality and, 196
 in superhero comics, 16, 215,
 218
Reconstruction, 79, 82
religion, 18, 107, 164–65, 202,
 204, 235n21
 See also Christianity;
 Judaism
Republican Party, 18, 52, 161
 See also Tea Party
respectability politics, 22, 36,
 53–56, 61, 69, 72, 82, 96, 101
 as assimilation, 235n21
 children and, 147
 patriotism and, 111
the revolutionary leader, 6,
 18–21, 25–26, 71–110, 112,
 128–29, 188
Richardson, Afua, 24
Rickles, Don, 173
Robbins, Trina, 173
Robin (Batman's partner), 160
Rogers, Steve (Captain America),
 113–14, 122–27, 129, 134–35,
 233n12, 233n27, 234n43
Roosevelt, Franklin Delano, 145
Rosenkranz, Patrick, 176
Ross, Everett, 210
Runstedtler, Theresa, 226n27
Rushdy, Ashraf H. A., 84
Russo, Mary, 144
Rustin, Bayard, 96, 211
Ryan, Jennifer, 124

Salus-Grady libel law, 17
San Francisco Comic Book
 Company, 186
Satrapi, Marjane
 Persepolis, 163
Schulz, Charles, 14–15
 Peanuts, 13, 140, 144, 226n40
 See also Brown, Charlie;
 Franklin
scientific racism, 4, 117
Scott, Anna Beatrice, 159–60
Scott, Darieck, 181, 186–87
Sedgwick, Eve, 196
sexism, 27, 59, 172–77, 190, 192,
 202, 204
 See also misogynoir
sexuality, 17, 165, 217, 225n12
 Comics Code and, 17
 racially gendered, 10, 57, 61,
 237n20
 sex education, 143
 in underground comix,
 171–205
 See also queerness
sexual violence, 27–28, 171–205
Shannon, Edward A., 42–43
Sharpe, Christina, 208
Shearer, Ted
 Quincy, 139, 151
Simon, Joe, 123
simulacrum, 75, 96, 98, 232n75
Singer, Marc, 72, 126
Sklar, Rachel, 18, 20
slavery, 22, 127, 141, 158–59, 164,
 193, 208
 citizenship and, 25
 in editorial cartoons, 1–2, 7, 75
 in graphic biographies,
 71–98, 230n4
 slave codes, 86
 See also Middle Passage;
 neo-slave narratives
Smith, Shawn Michelle, 117
Smith, Valerie, 164
Snoid, 182–85
Snyder, Zach
 Man of Steel, 230n15
the soldier, 72, 74, 101
 citizenship and, 15, 24, 63
 racialized, 7, 26, 48, 78,
 81–82, 112–38
Southern Christian Leadership
 Conference, 100
Spade, Wiley. *See* Fuller, Larry
Spiderman, 15, 227n45
Spillers, Hortense, 88, 219
Starr, Brenda, 12
stereotypes, 30, 33, 36, 39–41, 59,
 117
 in children's comics, 12–14,
 141, 146–47, 155, 158,
 161–64, 197–204
 citizenship and, 6, 66
 definition, 5
 in editorial cartoons, 1–2,
 20–23

in graphic biographies, 74,
 89, 125
 history of, 225n12
 in superhero comics, 15, 27,
 207–8, 212
 in underground comix,
 172–82, 189
 See also Beulah trope; big
 black dick trope; black
 rapist trope; Eva trope;
 Golliwog trope; mammy
 trope; pickaninny trope;
 Topsy trope; Uncle Tom
 trope; unwed teenage
 mother trope
Stevens, J. Richard, 113
Stonewall Rebellion, 173
Storm, Johnny, 209
Stowe, Harriet Beecher Stowe
 Uncle Tom's Cabin, 41, 78,
 139
Student Nonviolent Coordinat-
 ing Committee (SNCC),
 54–55, 99
Studio Museum, 56
Styron, William
 *The Confessions of Nat
 Turner*, 84
superhero comics, 3, 62, 72, 84,
 186–87, 205
 children and, 140–42
 gender in, 158–63
 race and, 14–16, 26, 111–38,
 172, 207–20
Superman, 15–17, 113, 124, 158,
 161–62
*Superman's Girl Friend, Lois
 Lane*, 15–17
surface reading, 21
surrealism, 34, 37–38
sympathy, 7, 26–27, 53, 77, 82, 96,
 142–43, 154, 217

Tammany Hall, 225n17
Tarzan, 185, 209
Taylor, Paul, 35
Tea Party, 114
temporality, 23, 30
 gender and, 57, 175–76
 race and, 64–67, 75–86,
 175–77, 214
terrorism, 18, 114, 156–57,
 227n46
Texeira, Max, 210
Thomas, Clarence, 235n40
Till, Emmett, 63
Tisserand, Michael, 31, 37
Töpffer, Rodolphe, 4
Topsy trope, 139
Torres, Sasha, 95
Tracy, Dick, 12
triangulated interpretive
 structure, 20–21, 148, 180, 185,
 192, 210
 humor and, 48, 141, 174–75,
 197

About the Author

Rebecca Wanzo is Associate Professor of Women, Gender, and Sexuality Studies at Washington University in St. Louis. She is the author of *The Suffering Will Not Be Televised: African American Women and Sentimental Political Storytelling* (2009) and writes about race, feminism, popular culture, and political discourse.